cyberfeminism
2.0

Steve Jones
General Editor

Vol. 74

The Digital Formations series is part of the
Peter Lang Media and Communication list.
Every volume is peer reviewed and meets
the highest quality standards for content and production.

PETER LANG
New York • Washington, D.C./Baltimore • Bern
Frankfurt • Berlin • Brussels • Vienna • Oxford

cyberfeminism
2.0

EDITED BY
Radhika Gajjala AND Yeon Ju Oh

PETER LANG
New York • Washington, D.C./Baltimore • Bern
Frankfurt • Berlin • Brussels • Vienna • Oxford

Library of Congress Cataloging-in-Publication Data

Cyberfeminism 2.0 / edited by Radhika Gajjala, Yeon Ju Oh.
p. cm. — (Digital formations; v. 74)
Includes bibliographical references and index.
1. Cyberfeminism. 2. Women—Computer network resources.
I. Gajjala, Radhika. II. Oh, Yeon Ju. III. Title: Cyberfeminism two point oh.
HQ1178.C925 302.23'1—dc23 2011037848
ISBN 978-1-4331-1359-8 (hardcover)
ISBN 978-1-4331-1358-1 (paperback)
ISBN 978-1-4539-0209-7 (e-book)
ISSN 1526-3169

Bibliographic information published by **Die Deutsche Nationalbibliothek**
Die Deutsche Nationalbibliothek lists this publication in the "Deutsche
Nationalbibliografie"; detailed bibliographic data is available
on the Internet at http://dnb.d-nb.de/.

The paper in this book meets the guidelines for permanence and durability
of the Committee on Production Guidelines for Book Longevity
of the Council of Library Resources.

© 2012 Peter Lang Publishing, Inc., New York
29 Broadway, 18th floor, New York, NY 10006
www.peterlang.com

Printed in the United States of America

Contents

Acknowledgments

We would like to thank our series editor, friend, and mentor, Steve Jones; the acquisitions editor, Mary Savigar; and the production editor, Sophie Appel for giving us guidance and reading the manuscript with great care. We are very grateful for their enthusiasm and congeniality, which encouraged the contributors and us to complete this project. Radhika especially thanks them for having the patience to work with her again!

In addition, Radhika Gajjala would like to acknowledge all her graduate student advisees and collaborators for the continuing insights that her interaction with them and their words provide into her own research and publishing projects. As always she would like to thank her spouse, "Vinnie" Gajjala, for his quiet support of her manic frenzy as she gets her continuing projects done while simultaneously starting new ones. The son (Pratap) must also be acknowledged for not disowning her (yet). Also, it has been a great pleasure working with Yeon Ju as co-editor.

Yeon Ju Oh would like to thank the School of Media and Communication at Bowling Green State University for providing a supportive environment that enabled her to work on this book project. She owes a great debt to the professors and colleagues in the school for their invaluable comments that constantly gave her inspiration not only for this project but also for her entire academic journey. She would like in particular to thank her advisor Radhika Gajjala for the great ethics she has shown in her research, teaching, and relationship with colleagues and students.

Introduction

Cyberfeminism 2.0:
Where Have All the Cyberfeminists Gone?

Radhika Gajjala and Yeon Ju Oh

As early as 1997, Faith Wilding and Critical Art Ensemble attempted to define cyberfeminism as "a promising new wave of thinking and practice" (1998, p. 47) that had emerged with the growing presence of women on the Net. While they admit that technology as a male domain had often been used in a way that reinforced women's status as locked in the domestic life, they view the Net as a site where subversion of existing gender relations can be incubated. Their persistent use of the word "Net," now somewhat archaic, reflects the vision of new media technology as a ground for networking, that is, collective feminist theorizing and practice. Thus, "the territory of cyberfeminism is large. It includes the objective arenas of cyberspace, institutions of industrial design, and institutions of education—that is, those arenas in which technological process is gendered in a manner that excludes women from access to the empowering points of techno-culture" (p. 50). In other words, cyberfeminism necessitates an awareness of how power plays not only in different locations online but also in institutions that shape the layout and experience of cyberspace. However, this does not mean that individual experiences become overshadowed and determined by institutional structures; rather, it means that the understanding of those institutions should be examined with decentered, multiple, and participatory practices.

In the 1990s, several scholars and activists came forth with cyberfeminist interventions and analyses of techno-cultures worldwide, and their work connected with that of well-known feminists such as Donna Haraway, Katherine Hayles, and Vandana Shiva, among others. This collection is meant to be an exploration of what it means to be cyberfeminist now, more than a decade after feminists burst forth onto the Internet scene to demand material access and social intervention both online and offline. What, for instance, does it mean to be "cyberfeminist" at a time when women are omnipresent on the Internet as consumers and as paid and free laborers? How does cyberfeminism play out in relation to forms of social entrepreneurship and online phi-

lanthropy? What role do feminists play in a digital era of social networks, gaming cultures, and digital finance, when claims are made that feminism is no longer necessary? How do race, class, place, space, ethnicity, religion, and nationalism play into how women negotiate various techno-mediated environments online and offline? In other words, where have all the cyberfeminists gone? To find the answers, the authors in this collection delve into the way in which digital technologies play out while interweaving the themes of female body politics, affective/reproductive labor, feminist geography, subjectivity formation, and social/cultural divide.

The answers are not simple. Technological determinism, prevalent during the nascent stage of the Internet, has faded away. As Judy Wajcman (2004) contends, either technological utopianism or dystopianism is all too simple. Most important, as the relationship between new media/information technology and neoliberalism has been interlocking, the boundary between empowerment/subjectivity/agency and market-driven formation of self, which in fact has never been clear, becomes more nebulous. Scholars who examine techno-cultures have addressed this issue with different foci. Terranova (2004), examining free labor in the digital era, located the conflicting point where voluntary, creative labor can be either a means of self-expression or exploitative power that mobilizes "creative and effective desire for creative production" (p. 77) for market value. In a similar vein, Castells (2000) contends that capitalism is reshaping itself to appeal to a newly emerging class in techno-informational areas that suggests a decentralized organization, but in fact is more centralized than ever before, with the power of managing labor, capital, and information. Barbrook (2006), in his study of the new class equipped with techno-culture-related knowledge and dedicated to an ongoing effort to refashion itself to keep up with that knowledge, states that this class can be both a new ruling and working class. What can be drawn from these works is that it is never possible to claim that the new digital technology generates fixed responses or sides with a certain political viewpoint. For cyberfeminist scholars and activists, this conflicting position poses challenges. How must we respond to the pleasing discourses of women's empowerment through blogging, networking, financing, or entrepreneurship when we suspect that digital technologies, intertwined with neoliberal market logic, exercise subtle, indeed invisible, power? How do we intervene when cyberfeminism is not considered to embody feminist politics but is used as a buzzword to celebrate women's mere presence and self-expression online? As Couldry (2010) contends, if voice does not mean the

PROBLEMA COMO LIBERALISMO →

voice of the consumer, and the "notion of freedom is purely individualist and makes no reference either to people's socially oriented goals or to the conditions of social cooperation necessary for any meaningful notion of freedom" (p. 66), then cyberfeminists should look at women's participation online, avoiding the trap of hailing women's voices simply because they are women's voices. This should by no means encourage researchers to interpret women's voices from a privileged position, that is, suggesting that they are more epistemologically competent in seeing social and political structures. Rather, it is a call for rigorous examination by researchers in order to unpack contradicting and inconsistent voices of women. The authors of this collection attempt to reveal the struggle and negotiations as these competing voices enact women's presence online.

The first section of this book visits online sites that have been celebrated for their empowering potential for women: Health 2.0, user-generated content, and the blogosphere. Biotechnology, in particular reproductive technology, is an area in which feminists have been involved for the last 4 decades. Among the specific applications of biotechnology, artificial insemination— more often known as intrauterine insemination (IUI)—has fostered debate in feminist circles regarding a woman's right to control her body versus the male-dominated medical institutions' surveillance of women's bodies. Feminists who have criticized this new technology have seen it as a male desire to control female bodily functions, leaving women unaware of their bodies. Marina Levina focuses on how market forces refashion this criticism in a way that restores women's rights over their own bodies. Levina argues that the emerging Health 2.0 websites that celebrate Internet users' participation in their own health management are intertwined with feminist discourses of empowerment. While Health 2.0 websites encourage users to take control of their health-related data and thus resist medical institutions through the notion of "virtual kinships," there is an absence of questions that ask who benefits from the data collected and what drives the empowerment discourses. Although the current Health 2.0 sites resemble the 1970s feminist health movement, Levina contends that Health 2.0 services lack feminist input that would explore the systemic problems that generate inequalities in the management of health and the treatment of illness. That is, under the self-management discourse, there is a lack of public intervention that would narrow the gap between those who can afford to learn and manage health-related

data and those who cannot. The consequence is that the marginalized are left vulnerable to ill health.

The influence of market forces is also examined in Daniels's chapter, with an emphasis placed on the blogosphere. Daniels uses a political economy approach to examining conventions for mother bloggers. Through observations of two blogger conferences—one primarily attended by white women and the other by women of color—Daniels finds that there is a feminist motivation behind the work of women bloggers, who represent motherhood in alternative ways and who link women's diary keeping in the print era to women's blogging in the digital era as a part of feminist history. However, Daniels points out that corporate pressures often drive women to reinscribe and reinforce their roles as mothers and wives in order to make their blogs marketable to advertisers, and so corporations have come to have the power to determine what is relevant to women's lives. Further, as the blogosphere gains more market clout, black upper-middle-class or middle-class women who have purchasing power have become the main focus in the conference for women of color.

As Daniels shows, social networking sites and blogs, located at the intersection of affective/reproductive labor and technology, are the venues for women to explore subjectivity formation and identity construction as they simultaneously face objectification and placement in hierarchies of race, gender, geography, and class. Social/educational status as well as political economy and race complicate this practice. Rather than seeing cyberspace merely as an emancipatory arena, the authors of this collection look at the way in which the contestation surrounding the meaning of gender and the hegemonic discourses of gender are reinforced and, at the same time, shifted and deconstructed. In an analysis of female doctoral students' "about me" pages, Angelone looks at the ways in which the students represent their subjectivities as a part of learning and negotiating their identities. On the one hand, female doctoral students challenge what are considered to be normative femininity by discussing academics, subverting the myth that women are non-technical, and sometimes labeling themselves as feminists. On the other hand, feminine qualities appear in their self-representation as relationship-focused, emotional, and friendly. Although Angelone does not see femininity as a fixed notion or one that is in opposition to feminism, she argues that female doctoral bloggers need to contemplate whether their blogging generates normative meanings of femininity that sustain gendered power relations.

Along with the blogosphere, user-generated content has been considered one of the promising areas for accommodating Internet users' self-expression. It is often claimed that the processes of creating cultural content have resistant potentials by collapsing the hierarchical boundary between producer and consumer and by helping consumers to create their own meaning from cultural texts. However, when the content reproduces the existing power relations, the potential of user-generated content is called into question. Sibielski, examining *Twilight*-based machinima, problematizes the representation of dominant culture that neither challenges the power relations surrounding race, sex, and sexuality, nor creates subversive meanings. Often overshadowed by a desire to discover democratic and resistant potentials from the participatory culture, Sibielski contends, scholarly examinations of user-generated creative works, especially those produced by girls, often lack critical stances toward its reinscription of hegemonic culture. Criticizing the naïve interpretation of independently produced content as an alternative to the existing cultural representation, Sibielski asks whether a participatory culture can generate social changes that lead to material and symbolic improvements in women's lives.

Kruse also finds the contradictory aspects of user-generated content online. In her examination of girls' and young women's creative works of tribute to a female racehorse champion, Kruse values their skills in appropriating popular culture and producing non-commercial content. However, she argues that cultural poaching is not independent of institutional and patriarchal power embedded in the existing cultural text. That is, without challenging current popular culture, user-generated content itself cannot generate subversive meanings. Further, the "attention economy" that dominates the online environment often facilitates the reproduction of commercial values and hegemonic discourses as users employ these tools as a way of getting attention.

The last chapter of this section looks at the role played by digital technology when it is opened up to groups who do not have their own infrastructure. In an analysis of UNESCO's audiovisual E-Platform, which was designed to distribute public-oriented television content produced in developing countries, James locates institutional barriers that prevent the producers from accessing the tool. The submission process, requiring text-based literacy skills that target Anglophone populations, reveals that the empowering tool continues to exclude the marginalized from knowledge building and

sharing processes. In assessing problems related to the claim of technological determinism that new digital technologies provide liberating and democratic tools, James examines the accessibility and usability of new technological platforms for the marginalized.

The second section of this book addresses the issue of the mythological association between masculinity and technology that serves to shape women's agency and identities online. As this section's chapters reveal, women's experiences and practices online are influenced by the old assumption of what it means to be a woman. Gaming that has been constructed as a male domain is investigated in chapters by Kubik and Beyer. Although these two chapters do not directly incorporate economic factors, they imply that what it means to be a male gamer is defined in relation to the video game industry. Hegemonic voices in game environments come from those who believe themselves to be valuable contributors to the game industry. They are often male, hardcore gamers who connect hardcoreness and masculinity to industrial values.

Kubik contends that the binary between "hardcore" and "casual" gamers sustains the idea that hardcore gamers, mostly males, are the normative subjects in video gaming environments, othering casual gamers who are often women. While hardcore gamers are framed as "true gamers" and beneficial to the game world as a whole, casual gamers are devalued as inauthentic and even dangerous to the community. What is notable in Kubik's chapter is that types of gamers are still in the process of being defined, not already determined. She elaborates on how the process functions to position masculinity as normative in the game world, marginalizing Others' identities as gamers.

As hardcore games are considered to be male domains, women's experiences in these games are colored by aggressive and sexist climates created by male gamers. Beyer, examining *World of Warcraft*, one of the most male-dominated game environments, argues that it reflects the gender politics of offline spaces. Women appear to be attention seekers who destroy the order of the male enclave by being sexual objects, although their physical bodies are invisible. Beyer suggests that for a woman to be a neutral gamer is to pretend to be a man in the male-dominated space. As a strategy to survive as female gamers, Beyer finds that women often join guilds that are open to gamers with diverse identities. Downey makes a cautious observation of guilds through "tween" girls' involvement in gaming environments. While Downey recognizes the potential of guild involvement as a way of socializing and building skills for collective problem solving beyond a safety strat-

egy, she identifies problems wherein such potentials are diminished by individual plays such as avatar or interior decoration, which shape identities as commodities.

Way contends, however, that technology as a male domain is more mythical than real. Way conducted an oral history project in an attempt to deconstruct the association between masculinity and technology. She attempts to disclose the constitutive construction of technology and gender relations rather than take a determinist view of technology. In particular, she focuses on female artists who have used technology in their work in order to unpack the historical phases in which technology became framed as a male realm. Way also values the learning experiences of her students who were involved in the project. She contends that the project not only engages students with women's history writing but also helps them to learn the intertwined relationship between the social and technological.

The last section of the book examines the potential for, and limitations of, communicative aspects online for women. Murray's examination of a pro-eating-disorder website reveals the ways in which communicative aspects online are used as tools for forming feminist agency, and, at the same time, for buttressing ideologies surrounding gender. Murray views the webmistress of the website as a "cyberpostfeminist" who communicates "a postfeminist view of agency" and exercises power over members through affective/immaterial labor. Meanwhile, she problematizes the community as it functions as a place where women practice and support beauty ideologies. Whereas the community seems to oppose the institutional discourses of diet and eating disorders, it often replicates institutional power that shapes the perception and management of women's bodies.

Walker examines online discussions about lesbian relationships that have been represented in popular culture. As intimate partner violence among lesbian relationships is a relatively new topic, the public online discussions offer a venue in which researchers can examine how same-sex violence is defined and received by lesbian communities. Walker's observation shows contradictory responses: while some of the participants criticized the media representation that diminishes the problems of same-sex violence, some of them denied even the possibility of violence among lesbian relationships. Walker contends that these online forums allow for debate and deliberation over lesbian issues that do not often emerge in offline spaces.

Oh's chapter looks at *Unnine*, a South Korean cyberfeminist online community. As this community works against online violence while attempting to build a cyberfeminist community, Oh frames it as both a cyberfeminist movement for safety online and a feminist movement in an online space. Connecting *Unnine* to the 1970s feminist movement for safety at night, Oh contends that the awareness of systematic but often invisible violence online should be preceded by the feminist vision of cyberspace as liberating. *Unnine*'s movement to intervene in violence online—from sexual assault to male-focused knowledge building and sharing—suggests what should be one of the feminist agendas in online space.

Rybas explores a Facebook group that was formed to protest Facebook's framing of breastfeeding profile pictures as obscene. Her observation of the group reveals that members have critical views of the sexualization of female breasts and often see nursing and parenting as an appropriate way to understand women's bodies. Although Rybas values the group's attempt to rethink women's bodies and freedom of expression online, she is attentive to unheard voices. Under the discourses normalizing parenting and breastfeeding, Rybas contends that women who make different choices over their bodies become invisible.

Leurs addresses the way in which migrant youths negotiate their identities in online spaces where they are deemed "space invaders" who do not fit within the "digital template." Leurs criticizes the absence of migrant adolescents in cyberfeminists' studies, which are often overshadowed by white, tech-savvy, and middle-class girls, and calls attention to "intersectional cyberfeminism." In this exploratory chapter about migrant youth online, Leurs identifies three communicative spaces online—social networking service, instant messaging, and discussion board—as research sites for intersectional cyberfeminists' investigations on migrant youth.

As we stressed at the outset, the exploration of what it means to be a cyberfeminist necessitates privileging "decentered, multiple, and participatory practices." The research sites that each author examined were selected in order to examine women's participation and voice, which inform how "the new promising way of thinking and practice" online can be connected to existing feminist politics. As will be revealed in these authors' writings, women's experiences online are shaped not only by the technological aspects of new digital technologies but also the ever-growing market values and the deep-rooted gender structure that constitute or are constituted by emerging technologies. This book is dedicated to narrowing the boundary between the "new" online territory and its "old" offline counterpart, and examining what

role cyberfeminists can play in interrogating the intersected points of two territories in relation to women's experiences in crossing that boundary.

Works Cited

Barbrook, R. (2006). *The class of the new*. London: Mute.

✳ Castells, M. (2000). *Rise of the network society* (2nd ed.). Oxford, UK: Blackwell.

✳ Couldry, N. (2010). *Why voice matters: Culture and politics after neoliberalism*. London: Sage.

Terranova, T. (2004). *Network culture: Politics for the information age*. London: Pluto Press.

Wajcman, J. (2004). *Technofeminism*. Cambridge, UK: Polity.

Wilding, F. (1998). Notes on the political condition of cyberfeminism. *Art Journal, 57*(2), 47–59.

Section I

Rethinking the Discourse on Empowerment

Chapter 1

Our Data, Ourselves: Feminist Narratives of Empowerment in Health 2.0 Discourse

Marina Levina

Introduction

Cyberfeminism has long been concerned with issues of empowerment on-line. Studies of women's online activities explore how—and if—technology can transcend structures of power and liberate women from patriarchy. The premise of technology as a means of liberation also has detractors, who argue that technology reflects already-existing social, political, and economic in-equalities. Cyberfeminist scholars, however, have agreed that the connectivity provided by digital technologies can offer, through its very presence, an important tool of empowerment (Brophy, 2010; Daniels, 2009; Everett, 2004; Kember, 2002; Munster, 1999; Orgad, 2005, 2006; Suchman, 2006; Van Zoonen, 2002; Wilding, 1997, 1998). The importance of connectivity for the feminist movement was evident even before the emergence of digital technology. As Hawthorne and Klein (1999) write: "[C]onnectivity is at the heart of feminism" (p. 5). Development of sisterhoods in the face of isolation inside patriarchal households was one of the founding tenets of the feminist movement. The Internet has introduced a seemingly infinite potential for connectivity, crossing boundaries of nation-states, languages, and cultures. More important, through connectivity we could do more than simply organize. We could form what Blair, Gajjala, and Tulley (2009) call "virtual kin-ships" (p. 3). Theoretically, virtual kinships could offer opportunities for women's empowerment—the potential to draw alliances, declare sisterhoods, and affect political, social, and economic change. In this chapter I argue, however, that online companies often use the discourse of virtual kinship to encourage user participation—and, specifically, data donation. Data donation then becomes a tool through which online empowerment can be achieved. I explore a new online movement, Health 2.0, and its deployment of feminist empowerment discourse to facilitate female participation in its services.

First, I examine the overarching Health 2.0 discourse to illustrate how to utilize a feminist discourse of empowerment to align itself with feminist movements of the past and to draw a connection between virtual kinships—defined as participation in Health 2.0 companies—and empowerment. I then select two particular Health 2.0 companies, CureTogether (and its affiliate Quantified Self) and HealthTap (and its affiliate TapMommies) to argue that Health 2.0 services "empower" users to embrace the notion of "quantified self"—a self as divided into data points that are constantly and consistently donated to the network for the sake of the "common good." I chose these companies because they best exemplify these particular trends in data donation and tracking, although such reassessments of empowerment are evident throughout the whole Health 2.0 movement. Finally, I argue that empowerment becomes part of an anticipatory regime that obscures the present interworking of network power in promising an empowered future self. I contend that Health 2.0 positions itself as a feminist apparatus ready to further the cause of women in cyberspace, while disguising its function as an anticipatory regime that appropriates feminist narratives of empowerment and then resells them to individual users. I argue that through narratives of data tracking and data donation, Health 2.0 promotes individualized responses to systemic crises. Proto-feminist discourses of empowerment then obscure relationships of network power and promote data tracking and virtual kinships as unproblematic tools of control over life itself.

Empowerment and Health 2.0 Discourse

In May 2008, Google unveiled its entry into the burgeoning participatory medicine industry: Google Health.[1] Billed as an easy, hassle-free way to gather and organize one's medical records, Google Health's claimed purpose is to put "you" in charge of "your" health information. It purports to rescue individuals from the inconvenience, and sometimes oppression, of medical institutions by putting them in control of their data. This is the latest development in Health 2.0: a growing effort to marry Web 2.0 technology, participatory discourse, and network subjectivity to health care and management. At its core, Health 2.0 makes the proposition that access to more medical information leads to greater control over one's health and that, combined, control and information rescue individuals from institutional power. The past few years have seen an emergence of health information technology initiatives that promote access and interconnectivity between users and clinics.

These are also considered to be a part of Health 2.0, traditionally defined as "the use of social software and its ability to promote collaboration between patients, their caregivers, medical professionals, and other stakeholders in health" (Sarasohn-Kahn, 2008, p. 2). However, there is more to Health 2.0 than the promotion of information communication technology as an enabler of health care collaborations. While issues of access are important, Health 2.0 sees itself as a movement that stresses community building and patient participation. An expanded definition describes Health 2.0 as a four-point system that emphasizes:

> (1) Personalized search that looks into the long tail, but cares about the user experience, (2) Communities that capture the accumulated knowledge of patients and caregivers; and clinicians—and explain it to the world, (3) Intelligent tools for content delivery—and transactions, and (4) Better integration of data with content. All with the result of patients increasingly guiding their own care. (Holt, 2009)

The Health 2.0 movement also regards improvements in health information technology as a way of stressing wider health care reform and furthering advances and competition in the health care industry:

> New concept of health care wherein all the constituents (patients, physicians, providers, and payers) focus on health care value (outcomes/price) and use competition at the medical condition level over the full cycle of care as the catalyst for improving the safety, efficiency, and quality of health care. (Shreeve, 2009)

Finally, and most importantly to this discussion, the Health 2.0 movement positions itself as a participatory process, one through which users of health information technology are reconstituted as responsible and active patient-citizens as evidenced by these definitions:

> Health 2.0 defines the combination of health data and health information with (patient) experience through the use of ICT, enabling the citizen to become an active and responsible partner in his/her own health and care pathway. (Bos et al., 2008)

Or:

> Health 2.0 is participatory healthcare. Enabled by information, software, and community that we collect or create, we the patients can be effective partners in our own healthcare, and we the people can participate in reshaping the health system itself. (Eytan, 2008)

This particular discourse of Health 2.0, taken up by numerous advocates, juxtaposes active patient-citizen participation with institutional practices that ail the health care system. They oppose the paternal nature of the medical establishment and align themselves with acts of rebellion against medical patriarchy. For example, stories position Health 2.0's origin as being in line with patient movements that challenged social norms, promoted the rights of the underprivileged, and upended pharmaceutical monopolies and government policies. In an effort to lend gravitas to the narrative of Health 2.0 as a health revolution, these stories evoke feminist health movements of the 1970s and the AIDS activism of the 1980s and 90s:

> The practices, technologies and social behaviors, now collectively referred to as Health 2.0, actually started in the late 1990s as consumers began to use the Internet to publish information about their own health experiences and to connect with others, through list-servs and websites such as ACOR, BrainTalk and iVillage.... Health 2.0 stands on the shoulders of previous patient-led movements, like those which created the book *Our Bodies, Ourselves* and powered AIDS activism.... (Holt et al., 2010)

Of course, these mythological comparisons are problematic at best. The feminist health movement of the 1970s produced *Our Bodies, Ourselves*. And AIDS activism of the 1980s produced ACT-UP. Disenfranchised populations initiated both movements to draw attention to inequalities of the scientific and medical establishments and to give voice to those considered "deviant." Theirs was a desperate effort to fight for the lives of those private and public institutions deemed unworthy of assistance. Health 2.0, on the other hand, is a loose collective of mostly Silicon Valley–based tech start-ups looking to capitalize on new trends in social media and health information technologies. Their conferences cost thousands of dollars to attend. Pharmaceutical companies often sponsor these conferences while looking to capitalize on the surge of health data donation online (more on that later). However, what is most interesting about Health 2.0 is the way it portrays empowerment as an automatic guarantee of cultural change. The claim that Health 2.0 services empower patients immediately positions the movement as a champion of the people and therefore obscures complicated relations and positions of power behind the laptop screen. And because of its wish to connect to a larger social change mythology, Health 2.0 often evokes a feminist agenda.

For example, "Disruptive Women in Health Care" is a platform for women bloggers associated with Health 2.0 services and ideas. The blog uses

feminist rhetoric to position itself as a place for women's empowerment and cultural change. Its mission is to serve

> as a platform for provocative ideas, thoughts, and solutions in the health sphere. We recognize that to accomplish this, we need to call on experts outside of the health industry. The founding Disruptive Women have audacious hopes for our blog: We're not managing change; We're not thriving on chaos; We're not waiting for cures; We're driving change; We're creating chaos; We're finding cures; We're disrupting the health care status quo. (Disruptive Women in Health Care, 2010)

The bloggers here are an accomplished group of women. They are the founders of biotech companies, secretaries of health, and consultants for GE and other corporations delving into health information technologies. But they are not, as evidenced by their affiliations, completely outside of the health care industry. Nor is the blog the grassroots movement that its language of empowerment suggests. If one digs a bit deeper, one can find that "Disruptive Women in Health Care" is a project conceived of and owned by Amplify Public Affairs. Amplify is a public relations firm that does PR for Health 2.0, Microsoft Health Solutions Group, Novartis Pharmaceuticals, and AARP, to name but a few. An educated guess is that "Disruptive Women in Health Care" serves as a public relations initiative to bring a feminist political position and discourse of empowerment to Health 2.0. Empowerment here is used as a tool that renders everything that happens behind it invisible and unproblematic. As a woman sits at the computer screen and participates in Health 2.0 communities, she can think of herself as empowered simply through participation in a blog that evokes feminist narratives.

Empowerment and Virtual Kinship

Scott Shreeve, a prominent physician advocate of the Health 2.0 movement, argues that "the traditional paternalism (structural, cultural, regulatory, and political) inherent in medicine is giving way to the participatory nature of Health 2.0" (Shreeve, 2009). The movement's narratives hail the revolutionary potential of patient participation, advocate for an overhaul of the traditional care delivery system, and position the Health 2.0 network as an alternative to the institutional medical system. They also deploy empowerment as a category that is capable of delivering "revolutionary" change in the medical system:

Health 2.0 has already changed the landscape of health by delivering tools and technology that empowers patient communities, results in connected physicians, forces transparency to the system, and restores the patient to the center of the health experience. However, much of this has happened at the margins, outside the traditionally paternalistic medical-industrial system. While this has populist and even revolutionary appeal, the quest for far broader adoption of these concepts must penetrate deeper into the underbelly, into the very heart of the plumbing, to attack the calcified hairball where a thousand health revolutions have died before. (Shreeve, 2009)

This sentiment is echoed throughout Health 2.0 discourse. Organizations that consider themselves part of Health 2.0 evoke the value of virtual communities and empowerment through online connectivity. For example, online communities such as PatientsLikeMe.com connect patients and provide a virtual space for support groups, but also mine patient data to affect medical research and trials. These sites, as well as access engines such as Google Health, fully embrace and use the participatory discourse of the Health 2.0 movement. Further, their supporters argue that health information technology and social media tools have already had potentially radical effects on the health care industry in general. For example, Shaw (2009) argues that we are witnessing a health care reformation equivalent to the 16th-century religious Reformation, in which the printing press and radical thinking took the proprietary interpretation of the Bible away from the Catholic Church. She writes that

traditional paternalistic relationships between patients and doctors are being undermined in much the same way as the religious Reformation of the 16th century empowered the laity and threatened the 1,000-year-old hierarchy of the Catholic church in Europe. The Reformation had irreversible consequences for Western society; the implications of the health-care reformation could also be profound.... In our age, the "bible" is medical information, the technology is the Internet, and the priests are the medical profession. The Internet has brought the canon of medical knowledge—previously accessible only in expensive textbooks, subscription journals, and libraries—into the hands and homes of ordinary people.

And in a *New York Times* article entitled "Logging in for Second, Third Opinion," Dr. Ted Eytan, medical director for delivery systems operations improvement at the Permanente Federation, is quoted as saying that "patients aren't learning from Web sites—they're learning from each other." The shift is nothing less than the democratization of health care, he went on, adding: "Now you can become a national expert in your bedroom" (Schwartz, 2008).

Here, expertise is redefined not through institutional medical training but rather as access and participation in web-based communities or networks where information is shared among many interested parties and individuals. Moreover, access and participation are described as the virtues of online patient communities—as sites of resistance and systematic change.

The potential of the Internet in transforming patient-doctor relationships, health information availability, and patient identities in general has been the subject of numerous sociological and cultural analyses. In these studies, scholars have debated the question of whether online access to health information and patient support groups could indeed constitute empowerment. As Seale (2005) writes, the interest in "the phenomenon of the internet-empowered patient" has been strong in medical and sociological communities. He argues that "sociological analysis of health on the web has been influenced by the enthusiastic endorsement of the democratizing potential of the internet widespread in popular media and certain academic arenas" (p. 518). Maybe because of that endorsement, most scholarship on Internet health looks mainly at the accuracy of information and concludes that "where speakers are reliable and information is accurate, Internet health simply *empowers* patients" (Segal, 2009, p. 352). For example, Hardey (2001) writes: "the Internet provides a new rich source of health information, advice and treatment. As a resource for the publication and consumption of health information it is essentially pluralistic, democratic and both global and local.... This suggests the potential transformation of the doctor/patient relationship in the face of the end of the medical monopoly over medical information" (pp. 401–402). And Pandey, Hart, and Tiwary (2003) argue, specifically in relation to women's health, that access to health information offers ways in which to engage the "new age woman" and can empower women in dealing with health issues.

There are, of course, those who complicate the narratives of empowerment on the Internet, especially in relation to women's rights. Some critical media scholars argue that the Internet furthers a neoliberal capitalist system by emphasizing personal responsibility in overcoming what are essentially systemic social issues and inequalities. For example, Orgad (2005) writes about online support groups for breast cancer:

> The key message that emerges from representations produced by breast cancer websites, and patients' personal accounts published there, concerns women's self-responsibility. Women are commonly called upon, whether by their fellow-sufferers

or by the websites' producers, to take responsibility for the management of the ill-
ness and its treatment.... It is the individual control of the disease, rather than the
social control, that has been foregrounded. (pp. 155–156)

This ignores not only environmental causes of cancer, but also health care
inequalities inherited in treatment. In other words, "we shall overcome" rhe-
toric obscures systematic problems in the treatment of an illness. In another
example, Gajjala, Zhang, and Dako-Gyeke (2010) write: "the 'new languages'
of women's emancipation in globalized media spaces are in fact re-codings
of familiar liberal feminist discourses interweaved with a capitalist, consu-
merist rhetoric of individual choice" (p. 70). I agree wholeheartedly with
these criticisms of empowerment discourse and suggest that new media scho-
lars need to reformulate the question of empowerment to ask, "empowerment
to do what?" In Health 2.0 discourse, it is often the case that empowerment is
measured through data tracking and donation. In other words, participants in
Health 2.0 are often "empowered" to keep track, manage, and donate their
data. The question then becomes: Who benefits from that data donation, and
what inner workings of network society and its neoliberal economy are ob-
scured when we donate our data online?

Empowerment and Data Donation

While many of the communities that Health 2.0 claims as its own serve as
online clearinghouses that connect patients, the trend has been moving away
from simple community building toward a more complicated realm that uses
"virtual kinship" and virtual communities discourse to encourage participants
to track and donate data. *The Past and Future of Health 2.0* report explicitly
confirms this trend:

Communities move from support and networking to tracking data: Communities
have continued to grow greatly in number and in what they allow members to do.
Many communities stick very successfully with simple list-serv and bulletin boards,
but the development of new community tools allows members to create profiles,
connect with friends, vote on issues, tag and identify content, and share more than
just text. Some communities, like CureTogether and PatientsLikeMe, are harnessing
these technologies to record masses of data points about their members' health con-
ditions. Many others are combining tracking tools with community support, in the
realms of fitness or diet. Meanwhile, health groups are also appearing on the major
online communities like Facebook and are using micro-blogging services like Twit-
ter—both of which have of course been growing very fast. (Holt et al., 2010)

A Health 2.0 forerunner in the field of self-tracking and data donation is CureTogether, an online service that allows users to track their health data, alongside others, in hundreds of conditions ranging from "depression" to "aging." On its "About" page, the company describes itself this way:

> Imagine patients around the world coming together to share quantitative information on over 500 medical conditions. They talk about sensitive symptoms and compare which treatments work best for them. They track their health. New research discoveries are made based on the patient-contributed data. This is happening at CureTogether, and we believe it can have a massive global impact. (CureTogether, 2010)

When you become a member of CureTogether, you can choose among various conditions, take surveys tracking symptoms you have and treatments you find most helpful, compare your answers with others who share your condition, and see how various treatments rank in effectiveness. You can also connect with other members who are like you, although that feature does not provide access to forums but rather just an ability to send private emails. Most important, you can participate in daily tracking, a feature of the forum that allows you to track weight, sleep, exercise, caloric intake, and other daily events using a day-to-day calendar. You can also choose to fill out lab reports—a feature that essentially asks users to report their blood tests. Your personal information (name, address, email, gender, date of birth) is kept private but can be used when it is supplemental to your health information (such as a study on gender differences in sleep patterns). According to CureTogether's privacy policy, your aggregated, anonymized health information is used to conduct scientific research studies. More important, in its privacy policy, CureTogether explicitly links data donation and empowerment:

> CureTogether is dedicated to conducting open source, member-driven, patient-empowered scientific research studies. We may use or open up any information you provide for this research purpose, in an anonymized and aggregate way, unless you explicitly decide to exclude your information from the studies.... Our goal is to help people find both short-term and long-term answers that will help reduce their suffering.

The company has received many accolades, and publications such as *The New York Times* and *Wired* hailed the potential of open-source, patient-driven science (Miller, 2010; Goetz, 2010). In *Wired*, Alexandra Carmichael—a co-founder of CureTogether—recounts her experiences with vulvodynia and describes how CureTogether empowers women with similar

conditions: "It took me 10 years to find out what I had, and it took two years to find the right treatment," she says. "That simply wouldn't be the case anymore. It would not take anywhere near that long for somebody who finds CureTogether. Now there are other women like me, sharing ideas and data. It shortens the decision tree considerably" (Goetz, 2010).

CureTogether also has a familial association with Quantified Self—Carmichael is a director of Quantified Self—a web company and a movement that encourages people to track their data as a way of empowering self-knowledge and change. Gary Wolf (2010)—a co-founder of Quantified Self—writes that "personal data are ideally suited to a social life of sharing. You might not always have something to say, but you always have a number to report." Predictably, perhaps, most data discussed on the Quantified Self website are in some ways pertinent to either productivity or health. While the Quantified Self serves as a clearinghouse for connecting people interested in self-tracking either to meet-up groups in their area or, even better, to more efficient data-tracking tools (phone apps being most popular), it is sponsored by CureTogether and HealthTap. HealthTap is a relatively new start-up whose mission is to provide empowerment through data collection and donation:

> At HealthTap, *we are committed to creating a healthier, happier world—one decision at a time* [emphasis added]. We envision people everywhere making confident, informed, fact and data based choices that maximize their health and improve their well-being. We see a future of true individualized medicine, where people's increased control of their health reduces anxiety and increases optimism. (HealthTap, Vision Credo, 2010)

HealthTap's first venture is TapMommies—an online community and personal data tracker—that helps "lead you to make the best decision for you and your child." TapMommies is still in beta and available only by limited invitation, but it already promotes "cool tracking apps," including the Grow with MeiPhone app that allows mothers to track their babies' diapers, sleep, fevers, and rashes. Right now, the financial goals of HealthTap and Tap-Mommies are unclear—one assumes that eventually the data crowd-sourced through TapMommies will be collected and sold to various research interests. However, it is evident that TapMommies is banking on narratives of female empowerment. For example, it states: "We know that moms are often the 'Chief Medical Officers' of families, and the Chief Educators of the next generation. If we can help these women make better decisions and foster

healthy habits in their young children, we can help build a new foundation for a healthier happier world" (HealthTap, 2010). Here we can see once more how narratives of empowerment, information-based decision-making, and virtual community building are brought together in an unproblematic and uncomplicated narrative.

What remains unacknowledged in these narratives is a correlation among data tracking, empowerment discourses, virtual kinship, and network power. As we track our data we become flexible and adaptable workers—our bodies and our time in constant service to kinship networks. As I have argued elsewhere, Health 2.0 needs to be theorized within the rise of a network society and, with it, a system of power relations necessitated by the rise of globalization and the emergence of information technology (Levina, 2010). Health 2.0 discourse is not outside of power relations, but its very interworking is grounded within network power, which operates through decentralized relations of sociability, and as such is always relational, always circumstantial, and always mutable (Singh Grewal, 2008). It also encourages relations of sociability in order to facilitate expansion. This does not make the exercises of power benign; indeed, network power operates through incorporation of dividend elements. Nothing can or should be outside of the network (Galloway & Thacker, 2007; Hardt & Negri, 2000; Singh Grewal, 2008; Terranova, 2004). The individuals in the network are always working to expand and grow the network—through practices of data donation they become an integral part of the network's health. In Health 2.0 online communities, these practices translate into what I call "the work of being healthy," that is, a constant affective donation of self as represented by data to the growth and wellness of the network (Levina, 2010). Health 2.0 encourages virtual kinship precisely because it integrates users and the network—one's data benefits network health and capital. As Jane Sarahson-Kahn (2010), a blogger on Disruptive Women in Health Care and one of the principals of the Health 2.0 "revolution," summarizes:

> The common theme for New Patients is data: accessing it, understanding it, and acting on it. There are several lenses on data that came out of the dialogue: Data must be accessible; Data must be actionable; Data can make you dangerous…in an empowered sense;…Data is personal….Finally, the New Patient is the Networked Patient.

Moreover, as we work to be healthy, our affect and our labor contribute to the growth of the network and the neoliberal capitalist structures that pro-

mote and encourage that growth. Data tracking and donation are presented as an empowering—and therefore pleasurable—experience. It is also exceedingly important that narratives of empowerment that accompany calls of data donation often evoke feminist calls for action and control. Health 2.0 appropriates feminist narratives of empowerment in a way that distracts from systemic health inequalities that still plague the United States. Instead, the message is clear: if you feel confused, disempowered, and scared, then virtual communities, and accompanied data donation, will rescue you. Health 2.0 discourse does not consider that fear and anxiety are an appropriate, affective response to the reality of an unjust and corrupt health care system. Health 2.0 promotes individualized responses to systemic crises. Protofeminist discourses of empowerment obscure relationships of network power and promote data tracking and virtual kinships as unproblematic tools of control over life itself.

Moreover, empowerment here is not portrayed as an immediate political and medical shift in policy or research, but rather as a mastery of one's future self. They are a part of what Adams, Murphy, and Clarke (2009) call "the regime of anticipation," wherein "anticipation is a strategy for avoidance of surprise, uncertainty and unpreparedness, but it is also a strategy that must continually keep uncertainty on the table. The sciences and technologies of anticipation demand that the phenomena be assessed and calculated—producing probabilities for anticipatory projects as interventions in the present." (p. 250). Whereas feminist empowerment of *Our Bodies, Ourselves* demanded change now, empowerment of *Our Data, Ourselves* establishes current actionable conditions for future selves—an unidentifiable point in time when data donation will lead to a more productive, healthier, more optimized self. This is "a moral economy in which the future sets the conditions of possibility for action in the present, in which the future is inhabited in the present" (Adams, Murphy, & Clarke, 2009, p. 249). Gary Wolf (2010) writes in a *New York Times* article entitled "The Data-Driven Life" that "for many self-trackers, the goal is unknown. Although they may take up tracking with a specific question in mind, they continue because they believe their numbers hold secrets that they can't afford to ignore, including answers to questions they have not yet thought to ask." In short, anticipation becomes an ethical and moral obligation of good citizenship. Adams and colleagues write:

Anticipation calls for a heralding of the emergent "almost" as an ethicized state of being. Being ready for, being poised awaiting the predicted inevitable keeps one in a

perpetual ethicized state of imperfect knowing that must always be attended to, modified, updated. The obligation to "stay informed" about possible futures has become mandatory for good citizenship and morality, engendering alertness and vigilance as normative affective states. (Adams, Murphy, & Clarke, 2009, p. 254)

And as data donation links to good citizenship, it also becomes a way to encourage and sustain virtual kinships. CureTogether, HealthTap—and Health 2.0 in general—make a powerful argument that we do not donate data just for ourselves, but to connect and help others. Health 2.0 companies try to appeal especially to women through stories of empowered women getting together and donating data for change. However, as I have argued above, these are not authentic bottom-up expressions of a community, but rather a prebuilt component of a culture of self-tracking and anticipation.

In this chapter I have argued that Health 2.0 discourse utilizes a feminist discourse of empowerment to align itself with feminist movements of the past and to draw a connection between virtual kinships—defined as participation in Health 2.0 companies—and empowerment. I have argued that Health 2.0 services "empower" users to embrace the notion of "quantified self"—a self divided into data points that are constantly and consistently donated to the network for the sake of the "common good." Health 2.0 positions itself as a feminist apparatus ready to further the cause of women in cyberspace, while disguising its functioning as an anticipatory regime that appropriates feminist narratives of empowerment and then resells them to individual users. The implications of Health 2.0 reach far beyond its own case study. As cyberfeminist scholars, we must ask how discourse of empowerment is deployed, by whom, and for what purposes. Data tracking and data donation are not just individual choices; they emphasize how we define, classify, and manage life itself. They also indicate how empowerment has come to be defined in terms of future selves, not in terms of concrete political actions in the present. Health 2.0 services also point to the necessity of critically examining how discourses of empowerment and kinship remain firmly entrenched within the functioning of network power. This has a special potency for feminist movements, because they illustrate how revolutionary discourses can be appropriated in terms of individual actions and goals of self-improvement. These appropriations are not without consequences. If we are supposed to feel empowered by tracking our individual health online, will we still feel empowered to engage in social and political actions that challenge the status quo and help the sisterhood at large?

Note

1 Personalized medicine is a medical model that seeks to customize and individualize health care delivery practices. There are several aspects of personalized medicine, including customization of drugs to the individual patient (Olivier et al., 2008). For the purposes of this essay, however, I will focus on those personalized medicine companies that use social media and new information technologies to provide a virtual space for patient communities, individual health data tracking, and proposed research sites where researchers and pharmaceutical companies can survey online users directly.

Works Cited

Adams, V., Murphy, M., & Clarke, A.E. (2009). Anticipation: Technoscience, life, affect, temporality. *Subjectivity*, *28*(1), 246–265.

Blair, K., Gajjala, R., & Tulley, C. (Eds.). (2009). *Webbing cyberfeminist practice: Communities, pedagogies and social action*. Cresskill, NJ: Hampton Press.

Bos, L., Marsh, A., Carroll, D., Gupta, S., & Rees, M. (2008). Patient 2.0 empowerment. In H.R. Arabnia & A. Marsh (Eds.), *Proceedings of the 2008 international conference on semantic web & web services SWWS08* (pp. 164–167). Retrieved from www.icmcc.org/-pdf/ICMCCSWWS08.pdf

Brophy, J.E. (2010). Developing a corporeal cyberfeminism: Beyond cyberutopia. *New Media & Society*, *12*(6), 929–945.

CureTogether. (2010). About CureTogether. Retrieved from http://curetogether.com/blog/about/

Daniels, J. (2009). Rethinking cyberfeminism(s): Race, gender, and embodiment. *Women's Studies Quarterly*, *37*(1/2), 108–124.

Disruptive Women in Health Care. (2010) About. Retrieved from http://www.disruptivewomen.net/about/

Everett, A. (2004). On cyberfeminism and cyberwomanism: High-tech mediations of feminism's discontents. *Signs: Journal of Women in Culture and Society*, *30*(1), 1278–1286.

Eytan, T. (2008, June 13). *The Health 2.0 definition: Not just the latest, the greatest! E-health. Patient empowerment*. Retrieved from http://www.tedeytan.com/2008/06/13/1089

Gajjala, R., Zhang, Y., & Dako-Gyeke, P. (2010). Lexicons of women's empowerment online. *Feminist Media Studies*, *10*(1), 69–86.

Galloway, A., & Thacker, E. (2007). *The exploit: A theory of networks*. Minneapolis: University of Minnesota Press.

Goetz, T. (2010, 19 January). The decision tree: How smarter choices lead to better health. *Wired*. Retrieved from http://www.wired.com/magazine/2010/01/ff_decisiontree/

Hardey, M. (2001). E-health: The Internet and the transformation of patients into consumers and producers of health knowledge. *Information, Communication & Society*, *4*(3), 388–405.

Hardt, M., & Negri, A. (2000). *Empire*. Cambridge, MA: Harvard University Press.

※Hawthorne, S., & Klein, R. (Eds.). (1999). *Cyberfeminism: Connectivity, critique and creativity*. Melbourne, Australia: Spinifex.

HealthTap. (2010, November 23). HealthTap Introduces TapMommies. Retrieved from http://www.healthtap.com/2010/11/healthtap-introduces-tapmommies/

Holt, M. (2009, February 3). *Health 2.0: User-generated healthcare*. Retrieved from http://www.ncvhs.hhs.gov/090226p3.pdf

Holt, M., et al. (2010). *The past and future of Health 2.0*. Retrieved from http://www.health2con.com/health-2-0-advisors/report-the-past-and-future-of-health-2-0/

Kember, S. (2002). Reinventing cyberfeminism: Cyberfeminism and the new biology. *Economy and Society, 31*(4), 626–641.

Levina, M. (2010). Health 2.0 and managing "dividual" care in the network. In M. Levina & G. Kien (Eds.), *Post-global network and everyday life* (pp. 113–126). New York: Peter Lang.

Miller, C. (2010, March 24). Social networks a lifeline for the chronically ill. *The New York Times.* Retrieved from http://www.nytimes.com

※Munster, A. (1999). Is there postlife after postfeminism? Tropes of technics and life in cyberfeminism. *Australian Feminist Studies, 14*(29), 119–129.

Olivier, C., Williams-Jones, B., Godard, B., Mikalson, B., & Ozdemir, V. (2008). Personalized medicine, bioethics and social responsibilities: Re-thinking the pharmaceutical industry to remedy inequities in patient care and international health. *Current Pharmacogenomics and Personalized Medicine, 6*(2), 108–120.

Orgad, S. (2005). The transformative potential of online communication: The case of breast cancer patients' Internet spaces. *Feminist Media Studies, 5*(2), 141–161.

Orgad, S. (2006). The cultural dimensions of online communication: A study of breast cancer patients' Internet spaces. *New Media & Society, 8*(6), 877.

Pandey, S.K., Hart, J.J., & Tiwary, S. (2003). Women's health and the Internet: Understanding emerging trends and implications. *Social Science & Medicine, 56*(1), 179–191.

Sarasohn-Kahn, J. (2008). The wisdom of patients: Health care meets online social media. ihealth reports. *California HealthCare Foundation*. Retrieved from http://www.chcf.org/topics/chronicdisease/index.cfm?itemID=133631

Sarasohn-Kahn, J. (2010, October 13). Patient 2.0: The growing demographic of networked patients. *Disruptive Women in Health Care*. Retrieved from http://www.disruptivewomen.net/author/jsarasohnkahn/page/2/

Schwartz, J. (2008, September 30). Logging on for a second (or third) opinion. *The New York Times*. Retrieved from http://www.nytimes.com/2008/09/30/health/30online.html

Seale, C. (2005). New directions for critical Internet health studies: Representing cancer experience on the web. *Sociology of Health & Illness, 27*(4), 515–540.

Segal, J.Z. (2009). Internet health and the 21st-century patient. *Written Communication, 26*(4), 351–369.

Shaw, J. (2009). A reformation for our time. *British Medical Journal, 338*, b1080.

Shreeve, S. (2009, April 22). Building Health 2.0 into the delivery system. Message posted to http://blog.crossoverhealth.com/2009/04/22/building-health-20-into-the-delivery-system/

Singh Grewal, D. (2008). *Network power: The social dynamics of globalization*. New Haven, CT: Yale University Press.

Suchman, L. (2006). Wajcman confronts cyberfeminism. *Social Studies of Science*, *36*(2), 321–327.

Terranova, T. (2004). *Network culture: Politics for the information age.* London: Pluto Press.

✳Van Zoonen, L. (2002). Gendering the Internet: Claims, controversies and cultures. *European Journal of Communication, 17*(1), 5–23.

✳Wilding, F. (1997).*Where is feminism in cyberfeminism?* Retrieved from http://www.neme. org/392/cyberfeminism

✳Wilding, F., & Critical Art Ensemble. (1998). Notes on the political condition of cyberfeminism. *Art Journal, 57*(2), 46–59.

Wolf, G. (2010, April 26). The data-driven life. *The New York Times.* Retrieved from http://www.nytimes.com/2010/05/02/magazine/02self-measurement-t.html?hp

Chapter 2

BlogHer and *Blogalicious*:
Gender, Race, and the Political Economy of
Women's Blogging Conferences

Jessie Daniels

Introduction

Women are blogging in record numbers. According to one study of women in the United States, an estimated 36.2 million participate in the blogosphere each week, with 15.1 million posting blog entries at least once a week and 21.1 million reading and posting comments (Wright & Camahort, 2008). Rather than a unified field of representation, there is an almost unimaginable array of subcultures into which women's blogging has fragmented as it has expanded (Rosenberg, 2009, pp. 263–264). Of the millions of women blogging, a small but growing number attend face-to-face gatherings each year to discuss their engagement in cyberspace and connect with other women who are similarly engaged. While these events are not billed as overtly feminist (or womanist), there is a strong subtext of women's empowerment that runs through the conferences. Feminism and cyberspace have been linked both theoretically and in cyberfeminist practices since the early 1990s (Everett, 2004; Fernandez, Wilding, & Wright, 2002). The emergence of women's blogging conferences offers an important opportunity to examine the link between Internet technologies and gender/race.

Some cyberfeminists (Orgad, 2005; Plant, 1997; Podlas, 2000) have suggested that Internet technologies can be effective media for resisting repressive gender regimes and enacting equality, while others have called into question such claims by pointing to the political economy of women's labor in the global south, which enables such resistance (Gajjala, 2003). Implicit in claims and counterclaims about the subversive potential of Internet technologies is theorizing that constructs women of color as quintessential cyborgs (Fernandez, 2002, p. 32), as when Haraway (1985) writes about the "cyborg women making chips in Asia and spiral dancing in Santa Rita" (p. 7). Sassen (2002) notes the ways in which the digital and material are imbricated. Draw-

ing on this insight, Daniels (2009) argues that the lived experience and actual Internet practices of girls and self-identified women suggest that they use the Internet to transform their material, corporeal lives in a number of complex ways that both resist and reinforce hierarchies of gender and race. In this chapter, I extend this analysis further through an ethnographic account of women's blogging conferences.

Both journalists and scholars have suggested an affinity between women's blogging and feminism. Oreoluwa Somolu (2007) documents the fact that African women have embraced blogging and chronicles the myriad ways blogs can be used to promote women's equality and empowerment. In 2004, *Time* magazine noted that in the United States, women make up the majority of bloggers, and suggested that readers "call blogging a 21st-century room of one's own," evoking Virginia Woolf's famous requirement for feminist consciousness. Fereshteh Nouraie-Simone (2005b), an Iranian blogger, paraphrases Woolf when she describes her experience online as a "liberating territory of one's own" (p. 62). The notion that cyberspace is a "room of one's own" that offers an escape from the constraints of being a gendered woman tied to embodiment echoes the writing of some early cyberfeminists (e.g., Plant, 1997).

Among women bloggers, the so-called "mommy bloggers" have garnered the preponderance of media attention. *The New York Times* has published two articles on "mommy bloggers" since 2005.[1] While neither of the articles mentions "mommy blogging" as inspired by, or an expression of, feminism, *Ms.* magazine makes this connection explicit. A recent issue of *Ms.* featured a cover story about mothers who blog, suggesting that the very act of blogging by women is a feminist, political act. The article acknowledges that not all mommy bloggers self-define as feminists—"although certainly there is a feminist impulse behind the avowed goal of many of them to change cultural perceptions of motherhood—but one might argue that what they're doing is a virtual version of feminist consciousness-raising: They're being exceedingly open about their experiences of mothering, and sharing those experiences in an (online) community with other mothers."[2] The idea that blogging by women is a feminist act is a view that scholar Lori Lopez (2009) shares. She contends that "mommy blogging is a radical act" because it offers women the potential to build communities and challenge dominant representations of motherhood. The title of Lopez's article, "The Radical Act of 'Mommy Blogging,'" is a reference to a recurring session at the *BlogHer* conference.

In response to the question "Where have all the cyberfeminists gone?" that this volume poses, one answer seems to be that they have become bloggers and started attending blogging conferences. In this chapter, I examine women's blogging conferences as a site for interrogating gender, race, and cyberfeminism. Specifically, I explore the ways in which the political economy shapes what is possible for a feminism articulated within and through these conferences.

Background: Gender (Race) and the Blogosphere

In 2004, the new media landscape of the Internet was marked by a sharp rise in the number, and visibility, of political blogs (Perlmutter, 2008). Howard Dean's bid for president of the United States benefited from the emergence of bloggers. Dean's campaign workers posted an online diary of life on the campaign trail; those posts were then linked to, commented on, and republished by bloggers who were not employed by the campaign. This amplification of Dean's candidacy helped generate $20 million in contributions via the Internet by the end of January 2004. Although he did not win the election, his campaign's reliance on blogs marked their place in the political mainstream (Perlmutter, 2008, p. 89). In December 2004, the U.S. dictionary publisher Merriam-Webster declared "blog" the most looked-up word on their website.[3]

There are somewhat contradictory data about the proportion of women and men who blog. *Time*, in its 2004 year-end review, noted the rise of blogging and the preponderance of women bloggers, citing a survey of more than 4 million blogs by Perseus Development Corporation (now Vovici), which found that women created 56% of blogs.[4] According to a different report, there is some measure of gender parity in blogging among Internet users, with 14% of men and 11% of women reporting that they blog.[5] A third study finds that men constitute the majority (67%) of the blogosphere, while women are a minority (33%).[6] Much of the disparity between these reports has to do with what gets counted as a "blog" and what does not. Typically, blogs at online spaces like Diaryland and LiveJournal have long been dominated by women, yet are not counted in most analyses of blogs (Herring, Scheidt, Kouper, & Wright, 2007). This is part of a larger trend in media that tends to minimize the importance of women's contributions to blogging.

While mainstream media attention to blogging has been on the rise, the reporting on the emergence of blogs has focused almost exclusively on male

bloggers and a rather narrow conceptualization of "politics" that primarily means electoral politics (Herring et al., 2007). For example, when Techcult, a technology website, recently listed its top 100 web celebrities, only 11 of them were women.[7] In 2009, Forbes.com ran a similar list of 25 Web celebrities, and only one woman (Heather Armstrong[8]) made its list of 25.[9] Megan McArdle, an associate editor at the *Atlantic Monthly*, who writes a blog about economic issues, observes that "women get dismissed in ways that men don't," adding that women are taught not to be aggressive and analytical in the way that the political blogosphere demands.[10] A 2005 report on blogging by CNN conveyed the gendered difference by referring to "pundits and knitters." In an interview with Internet entrepreneur Mena Trott, the reporter asks, "Where are the women bloggers?"[11] References in the mainstream press about women blogging, whether as "knitters" or "mommy bloggers," typically show a condescending tone indicating that women's blogs do not have the gravitas of men's blogs (Rosenberg, 2009, p. 263). The fact that the two articles on women bloggers published by *The New York Times* (2005, 2009) appeared in the "Fashion & Style" section, rather than, say, "Politics" or simply "News," has been interpreted by many feminist bloggers as evidence of the trivialization of women's blogging.[12]

Unlike the oft-repeated meme of "Where are the women bloggers?" there has been relatively little attention paid by mainstream news media to the question, "Where are the people of color bloggers?" Of course, when taken together, both questions highlight the fact that blogs published by white men garner the most media attention. It was not until 2007, some 3 years after the word "blog" was the word of the year, that the *Boston Globe* ran the story, "Blog is Beautiful: People of Color Challenge Mainstream Views Online,"[13] signaling at least some recognition from the mainstream media of non-white bloggers.[14] In addition to reporting by the mainstream news outlets about the race and gender of bloggers, some scholarly literature is beginning to emerge that explores blogging beyond an exclusive focus on those who are white and based in the United States.

The web has been important in shaping identity and community within and among multiple diasporas across a variety of Internet technologies[15] (Gajjala, 2004; Ignacio, 2006). Using media ethnography and qualitative content analysis of language, symbols, and cultural influences to examine blogging among queer South Asian bloggers, Mitra and Gajjala (2008) identify themes related to how power is shifted and relayered through the interactional features of blog writing and commenting. The authors find that while

these blog communities allow for certain kinds of self-expression not available offline, these spaces are simultaneously shaping their performance of sexuality (Mitra & Gajjala, 2008; Mitra, 2010). A few studies explore non-white bloggers in the United States. For instance, Karlsson (2006) investigates a small sample of Asian American diary bloggers, explores the ways in which these blogs foster diasporic connections, and finds that they are above all shaped by the real and imagined audience of fellow Asian American diary bloggers. Research by Pole (2009) examines African American and Latino political bloggers. Part of Pole's research explores how African American and Latino bloggers use their blogs to encourage civic engagement in politics (e.g., "Chapter 2: Rainbow Bloggers: Race and the Blogosphere"). Yet the writing that does focus attention on bloggers of color tends to assume they are all male, just as the writing about women bloggers assumes they are white, thus repeating the critical lack of inclusion of second-wave feminism (Hull, Scott, & Smith, 1982; Spelman, 1988). Set against this research and examined as a whole, the whiteness (not to mention U.S.-centric quality) of the blogosphere is much less remarked upon by both the mainstream media and scholars writing about it (e.g., Jenkins, 2006, Perlmutter, 2008).

It is within this social and political context of the rising phenomenon of blogging and the reverberating meme of "where are all the women bloggers?" that three white women in Silicon Valley launched the first *BlogHer* conference in early 2005 to highlight the work of women bloggers. In the 4 years after the launch of *BlogHer* conferences, there was still relatively scant attention paid to blogs by people of color and almost none to blogs by women of color. Thus, in 2009, three African American women in Atlanta launched *Blogalicious*, a conference for women bloggers of color. These face-to-face gatherings are instructive spaces in which to examine the ways that gender, race, and cyberfeminism are imbricated, and the political economy of women's blogging.

Methodology

The primary method I used to conduct this phase of research (part of a much larger study that includes interviews with women bloggers and analysis of blog text) was ethnographic fieldwork conducted at three women's blogging conferences. The blogging conferences I attended were *BlogHer* and *Blogalicious*. I attended two *BlogHer* conferences: the first was in July 2008 in San

Francisco, the second in Boston in October 2008. I attended the first *Blogalicious* conference held in October 2009 in Atlanta.

As a participant-observer, I attended the conferences and sat in on workshops, sessions, and plenaries. While attending, I took both handwritten notes and typewritten notes with my wifi-enabled laptop. Using multiple Internet technologies, I was able to augment traditional ethnographic field notes in a number of ways. At *Blogalicious*, I live Tweeted the event, meaning that I used the microblogging tool Twitter to post short, 140-character updates about what was happening at the conference in real time. This served a number of purposes: (1) it allowed me to connect with others at the conference while it was happening; (2) it provided me with a record of what seemed noteworthy at the time; and (3) it gave me leads about where to look for post-conference updates. Immediately following each conference, I typed up additional notes about my overall impressions of the event.

In the weeks and months after each conference, I searched for "post-conference write-ups" by those who attended and saved these in a plain text file along with the source URL. This allowed me to gain additional perspective on the conferences from participants themselves. Thus, rather than relying solely on my own observations and field notes, as in traditional ethnography, I was able to broaden this to include a multidimensional, multivocal lens.

Finding Community, Looking for Economic Power

Women who attend *BlogHer* and *Blogalicious* underscore the value of finding community at the conferences. Women at both the conferences also emphasize the importance of "monetizing," or making money from their blogs. These two themes, finding community and looking for economic power, are woven through the women's blogging conferences I attended. On the one hand, women at the conferences are looking to connect with like-minded women who share a passion for blogging while on the other hand, many are also looking for ways to turn a profit from what is essentially a hobby for most women bloggers.

The opening plenary of a *BlogHer* conference is an exuberant event with a festive, celebratory atmosphere. The *BlogHer* conference in July 2008 was held in the grand ballroom of a hotel in downtown San Francisco. The ballroom was filled with round banquet tables that seat 10, and I estimated that there were 1,000 people in the room.[16] Almost all those attending were white,

a majority were in their 30s and 40s, a handful were younger (a few women appeared to be in their mid-20s), and another handful were older (another few women appeared to be 55 and up).There were about a dozen or so men attending as well, mostly white men, who appeared to be accompanying wives and partners. All of the men attending were primarily engaged in caring for their young children, and many ran freely about the conference hotel. Participants carried canvas tote bags filled with "swag" (an acronym for Stuff We Always Get) donated by corporate sponsors: water bottles, snack items, samples of lotions, key chains, and larger items such as slippers. Along the walls on either side of the grand ballroom were large light-banners displaying the logos of some of the more than 40 corporate sponsors: such as Wii, General Motors (GM), Wiley Publishers, and less-well-known dot-coms, such as Picnik.com.

The focus of the opening plenary in 2008 was data from a just-completed survey made with partner organization Compass Media and displayed in a slide show on a screen in a large hotel ballroom. The survey data results illustrated that blogs written by women were now "mainstream, addictive, trusted." In addition to informing attendees about the state of the blogosphere, the presentation also served to foster a sense of community among those in attendance. Elisa Camahort Page, one of the founders of and co-author of the Compass Media study, presented the data and highlighted that women blogging at *BlogHer* were experiencing the "evolution of community." According to the report, "we live in an era in which people distrust institutions, but there is an increasing trust of each other" (Wright & Camahort, 2008).

The theme of community is echoed among the women who attend the conferences in blog posts from the event and in the days and weeks afterward. For instance, a woman who blogs as UppercaseWoman writes:

> No matter how small your blog is, *BlogHer* has something to offer you. I cannot describe the energy and atmosphere of the convention without sounding like a smitten teenager; it was unbelievable. There was just something about being surrounded by so many women, and so many people who live part of their life on the Internet. Do you know how awesome it was to never have to apologize for opening my laptop and starting to type while talking to someone? I didn't realize that at home I'm always saying sorry for cracking open the laptop to check my email.[17]

Here, UppercaseWoman articulates what women say repeatedly about the sense of community that they find at these conferences. Apart from the po-

tential for economic benefit that one might gain from community, UppercaseWoman makes note, instead, of what could be called the overlap between the digital and the material, as when she writes: "There was just something about being surrounded by so many women, and so many people who live part of their life on the Internet." In this, she is pointing to the material world—being "surrounded by" women and people—overlapping with the digital world, that is, those "who live part of their life on the Internet." The "awesome"-ness that UppercaseWoman experiences at the conference because she never has to apologize for opening her laptop suggests that in her daily, non-conference life there are those who insist upon more of a separation between the digital and the material. I contend that part of what she finds compelling about the sense of community at *BlogHer* is the way in which the digital and the material are imbricated at these conferences.

The key to monetizing blogs is to be able to find ways to tie community to generating income. Blogs are trusted for news and new information, Camahort emphasized, and this translates into "purchase decision influence." The discussion of economic power at women's blogging conferences is primarily focused around women's power as consumers within the domestic realm. This conclusion to Camahort's presentation is typical of the rhetoric of conference organizers: "Women control 80% of household spending and this translates into power, the power to participate and change the world. This is the evolution of power. Are you exercising your power?"

Some scholars have called into question data that suggest women's power in domestic economic decision-making (Burgoyne, 1990). More salient to my critique here is that such a conceptualization of women' economic power situates it firmly within a domestic sphere tied to a heteronormative construction of gender in which men are breadwinners outside the home and women located within the household as managers of the household and childrearing (Ingraham, 1994). This lens for understanding women's economic power obscures a number of other views. Chief among these is that women's economic power remains rather limited when measured in terms of wealth compared to men's, and that women are denied access to real economic power beyond the domestic realm. Yet it is not economic inequality that is the focus of women's blogging conferences. It is community.

At the same time that women are finding community at *BlogHer*, they are also trying to find ways to make money from their blogs. Generating revenue is foundational to the *BlogHer* network, which has grown into a social media empire that, in addition to the conferences, includes a website that

PESQUISAR SOBRE ASSO 100 BRASIL

helps publicize women's blogs and an advertising network to help women generate revenue for the site. The mission statement of the organization states that it is intended to "create opportunities for women who blog to pursue exposure, education, community, and economic empowerment."[18] Consistent with this mission was one session I attended entitled "What We Do: There's More to Monetization Than Advertising" that featured speakers who were "mom bloggers" and social media finance experts. The women on this panel talked about the myriad ways to earn money from blogging including advertising, affiliate programs, selling items via e-commerce, and doing consulting work as a result of publicity generated by blogging. There is also a recognition that monetizing is very difficult, even rare. Jory Des Jardins, one of the co-founders of *BlogHer*, moderated this session and gave this assessment of successful monetization:

> At BlogHer, we have over 1,000 mom bloggers. There are a bulk of women who are earning enough money not to cover a mortgage but would cover the groceries. $2–20 per 1,000 visitors. Food bloggers, yes they earn. Politics, that's a great space, but they just don't pay. (Field Notes, July 10, 2008)

Des Jardins's remarks are both true and not true. It's true that there are very few women who make money as political bloggers, but quite a few men who have political blogs make money. It might be more accurate to say that political blogs for women don't make money. This session about the contrasting earning potential of (women) food bloggers versus (women) political bloggers is worth noting for the way in which it illustrates the kinds of parameters placed on blogging in order to make monetization a reality. If corporate advertisers are more likely to compensate women food bloggers and unlikely to pay women political bloggers, then this economic reality shapes what kinds of blogs women create for those who want to get paid for blogging.

There is plenty of resistance to the idea of monetization among women bloggers who attend *BlogHer*. For example, the blogger Pillowbrook writes that she finds the "ferocious entrepreneurial zest" of so many of the women at BlogHer "downright intimidating" and "slightly depressing." In her recap of the conference, she offers this assessment:

> I do not appear to have a "mainstream" voice that dramatizes my flaws in a highly entertaining way that's marketable/relatable, or parent in a way that's again, relatable...or is remotely of interest to any car manufacturer, childcare product manufac-

turer, or children's television/stuffed animal/theme park complex.... I also appear to lack the savvy to stir up traffic to my blog in ways that would make it more marketable by running giveaways, doing Mr. Linky thingies, reviewing popular items, spreading comment love, twittering, or any number of things that help drive traffic.[19]

The point Pillowbrook makes here is a crucial one (and one to which I shall return later) about the parameters of women's blogging when corporate underwriting is involved. Although she does not use the term commodification, this is precisely the process that Pillowbrook is identifying here, and the process she aims to resist through her refusal to run promotional "giveaways" or do "Mr. Linky thingies."

However, this sort of resistance and critique appears mainly in blog posts outside the conference that are rarely voiced in real time within the sessions and workshops. Following her previously noted remarks about the relative earning potential for food bloggers versus political bloggers, Des Jardins (a co-founder of *BlogHer*) reassures the audience that "Corporations are really looking for you all." This assessment may overstate corporations' capacity to use women's blogs for marketing their products. The notion that corporations are "looking for you all" also obfuscates the way corporations perpetuate institutionalized racial inequality, as demonstrated by the *Blogalicious* conference.

The *Blogalicious* conference in Atlanta (2009) was organized by three African American women who together form the "Mamalaw Media Group." They describe themselves as "three moms and wives who just happen to be lawyers too. We have seven kids between us which means that we have no shortage of funny stories, touching moments, reasons to rant and the occasional kernel of parenting wisdom." The *Blogalicious* conference was small compared to *BlogHer* with about 175 people attending. Two themes—one of community and the other the pursuit of economic power—were interwoven throughout the conference, just as they were at *BlogHer*, with an additional foregrounded focus on race at *Blogalicious*.

The opening plenary at *Blogalicious* was one of the founders of Sunkissed Mommy.com, a "unique community for mothers of color." The back of the conference brochure featured a full-page ad for Sunkissed Mommy (SKM), and their tagline reads: "beauty, style, culture and motherhood." In this context, culture is a synonym for "race/ethnicity." In her welcoming remarks, Alana Jones reiterated the founding narrative of SunkissedMommy.com:

When I became pregnant with my first child, I immediately searched for a Web site where I could connect with women like me. I wanted the latest in fashion, beauty and decor as I embarked on this new chapter of my life. I wanted to read about the challenges and joys celebrity mothers of color were facing—minus the negativity and gossip.

I couldn't find the online haven I imagined, so I created it for us.

Sunkissed Mommy speaks to the woman of color in all her roles—woman, mother, wife and head of household. We are a unique community for mothers of color. Unlike other online communities that focus on moms or on women of color, SKM views the world through the twin lenses of motherhood and race, providing beauty, fashion, style, health, travel and parenting content that reflects the unique needs of the community.

Whether it's sharing experiences raising children in these challenging times, showcasing traditions and culture or reading web content developed for and about you, our members—whether a grandmother or a first-time mom, Asian, Hispanic or Black—can rely on SKM to keep your interests and needs firmly in focus.

In many ways, Jones's story here echoes that of the founding narrative of *BlogHer*. She looked for her own likeness in mainstream media representations and found none. Finding none, she created her own media to reflect her own experience. What is different here is that while race—specifically whiteness—is assumed, taken for granted, and goes unremarked upon at *BlogHer*, at *Blogalicious* race is given an equivalent status with motherhood. Thus, while a critical understanding of race is central to conference organizers and attendees at *Blogalicious*, motherhood remains embedded in conventional ideological constructions of gender (Glenn, Chang, & Forcey, 1994).

The equivalent status of "race" and "motherhood" at *Blogalicious* is evident in a number of places, such as when Jones says, "SKM views the world through the twin lenses of motherhood and race." All of the other topics she lists—"beauty, fashion, style, health, travel, and parenting"—are interpreted through the "twin lenses" of race and motherhood. This is an important, indeed paradigmatic, shift from the solitary lens of "women" at *BlogHer*. Yet the topics covered by the women attending *Blogalicious* and touted by Sunkissed Mommy—beauty, fashion, style, health, travel and parenting—are virtually identical to those discussed at *BlogHer*.

Participants at *Blogalicious*, like those at *BlogHer*, emphasize the feeling of community they experienced at the events. This blogger, who writes as "Xiaolin Mama" (tag line: "My kung fu is strong…but my martinis are stronger!"), is typical of the sort of effusive recaps I found following the conference:

> Just got back from Hot-lanta (and slightly humid) and the AWESOME Blogalicious conference. It was a weekend full of 175 sassy women of color bloggers from all over the country who gathered for support, laughter, connection and to take their blogs to a new level. Sounds trite, but connecting, laughter and dancing to Michael Jackson were key elements that made this conference stand out amongst the others that I have frequented over the past few years.
>
> First, props go to the ladies of MamaLaw, who put on an outstanding event. The parties were inviting and the food was good. But more importantly, the overall feel of the event was welcoming—whether their blogs were read by 20,000 or just by their intimate friends and family, the folks I met were sweet, sincere and ready to take on the world. The MamaLaw ladies are graceful, meticulous and fun and this event exuded that from beginning to end—Kudos Ladies![20]

Xiaolin Mama is quick to connect her sense of community at the conference to a system of exclusion in the social, economic, and political context beyond the conference. A bit later in the same post, she writes:

> Maybe it is because I am from Silicon Valley and am online constantly, but I was surprised by the lack of tech companies at the expo. It could be that the conference was small and in its first year, so it is hard to justify budget to staff a booth. But come on people, 175 women who are online, had cell phones/iphone/blackberries and twitter accounts were ready to check out your products and you all missed the boat. Too bad. You should be there next year![21]

This critique of marketing professionals' lack of attention to women of color bloggers framed the conference, based on their choice of plenary speakers rather than anything explicitly stated by the MamaLaw organizers.

The *Blogalicious* conference in October 2009 took place at a hip, but small, hotel in suburban Atlanta. There were the same round banquet tables, but many fewer, each with a flower arrangement in the middle. Almost all of those attending were African American, with a few Latina and Asian American women, a majority in their 30s and 40s. There were almost no younger women (one woman appeared to be in her mid-20s) and none who were older (another few women appeared to be 55 or up). There were about three men attending as well, mostly straight men, who appeared to be accompanying wives and partners. There were no young children attending, although there was frequent mention of children by conference organizers and attendees. Upon registration, participants received large canvas tote bags filled with swag donated by corporate sponsors: water bottles, snack items, samples of lotions, and keychains. The *Blogalicious* tote bags also included "Black Bar-

bie" dolls. Sponsors of this conference numbered in the low double digits (10–12). One of the sponsors was, in fact, *BlogHer*.

The plenary keynote was given by Stefania Pomponi Butler, who blogs at City Mama and at Kimchi Mamas, a collective blog written by women of Korean descent. She recounted her experience attending a previous women's blogging conference:

> In the "State of the Momosphere" session on day 1 of BlogHer07, I listened as not one, but two PR guys smugly stood up to tell us mothers how proud they were of their strategy to "hook" moms into trying their products by pretending to read our blogs (so we'll trust them) before offering up whatever it is that they'd like us to blog for free. And I fumed. My hand shot up and Jory passed me the mike, and I told them (essentially) to stop treating us all like we're stupid. We all know PR people don't read our blogs. I mean, if one more PR person starts an email with, "Hey! How was Hawaii!" because a quick glance through last month's posts mentions my trip, I'm gonna scream.
>
> I also told them that even though I get pitches everyday at City Mama, over at Kimchi Mamas we get none. Not a one. Ever.
>
> Because people of color do not matter to advertisers. To his credit one of the PR dudes came up to me after the session and asked "How should we pitch to mommy bloggers?"
>
> And I said, "Tell me you looked up my stats on Alexa. Tell me you picked me because you *think* I may be influential. Tell me that you know mombloggers get pitched to all the time but that you'd *pretty please* like me to listen to you. Just don't bullshit me by telling me 'you read my blog.' I know you don't."
>
> Then he admitted, "You're right. We don't pitch to bloggers of color." And here's the money quote: *"We just don't know what to do with them."*[22]

In many ways, Pomponi Butler's confrontation with the PR professional and—perhaps more importantly—her blog post about it, was a shot heard 'round the blogosphere, particularly for women of color who immediately identified with her experience. The position of Pomponi Butler as a blogger at both the ethnically identified Kimchi Mamas and at the assumed-to-be-white City Mama gives her a unique angle of vision on the disparate level of interest by PR professionals in women bloggers based on their racial and ethnic identity. She was invited to be the keynote speaker at *Blogalicious* precisely because of her perspective in this blog post, which she read as part of her opening remarks.

Conference participants at *Blogalicious* found Pomponi Butler's words a very powerful marker of community. Here is blogger Xiaolin Mama recount-

ing her reaction to the speech and what it meant to hear it in the context of the *Blogalicious* conference:

> So when Stefania re-read her post this weekend tears welled in my eyes. I came to the realization that I was sitting in a room full of women of color bloggers and the gathering was not an afterthought, but rather deliberate and strategic—a way for us to personally connect and for us to show companies that yes, we too buy shampoo, chips and laundry soap. It was a statement that WOC are serious about blogging and social media and are a force to be reckoned with. It was an opportunity on a silver platter for companies to connect with an underappreciated market of women. It was exhilarating to be part of this group of smart pioneers.[23]

Xiaolin Mama expresses a deep emotional response ("tears welled in my eyes," "exhilarating") to the physical, material presence of "sitting in a room full of women of color bloggers." She makes an explicit connection in the rest of that sentence to the quest for economic power and, in fact, economic parity with white women, when she writes that the gathering is "deliberate and strategic—a way for us to personally connect and for us to show companies, that yes, we too buy shampoo, chips and laundry soap."Here the twin themes of community and the pursuit of economic power are intertwined as they were at *BlogHer*. However, there is an important difference. At *Blogalicious*, "culture," a signifier for race and ethnicity, is at the forefront.

Doing the Third Shift, Doing Gender

Despite advances in gender equity in paid employment and the rise in dual-income households, women are still responsible for the overwhelming majority of housework and childcare. Doing this additional labor of housework and childcare after paid labor outside the home has been referred to as the "second shift" (Hochschild, 2001; Hochschild & Machung, 2003).

The emotional labor required to maintain relationships is part of the "second shift" of work that women perform. This is now being incorporated into the way in which women participate in the blogosphere. One woman named Charu (2008), attending *BlogHer*-Boston, remarked: "My family is in India and I live in here, in the U.S. I started a blog because this is the only way my family has ever seen my kids."[24] This comment describes the way in which women use blogging to maintain familial connections and build relationships across significant geographic distances. In addition, this blogger's remarks also hint at the challenges of building and sustaining extended family ties across diasporas. As a number of scholars have noted, Internet technolo-

gies have been crucial for people maintaining community in the midst of diasporic dispersion (Gajjala, 2004; Ignacio, 2006).

The significance of blogging as a way of maintaining a familial record for posterity is another way in which women's emotional labor has been grafted onto new technologies. Susan, presenting at a panel at *BlogHer* Boston, said she blogged because she wanted to create "an archive" for her son. Many of the women bloggers who are also mothers of young children spoke spontaneously about "leaving a record" for their children through their blogs. In many ways, this kind of blogging is similar to what previous generations of mothers created in "baby books" filled with photographs and mementos from a child's first years of life (Walzer, 1998). Elisa, one of the founders of *BlogHer* expressed the impulse for a record in this way:

> I think blogs are creating a beautiful cultural record for all of our children. I just think this is the most beautiful thing. I mean, my grandmother escaped from the Nazis and there is no record of that—just no stories. And, I think that what we're doing, parent blogging, is leaving a beautiful cultural record for all of our children.[25]

Here Elisa frames the need for a record in the light of the Holocaust and her grandmother's escape from Nazi persecution. Perhaps more to the point, she highlights the fact that there is "no record of that," and her attendant sense of loss for that non-existent record is a key motivator for the contemporary desire to leave a "beautiful cultural record" for "all our children." While she uses the gender-neutral "parent blogging," this particular kind of familial blogging, like the second shift, is overwhelmingly gendered female. What goes unremarked upon here is the dramatically different social context between the contemporary U.S. and Third Reich-occupied Europe and whether or not these more recently compiled cultural records of life from an affluent era will have the same (imagined) resonance as those of an earlier historical moment hold for this woman at *BlogHer*.

Whether or not the current milieu calls for such meticulous recordkeeping is a notion that some scholars have questioned. Rosalind Gill (2005), for example, takes exception to the notion that there is anything remarkable in these practices when she describes "women's depressingly familiar…use of the Internet in affluent northern countries…primarily for e-mail, home shopping and the acquisition of health information" (p. 99; see also Herring, 2004). Yet there is a competing claim that women's diaries, and their notation of the "depressingly familiar," make important contributions to history

(Benstock, 1988; Bunkers & Huff, 1996; Gannett, 1992). Liz Henry, a technical advisor to *BlogHer* was the only one at any of the conferences whom I heard put this in explicitly feminist terms when she said: "Why should we care about identity? To find women's participation in the public sphere is important…there is a long history of women's diaries as part of feminist history. Your biographer will thank you."[26]

Liz's comments stand out both for their overt framing of blogging as a feminist act linked historically to women's diaries and for placing blogging in the public sphere. In the print-only era, diary keeping was a private act associated with the domestic sphere, but with the move to the digital era, women's digital diaries have entered the public realm. While it is possible to adjust settings on blogs and make them private so that only approved friends or family can read them, blogging by women at the conferences is, for the most part, a decidedly public activity. This work of sustaining familial ties, connecting disparate family members to each other, and creating a record of a shared past for an imagined future is now part of what might be called a "third shift" for women who are mothering in the digital age.

It is rather remarkable that women—especially those with young children—find time to blog, given a workload that often includes a "second shift." Hochschild and Machung (2003) famously wrote that the mothers of young children she interviewed often "spoke of sleep the way a hungry person talks about food" (p. xx). And yet women do find time to blog by using a variety of strategies. A key strategy that many women reported is, as blogger Candelaria said, "I watch much less TV." According to the Compass Media survey, 43% of women bloggers said that they are spending less time watching TV to fit in time for blogging. Another woman, Christine, said that she plans out what she's going to write each week and then adds, "I don't cook dinner anymore." This remark received a loud laugh of recognition from the audience. Another woman at the same session, Judith, said: "I write after I put my daughter to bed at 8pm, and I turn off the computer at 10pm." In one of these strategies—watching less television—women are taking time from a massmedia leisure activity in order to create new media content. In a different strategy—not cooking dinner—women are doing less of the second shift labor of housework in order to devote time to their blogs.

Despite what seems to be a third shift of domestic labor, many women bloggers find a respite in their online writing. As Jill, blogger at Scary Mommy, writes:

INTERESSANTE

As a mother of three, there are very few things that are entirely mine. My bed is inevitably invaded by all of the kids sometime throughout the night. My favorite foods are devoured by mouths other than mine and my cosmetics are used for dress-up these days as often as on my own face. My car is filled with car seats and stale Cheerios and my purse is so stuffed with junk for the kids that I can't even carry my own sunglass case. But this blog? It's mine. All mine. And that's what I love about it.[27]

Here Jill places her enjoyment of blogging within the context of the demands on her time and attention as a mother of young children. In many ways, the way women use blogging is analogous to the way that Radway found that women used the reading of romance novels. While the narrative in the romance novels often reinforces existing gender regimes, the ways in which women consume the novels—carving out time away from children, family, and domestic labor—are very often subversive of those very same structures (Radway, 1984). Women bloggers are both producing content (as creators and writers) and consuming it (as readers and commenters). This combination of producing and consuming, or prosumption, makes women bloggers *prosumers* (Ritzer & Jurgenson, 2010). As a site of prosumption, women's blogs simultaneously offer an opportunity for a creative outlet that enables resistance to the "second shift" in which women are still overwhelmingly responsible for the labor involved in childcare and housework, at the same time that they demand additional labor—a "third shift"—in which women are responsible for the emotional labor of creating a record of childhood and maintaining familial ties.

Political Economy of Women's Blogging Conferences

Examining the corporate sponsors at *BlogHer* and *Blogalicious* highlights the political economy that supports the milieu of the conferences and, I contend, shapes what is possible at the nexus of feminism and women's blogging. In the section that follows, I examine the scope and type of corporate sponsorship at both conferences with an eye toward what these say about the racialization of women's blogging.

At each of the conferences, corporate sponsors pay to advertise directly to the women bloggers. In turn, corporate representatives hope to entice women to write posts on their blogs that are favorable to their products. In the parlance of advertising, these women are "influencers." When they recommend a product, other women are influenced by their recommendations

and buy these products. In some cases, public relations representatives from the corporations approach individual bloggers at the conferences about direct advertising on their blogs. However, the economic interests of corporations are not evenly distributed, and the disparate sponsorship at each conference highlights the political economy of women's blogging and the ways in which this is splintered by race.

There were over 40 sponsors at *BlogHer* San Francisco in 2008. These included the Fortune 500 companies General Motors, Hewlett-Packard, and Target, along with start-ups such as LeapFrog.com and Picnik.com.[28] The appeal of some women's blogs to advertisers makes sense, given their reliably large audience, as evidenced by the size of the audience at the closing plenary. Over one thousand women filled the large hotel ballroom eager to hear the last two speakers, Stephanie Klein and Heather Armstrong, bloggers who wield a considerable amount of economic power. Stephanie Klein is the author of a popular blog, Greek Tragedy (stephanieklein.com), that chronicles her personal life and that helped her earn a six-figure book deal for *Moose: A Memoir of Fat Camp*. Heather Armstrong's blog, Dooce.com, earns her a reported seven-figure income;[29] her blog is so economically successful that her husband quit his job to help her manage it full time.[30] By featuring Klein and Armstrong prominently on the program, conference organizers clearly signal that these bloggers are exemplars for other women to emulate. For advertisers, it is the estimated audience of five million readers per month that they find so appealing for their messages. It is these women, both producers and consumers of blogs, which corporate advertisers hope to reach through advertising at the blogging conferences and through advertising on the blogs themselves.

It makes sense that corporate advertisers from particular economic sectors would want to tap into women's blogging to reach potential customers. Marketing research suggests that women's spending priorities differ from men's. Because of their still-overwhelming responsibility for childcare and housework, women are more likely to buy goods and services that meet these needs. Sectors likely to expand when women's buying power increases include food, health care, education, childcare, apparel, home furnishings, appliances, and financial services.[31] Advertisers for most of the sectors were well represented at *BlogHer*.

At *Blogalicious*, there were fewer than a dozen sponsors, and only a handful were from *Fortune* 500 companies.[32] For example, "one of the sponsors was Pine-Sol (a cleaning product made by Clorox), which was promot-

ing Powerful Difference," their social media campaign. The campaign was described in promotional materials as celebrating "women who make a powerful difference and provides tools & resources to everyday women that enable success for their communities." Conference attendees stood in line to get their photos taken with Diane Amos, the actor popularly known as "the Pine-Sol lady." The "Pine-Sol lady" advertising campaign is an interesting one that simultaneously evokes another era in which black women were almost exclusively portrayed as maids or servants (Collins, 1995) while updating the image with Ms. Amos's peppy delivery and decidedly non-servile performance. The Pine-Sol/Clorox campaign appeals to African American women by signaling both recognition of a history of struggle by being marked as different and evoking a more hopeful future in which black women, along with the help of the Pine-Sol brand, "enable success for their communities."

American Airlines, another of the *Fortune* 500 companies at *Blogalicious,* was represented by company spokesperson Nelson George. George attended the conference to promote the airline's new travel product, BlackAtlas.com, niche marketed primarily to relatively affluent African Americans. The product is an online guide to global destinations of interest in the African diaspora, which Nelson George—billed as "Travel Expert-at-Large"—has visited at the airline's behest and narrated for curious travelers. BlackAtlas.com is an interactive site that invites travelers to post videos and text entries about their travel abroad. To promote this social media product, American Airlines took out a full-page ad in the conference brochure. The ad featured an attractive, business-suited, middle-class African American woman striking a thoughtful pose—arms folded across her chest, one finger lightly touching her chin, her eyes looking up and to the left—above a caption that reads: *"Are any black folks here?"* The text in the rest of the ad reads:

> It's an age-old question. But when you're traveling someplace new, you want to know. Introducing BlackAtlas.com from American Airlines. Travel Expert-at-Large Nelson George will give you the inside tip with travel reviews, videos, articles and much more. All from a Black Traveler's point of view. Are you ready for departure?

The iconography here is markedly different from that in the "Pine-Sol Lady" ads and campaign. Rather than more or less directly evoking a history of struggle, the ad for American Airlines's BlackAtlas.com speaks to a different legacy, one of a black elite that asks the "age-old question" when they travel the globe, "are there black folks here?" The content of BlackAtlas.com

includes interesting historical information about a variety of locations such as
the presence of a large community of African American ex-pats living in Paris
in the years following World War I. Unusual for a corporate marketing ef-
fort, BlackAtlas.com includes explicit references to American racism
throughout. For instance, the caption to the video of Nelson George narrating
an introduction to Paris reads: "After the First World War, African American
Artists Fled Racism in the U.S. for the Multi-Cultural Streets of Paris."
While most corporate advertising campaigns embrace the rhetoric of color-
blindness in order to sell their products to the widest possible base of con-
sumers (Crockett, 2008), American Airlines is intentionally referencing
racism in the ad copy in order to sell this product to African American con-
sumers.

Given that more people than ever are planning trips online, and it is
women who are most often doing the travel planning in families, it made
sense for American Airlines to reach out to the women at the *Blogalicious*
conference. A 2005 Travel Industry of America (TIA) report indicates that an
estimated 78% of Americans (79 million) turned to the Internet for travel or
destination information in 2005 (up from 65% in 2004). Of those, women are
more likely to use online travel services than men.[33] Thus, finding women
who are upwardly mobile and web savvy, like the women of *Blogalicious*,
makes perfect sense from a marketing perspective.

Of course, American Airlines is not trying to reach all women with this
campaign, as evident from the tagline for BlackAtlas.com: "Your passport to
the Black Experience." This slogan signals an essential and unified concep-
tualization of African Americans as seekers of an authentic "Black Expe-
rience." In so doing, the history of global racial oppression gets cordoned off
as knowledge appropriate for one "niche," that is, African Americans who
have an interest in "black history." As one white woman described the ses-
sion via Twitter, "video of Nelson George talking about black history and
travel," this is a way of containing discussions of race and racism and locat-
ing them within "black history," of interest only and exclusively to blacks,
rather than saying, "the history of white racism." This reinforces the un-
marked quality of whiteness and the seemingly willful ignorance on the part
of whites about the history of systemic racism and white people's participa-
tion in it. Of course, the world is more diverse than a simple black-white di-
chotomy, and products like BlackAtlas.com raise further questions about
other diasporas. One of the *Blogalicious* conference attendees said via Twit-
ter during Nelson George's presentation about BlackAtlas.com: "looking

fwd2 AsianAtlas.com so [I]can find the best Dim Sum in Mexico when traveling." Racialized niche marketing like that of BlackAtlas.com simultaneously essentializes, contains, and commodifies experiences of racism, while excluding other narratives from view.

The premiere sponsor at *Blogalicious,* and easily the most eagerly anticipated among conference attendees, was Disney Studios, which was promoting the release of its animated film *The Princess and the Frog.* The film included voice-overs from Oprah Winfrey as Tiana, the princess, and Terrence Howard as the frog. Disney sponsored a luncheon and an evening cocktail party. For the luncheon, the dreary hotel conference room was transformed with new, elaborate place settings, floral arrangements on each banquet table, and Disney-product-filled gift bags. The lights were turned off so that the room was illuminated only by the candles on each table and the splashy, multimedia show presented by the Disney spokeswoman, a white woman who emphasized over and over how many black people worked behind the scenes of this animated film. While some in the audience noted the lack of women on the production team (e.g., via Twitter: "Makers of Frog Princess seem to be all men. No women in creative process in a girls film?"), there was no criticism of the princess-theme from the core *Blogalicious* audience. In some ways this is surprising, given the formidable critique of Disney's female film characters as passive, even sexist and racist (Bell, Haas, & Sells, 1995). In contrast to this tradition, *The Princess and the Frog* was sold by Disney and received by *Blogalicious* conference attendees as a major advance in representation for black women.

The link between Disney's *The Princess and the Frog* and the *Blogalicious* conference signifies a deep resonance between the message of the film and the zeitgeist of the conference. A glimpse into how the film was received by the organizers of the conference is available through their writing following the event. Four months after the conference, one of the *Blogalicious* organizers, Justice Ny, wrote a blog post reviewing the film, calling it "inspirational":

> The movie's message is so grounded and inspirational. Dream big and work hard! I loved that Tiana's dreams were centered around making something of herself and they weren't simply to get married to a prince and live happily ever after, as so many fairy tales end. I was also impressed that their challenges weren't simply solved by the prince. She was as involved in solving their problems as anyone else. Also, the music was so culturally rich and the message was so powerful that I appre-

ciate and welcome my princess listening everyday—"I'm almost there" and "Dig a little deeper" are mantras that I hope she will live by.[34]

Here, Justice Ny reads the film as a story of empowerment for herself and her daughter ("my princess") through what she sees as the central message ("Dream big and work hard!"). While she does not explicitly note the critique of the princess narrative as reinforcing passivity in girls, she implicitly evokes it when she notes that her "challenges weren't simply solved by the prince." Yet by accepting the inevitability of the princess and the prince, she elides the critique that this narrative reinforces heteronormativity. Similarly, the *Blogalicious* conference conveyed an implicit message of empowerment in which women are viewed as self-sufficient and decidedly not in need of rescue (by "the prince" or any other male figure). However, this notion of women's self-sufficiency is deeply embedded within a conceptualization of women as situated firmly within a domestic sphere tied to a heteronormative construction of gender.

The experience of watching the film some months later is interwoven with the Disney-sponsored lunch at *Blogalicious*. In the following passage (just after the one quoted above), Justice Ny refers back to the conference:

> For those of you who attended Blogalicious, you may remember one of our keynote speakers, Karen Walrond's (@chookooloonks) presentation during the Disney sponsored lunch. Her talk was entitled "The Beauty of Different" and it tied perfectly to the movie's theme. Karen gave us a glimpse into her life and walked us through how she ended up pursuing her passion and her dream of being an author/ photographer/business woman.[35]

The woman she references, Karen Walrond (who adopted the name "chookooloonks" based on a Trinidadian term of endearment), addressed the *Blogalicious* conference immediately after the screening of the film. She explained that she started blogging because she and her husband were adopting, and she wanted to update family members about the adoption. She found that adoptive parents are "voracious about looking for and reading info online." Her adoption-focused blog eventually became a successful photography blog. Walrond described her success this way: "I got a book deal, Oprah called, I enjoy blogging every day," in contrast to her job as a corporate lawyer, which she did not enjoy, and "I get to see my kid." This vision of commercial and media success combined with a version of stay-at-home and working-outside-the-home motherhood is central to the ethos of both women's blog-

ging conferences. It is also very consistent with the upwardly mobile, Oprah-driven meme "live your best life" that pervaded the *Blogalicious* conference, and with the message of the Disney film. The issue of race is also very much part of the discussion about the film and, by extension, the *Blogalicious* conference.

The connection between how the film was received by *Blogalicious* conference organizers and the central theme of the conference is evident in the call for marketplace activism. Justice Ny ends her blog post about *The Princess and the Frog* by referring to wider audience response to the film:

> I read somewhere that the movie did not meet Disney's revenue target and may be considered as an under-performing film. We cannot affect box office sales, but we've got to get out there and buy the dvd. It's a great film and it's the first black princess and I think it's imperative that we support this effort to show the buying power of people of color. It hurts my heart that despite the great recession, at the end of the day, Disney (and maybe others) may attribute lower revenues than expected to the fact that the princess was of color. I feel like we've got to show them…that we are a force in the marketplace and that they should continue to market product that specifically appeals to people of color. Please don't spend your $14.99 on Hannah Montana or the Backyardigans before spending it on The Princess and Frog![36]

The call to "show them" that black women consumers "are a force in the marketplace" captures the central theme of the *Blogalicious* conference. The call to demonstrate purchasing power and inclusion in marketing campaigns is a kind of "marketplace activism" (Branchik & Davis, 2009; Butler, 2005; Wingfield, 2009). This race-conscious activism involving the marketplace is one rooted to traditions in the black middle and upper-middle classes. Given the decades of systemic exclusion from hiring and representation by the oldest and most widely distributed maker of animated films in the United States (Project on Disney, 1999; Feagin, 2006), it is perhaps not surprising that African Americans, and in particular African American women, would celebrate the creation of the first black princess by Disney as a sign of racial progress. Yet the embrace of "our first black princess" stands in contradiction to some white feminists' critiques of Disney's perpetuation of heteronormativity (Martin & Kazyak, 2009; Williams, 2006). In many ways, the uncritical embrace of Disney's black princess, and the call to demonstrate African American women's "force in the marketplace," is emblematic of the cultural milieu at the *Blogalicious* conference.

ISSO ME
INTERESSA!
LER!

Discussion

Women's blogging conferences can tell us a number of things about the digital and the material, about gender and cyberfeminism, and about race, racism, and political economy.

Digital and Material

The emergence of *BlogHer* and *Blogalicious* as compelling events that women bloggers attend illustrates the way in which the digital and the material overlap. In the early days of the Internet, some imagined a digital world free of material embodiment in which we would all experience a "place without race" and "with no genders" and where "there are only minds." A decade later, we know this is not the case. In fact, people go online to find community and identity, specifically around race and gender (Byrne, 2007; Everett, 2004, 2007). Women's blogging is a digital medium that relies on, reinforces, and reinscribes the material circumstances of women's lives, embedded as they are in regimes of gender in which women are wives and mothers with primary responsibility of childcare and housework. Rather than a place where women go to escape (or play at changing) their embodied gender, the blogs created by the women attending the conferences affirm their material, corporeal reality as women, often mothers and wives. Further, women's blogging offers them a mechanism for coping with the exigencies of that reality. Through the conferences, women seek out other women who have also created online, digital personas that match their material existence. These face-to-face meetings in real time then further cement the asynchronous online connections made through hyperlinks, blog rolls, and comments. Thus, women's blogging conferences illustrate way in which the digital and the material are imbricated (Sassen, 2002).

Gender and Cyberfeminism

Women attending blogging conferences are seeking—and largely report finding—community among other women bloggers. Whether or not this community of women bloggers constitutes cyberfeminism, or womanism, remains an open question. Lopez (2009) argues that "mommy blogging is radical" because women get to tell their stories unfiltered by corporate media. The opportunity to counter the lack of representation in corporate-controlled media portrayals, especially of women of color, is an appealing feature of women's blogging. Yet, the blogging conferences seem to reinforce hierarchies of

gender and race. Although the organizers of *Blogalicious* have a more critical view of the existing social order than the *BlogHer* conference organizers, both conferences are steeped in the language of liberal feminism and a deeply conventional view of gender and sexuality. The embrace of liberal feminism and the domestic narratives of working mothers are central to the appeal of women bloggers to advertisers. The commodification of women's blogging is also the commodification of feminism, as it takes women's emotional labor and the crypto-feminist impulse toward diary keeping, (e.g., in order to leave a "beautiful cultural record" for "all our children") and uses it to sell back to women their own experience. A number of individual bloggers (e.g., Pillowbrook) resist the push toward commercialization of their blogs by refusing to monetize them (e.g., "doing Mr. Linky thingies"), but these individual acts of resistance are lost at the blogging conferences, where the goal is still to get a corporate advertising deal. It is through this desire to attract corporate advertisers by writing that appeals to a wide audience of wives and mothers that hegemonic discourses of gender are reinforced by the political economy.

Advertising support brings with it legitimation. The fact that advertisers are targeting predominantly white women bloggers in the United States has global implications. As gender equality improves and coincides with the growth of a global middle class,[37] the power of white women's blogs in the United States will likely expand their scope of influence as more women go online to read and create blogs. Advertising that subsidizes white, middle-class, American women's blogs privileges their discourse within this context and skews the importance of these blogs over the blogs of other women— those without advertising, those outside the United States, those without young children. Thus, corporate advertisers and the women whose blogs they subsidize become the arbiters of what is relevant and important in women's lives. Of course, these gender regimes do not exist apart from race and institutionalized racism.

Race, Racism, and Political Economy

The whiteness of the blogosphere and of women's blogging conferences such as *BlogHer* is rarely remarked upon by the mainstream media, yet the racial composition of these conferences is set in relief when contrasted with the *Blogalicious* conference. The stark difference in sponsorship between the two conferences—over 40 sponsors at *BlogHer*, fewer than 10 at *Blogali-*

cious—speaks in part to the role of institutionalized racism in the political economy that women's blogging conferences find themselves in.

The kind of niche marketing represented by American Airlines illustrates the way in which not only a particular experience of gender and sexuality, but also race, has been commodified. American Airlines, with its BlackAtlas.com product, has effectively commodified the black experience of racial oppression. In other words, the airline has taken the experience of racism, made it a product, and is now selling it back to African Americans by seeking to enlist the participation of the women at *Blogalicious* as prosumers—both consumers of this product and producers of content for the site. Further, racial divisions are also reinforced by the stark differences in corporate sponsorships based on race.

Conclusion

This volume poses the question: "Where have all the cyberfeminists gone?" One answer seems to be that they have become bloggers and have started attending blogging conferences. Women's blogging conferences are an important location for interrogating contemporary expressions of gender, race, and cyberfeminism. The political economy, in the form of corporate advertisers looking for women bloggers as prosumer advocates for their products, shapes what is possible for a feminism articulated within and through these conferences.

Notes

1 "Mommy (and Me)," *The New York Times*, January 20, 2005; and "Honey, Don't Bother Mommy, I'm Busy Building My Brand," *The New York Times*, March 12, 2010.
2 Kara Jesella, "Cyberhood Is Powerful: The Maternal Impulse Turns Political When You Mix Moms, Feminism and the Blogosphere," *Ms.*, Summer 2009, http://www.msmagazine.com/summer2009/mommyblogs.asp
3 BBC News, Technology, "'Blog' Picked as Word of the Year," December 1, 2004. Accessed March 15, 2010, at: http://news.bbc.co.uk/2/hi/technology/4059291.stm
4 Chris Taylor, "10 Things We Learned About Blogs," *Time*, December 19, 2004. Accessed March 15, 2010, at: http://www.time.com/time/personoftheyear/2004/poymoments.html
5 The Pew Research Center's Internet & American Life Project's Spring Tracking Survey conducted April 26–May 22, 2011. Accessed September 20, 2011 at: http://pewinternet.org/Trend-Data/Whos-Online.aspx See also, U.S. adult blog reading and writing by gender, 2000–2010. Accessed September 20, 2011 at: http://thesocietypages.org/graphicsociology/2011/07/29/us-adult-blog-reading-and-writing-by-gender-2000-2010-pew/

6 Technorati, State of the Blogosphere, 2010. Accessed November 4, 2010 at: http://techno rati.com/blogging/article/state-of-the-blogosphere-2010-introduction/

7 "TechCult's Top 100 Web Celebrities," July14, 2008. Accessed March 3, 2010, at: http:// www.techcult.com/top-100-web-celebrities/

8 Heather Armstrong is the blogger also known as "Dooce," and she was a featured speaker at one of the BlogHer conferences I attended (more about which below).

9 David M. Ewalt and Michael Noer (Eds.), "The Web Celeb 25," *Forbes*, January 29, 2009. Accessed March 5, 2010, at: http://www.forbes.com/2009/01/29/web-celebrities-internet-technology-webceleb09_0129_land.html

10 Kara Jessela, "Blogging's Glass Ceiling," *The New York Times*, July 27, 2008. Accessed March 28, 2010, at: http://www.nytimes.com/2008/07/27/fashion/27blogher.html

11 "Pundits and Knitters Find Common Ground in Web Logs," CNN, November 3, 2005. Accessed March 15, 2010, at: http://www.cnn.com/2005/TECH/internet/08/10/mena.trott/

12 There is a resurgence of the meme that *The New York Times* is trivializing women bloggers each time the paper has published a story about this topic. One of the more recent examples is Joanne Bamberger, "An Open Letter to *The New York Times* about Mom Bloggers, Women Writers & the Universe," *Huffington Post*, March 15, 2010. Accessed March 18, 2010, at:http://www.huffingtonpost.com/joanne-bamberger/an-open-letter-to-the-emn_b_499087.html

13 Vanessa E. Jones, November 13, 2007. Accessed March 14, 2010, at:http://www.boston.com/ae/media/articles/2007/11/13/blog_is_beautiful/ 14, 2010.

14 There is no data, that I could find, on the number of non-white bloggers. This lack of data collection on this segment of bloggers is, in itself, telling about the lack of attention to people of color bloggers.

15 E.g., e-mail discussion groups, listservs, newsgroups, and other e-spaces.

16 This estimate was later confirmed by a *New York Times* story about this event. (See note 10.)

17 Accessed at: http://www.uppercasewoman.com/wastedbirthcontrol/2008/07/blogher-08-the.html

18 Accessed March 3, 2010, at: http://www.blogher.com/our-mission

19 Accessed August 28, 2008, at: http://cynematic.wordpress.com/2008/07/28/wow-blogher-decompression/

20 Accessed November 3, 2009, at http://www.xiaolinmama.com/2009/10/blogalicious-09-recap.html

21 Ibid.

22 Emphasis in the original text. Accessed November 3, 2009, at: http://kimchimamas.typepad.com/kimchi_mamas/2007/07/putting-pr-peop.html

23 Accessed November 3, 2009, at: http://www.xiaolinmama.com/2009/10/blogalicious-09-recap.html

24 Field Notes, October 2008.

25 Field Notes, July 2008. Accessed at: http://freeandflawed.com/2008/07/20/live-blogging-from-blogher-08-3/

26 Field Notes, October 2008.

27 Quoted in Ms., Summer 2009.

28 Sponsors for BlogHer are listed here: http://www.blogher.com/node/150915/sponsors
29 http://www.abdpbt.com/personalfinance/how-much-do-bloggers-make-case-study-heather-
 b-armstrong-aka-dooce/
30 http://www.nytimes.com/2008/07/27/fashion/27blogher.html
31 "Power of the Purse: Gender Equality and Middle-Class Spending," Goldman-Sachs Re-
 port, August 2009. Accessed at http://www2.goldmansachs.com/ideas/demographic-cha
 nge/power-of-purse.html
32 Sponsors for Blogalicious are listed here: http://www.blogaliciousweekend.com/category
 /sponsors/.
33 "Women Research Travel Online: A New Study By TIA Reports More Women Use the
 Internet for Travel Research and Bookings." Accessed at: http://www.roadandtravel.
 com/company/marketing/womentravelonline.htm
34 Justice Ny, "The Power of the Princess and the Frog," posted April 2, 2010. Accessed at
 http://mamalaw.com/2010/04/power-of-princess-and-frog/
35 Ibid.
36 Ibid.
37 "Power of the Purse: Gender Equality and Middle-Class Spending," Goldman-Sachs Re-
 port, August 2009. Accessed at http://www2.goldmansachs.com/ideas/demographic-
 change/power-of-purse.html

Works Cited

Bell, E., Haas, L., & Sells, L. (1995). *From mouse to mermaid: The politics of film, gender,
 and culture*. Bloomington: Indiana University Press.
Benstock, S. (1988). *The private self: Theory and practice of women's autobiographical writ-
 ings*. Chapel Hill: University of North Carolina Press.
Boyd, D. (2004, April). *Friendster and publicly articulated social networks*. The Association
 of Computing Machinery. Paper presented at the Conference on Human Factors and
 Computing Systems. Vienna, Austria.
Branchik, B.J., & Davis, J.F. (2009). Marketplace activism: A history of the African American
 elite market segment. *Journal of Macromarketing, 29*(1), 35–57.
Bryson, M. (2004).When Jill jacks in: Queer women and the net. *Feminist Media Studies, 4*(3),
 239–254.
Bunkers, S.L., & Huff, C.A. (1996). *Inscribing the daily: Critical essays on women's diaries*.
 Amherst: University of Massachusetts Press.
Burgoyne, C.B. (1990). Money in marriage: How patterns of allocation both reflect and con-
 ceal power. *Sociological Review, 38*(4), 634–665.
Bury, R. (2005). *Cyberspaces of their own: Female fandoms online*. New York: Peter Lang.
Butler, J. (2004). *Undoing gender*. New York: Routledge.
Butler, J.S. (2005). *Entrepreneurship and self-help among Black Americans: A reconsidera-
 tion of race and economics* (2nd ed.). Albany: State University of New York Press.

Byrne, D. (2007). The future of (the) race: Identity and the rise of computer-mediated public spheres. In A. Everett (Ed.), *Learning race and ethnicity: Youth and digital media* (pp. 15–38). Cambridge, MA: MIT Press.

Chatterjee, B.B. (2002). Razorgirls and cyberdykes: Tracing cyberfeminism and thoughts on its use in a legal context. *International Journal of Gender and Sexuality Studies, 7*(2/3), 197–213.

Collins, P.H. (1995). *Black feminist thought.* New York: Routledge.

Crockett, D. (2008). Marketing Blackness: How advertisers use race to sell products. *Journal of Consumer Culture, 8*(2), 245–268.

Daniels, J. (2009). Rethinking cyberfeminism(s): Race, gender and embodiment. *Women's Studies Quarterly, 37*(1/2), 101–124.

DiMaggio, P., Hargittai, E., Neuman, W.R., & Robinson, J.P. (2001). Social implications of the Internet. *Annual Review of Sociology, 27*, 307–336.

Epstein, S. (2003). Sexualizing governance and medicalizing identities: The emergence of state-centered LGBT health politics in the United States. *Sexualities, 6*(2), 131–171.

Everett, A. (2004). On cyberfeminism and cyberwomanism: High-tech mediations of feminism's discontents. *Signs, 30*(1), 1278–1286.

Everett, A. (Ed.). (2007). *Learning race and ethnicity.* Cambridge, MA: MIT Press.

Feagin, J.R. (2006). *Systemic racism: A theory of oppression.* New York: Routledge.

Fernandez, M. (2002). Cyberfeminism, racism, embodiment. In M. Fernandez, F. Wilding, & M.M. Wright (Eds.), *Domain errors! Cyberfeminist practices* (pp. 29–44). Brooklyn, NY: Autonomedia.

Fernandez, M., & Booth, A. (Eds.). (2002). *Reload: Rethinking women + cyberculture.* Cambridge, MA: MIT Press.

Fernandez, M., Wilding, F., & Wright, M. (Eds.). (2002). *Domain errors! Cyberfeminist practices.* Brooklyn, NY: Autonomedia.

Gajjala, R. (2002). An interrupted postcolonial/feminist cyberethnography: Complicity and resistance in the "cyberfield." *Feminist Media Studies, 2*(2), 177–193.

Gajjala, R. (2003). South Asian digital diasporas and cyberfeminist webs: Negotiating globalization, nation, gender and information technology design. *Contemporary South Asia, 12*(1), 41–56.

Gajjala, R. (2004). *Cyber selves: Feminist ethnographies of South Asian women.* Walnut Creek, CA: Alta Mira Press.

Gannett, C. (1992). *Gender and the journal: Diaries and academic discourse.* Albany: State University of New York Press.

Gill, R. (2005). Review: Technofeminism. *Science as Culture, 14*(1), 97–101.

Glenn, E.N., Chang, G., & Forcey, L.R. (1994). *Mothering: Ideology, experience, and agency.* New York: Routledge.

Green, R.M. (2005). *Predictors of digital fluency.* Unpublished doctoral dissertation, Northwestern University, Evanston, IL.

Green, R.M. (2006, March). *Personality, race, age, and the development of digital fluency.* American Educational Research Association. Paper presented at the American Educational Research Association's Annual Conference. San Francisco, CA.

Haraway, D. (1985). A manifesto for cyborgs: Science, technology, and socialist feminism in the 1980s. *Socialist Review, 80,* 65–108.

Hawthorne, S., & Klein, R. (Eds.). (1999). *Cyberfeminism: Connectivity, critique and creativity.* Melbourne, Australia: Spinifex.

Herring, S.C. (2004). Slouching toward the ordinary: Current trends in computer-mediated communication. *New Media & Society, 6*(1), 26–36.

Herring, S.C., Scheidt, L.A., Kouper, I., & Wright, E. (2007). Longitudinal content analysis of blogs, 2003–2004. In M. Tremayne (Ed.), *Blogging, citizenship and the future of media* (pp. 3–20). New York: Routledge.

Hochschild, A. (2001). *The time bind: When work becomes home, and home becomes work.* New York: Macmillan.

Hochschild, A., & Machung, A. (2003). *The second shift* (2nd ed.). New York: Penguin Books.

Hull, G.T., Scott, P.B., & Smith, B. (1982). *But some of us are brave: All the women are White, all the Blacks are men.* New York: The Feminist Press.

Ignacio, E.N. (2006). E-scaping boundaries: Bridging cyberspace and diaspora studies through ethnography. In D. Silver & A. Massanari (Eds.), *Critical cyberculture studies.* New York: New York University Press.

Ingraham, C. (1994). The heterosexual imaginary: Feminist sociology and theories of gender. *Sociological Theory, 12*(2), 203–219.

Jenkins, H. (2006). *Convergence culture: Where old and new media collide.* New York: New York University Press.

Karlsson, L. (2006). The diary weblog and the traveling tales of diasporic tourists. *Journal of Intercultural Studies, 27*(3), 299–312.

Kolko, B., Nakamura, L., & Rodman, G.B. (Eds.). (2000). *Race in cyberspace.* New York: Routledge.

Lopez, L.K. (2009). The radical act of "mommy blogging": Redefining motherhood through the blogosphere. *New Media & Society,11*(5), 729–747.

Martin, K.G., & Kazyak, E. (2009).Hetero-romantic love and heterosexiness in children's G-rated films. *Gender & Society, 23*(3), 315–336.

Mitra, R. (2010). Resisting the spectacle of pride: Queer Indian bloggers as interpretive communities. *Journal of Broadcasting & Electronic Media, 54*(1), 163–178.

Mitra, R., & Gajjala, R. (2008). Queer blogging in Indian digital diasporas. *Journal of Communication Inquiry, 32*(4), 400–423.

Nakamura, L. (2002). *Cybertypes: Race, ethnicity, and identity on the Internet.* New York: Routledge.

Nakamura, L. (2008). *Digitizing race.* New York: Routledge.

Norris, P. (2001). *Digital divide: Civic engagement, information poverty, and the Internet worldwide.* Cambridge: Cambridge University Press.

Nouraie-Simone, F. (Ed.). (2005a). *On shifting ground: Muslim women in the global era.* New York: The Feminist Press at the City University of New York.

Nouraie-Simone, F. (2005b). Wings of freedom: Iranian women, identity and cyberspace. In F. Nouraie-Simone (Ed.), *On shifting ground: Muslim women in the global era* (pp. 62–80). New York: The Feminist Press at the City University of New York.

O'Brien, J. (1997a). Changing the subject. In T. Senft & S. Horn (Eds.), *Women & performance: A journal of feminist theory* (pp. 55–68). New York: Women and Performance Project.

O'Brien, J. (1997b). Writing in the body: Gender (re)production in online interaction. In M. Smith & P. Kollock (Eds.), *Communities in cyberspace*. New York: Routledge.

Orgad, S. (2005). The transformative potential of online communication: The case of breast cancer patients' Internet spaces. *Feminist Media Studies, 5*(2), 141–161.

Perlmutter, D.R. (2008). *Blogwars*. New York: Oxford University Press.

Pitts, V. (2004). Illness and Internet empowerment: Writing and reading breast cancer in cyberspace. *Health: An Interdisciplinary Journal for the Social Study of Health, Illness and Medicine, 8*(1), 33–59.

Plant, S. (1997). *Zeroes and ones: Digital women and the new technoculture*. London: Fourth Estate.

Podlas, K. (2000). Mistresses of their domain: How female entrepreneurs in cyberporn are initiating a gender power shift. *Cyber Psychology and Behavior, 3*(5), 847–854.

Pole, A.J. (2009). *Blogging the political: Politics and participation in a networked society*. New York: Routledge.

Project on Disney. (1999). *Inside the mouse: Work and play at Disney World*. Durham, NC: Duke University Press.

Radway, J. (1984). *Reading the romance: Feminism and the representation of women in popular culture*. Chapel Hill: University of North Carolina Press.

Ritzer, G., & Jurgenson, N. (2010). Production, consumption, prosumption: The nature of capitalism in the age of the digital "prosumer." *Journal of Consumer Culture, 10*(1), 13–36.

Rosenberg, S. (2009). *Say everything: How blogging began, what it's becoming, and why it matters*. New York: Random House.

Sassen, S. (2002).Towards a sociology of information technology. *Current Sociology, 50*(3), 365–388.

Shih, J. (2006). Circumventing discrimination: Gender and ethnic strategies in Silicon Valley. *Gender & Society, 20*(2), 177–206.

Singh, S. (2003). Gender and the use of the Internet at home. *New Media & Society, 3*(4), 395–416.

Somolu, O. (2007). "Telling our own stories": African women blogging for social change. *Gender & Development, 15*(3), 477–489.

Spelman, E.V. (1988). *Inessential woman: Problems of exclusion in feminist thought*. Boston, MA: Beacon Press.

Sutton, J., & Pollack, S. (2000). Online activism for women's rights. *& Behavior, 3*(5), 699–706.

Tobias, V. (2005). Blog this!: An introduction to blogs, blogging, and the feminist blogosphere. *Feminist Collections, 26*(2/3), 11–17.

Walzer, S. (1998).*Thinking about the baby: Gender and transitions into parenthood*. Philadelphia: Temple University Press.

Williams, C.L. (2006). *Inside toyland: Working, shopping, and social inequality*. Berkeley: University of California Press.

Wingfield, A.H. (2009). *Doing business with beauty: Black women, hair salons, and the racial enclave economy*. Lanham, MD: Rowman & Littlefield.

Wright, M.M. (2002). Racism, technology, and the limits of Western knowledge. In M. Fernandez, F. Wilding, & M.M. Wright, (Eds.), *Domain errors! Cyberfeminist practices* (pp. 45–62). Brooklyn, NY: Autonomedia.

Wright, S., & Camahort, E.P. (2008). The BlogHer/Compass Partners 2008 social media study. Retrieved from at:http://www.blogher.com/files/BlogHer.CompassPartners.Social%20Media%20Study.ppt.pdf

Chapter 3

A Critical Discourse Analysis of Representations of Female Doctoral Student Bloggers and Implications for Education

Lauren Angelone

Introduction

"It seems today that everyone" has a blog. Many of these blogs have minimal readership, and yet millions of people have begun blogs and maintain them regularly. Young girls and women seem to be particularly drawn to this medium (Lenhart, Madden, & Smith, 2007; Pedersen & Macafee, 2007). Though men dominate the blogosphere with blogs related to technology, politics, and business, women dominate the "personal" genre of blogs (Nowson & Oberlander, 2006) and tend to make use of the social components of blogs more than their male counterparts (Pederson & Macafee, 2007). The medium of a blog is essentially an online space. Women and girls are engaging with this space in ways that could have implications for critical media literacy, education broadly defined, and subjectivity.

I have taken a look at the ways in which female doctoral students have engaged with blogs in different ways. The reason for the choice of this group is a personal one. I am a female doctoral student who began blogging 3 years ago. In this article I use semiotics and discourse analysis to take a critical poststructural look at the "about pages" of these bloggers as a tool for understanding the ways in which these women represent their subjectivity in this medium as a part of learning their identities. The about page of a blog is a somewhat static space, separated from the dynamic posts that comprise the majority of a blog, wherein the blogger tells the audience "who she is."

My main research question is: How are women using new media to perform, learn, and resist their subjectivity? More specifically: What do the about pages of female, doctoral-student bloggers say about how women are using new media to perform, learn, and resist their subjectivity? As media become more a part of everyday life, asking these types of questions is important in order to maintain a critical awareness of "everyday" uses, De Cer-

teau (1984) studied the practices of everyday life as a type of agency in which social changes can occur as a result of "everyday" sorts of choices. The "everyday" uses of technology could also easily become normalized (Foucault, 1977) without thought to what the simple creation of a profile or an about page is producing or reproducing. This online space could-be a place for resistance of dominant discourse or a place for the reinscription of the dominant discourse, and by asking questions and looking closely we can remain critical of the way in which technology shapes us and we are shaped by technology. Critical media literacy, as advocated by Alverman and Hagood (2000), Horn (2003), and Sturken and Cartwright (2001), is a literacy that individuals learn in order to look closely at issues of power as they both read and create a variety of texts. The online space is an opportunity for women to exist in a space without a body and to participate in the creation of their own representation, learning to be critical (or not) of what they are saying to others and what they are thus telling themselves about themselves. Taking a poststructural position on literacy means paying attention to power and those practices (resulting from the flow of power) that generate certain knowledges that create different types of power, subject positions, and possibilities. This is a place in which to reflect on the discourses that shape us and to potentially create new knowledges with the potential for "thinking otherwise" (Foucault, 1991).

Frameworks

Poststructuralism

In this article I take a poststructural stance that helps to see identity, knowledge, and power as fluid and unstable rather than fixed. Jenks (1995) describes the postmodern terms by stating that "tidiness is not to be expected" (p. 3). The identities of the five female doctoral students studied here and the contexts and discourses in which they are situated are always partial and in process. Power flows through a system (Foucault, 1980) at once shaping subjects and being shaped by them in a mutual relationship (Butler, 1990). I borrow this notion mainly from Butler, who was influenced by Foucault. Davies (2006) explains Butler's notion nicely in the following passage:

> The formation of the subject thus depends on powers external to itself. The subject might resist and agonize over those very powers that dominate and subject it, and at the same time, it also depends on them for its existence....Butler's subjects have agency, albeit a radically conditioned agency, in which they can reflexively and crit-

ically examine their conditions of possibility and in which they can both subvert and eclipse the powers that act on them and which they enact. (p. 426)

Foucault, in his *Remarks on Marx: Conversations with Duccio Trombadori* (1991), explains that the purpose of his own analysis is to understand how power/knowledge works in a society in order to be able to do something. "I do not conduct my analyses in order to say: this is how things are, look how trapped you are. I say certain things only to the extent to which I see them as capable of permitting the transformation of reality" (p. 174). Therefore, I will look at my participants in this study as being shaped by discourses and shaping discourses, noticing both the ways they are "trapped" by discourses and the ways in which they subvert those same discourses. At the same time, I will be keeping in mind my own trappings and imaginings as both a researcher and a blogger, in a messy complexification of this seemingly banal object, the about page.

Following Butler's concept (1990), I view gender as a poststructural construction, a performance constituted by particular discourses in which the subject is situated. This subject, though, also has the power to both accept and challenge these discourses in various ways. I keep this in mind even as I group these bloggers as women, so that I am also aware of their differences and ever-changing identities and do not seek to find similarities *per se*, though similarities may exist. Cavallaro (2001) explains gender as part of an identity in the following way:

> Social identities are not centered on fixed properties acquired at birth and bound to remain stable thereafter. In fact, they result from multiple and shifting roles that people are required to play in both private and public contexts on the basis of their genders and sexualities. (p. 109)

Genders are also performed using the body, an object of regulation and control for women in our society. As such, I am interested in the way that a blog is a disembodied space for women wherein their performance can be separate from their physical body and how their constructed gender is either reinscribed or subverted as a result.

Critical Media Literacy

Blogs may also be a space for learning identity. To look at learning in this space, I use Lave and Wenger's (1991) understanding of learning as situated. In situated learning, "newcomers" move closer to legitimate peripheral par-

ticipation with the help of the "old-timers." This involves actual practice and
the use of tools by the newcomers. Though not the focus of this chapter,
community is a major component of blogging. Bloggers read one another's
blogs, leave comments, and model for one another what is appropriate in the
way of writing, being a woman, being a doctoral student, and so forth. As a
result, new bloggers, in the practice of creating and writing a blog, move to-
ward legitimate peripheral participation in the practice of blogging as well as
in society. The importance of this look at the about page is that creating an
about page is one practice in which bloggers participate in order to "be-
come," but in the process always remain bloggers, women, students, and
many other identities (Deleuze & Guattari, 1987). Sturken and Cartwright
(2001) regard a representation as the use of language and images to create
meaning about the world around us (p. 10). This visual representation is the
result of a practice of learning how to create meaning, which is invariably
social and cultural.

Blogs are included in the category of emerging technologies, which is a
contested term, but which typically includes web-based technologies that are
multimodal and interactive. The spread of the Internet and these emerging
technologies, along with a changing political and economic climate, "alter
conceptions of reading and writing" (Alvermann & Hagood, 2000, p. 1), sub-
sequently expanding and changing notions of literacy. I see the need for a
critical media literacy, one in which users develop a "critical understanding
of how all texts position them as readers and viewers within different social,
cultural and historical contexts" (Alvermann & Hagood, 2000, p. 1). In addi-
tion, Rose (2007), in calling for a critical visual methodology, describes this
type of reading as having three attributes: (1) taking images seriously; (2)
thinking about social conditions and effects of visual objects; and (3) consi-
dering one's own way of looking at images (p. 12). This type of critical look
at media is consistent with a poststructural stance that looks at the ways in
which power flows through a society in multiple and diffuse ways, ways that
both create subjectivities and are subverted by subjectivities.

The creation of media is an essential component of critical media lite-
racy. In Van Heertum and Share's (2006) discussion of a new direction for
multiple literacies, they discuss both teaching about and teaching through
media (p. 256). By teaching "through" media, students (and people) can at-
tain the skills not only of reading and interpreting, but also of using the tools
to deconstruct hegemonic texts as well as to understand the gaps that exist in
that hegemony (p. 257). In addition, Spalter and van Dam (2008) discuss

what they call digital visual literacy, and they advocate for the creation of digital images as a part of this literacy in order to make decisions on representations of data and ideas and to use computers to create effective visual communication (p. 94).

The importance of critical media literacy, particularly taking into consideration the creation of media, is highly relevant in looking at the about page of these blogs. The about page is the construction of a visual/media created by these women. This visual should be looked at carefully in an effort to understand the ways in which an individual situated in certain discourses constructs it. As I critique this visual, I should also try to understand how my own situatedness is informing my critique, as I have included the analysis of my own blog in this study. I would like to consider whether or not these women have an understanding of critical media literacy and whether they subvert the medium with this understanding. If not, could an understanding of critical media literacy change the way they construct themselves on their blogs?

Semiotics and Discourse Analysis I

In order to take a critical look at these about pages, I have chosen to use semiotics and discourse analysis I (Rose, 2007). I use the term "look" purposefully here as defined by Sturken and Cartwright (2001) in opposition to "seeing" and as a way of learning to interpret relationships of power. I also borrow Natharius's concept (2004) that what is not seen is just as important as what is seen (or looked at) (p. 244). So, in taking this look, I begin with semiotics as outlined by Rose (2007), essentially involving the following five components: (1) deciding what the signs are, (2) deciding what the signs signify in themselves, (3) thinking about relations to other signs, (4) exploring the connections to a wider system of meaning, and (5) exploring the mythology of the signs as a whole (p. 98), mythology here meaning the second order, or connotative, meaning behind denotative signs as defined by Roland Barthes. This analysis will be used only as a means of "immersing myself in the materials" (Rose, 2007, p. 159). Rose gives an overview of many semioticians, but I have selected the terms used by Roland Barthes to describe and understand the signs in the about pages. These terms include denotation, connotation, and mythology, among others.

I will then use the semiotic analysis to conduct a discourse analysis of the connotations and mythologies present in the about pages as I perceive

them. I follow Rose's (2007) insistence that there cannot be a strict guideline to follow, due to the nature of discourse analysis, but I also use her rough outline. She suggests that you first immerse yourself in the materials (which I plan to do via semiotics), identify key themes (I will use mythologies), then find connections "between and among" these key themes, and then consider how these key themes were produced and what they themselves produced (p. 157). Using this framework, I will look at the about pages and not only notice discourses within and surrounding the signs, but then attempt to notice in what ways some discourses are constructed as natural and some are silenced.

bugsii

Semiological Analysis

I should begin by disclosing that this is my own blog, which will impact the way in which I look at the signs in this particular about page. The audience for my blog began as family and friends but has expanded to include other students, co-workers, and a few people whom I do not know. The signs contained in my about page are the URL (bugsii.com), the background (black, teal, and white that looks like different fabric), the title (bugsii), a small penguin, a small picture of me, and the text about me (which includes an explanation of the title and the penguin). Along the right side are a few more signs, such as the archives, a list of blogs, a tag cloud, and my Facebook updates.

Now I will attempt to determine what the signs mean "in themselves" or the denotative meaning. The URL as a sign signifies the text used to locate the website on the Internet. The background signifies a space where text and images can be placed. This space is often selected by the creator of the blog from a limited number of backgrounds, or it can be custom-created. The title signifies that this is what the site is called. The name of the site is essentially the same as the URL in this case. The small penguin is the logo of the site. The picture of me is the picture of the author of the site, which is anchored by the text above it, "Mii." The main text of the page signifies that the main content of the page will be information about the author of the site, anchored by the title of the page "about mii." The archives signify that there are older posts on the site and that the site is about a year and a half old. The list of blogs signifies a list of blogs that the author has placed on the site. The tag cloud signifies topics about which the posts of the blogs are marked or "tagged." The larger tags are topics that are discussed more frequently. My

Facebook updates signify the updates that I have made on Facebook and that they appear on my blog as well.

Some of these signs have relations to other signs "in themselves." The format of the about page in itself is a common feature of many personal websites/blogs. The URL is a standard feature of websites as well. The picture is a standard headshot, common to any sort of information that gives a description of the author of something. The Facebook updates are related to the social networking site Facebook.

Figure 1. A screenshot of bugsii's blog

Next, I will attempt to identify the connotative meaning of the signs on this page. Not all of the signs have a connotative meaning. The URL alone has a connotative meaning in that it is its own domain name, not attached to any of the free blogging platforms. This might connote that I have the skill to create my own website; however, the main text anchors the URL by explaining that my husband is a "tech geek" who helps me with the website. The title and the URL have a connotative meaning that is anchored by the main text. "Bugsy" was a childhood nickname given to me by my late father. It was given because, as a child, I liked the cartoon character. The penguin also has a connotative meaning that is anchored by the text. It was a childhood toy that I kept on my bed for a very long time. The connotative meaning of the background symbolizes a feminine site. The fabric-like background symbolizes home and crafts, things typically constructed as feminine. The picture shows me not smiling, which could connote my personality as more somber. However, I chose that picture purposefully as an image that was not overly

feminized, as I am conscious of feminine stereotypes and wanted to try to look a little less feminine and more "serious." The connotative meaning of the main text of the page, as well as the Facebook updates, seems to indicate that I am sort of a happy, quirky person who uses humor to describe herself, as indicated by the final sentence of the first paragraph:

> I can be a bit neurotic and anal, but I try really hard to enjoy life. I love to travel, I love to play vicious games of Scattergories, I love to make terrible jokes and I love when I get the chance (and can remember) to not take myself too seriously.

Mythology and Discourse Analysis

There seem to be several mythologies represented by my about page. The first is that of the benign, friendly, modest, emotional female. This mythology seems to be evidenced by the childhood references, the soft background, the humorous tone, the references to my husband and family, the downplaying of my status as a doctoral student. The second is that of the female as nontechnical. This is at first not evidenced because it is a relatively sophisticated blog with its own domain name and a female author. However, the text references the fact that my husband helps me with the blog. The third mythology is of the female who needs connection. This is evidenced by the fact that the blog is public and written with an audience in mind. In addition, other blogs that I read are listed, and so are my Facebook updates, indicating multiple modes of communication that take place outside of my blog. The fourth is that of a person with a multiple but defined identity. Though I list several identities in the text (student, runner, wife, vegetarian, humorous person, daughter, former teacher, and so forth), the representation of these identities seems to be relatively complimentary and stable. The writing, in a sort of list style, does not seem to leave room for contradictions and openness to change. There is not any questioning of the self, though I do note one contradiction between liking to have fun and being serious. The fifth mythology is the female who defines herself. Though this is the one mythology that counters a feminine stereotype, it does so by reinscribing a feminine stereotype. I, as a female, am in control of my own representation and able to define myself, but I choose to do so mostly in ways that reinscribe my femininity.

By reinscribing this femininity, these discourses are othering "less feminine" (masculine, rational, outside of the home, blunt, unmarried, technical) women by fitting so closely to stereotypes of women in so many ways. I silence my doctoral student status (and take myself "seriously"), which is the

main focus of my life right now, and privilege hobbies, health, feminine constructions, and the past. I don't make any overt attempt to resist normalized discourses, but I'm not sure that this necessarily means reinscription. The blog has other spaces that are used in different ways (posts, for example) where perhaps other sorts of resistance or transgression are taking shape. Maybe the blog is itself a resistance of sorts, even if the message is reinscription. The blog is a way for a woman to write her own story rather than have it written for her, even as her story is laden with discourses that she cannot think without. And it is her own story in a large and interactive public space rather than the private sphere, allowed only recently by these emerging technologies.

runswithcarrots

Semiological Analysis

In my discussion with Vicki, the author of runs with carrots, I know that her intended audience is anyone interested, but that her readers are mostly friends, family, and fellow students, much like mine. Important to note, I think, in this reading, is that Vicki is an old friend of mine from my first foray into postsecondary education. We haven't kept in touch since then, but Vicki found my blog when we became friends again on Facebook. Since then we have been reading and commenting on one another's blogs. Also important to note is that Vicki is an English PhD but was a candidate during this period of analysis. This particularly literate subjectivity shows itself in her use of vocabulary and topics of discussion.

The signs included in Vicki's about page are the URL (runswithcarrots.wordpress.com), the background (basic white with a banner of cherry blossoms), the title ("running with carrots: adventures with a root veggie," and the title of the page, "about carrots"), the main text of the page (which discusses grad school, where she grew up, her husband, and random facts) including pictures (a picture created by her husband, an artist, and a picture of her cats). Along the right side, Vicki also has signs including lists of blogs separated into "bloggers i know" and "bloggers i wished i knew," a list of websites, a link to what she is reading and what she is watching, and a list of archives. The denotative meanings of the URL, backgrounds and titles are the same as those for bugsii. In this case the name of the site is essentially the same as the URL, though slightly modified and given a subtitle. The pictures denote a large man standing over a small man with a circus tent in the background (this picture is drawn) and another picture of two cats, one small and

gray, the other larger and multi-colored. Both seem to be hiding under a bed. The main text of the page signifies that this is the information given about the author of the site as anchored by the title "about carrots." The list of blogs signifies the list of blogs that the author reads and categorizes them as bloggers she knows personally and those she does not. The list of websites signifies a list of other sites she visits. The link to what she is reading and watching signifies texts with which she is currently interacting. The archives list signifies that there are many posts to this site and that Vicki has been blogging for over 5 years. Some of these signs have relations to other signs "in themselves." The format of the about page in itself is a common feature of many personal websites/blogs. The URL is a standard feature of websites as well. The picture of the cats seems to be a common shot of family pets.

Figure 2. A screenshot of Vicki's blog[1]

Next, I will attempt to identify the connotative meaning of the signs on this page. Not all of the signs seem to have a connotative meaning. The URL and title are a playful reference to the color of Vicki's hair, which is red, but red hair is really orange, like a carrot. She calls herself carrots by titling the page "about carrots," which could then mean that the title of the site (and the URL), "running with carrots," is a play on running with scissors, which is a "dangerous" childhood activity, often warned against by adults, which she then juxtaposes with the term carrots, possibly referring to her life's somewhat "dangerous adventures," which is also alluded to in the subtitle, "adventures with a root veggie." I'm not sure if Vicki thought about it that much, but there is surely a play on this common phrase and a reference to her red-headed self. The connotative meaning of the URL, aside from the associ-

ation with the title, is that it ends in WordPress.com. This means that this is a free and formulaic site hosted by WordPress.com. WordPress accounts are limited in functionality, but they do have customizable options. The background, then, is one of a select number of backgrounds that can be chosen on WordPress.com. This particular background is feminine (as a construction) in that there are red flowers and a soft background color connoting both beauty and nature. The text connotes a witty, nice, female doctoral student who has lived in several places, is married, and is interested in Victorian children's literature among other quirky things. Pictures that show two aspects of her personal life—her husband's art and her pet cats—anchor the text. What follows is a selection from the text that showcases her wit and quirky disposition:

> Running With Carrots is my blog, where I write about the shady underbelly of graduate school, my low-budget adventures in Texas, and the very esoteric topics I ponder while sitting alone at home, supposedly working on my dissertation.

Mythology and Discourse Analysis

This blog also seems to have several mythologies at work. The first is that of an intelligent, creative graduate student. This is evidenced by Vicki's use of a clever—though sometimes self-derisive tone, and a wide-ranging vocabulary. She also speaks about working on her dissertation and about her research interest. "Right now, I'm an English PhD student in Houston, Texas, where I'm working on finishing my dissertation so I can move on to a job with a salary. I'm writing about Victorian children's literature, which means at conferences I have to say smart things about Lewis Carroll's 'Jabberwocky' with a straight face. It also means I'm often asked questions about pedophilia. Good times." The second mythology that I think I might discern from Vicki's about page is that of a fairly traditional, though well-educated, feminine subjectivity. This is evidenced by her marital status and the introduction of her husband in a way that acknowledges his status as a "talented illustrator," her time as a volunteer in Americorps, and her interest in children's literature as an educational endeavor. In addition, her list of blogs, links, and what she reads and watches is an interesting mix of connection and intertextuality that could point to both a feminine construction of the need for human connection, an educated individual who interfaces with multiple texts on a daily basis, or the interactive potentiality of the Internet. The third mythology I see represented in Vicki's about page is a somewhat transgressive

mythology, that of identity as multiple and somewhat flexible. Vicki begins her page by stating "Hi, I'm runswithcarrots, aka Vicki. Or Victoria. Depending on when I met you." This introduction sets the tone as a person who has been called by different names at different times in her life and has therefore changed in certain ways. Vicki also creates a list of the places she lived throughout her childhood. While her description of identity seems to be somewhat static with regard to "who she is" and "who her husband is" ("He's a comic book nerd who loves golf and cannolis"), she is also cognizant of her changes in place-based identity. In addition, I think her use of random facts to define herself and her husband might be subverting the grand, broadly cohesive narratives of identity that surround a traditional view of "who I am." The fourth mythology is, like mine, that of a woman who represents her own subjectivity, a mythology that is context specific. Vicki has found and created this space in a way that both reinscribes some feminine stereotypes but that also leaves room for subverting traditional femininity by defining herself in multiple and diffuse ways that are open to change.

Vicki's about page, like mine but to a lesser extent, also others less feminine females, especially those not in dominant groups, those that are not married, not "nice," or concerned with educational issues, although I feel that Vicki's page leaves more room for less traditional roles. Vicki seems to embrace her status as a PhD student, a space left very much out of my description of myself. This status that Vicki has could have implications for othering women without access to the way she writes or the world in which she is/will be at the top of the hierarchy. The naturalness with which she speaks of her status makes it appear normal, which it certainly is not. However, this normalizing could also be seen as a "playing down" of a higher status, a possible construction of the modest female, who does not want to appear to be powerful. I am also curious about Vicki's listing of her "origins." This seems to mean that her multiple identities have been the result of shifting place and of not having a "real" origin, but I'm not sure how this "origin" (or lack thereof) contributes to her identity as a student, woman, wife, person, and so on. As Vicki has created this site and selected the design, she has chosen to leave out a photograph of herself. I wonder how this changes my perception and her audience's perception of her. I know her personally, as do many other readers, so we know who she is in the physical world, but I wonder about those who do not. How does this change/free/constrain the reading of her blog? I also wonder right now, as I read this analysis, if I am less harsh on Vicki because she is my friend than I am on myself and the other bloggers.

When I read Vicki's blog, for example, I can imagine her intonation, and I know her general demeanor in the physical world, so I feel as though I have a sense of what she *means* and so can interpret her intentions better. Although this might also mean that I analyze Vicki's blog and my own blog with a more narrow view to the meaning of the texts. How might this affect my analysis of myself and the other bloggers whom I do not know personally?

Seeking Academia

Semiological Analysis

Seeking Academia is a site I found by searching Google for doctoral student blogs and then following a few blogrolls. Seeking Academia calls herself JustMe and is an anonymous blogger. The signs included in JustMe's about page are the URL (seekingacademia.wordpress.com), the background (light blue with a header that has a picture of the branches of a few trees), the title ("Seeking Academia. Feminist. Catholic. Social Scientist. In no particular order. Oh, and all those other adjectives that identify me as an academic struggling to write."), the main text of the page (which is currently blank), and comments on the page (which includes one saying that they he/she loves the site, and one from me asking if she would like to be in my study). Along the right side, JustMe also has signs that include a section with conference paper drafts (link dead), archives, recent posts, a tag cloud, recent comments, favorite shows, a fairly long blogroll (102 blogs), a section called "on my nightstand" (you have to sign in to view the books she is reading), and a "test" section. Now I will attempt to determine what the signs mean "in themselves" or the denotative meaning. The denotative meanings of the URL, backgrounds, and titles are again the same as those for bugsii.

Next, I will attempt to identify the connotative meaning of the signs on this page. The URL and title refer to JustMe's status as a doctoral student. She also lists out a few of her identities ("in no particular order") and tacks on at the end "Oh, and all those other adjectives that identify me as an academic struggling to write." This seems to show that she embraces a lack of a singular identity, and even though she says that they are in no particular order, some of these identities may be privileged for the fact that they are listed first. The connotative meaning of the URL, aside from the association with the title, is that it ends in WordPress.com. This means that this is a free and formulaic site hosted by WordPress.com. As noted previously, WordPress

accounts are limited in functionality, but they do have customizable options. The background on this site, it seems, was modified by the user. The header of the picture of the tree seems to be a custom header, and the background— which is usually white—has been modified as well. This is a step beyond the formulaic background choices offered by WordPress. This particular background is feminine (as a construction) in that there are trees and a soft background color connoting both beauty and nature. The lack of a text could connote several things, including a change in JustMe's thoughts about herself. This is anchored by the fact that she has been posting less frequently lately, and her last post was a short update that read:

> JustMe is in a long distance relationship with a lovely man.*Is that why I'm so tired? [long space] *Haven't wanted to write anything on this for various reasons/fears, but let's not get into the paranoia. let's be happy! and also, not tired, please?

Mythology and Discourse Analysis

Despite the lack of any main text on the about page, the general layout of the page (and the site in general) seem to point to several mythologies, some contradictory in and of themselves. The first is that of a feminine feminist. The background of the site is soft, with a picture of nature, a "feminine" background and picture as constructed by discourses in our society, yet JustMe calls herself a feminist in the subtitle of her blog. Not that it is necessarily a contradiction in terms (a feminine feminist), but since there are several parts of this site that reinscribe stereotypical feminine norms, these feminine norms have not been typically considered feminist from a liberal feminist perspective. Examples include the soft/nature-themed background, the tag cloud (in which the largest—most written about—tag is "boys"), the list of TV shows (many of which also reinscribe gender norms and specifically target women or show women in traditional female roles: *Friends*, *Mad About You*, *Army Wives*, *Friday Night Lights*), and a large list of bloggers who suppose some sort of connection. On the other hand, some of the television shows rethink/subvert traditional gender roles and even what it means to be human (*Big Love*, *Third Rock from the Sun*, *Alias*, *Heroes*), and JustMe's blogroll is also full of feminist bloggers. Though JustMe may interpret these television shows and their portrayal of femininity differently, what is important to note is that JustMe has a range of signs on her blog that are both resisting and reinscribing dominant discourses. Another mythology that

SUPPORT
DEFENDS
→ ?!

buttresses the feminine feminist mythology is that of a person with multiple identities. JustMe in her subtitle identifies herself as many things, including two that might seem a bit contradictory, feminist and Catholic, as the Catholic Church carves out traditional roles for women and disallows what has been constructed as a liberal feminist position: abortion and the use of contraception. Though the main text of the page is missing and thus does not provide an anchor, it may also be pointing to the fact that she is rethinking the ways in which she represents herself, perhaps changing her mind or producing a revised version of the text that is "about" her. The third mythology, which closely mirrors the second, is that of a female who constructs her own identity. JustMe has spent time designing this WordPress site beyond the formulaic features; she has created a title that writes her identities in a multiple, complex way. However, she has also left the about page blank, a space ideal for literally writing an identity into being. This is confusing, but it could also be a conscious effort to subvert the space of the blog, which by convention asks users to express themselves in text in this section.

In JustMe's blog, as she represents herself with a contradictory and fluid identity, she calls attention to the importance of looking closely and critically at ourselves and the way we produce ourselves (rather than looking at society). By looking closely we may be able to see the ways in which we are produced by society and how in many ways society no longer has to produce us. We have internalized those norms and are producing the norms ourselves (perhaps without even noticing?). This is the idea of disciplinary power as described by Foucault (1977). The normalizing discourses of femininity have gotten into our bones, so to speak, in such a way that even those of us who study and make attempts to resist them still end up reinscribing them in our very being. Butler (1990) and Foucault (1991) might say that we have to use the discourses that produce us, because those are the discourses available, but that we must then use those to tear ourselves from ourselves. This is difficult and requires constant attention. I think the connected and modifiable nature of blogs offers a space in which this becomes a possibility. However, the format of blogs and society, that already have conventions, causes this possibility to be more challenging than it might seem.

Rumble Strips

Semiological Analysis

Rumble Strips is another site I found by searching Google for doctoral student blogs and then following a few blogrolls. The author of Rumble Strips is named Cathy, and she has several other blogs (though most are private). The about page of this site is slightly different than the previous three (all of which use WordPress). Cathy uses Blogger, a Google product, and the about page is a much more formulaic page with less customization available and more form-type questions (activities, favorite movies, and so forth). The main text and profile picture always appear on the right side of the main page. You can click to see more of the profile, but this then takes you away from the main page of the site (and things such as the title, archives, and so on). I will include the main features of the site in this analysis, though they do not appear on the actual about page. The signs included in Cathy's about page are the URL (rumblingstrips.blogspot.com), the background (a very pale pink with dark pink titles), the title ("Rumble Strips"), the main text of the page (a very short description of Cathy), and a profile picture (a yellow street sign that reads "Rumble Strips 200m"). Along the right side, Cathy also has signs that include a short "About Me" section (click further for full profile), Twitter updates, shared items (links to articles and blog posts), three separate blogrolls (academic, Irish, and French), a list of links to books she is reading, and an archive. Now I will attempt to determine what the signs mean "in themselves" or the denotative meaning. The denotative meanings of the URL, backgrounds, and titles are again the same as those for bugsii.

Figure 3. A screenshot of Cathy's blog

Next, I will attempt to identify the connotative meaning of the signs on this page. The URL and title are, I think, a reference to this blog as a place for Cathy to "rumble" or ramble? She also identifies herself in the about me section in a fairly singular way: "I am a PhD student in Dublin City University. My research is on blogs and more particularly young people's blogs, identity, community and authorship. I have been a voracious reader of blogs ever since my first Internet connection in 1999. I am, however, a sporadic blogger." This seems to show that she is using this blog for academic purposes, a more singular purpose than the previous bloggers. The connotative meaning of the URL, aside from the association with the title, is that it ends in blogspot.com. This means that this is a free and formulaic site hosted by Blogger (owned by Google). Blogger accounts are limited in functionality, but they do have customizable options. The background on this site is one of the basic choices offered when one designs a Blogger blog. This particular background is feminine in color. Also, when you click further to view Cathy's full profile, she has chosen not to fill out any of Blogger's predetermined categories, but there is a list of other blogs she has created. There are five in all: four are private (with two having an additional author), and one seems to be a website for a project she is working on (only one post). I think that this shows that she is a proficient, if not prolific, blogger.

Mythology and Discourse Analysis

There are several mythologies present on Rumble Strips, but they seem somehow less pronounced than on the previous three blogs. It seems that this blog has a more singular, less personal focus. Whereas the previous three bloggers write about their lives, their work in grad school, or whatever else they choose, Rumble Strips is blogging perhaps as a result of her interest in identity construction. Though I am focusing only on the about page, I think it is important to note in this case that most of Cathy's blog posts are short links to things she finds interesting about her work and occasionally about her personal interests (such as soccer). She does not use a narrative voice, as do Vicki, JustMe, and I. Having said that, I see a feminine discourse presented by Cathy in the choice of a pink background, the very basic features selected to be used on the blog, a large list of blogs that she reads, and her interest in young people. On the other hand, the feminine discourse is also less prominent in that she blogs almost exclusively about academic (I read this as "rational") interests. She also uses a picture of a street sign rather than

a picture of herself for her profile, which maintains a separation of her physical body from the space of the blog. Along this same vein, I also see a discourse of a unitary subjectivity. Cathy writes herself as a blogger interested in identity on the Internet, and she then supplies links regarding that interest. The unitary subject is subverted when she posts links that are somewhat personal in nature and by the listing of five other private blogs. Perhaps these are spaces where she is choosing to perform other parts of her identity away from the public eye, or perhaps not.

It seems that here Cathy, like JustMe, is working within a contradictory discourse of femininity (non-technological, light colors, children) and masculinity (rational, academic, singular interest). Neither of these are clear-cut distinctions; rather, they mingle with one another, both reinscribing gender norms and rethinking them. Though this space seems to be less of a space to write oneself into being, as did the first three bloggers, and more of an academic exercise, the same types of contradictions are evident. Though Cathy does not use her blog as a reflective space, I wonder what sorts of reflections occur as she creates posts. Are they qualitatively different than those of the more personal/reflective bloggers? Is she more/less aware of what she is representing? Does she feel more or less powerful?

Apophenia

Semiological Analysis

Apophenia is the blog of a well-known academic (danah boyd) who began studying social networking very early. She also began blogging before it became a more common Internet activity with the emergence of sites such as Blogger or WordPress. Though already a practicing academic, she is included in this study because she blogged during her doctoral work. The about page of this site is slightly different from the previous four in that you must click on danah's name to get there, and when you get there the domain name changes from zephoria.org/thoughts to danah.org. (Even the favicon changes from a picture of danah to a rainbow icon.) danah was first a computer scientist and was able to create her site in a much more "sophisticated" way (using html) than the other bloggers in this study. The signs included in danah's about page are the URL, the background (a plain, off-white color), the title (apophenia for the main site, and danah boyd for the about page), the main text of the page (a mostly academic bio), a picture within the text (the cover of her latest book with a link to purchase at Amazon), and a profile picture (a

close-up of danah smiling). Along the left side and the bottom, danah also has signs including links to her writing, recent publications, recent blog posts, research, random links (to her ani difranco site, an explanation of her decapitalized name, and so on), and an "elsewhere" section (Twitter, delicious, Myspace, and others). Now I will attempt to determine what the signs mean "in themselves" or the denotative meaning. The URL again signifies the address where the site can be found on the Internet. The background signifies a space where text and images can be placed. The title signifies that this is what the site is called. The name of the site is essentially the same as the URL—in this case, her name.

Figure 4. A screenshot of danah's blog

Next, I will attempt to identify the connotative meaning of the signs on this page. The URL is zephoria.org, and I have no idea where this title came from. When I google "zephoria," it appears to be the username that danah uses for almost every social networking site. The title of her blog, apophenia, means "the experience of seeing patterns or connections in random or meaningless data," according to Wikipedia. This has interesting connections to her as a researcher studying a relatively new and complex phenomenon. The connotative meaning of the URL, aside from the definition, is that it is its own domain, showing danah's technical competency. In addition, the favicon that goes along with the URL becomes a rainbow on the about page. The rainbow is indicative of her self-representation as bisexual (as noted in her more detailed biography, a link from the about page). The background on this site is a plain, light color that is relatively neutral (as far as gender is

concerned), though she does choose to put the titles in pink. The large number of links to writing and other areas on online presence (at the left and bottom of the about page) show the nature of danah's engagement in digital media, both professionally and personally. She has by the far the greatest intertextual life on the web (or has displayed it most skillfully) as compared to the other bloggers in this study.

Mythology and Discourse Analysis

There are several mythologies at work on apophenia, and these mythologies appear to be much more political—or at least more purposeful—than those of the other bloggers. danah is a woman in a technological field, and I think that the mythology of her blog is a more feminist mythology. The sophistication of her blog subverts the traditional mythology that women are nontechnical. Although she presents herself as an academic (a singular subject) with varied interests, she also supports a mythology of a multiple and complex identity. She uses the digital medium to extend her identity to additional pages about her that detail what she likes, what she writes, and her location in multiple sites on the Internet. She also ends the text of her about page with these thoughts as follows:

> Outside of academia, I have worked at various non-profits and corporations. For five years, I worked at V-Day, an organization working to end violence against women and girls worldwide. I helped build an online community to support activists around the world and I continue to do volunteer work for them. For a complete bio, click here. On the web, I'm known for two things: maintaining an Ani DiFranco lyrics site and blogging prolifically. Personally, I love music, dancing, politics, reading, and all things fuzzy. At my core, I'm an activist and a scholar.

It is interesting to me that she ends this statement with the phrase "at my core." Although she has used the space of her about page to construct herself multi-dimensionally, with this statement she seems to be pointing to an essential self. This appears contradictory, but having an "essential core" does not necessarily exclude the notion of multiple identities. However, it does seem to exclude a fluidity of that core. This makes me curious about the ways in which this about page has changed throughout the long life of this blog.

Apophenia contains the mythology of a non-maternal, somewhat threatening academic that defines herself. For example, while critiquing a back

channel conversation taking place while she was making a public speech, danah says in a post dated November 24, 2009 (see http://www.zephoria.org/thoughts/archives/2009/11/24/spectacle_at_we.html):

> Speaking of which…what's with the folks who think it's cool to objectify speakers and talk about them as sexual objects? The worst part of backchannels for me is being forced to remember that there are always guys out there who simply see me as a fuckable object. Sure, writing crass crap on public whiteboards is funny…if you're 12. But why why why spend thousands of dollars to publicly objectify women just because you can? This is the part that makes me angry.

At the same time that I see her subverting traditional gender norms, I wonder if these more "masculine" traits are a sort of representation of second-wave feminism rather than a "true" subversion. These "masculine" traits in her about page are more about what she leaves out. She discusses academics, but very little about her family, relationships, and so on, traits three of the four other bloggers in this study include on their blog. However, in interviewing danah, I know that she also has a blog that is more personal in nature and that is made available only to people of her choosing. So, are these nontraditional feminine traits just the masculinized, dominant discourse being reinscribed, or is danah creating a new sort of space and subjectivity for herself? Of the five bloggers whom I have looked at in this study, danah seems to be the most overtly aware of her subjectivity. She has spent years on this blog defining herself. This makes me wonder if the length of time spent blogging has anything to do with how much purposeful "work" or critical thought goes into the representations of the woman. danah has spent a significant amount of time participating in various Communities of Practice (including this blog). Does the participation in these communities increase reflection and the critical media literacy to open up new subjectivities? These are questions for further study.

Implications for Education

As an educational technology scholar, I am interested in the implications that this study has for education. Women are using the space of the about page to construct their identities, and this identity is often a traditional, feminine one. There are, however, indications that in the simple act of defining oneself, opportunities arise to push those traditional notions, even if only bit-by-bit. These about pages have long since moved on, morphed, and changed since

my analysis, and they continue to contribute to what it means to be and learn on the Internet.

As emerging technologies continue to overwhelm the cultural landscape, critical media literacy becomes a pressing need. Looking carefully at the about pages of female doctoral student bloggers gives us insight into the ways in which women are representing their subjectivities online. It gives us both a way to see how stereotypes are being reinscribed in this medium and a way to see how spaces can be opened up as women have the chance to select how they are "looked upon" by the virtual public. These blogs are not separate from the physical world, as the two worlds continuously overlap and mesh. The informal use of these blogs indicates the learning of identity as a part of a larger community and as a practice of representation. This informal use can lend insight into how blogs and emerging technologies can be brought into more formal settings, or perhaps how more formal settings can begin to accept informal educational environments as part of "what counts" in higher education. Rather than popular culture being subjugated as "low culture" and students being required to "leave lived experience at the door" (Alvermann & Hagood, 2000, p. 1), perhaps students can use the learning mechanisms and communities that they have already been establishing (those with access, anyway) in the school environment. Perhaps these new media can help us rethink educational practices and environments as we expand our definition of schooling. Rather than "imposing elaborated shapes into the boundless space of the digital environment" (Stroupe, 2007, p. 432), schools could allow the boundless space to open up its own imposed shapes. What if, instead of trying to bend blogs or technology to fit the classroom if the classroom could expand to include these informal types of learning? What would then be possible for women and their blogs?

And, more to the point of this study: the study of female doctoral students and the representation of their identities and subjectivities online could become an important object of study for both researchers and students who are representing themselves online in new and old ways. Researchers should be tracing subjectivities in these spaces, exploring how power/knowledge networks are changing and staying the same. Students should be learning how to pay attention to how they are representing themselves and what sorts of discourses they are contributing to and undermining. Both of these practices have implications for the continued work of feminism and educational technology.

Note

1 Vicki changed her background image just after my analysis and just before I took this screenshot.

Works Cited

✳Alvermann, D., & Hagood, M. (2000). Critical media literacy: Research, theory, and practice in new times. *Journal of Educational Research, 93*(3), 193–205.

✳Butler, J. (1990). *Gender trouble: Feminism and the subversion of identity.* New York: Routledge.

Cavallaro, D. (2001). *Critical and cultural theory: Thematic variations.* London: Athlone Press.

de Certeau, M. (1984). *The practice of everyday life.* Berkeley: University of California Press.

Davies, B. (2006). Subjectification: The relevance of Butler's analysis for education. *British Journal of Sociology of Education, 27*(4), 435–438.

Deleuze, G., & Guattari, F. (1987). *A thousand plateaus: Capitalism and schizophrenia.* Minneapolis: University of Minnesota Press.

Foucault, M. (1977). *Discipline and punish: The birth of the prison.* New York: Pantheon Books.

Foucault, M. (1980). *Power knowledge: Selected interviews and other writings, 1972–1977.* New York: Pantheon Books.

Foucault, M. (1991). *Remarks on Marx: Conversations with Duccio Trombadori.* New York: Semiotext(e).

Horn, R. (2003). Developing a critical awareness of the hidden curriculum through media literacy. *The Clearing House, 76,* 298–300.

Jenks, C. (1995). The centrality of the eye in Western culture: An introduction. In C. Jenks (Ed.), *Visual culture* (pp. 1–25). New York: Routledge.

Lave, J., & Wenger, E. (1991). Situated learning: Legitimate peripheral participation. Cambridge, England: Cambridge University Press.

Lenhart, A., Madden, M., & Smith, A. (2007). *Teens and social media: The use of social media gains a greater foothold in teen life as they embrace the conversational nature of interactive online media.* Pew Internet and American Life Project. Retrieved from http://www.pewinternet.org/pdfs/PIP_Teens_Social_Media_Final.pdf

Natharius, D. (2004). The more we know, the more we see: The role of visuality in media literacy. *American Behavioral Scientist, 48*(2), 238–247.

Nowson, S., & Oberlander, J. (2006, July). *The identity of bloggers: Openness and gender in personal weblogs.* Association for the Advancement of Artificial Intelligence. Symposium conducted at the 21st National Conference on Artificial Intelligence. Boston, MA.

Pedersen, S., & Macafee, C. (2007). Gender differences in British blogging. *Journal of Computer-Mediated Communication, 12*(4). Retrieved from http://jcmc.indiana.edu/vol12/issue4/pedersen.html

Rose, G. (2007). *Visual methodologies: An introduction to the interpretation of visual materials* (2nd ed.). London: Sage.

Spalter, A., & van Dam, A. (2008). Digital visual literacy. *Theory into Practice, 47*(2), 93–101.

Stroupe, C. (2007). Hacking the cool: The shape of writing culture in the space of new media. *Computers and Composition, 24*(4), 421–442.

Sturken, M., & Cartwright, L. (2001). *Practices of looking: An introduction to visual culture.* Oxford: Oxford University Press.

Van Heertum, R., & Share, J. (2006). A new direction for multiple literacy education. *McGill Journal of Education, 41*(3), 249–266.

Chapter 4

Beyond Democratization and Subversion: Rethinking Feminist Analytical Approaches to Girls' Cultural Production on the Internet

Rosalind Sibielski

The machinima "Twilight [Sims 2] Episode 5, Part 1" is the fifth in a multi-part adaptation of the first novel in Stephenie Myer's *Twilight Saga*. Posted to YouTube in June 2009 by user alittlemid, it is part of a project to recreate the novel chapter by chapter using the video game *The Sims 2*. At the time of writing, this project was still incomplete, the eighth and most recent installment (which covers events in Chapter Seven of the 24-chapter novel) having been posted to YouTube in July 2010. What has been completed thus far, though, is executed with remarkable fidelity to the source material. This is particularly true of "Episode 5, Part 1," which depicts events in the fifth chapter from Edward asking Bella to sit with him at lunch through him driving her home after she faints during her biology class. Other episodes in alittlemid's version of *Twilight* deviate at times from the novel, whether due to the limit placed on the running time of YouTube videos, the technical limits of *The Sims 2* to reproduce action in the book, or the limits of alittlemid's skill in manipulating game play to mimic the book. However, "Episode 5, Part 1" exactly duplicates its source material, right down to the inclusion of dialogue taken directly from the novel.

Involving as it does the reproduction of an existing popular culture text created using a video game for purposes outside of its (principally) intended use and posted to a video-sharing website widely employed for the circulation of user-generated content, this machinima version of *Twilight* would seem to constitute a textbook case study of non-commercial media production as countercultural work. Indeed, on the surface it almost perfectly illustrates contemporary scholarship in the fields of media and cultural studies surrounding user-created content on the Internet, fandom practices, and participatory culture, all of which tend to position acts of textual appropriation for the purposes of amateur cultural production as either democratizing or sub-

versive acts. Upon closer examination, however, alittlemid's recreation of *Twilight* actually presents something of a challenge to such scholarship, since both the intent and the execution of this project of producing a machinima version of the novel run counter to conceptualizations of amateur media that see its creation primarily as a site of resistance to hegemonic values and practices.

alittlemid's remake of *Twilight* may or may not qualify as a fan text, since it is unclear from the descriptions that accompany it whether it was undertaken as a fan tribute or merely as an exercise in machinima production using *The Sims 2*, in which the choice of *Twilight* as source material was not necessarily motivated by a love of the novel or a desire on alittlemid's part to give expression to "personal meanings and pleasures" (Jenkins, 2006b, p. 41) derived from its consumption. Either way, the use that alittlemid makes of *Twilight* falls outside of the practices of textual poaching and détournement that together comprise the theoretical frameworks that structure virtually all contemporary scholarship surrounding the reproduction of existing popular culture artifacts within online, user-generated content (fan-produced or otherwise).

In seeking to recreate the novel in as exact detail as possible, this machinima version of *Twilight* departs significantly from Henry Jenkins's model of textual poaching, which, following Michel de Certeau, involves "a kind of cultural bricolage through which [media consumers] fragment texts and reassemble the broken shards according to their own blueprint, salvaging bits and pieces of found material in making sense of their own social experience" (Jenkins, 2006b). Likewise, in its uncritical reproduction of the hegemonic sexual and gender politics articulated by the book, it equally falls outside of the practice of détournement as originally conceptualized by Guy Debord and the other members of the Situationist International, which involves recreating hegemonic cultural texts for the purposes of ideological subversion by investing them with oppositional meanings. Thus, far from illustrating the theoretical understandings of textual appropriation that currently dominate media and cultural studies scholarship, alittlemid's *Twilight* machinima opposes—and, in the process, exposes—the dominant theoretical assumption underpinning such work that media produced outside of the culture industries automatically positions itself in opposition to hegemonic cultural values.

Not all amateur media production is subversive in content or intent, however, as a glance at the most popular DIY videos linked to the YouTube homepage on any given day will attest. As such, while the focus within

contemporary media and cultural studies scholarship on amateur cultural production as a site of resistance has helped to spotlight the ways in which such production can function as a tool of ideological subversion, it has simultaneously obscured the extent to which amateur cultural production can (and often does) also function as a site at which dominant cultural discourses are upheld. It is this aspect of amateur cultural production—and its analysis within the academy—that this essay seeks to address by shifting the focus of inquiry to those texts like alittlemid's *Twilight* machinima that are routinely ignored in analyses of DIY media because they neither represent original work that challenges the status quo of power relations within dominant culture nor rework existing popular culture texts in ways that invest them with subversive meanings.

My aim in undertaking this inquiry is to suggest that those of us who study amateur media production need to rethink the ways in which we approach questions of textual appropriation, in order to move beyond the democratizing-subversive paradigm currently used to evaluate DIY media derived from existing popular culture sources, and toward a critical framework that allows us to acknowledge that the narratives and the values of independently produced media are not always antithetical to hegemonic discourse. This is necessary because a critical stance that only sees textual appropriation in terms of its potential to subvert the hegemonic status quo limits our options for critical engagement to one of two choices: either we dismiss acts of textual appropriation as instances of false consciousness when they fail to critique the dominant cultural values endorsed by their source texts, or else we celebrate them as radical instances of "liberating" popular culture from the control of the culture industries, even though their uncritical celebration of their source texts is in no way radical in and of itself.

As I will argue throughout the rest of this chapter, neither of these positions is satisfactory for analyzing DIY media like alittlemid's *Twilight* machinima that recreate existing popular culture texts without alteration. This is in large part because the former position denies the active engagement with which the creators of *Twilight* machinima approach their roles as both media consumers and producers, as well as the agency they demonstrate (however problematic) in embracing the hegemonic values endorsed by the original *Twilight* novels and their Hollywood film adaptations. Conversely, the later position glosses over the ways in which fan-produced texts often unproblematically reproduce the dominant discourses surrounding racial, sexual, gender, and bodily difference articulated within their source materials, effec-

Rosalind Sibielski

tively foreclosing any cultural critique of cultural production enacted by fans. In the process, it also occludes all the ways in which practices like textual poaching can intervene in "the creation and circulation of central cultural myths" (Jenkins, 2006a, p. 256) without necessarily challenging—or altering—the ideological function of those myths.

That the reworking of "central cultural myths" on the part of amateur media producers does not always constitute a radical transformation of their meaning is a corrective that is applicable to the study of media across disciplines. However, I would like to suggest that it has a particular relevance for those of us who work in the field of girls' studies, in part because the study of media produced by and for girls within girls' studies scholarship is often guided by a political investment in the uses of media for the articulation of oppositional discourse. In response to feminist media and cultural studies scholarship in the 1970s and 1980s that largely saw corporately produced media as inextricably aligned with dominant cultural values, there has been a shift in the focus of inquiry within these fields over the last 2 decades toward uncovering textual strategies through which mainstream media productions can also challenge those values. Likewise, in response to scholarship that tended to position audiences of corporate media as passive recipients of media messages, there has also been a concomitant shift toward acknowledging resistant consumption practices that enable audiences to interpret subversive messages from even the most ideologically orthodox content. However, this emphasis on the power of mainstream media texts to subvert rather than perpetuate hegemonic values has been qualified by scholarly analyses (e.g., Dow, 1996) that posit that any challenge to the status quo of the patriarchal social structure within mainstream media is ultimately limited by the fact that it is produced by those with a vested interest in maintaining that structure. As a result, within feminist media and cultural studies scholarship there has been a marked privileging of alternative media as a site of feminist resistance. This extends from Laura Mulvey's assertion (1989) that the visual language of Hollywood filmmaking is so imbued with the values of patriarchal culture that feminist representational practices can only find articulation in avant-garde textual spaces to the VNX Matrix's positioning of cyberspace as a site for "infiltrating disrupting disseminating" patriarchy in their "Cyberfeminist Manifesto" (2003, p. 530).

It is on this point that feminist media and cultural studies scholarship intersects with analyses of DIY media within the field of girls' studies, beginning with Mary Celeste Kearney's call (2006) for more critical attention to

the ways in which "girl media producers often appropriate and reconfigure commercial media texts" (p. 4) for the purposes of negotiating or challenging dominant constructions of the identity category girl. Informed by the discourses of the "girl problem" circulating within U.S. culture at the turn of the millennium, in which negative media representations are frequently identified as a cause of girls' oppression on both the individual and the institutional levels, girls' studies scholarship following Kearney has also increasingly looked to girls' cultural production as a strategy for their empowerment. This focus on girls as active producers of independent media, rather than passive consumers and/or victims of commercial media, has directed attention to the ways in which girls "give voice to and work through" their "identities and experiences" as members of a socially marginalized group by reconfiguring "commercial cultural artifacts into personalized creations that speak more directly to their concerns, needs, fantasies, and pleasures" (Kearney, 2006, p. 13). At the same time, though, it has also contributed to the impression left by a great deal of recent girls' studies scholarship that all media produced by girls critiques and/or opposes hegemonic girlhood.

The immense popularity of *Twilight* has posed a significant problem for girls' studies scholars in this regard. While the *Twilight Saga* claims a fan base that spans both gender and generation, the majority of *Twilight* fans are adolescent and pre-adolescent girls, the target audience for both the books and the films, and the primary demographic to which they have been marketed. Many of these girls have turned to amateur media production as a way of expressing their pleasures in the text and have likewise turned to YouTube as a platform for posting vlogs, mashups, and machinima celebrating *Twilight*. It is in this respect that alittlemid's *Twilight* machinima might also be viewed as a challenge to girls' studies scholarship that mostly conceives of girls' cultural production in terms of resistance to hegemonic values and practices.

While it is not surprising that fan-produced media that either recreates or pays tribute to *Twilight* does not engage in a critique of its politics, the specific problem that alittlemid's machinima poses for girls' studies scholars arises from the fact that on her YouTube channel page, alittlemid identifies herself as a 17-year-old girl. This reveals her to fall within the very same demographic represented in girls' studies scholarship as using DIY cultural production to challenge the passive, self-subordinating model of white, heterosexual, adolescent femininity that both the novel and the film versions of the *Twilight Saga* endorse. And yet, alittlemid's faithful reproduction of the

novel also results in a replication of this model of girlhood. As such, it raises the question of how we, as feminist scholars, reconcile the social empowerment routinely attributed to girls' acts of cultural production within girls' studies scholarship with their production of media that supports oppressive constructions of adolescent female identity.

This is a question that can only be addressed if we first acknowledge that media produced by girls is not always subversive in nature, nor is it always undertaken with a feminist intent. It therefore returns me to the proposal with which I began, that we need to rethink our approach to the study of amateur cultural production in order to allow for the possibility that it can sometimes be aligned with the values and the interests of dominant culture even if it is enacted from the margins. It is my hope that the analysis of *Twilight* machinima that follows will serve to foreground the need for feminist media and cultural scholars to begin searching for new critical frameworks within which to conceptualize girls' cultural production, both on the Internet and in other media spaces. At the same time, I hope that within the context of the cyberfeminist anthology in which it appears, this essay will also serve to foreground the need for feminist scholars to examine the ways in which, in turning our attention to the power of DIY media produced by girls to articulate feminist messages, we have tended to lose sight of the fact that not all girl-created media is feminist media, just as not all girls who use digital technologies to reshape existing popular culture content within cyberspace are cyberfeminists.

DIY Media, Amateur Cultural Production, and Ideological Resistance

Before turning to my research, it might be helpful to look briefly at the evolution of media and cultural studies scholarship surrounding DIY media, in order to provide a context for understanding the ways in which amateur cultural production has become virtually synonymous with ideological resistance in feminist analyses of media produced by girls. The idea that marginalized groups can appropriate existing popular culture texts for resistant purposes has its roots in two separate, though related, spheres of study: audience reception and fan culture/practices. Inquiry in both of these areas focuses on the ways in which individuals interact with popular culture texts, the former through the interpretive practices that audiences use to make meaning from those texts, and the latter through productive practices, such as the writing of fan fiction, through which fans appropriate them in order to

reimagine them, in the process reshaping them according to their own fantasies or desires.

Neither audience reception nor fan production need necessarily be ideologically subversive. However, beginning in the early 1990s there has been a predominant strain of media studies scholarship that has focused specifically on interpretive practices that read "against the grain" of dominant meanings, as well as fan production that inscribes alternative meanings onto popular texts. Significantly, while studies such as Fiske's *Television Culture* (1987) examine oppositional reception practices that range from sympathetic identification with villains to the rejection of narrative morals, studies like Doty's *Making Things Perfectly Queer* (1993) and Penley's *Nasa/Trek* (1997) focus more specifically on instances of textual interpretation or appropriation that reject dominant cultural values along with dominant readings of the text.

In the case of both Doty's and Penley's studies, queer interpretations or appropriations of popular media open up spaces for the articulation of queer identity and desire, with the result that both media consumption and production take on a political dimension in these studies, insofar as they are deployed for the purposes of ideological resistance. Penley's book in particular has served to foreground the ways in which fan fiction can intersect with other, more explicitly political practices of textual appropriation, such as culture jamming, that alter "known elements of commercial culture...so that their meanings are changed" (Harris, 2004, p. 168). However, all of the subsequent critical attention directed to examining intersections between amateur cultural production, textual appropriation, and ideological subversion has inadvertently contributed to the impression that *all* practices of textual appropriation are subversive in nature and are expressly undertaken as progressive political work.

Indeed, even when texts produced using appropriated media content do not themselves challenge hegemonic values, they are often still conceptualized in terms of either subversive or libratory effects. In particular, there has been a marked tendency in contemporary media studies to characterize practices like textual poaching in terms of "resistance to capitalism" (Burgess & Green, 2009, pp. 12–13), especially when analyzed within the context of debates over media piracy and the parameters of fair use within the cultural commons. To the extent that the unauthorized appropriation of copyrighted content is often positioned within such analyses as "liberating" corporate media from the capitalist structures in which it is produced and circulates, it has had the effect of making textual poaching seem like a political act even

when the resulting text reassembled from appropriated source material is apolitical or reactionary in nature. It also ignores the ways in which, as Jenkins (2006b) points out, corporate media producers are increasingly shifting their marketing strategies to encompass acts of textual appropriation in an attempt to "link consumers directly into the production and marketing of media content" (pp. 145–148).

As a result, studies of amateur cultural production that focus on acts of textual appropriation only as a subversion of capitalism very often elide the ways in which such appropriation is rendered complicit in capitalist media production when it is harnessed for the purposes of better "sell[ing] goods...in an interactive environment" (Jenkins, 2006b, p. 148). They also have a tendency to conceptualize textual appropriation as subversive in and of itself, with the very act of "poaching" media content seen as revolutionary, regardless of the ideological orientation of what is produced. Ultimately, then, while the relative lack of critical attention paid to amateur cultural production that reinforces dominant cultural values has encouraged the impression that the majority of DIY media created using appropriated content is subversive in nature, it has also left the impression that media texts that support hegemonic discourses are only produced by the culture industries. This has been particularly true in the field of girls' studies, where almost all of the scholarship examining girls' cultural production has focused on DIY production that explicitly challenges hegemonic understandings of girlhood.

The zines, films, and websites examined by Kearney (2006) uniformly demonstrate a commitment to critiquing hegemonic models of adolescent femininity. This is also true of the essays collected in Mazzarella's edited volume *Girl Wide Web: Girls, the Internet, and the Negotiation of Identity* (2005a) that examine girls' interactions with cyberculture and their cultural production on the Internet in the form of websites and online zines. At the same time, there has been a tendency in scholarship on girls' online fan activities to conceive of those activities as both political and feminist acts, even while acknowledging that fan practices are not always political in nature. Mazzarella (2005b), for instance, invests girls' online fandom with a feminist use, even when their fandom practices or the texts that they celebrate do not promote feminist values, insofar as she suggests that girls' fandom practices constitute attempts to reclaim aspects of girl culture generally held in contempt by U.S. culture at large. In this way, expressions of fandom are conflated with resistance to the institutional structures in which girls are relegated to a subordinate social status, and fandom takes on the effect of

feminist political work regardless of whether or not it is aligned with feminism.

Along these same lines, there has also been a tendency within recent girls' studies scholarship to see girls' cultural production on the Internet in emancipatory terms—again, regardless of the aims toward which it is deployed—because it represents girls' engagement in traditionally male-dominated activities. Kearney, for example, couches her examination of girls' web design in terms of the narrowing of the gendered digital divide, as well as girls' transgression of the "male and masculine world of computer culture" (2006, p. 244). Likewise, Reid-Walsh and Mitchell (2004) set their examination of girls' computer use against the disparity between "girls and boys and their voluntary engagement with computers and technological games" (p. 173). Thus in this way, too, girls' cultural production on the Internet is cast in this scholarship in terms of libratory, resistant and/or feminist practices, because it is conceptualized as a challenge to hegemonic gender roles.

It is against such theorizations that I want to position the examination of *Twilight* machinima below, in order to trouble the prevailing assumption within girls' studies scholarship that girls' cultural production on the Internet is, in and of itself, an act of feminist resistance. Because the *Twilight Saga* has been the subject of a fair amount of ridicule and disdain within mainstream U.S. culture, girls' production of *Twilight* machinima can certainly be positioned as an attempt to reclaim, and to celebrate, aspects of girl culture. Likewise, because machinima production uses video games and digital editing software to create films, girls' involvement in machinima-making can also be read in terms of their transgression of three traditionally male-dominated spheres of cultural production and consumption: filmmaking, computer technology, and video game play. And yet, if the activity of girls' producing *Twilight* machinima can be read in feminist terms, the machinima itself often cannot. Not only is the feminist critique found in girls' cultural production in the scholarship discussed above decidedly absent from the machinima examined in this study, but all of the machinima in this study reassert patriarchal constructions of "normative" adolescent femininity and heterosexuality rather than challenging them. The challenge this machinima presents to feminist media and cultural scholars, therefore, becomes how to read such work outside of libratory or subversive theoretical models, without denying the agency exercised by the girls who produce it, and without dismissing the work itself as simply an anomaly in what is otherwise assumed to

be the primarily subversive media that girls create. I will admit that I don't yet have a solution to this challenge, but it is my hope that by drawing attention to it through the analysis that follows, I can also draw attention to the need for those of us who work in the field of girls' studies to begin to address it.

Twilight Machinima: A Qualitative Analysis

The data sample for this study was collected by conducting a YouTube search for *Twilight* machinima using the search terms "Twilight machinima." This search yielded 1,770 results, out of which a random sample of 200 videos (approximately 10%) were chosen by selecting every tenth video in the search results. After eliminating machinima not related to the *Twilight Saga*, 32 videos remained. An additional 359 videos were then selected by following the links under the "Suggestions" section on the pages for the original 32 videos, as well as searching for additional *Twilight* machinima posted on the YouTube channel pages for those users who posted the original videos. The resulting sample represents machinima created by 62 users, out of which 5 identified themselves in their profile information as male, 36 identified themselves as female, and 21 did not disclose information pertaining to gender. (Because this analysis is concerned primarily with assumptions about girls' online cultural production within girls' studies scholarship, the machinima produced by the five male users is not cited as examples in the analysis below although it followed the same representational patterns.) The ages of the female users in this study ranged from 13 to 35, with a median age of 19. Although information on socio-economic status and race/ethnicity was not included in any of the profiles, these 62 users were located in 13 countries in North America, South America, Europe, and Asia, with 12 listing the United States as their country of residence.

The 391 machinima analyzed for this sample can be divided into two general categories according to the model of DIY cultural production that they follow. The first category is comprised of those machinima that recreate the novels, films, or film trailers as closely as possible to the source material, a model of DIY cultural production that Bolter and Grusin (2000) describe as "remediation," which involves recreating an existing media text within another medium. Of the 62 users in this study, 29 posted videos that fall into this category, recreating the books/films/film trailers in the *Twilight Saga* either in whole or in part.

The second category of DIY cultural production employed by the machinima in this study follows Jenkins's model of textual poaching, in which content from the novels and/or films is reworked into original narratives or music videos. The remaining 33 users followed this model, creating either machinima mashups or fan fiction. These machinima enact the type of amateur cultural production most often positioned as subversive within media and cultural studies scholarship. As such, while one might not expect remediations of *Twilight* to critique the original novels/films, one might expect at least some of those that enact processes of textual poaching to engage in critique. And yet, this was not true of any of the mashups or fan fiction in this study. Even the seven machinima in the sample that consisted of parodies of *Twilight* did not engage in any kind of ideological criticism of the text. Instead, they all focused on poking fun at various textual elements, such as the tendency in both the novels and the films for the members of Jacob's werewolf pack to appear shirtless at all times.

While the parodies did occasionally mock the intensity with which Bella's romantic relationship with Edward is represented in the source texts, none critiqued the heteronormative terms in which that relationship is enacted, nor did any of them challenge the source texts' coding of the violent and emotionally abusive aspects of that relationship as an idealized model of heterosexual romance. This was also true of the non-parodies, which either celebrated this model of heterosexual romance or else uncritically reproduced it. Likewise, none of the machinima in this sample offered an alternative imagining of the terms within which Bella and Edward enact their relationship. There was also no critique in the parodies of the patronizing, controlling model of masculinity embodied by Edward or the submissive, self-abnegating model of femininity embodied by Bella in the source materials, nor were alternative enactments of gender presented in the non-parodies. Thus, even the machinima in this study that reimagine the story of Bella's and Edward's relationship outside of the narrative of the source texts do not reimagine gender and heterosexuality outside of the heteronormative models endorsed by those texts, while none of the machinima collected for this study sought to question, challenge, or otherwise subvert the gender and sexual politics of their source material.

This is most evident in the large number of machinima tributes to the "love" between Edward and Bella included in this sample, all of which uniformly accept—and celebrate—the problematic model of heterosexual romance promoted by the source texts. Heva602's "Bella and Edward in Sims 2,"

for example, features a montage of the two characters dancing, kissing, and sleeping beside one another. Similarly, Elllizzzen's "Twilight Tribute to Edward and Bella" is composed of a montage of recreated scenes from the first film chronicling the development of their relationship. In both cases, the oppressive and emotionally unhealthy aspects of this relationship as depicted in the source texts is completely elided, eclipsed by clichéd images of heterosexual romance that support the books' and films' coding of Bella's and Edward's union as an ideal love.

In fact, out of all of the machinima in this sample, there was only one that came close to addressing the negative aspects of Bella's and Edward's relationship in the source texts, and then it was addressed in the comments accompanying the video rather than the content of the machinima itself. "Edward Left Bella—New Moon—Sims3," posted by mysticGC7, recreates the scene from *New Moon* in which Edward ends his relationship with Bella "for her own good." In the description of the video, mysticGC7 states, "i know that this is just the worst part of twilight because its soooooo cruel what edward does but here it is…. " While acknowledging Edward's cruelty toward Bella in this scene, it is unclear from these comments whether mysticGC7 considers this "the worst part of twilight" because it highlights the tendency within the source texts to represent unilateral action on Edward's part without consideration for Bella's desires (and often in direct opposition to what she wants) as a supreme act of love, or if instead what mysticGC7 finds objectionable is the temporary obstacle this breakup poses to their romance. Either way, whatever critique is intended here stops short of overtly criticizing the model of heterosexual romance endorsed by the source texts, and, in fact, the video itself still reproduces it without alteration of any kind.

Along these same lines, the machinima in this study also replicate the heteronormative pattern that Bella and Edward's romantic relationship follows over the course of the four books/films. Even the two fan fiction machinima that imagine Edward's and Bella's future beyond the final novel are both idealized fantasies of heteronormative bliss in which marriage and parenthood (strictly enacted along orthodox lines) is the only path for heterosexual union. In Lauren1668's "Renesmee—Life After Breaking Dawn," shots of Edward playing piano are intercut with scenes of him playing with their daughter, Renesmee (born in the final novel), and watching Bella care for her. Similarly, wizkiz77's "Life After Breaking Dawn" is composed of a series of scenes of Bella, Edward, and Renesmee chronicling her childhood and

adolescence that end with Edward and Renesmee dancing on her wedding day.

Significantly, these two machinima proscribe an even more orthodox life for Bella and Edward (and later, Renesmee) than the books/films, in which they at least occasionally match wits with evil vampires. There is nothing unconventional about their lives in the machinima, though, and certainly no thought given to either a life outside of marriage and family or an enactment of marriage and family along less traditional lines. Instead, Bella feeds, changes, and otherwise cares for Renesmee while Edward looks on approvingly and dotes. This follows a larger pattern evinced by all of the machinima in this sample that take as their subject Edward's and Bella's romantic relationship, in which—modeling the gender roles promoted by their source texts—Edward is depicted controlling all decisions about if, when, and how he and Bella will pursue that relationship, while Bella is depicted subordinating all of her needs and desires to those of Edward.

If these machinima that celebrate Bella's and Edward's romance reify the heteronormative terms in which that romance is enacted in the source texts, though, they also elide the violence that characterizes their relationship, particularly the sexual aspects. In all of the fan fiction and mashups in which Edward and Bella kiss, cuddle, fawn over their child, and (in three instances) make love, their interactions are presented as tender and affectionate. This is a far cry from both the books and the films, in which every kiss or embrace is preceded by tears, argument, or emotional anguish, and also carry with them the possibility of death for Bella should Edward lose control over his vampire nature. In the final book in the series, *Breaking Dawn*, Edward and Bella consummate their relationship on their wedding night. While the details of their lovemaking are left to readers' imaginations, the scene chronicling the morning after includes a very graphic description of Bella standing before a mirror surveying her bruised, battered body. This is a particularly horrifying scene, not least because, despite the violence done to her, Bella is depicted fondly reminiscing about her night with Edward and dreamily anticipating being with him again.

While the dreamy anticipation carries over into the three machinima recreations of Edward and Bella's honeymoon included in this sample, the violence does not. Indeed, in 10twilight01's seven-part recreation of *Breaking Dawn*, Lauren168's two-part "Isle Esme," and AnnieCullenxx's "Bedward," the narrative of Bella's and Edward's honeymoon is rewritten so that their sexual union can be celebrated without celebrating the violence done to Bel-

la. However, by removing that violence from the story, these machinima don't critique the novel's version of romance as the willingness to have violence done to one's person in the name of love; they simply ignore it. Furthermore, in erasing the troubling aspects of Bella and Edward's sexual relationship, these machinima do provide an alternative version of heterosexual union to the one represented in the novel. However, that "alternative" is only an alternative in the sense that it stops short of representing violence as an expression of passion. It is still very much in line with the model of heterosexual romance endorsed by the *Twilight Saga*, in which the inequalities in power, agency, and desire that characterize Bella's and Edward's relationship are presented as the epitome of romance.

Within this context, it is worth noting that to the extent that the mashups and fan fiction in this sample do enact alterations to the source materials, even if those alterations only extend to plot details and not to the ideological orientation of the *Twilight Saga*, what is not altered also becomes significant, because it, too, points to the ways in which these machinima recapitulate rather than subvert the meanings attached to the source texts. While the resemblance between the characters in the machinima in this study and their appearances in the novels/films vary largely depending on the skill of the machinima creator, none of the machinima in this sample intentionally alters the characters in ways that extend representation within the text to members of marginalized social groups. In the same way that there is no queer version of *Twilight* among the machinima in this sample (outside of the spoof of the *Eclipse* trailer "Sims 3 New Moon Parody," produced by Electronic Arts Inc., (2009) in which a passionate kiss between Edward and Jacob is presented as a homophobic joke), there is also no version in which the protagonists are recast as people of color, nor one in which they are given body types outside of the thin, conventionally attractive, able-bodied cultural ideal. Thus, much in the same way that the machinima in this sample remain faithful to the gender and sexual politics of the books/films, they also remain faithful to their representational politics, which reaffirm the cultural hegemony of white, heterosexual, able-bodied subjects.

Ultimately, then, while the machinima in this sample are all examples of DIY cultural production, the majority of which were produced by creators who identify as female, when it comes to their appropriation of content from their source texts, they do not evidence any of the feminist critique that is routinely ascribed to girls' cultural production on the Internet in girls' studies scholarship. All of which returns me to the contention that those of us who

study media from a cultural studies perspective need to move beyond the subversive-democratizing paradigm in our approach to the analysis of media produced by girls. This is not merely because it places limits on the ways in which we are able to analyze texts like the machinima discussed above that support, rather than subvert, dominant culture, but also because it discourages our analysis of such texts in the first place. Locked into a theoretical framework in which cultural production outside of the culture industries is understood as a site at which alternative media can be produced, we focus on independently produced media that is subversive in nature, overlooking all of the instances in which dominant values are articulated in texts produced from the margins and not just the center.

I want to end by suggesting, therefore, that while we are rethinking our approach to DIY cultural production, we maybe should also turn a critical eye to the question of why we are so invested in the subversive potential of DIY media in the first place. I suspect that for those of us who work in the field of girls' studies, it is partly because we are not just invested in advocating for a more girl-friendly culture, but also in girls' taking an active role in creating that culture. I think it would do us well to remember, however, that in the same way that commercial media is not solely to blame for the structural inequalities in our society, independently produced media is not going to be able to remedy those inequalities, even if it does actively challenge them. Media production only works as social activism if it is part of a larger activist project. This is one reason why, as media scholars, we perhaps need to be a little more careful in how we qualify the claims that we make about the subversive potential of DIY media, as well as its effects. If our ultimate goal really is social transformation, then we need to stop confusing the democratization of media production with the democratization of society, and we need to acknowledge that one does not automatically lead to the other.

Works Cited

10Twilight01. (2009, June 20). Breaking dawn, parts 1–7 [Video File]. Retrieved from http://www.youtube.com/user/10twilight01

alittlemid. (2009, June 18). Twilight [Sims 2] episode 5, part 1. [Video File]. Retrieved from http://www.youtube.com/user/alittlemid#p/c/40A7D4EB3E2D6D4F/5/p7gzUwJsB_4

AnnieCullenxx. (2009, March 8). Bedward [Video File]. Retrieved from http://www.youtube.com/user/AnnieCullenxx#p/u/16/VxogJyPhjEw

Bolter, J.D., & Grusin, R. (2000). *Remediation: Understanding new media.* Cambridge, MA: MIT Press.

Burgess, J., & Green, J. (2009). *YouTube: Online video and participatory culture*. Cambridge, MA: Polity Press.

Doty, A. (1993). *Making things perfectly queer: Interpreting mass culture*. Minneapolis: University of Minnesota Press.

Dow, B. (1996). *Prime-time feminism: Television, media culture, and the women's movement since 1970*. Philadelphia: University of Pennsylvania Press.

Electronic Arts, Inc. (2009, November 19). Sims 3 New Moon parody [Video File]. Retrieved from http://www.youtube.com/watch?v=ATDwM7pN7BU&feature=related

Elllizzzen. (2010, February 6). Twilight tribute to Edward and Bella [Video File]. Retrieved from http://www.youtube.com/user/Elllizzzen#p/u

Fiske, J. (1987). *Television culture*. London: Methuen.

Harris, A. (2004). Jamming girl culture: Young women and consumer citizenship. In A. Harris (Ed.), *All about the girl: Culture, power and identity* (pp. 163–172). New York: Routledge.

Heva602. (n.d.) Bella and Edward in Sims2! [Video File]. Retrieved from http://www.youtube.com/user/heva602#p/u

Jenkins, H. (2006a). *Convergence culture: Where old and new media collide*. New York: New York University Press.

Jenkins, H. (2006b). *Fans, gamers and bloggers: Exploring participatory culture*. New York: New York University Press.

Kearney, M.C. (2006). *Girls make media*. New York: Routledge.

Lauren1668. (n.d.). Breaking dawn (Isle Esme), parts 1 and 2 [Video File]. Retrieved from http://www.youtube.com/user/Lauren1668#p/u

Lauren1668. (2009, November 25). Renesmee-Life after breaking dawn [Video File]. Retrieved from http://www.youtube.com/user/Lauren1668#p/u/2/_GZY6S5K9lk

Mazzarella, S. (Ed.). (2005a). *Girl wide web: Girls, the Internet, and the negotiation of identity*. New York: Peter Lang.

Mazzarella, S. (2005b). Claiming a space: The cultural economy of teen girl fandom on the Web. In S. Mazzarella (Ed.), *Girl wide web: Girls, the Internet, and the negotiation of identity* (pp. 141–160). New York: Peter Lang.

Mulvey, L. (1989). *Visual and other pleasures*. Bloomington: Indiana University Press.

mysticGC7. (2009, June 15). Edward left Bella-New Moon-Sims 3 [Video File]. Retrieved from http://www.youtube.com/watch?v=z92R0fgmlWQ

Penley, C. (1997). *Nasa/Trek: Popular science and sex in America*. New York: Verso.

Reid-Walsh, J., & Mitchell, C. (2004). Girls' Web sites: A virtual room of one's own? In A. Harris (Ed.), *All about the girl: Culture, power and identity* (pp. 173–182). New York: Routledge.

VNX Matrix. (2003). Cyberfeminist manifesto. In A. Jones (Ed), *The feminism and visual culture reader* (p. 530). New York: Routledge.

wizkiz77. (2009, November 18). Life after breaking dawn [Video File]. Retrieved from http://www.youtube.com/user/wizkiz

Chapter 5

Fandom, Technology, and Practice —and the Relevance of Cyberfeminism

Holly Kruse

Introduction

Many writers and activists involved in the decades-long project of cyberfeminism have urged women and girls to get involved and disrupt the largely patriarchal institutions that govern digital technology. In cyberfeminism's early days, writers such as Sadie Plant (1997) espoused the now-seen-as-naïve view that the online world was a feminine matrix, one that had escaped from its military origins and become resistant to patriarchy through its global mix of hardware, software, and wetware. They were part of an early wave of cyberfeminism that some, according to Jessie Daniels (2009), "characterized by a utopian vision of a postcorporeal woman corrupting patriarchy" (p. 102). The utopian vision of a post-human, cyborg world was usefully critiqued by Jenny Sundén (2001), who wrote that "there might be a weak link between the feminist cyborg and the reality where women who use the new technology find themselves" (p. 217), further explaining that arguments for the empowered female-machine hybrid "circulat[e] in a utopian space unmarked by a surrounding capitalist economy operating on levels of exclusions and limitations for many women" (p. 220).

Technologically deterministic arguments tended to ignore the real and complex relations of women's and girls' everyday lives, including the fact that entrance into a world mediated by high technology of the sort that emerged from military and big business settings was much more easily gained by men than women (see Luckman, 1999; Wilding and Critical Art Ensemble, 1998). Still, as Radhika Gajjala and Annapurna Mamidipudi (1999) state of cyberfeminism, "Even though there are several approaches to cyberfeminism, cyberfeminists share the belief that women should take control of and appropriate the use of Internet technologies in an attempt to empower themselves" (p. 8). This chapter focuses on the importance of studying practice in order to understand how women and girls engage with digital

technologies of production, dissemination and meaning co-creation, and whether we can consider these practices empowering, or even resistant and counter-hegemonic. The chapter looks at an example of located online practice—specifically, fan music videos created in tribute to champion female American racemare Zenyatta—to interrogate aspects of the emancipatory potential of the Internet.

Issues of Cyberfeminism

Even as Sadie Plant (1997) was celebrating the liberating qualities of the Internet for women, online spaces where one would have thought women would have a substantial voice often were not. One example was the Usenet newsgroup soc.women, which was popular in the 1980s and into the 1990s. Early on, men—often making misogynistic comments—dominated the group. As "The Unofficial soc.women" FAQ stated:

> Q: Should I read soc.women?
> A: Yes. You need a higher level of stress in your life. You need to know first hand that there really are people like *that* out there.
> Q: Why is this FAQ written by a man?
> A: This is soc.women; what do you expect?
> Q: Will it get any better?
> A: No.
> (Harter, 1998)

Saskia Sassen (2002) reminds us that "electronic space is inflected by the values, cultures, power systems, and institutional orders within which it is embedded" (p. 370). This embeddedness is inescapable, and therefore must always be part of analyses of counter-hegemonic interventions.

Because of the need for caution in stating the emancipatory potential of the Net for women, today cyberfeminism must look at an important facet of the relationship between gender and the digital world: real, embodied, situated technological and social practices. These are, of course, gendered practices and demonstrate the need to understand how practices—in this case, how girls and women engage with digital technology in their everyday lives—and institutions reproduce, subvert, or attempt to escape patriarchal relations. Seemingly successful feminist interventions, disruptions, and contestations may have little effect for women located elsewhere, both geographically and on the network, in the most common and popular places online, including those devoted to shopping, video-sharing, gambling, dating,

→ PESQUISA: ANÁLISE DE YA BOOKS QUE ABORDAM
EXPLICITAMENTE O FEMINISMO (QUAIS?)

Fandom, Technology, and Practice 103

and popular culture. These are the places that most clearly define the Net for everyday users.

Further, we need to keep in mind that cyberspace today is largely organized by the rules of the "attention economy," in which merely attracting and maintaining attention have become crucial to business and most economic relations (Falkinger, 2003, p. 2). With so much content, it is difficult to capture and keep people's attention, and for the most part, commercial interests ⟶ with substantial resources at their disposal to position themselves are the ones that command attention. This environment raises the question of how an online intervention by the marginalized can be successful without attention. As danah boyd argues,

> Switching from a model of distribution to a model of attention is disruptive, but it is not inherently democratizing. This is a mistake we often make when talking about this shift. We may be democratizing certain types of access, but we're not democratizing attention. Just because we're moving towards a state where anyone has the ability to get information into the stream does not mean that attention will be divided equally. (2009)

Effective participation in the attention economy means users employing the tools available to get attention for their content, even if the tools are provided by the largely patriarchal status quo (including heavily male-dominated tech companies such as Google and Facebook). Ordinary users—indeed, ordinary fans—may well not care about resisting a patriarchal, capitalist order or engaging in explicitly feminist interventions, as Christine Scodari (2003) demonstrates in her examination of narratives constructed by female science fiction television fans. The fan narratives she studied often eschewed strong female characters—Agent Scully in *The X-Files*, for instance—and inserted weaker female fan stand-in characters in their place.

Clearly, then, cyberfeminists must pay particular consideration to the ordinary practices of ordinary people, including how they access and use digital tools, and how they make meaning. In the second half of this chapter I examine the creation of horse racing fan videos as a case study of gender, digital technology, and media content production, consumption, and dissemination.

RELEVANTE

Bedroom Culture and Computing

In the mid-1970s, in the seminal volume *Resistance Through Rituals*, which came out of the University of Birmingham's Centre for Contemporary Cultural Studies and was edited by Stuart Hall and Tony Jefferson, Angela McRobbie and Jenny Garber (1975/1991) observed that contemporary studies of youth subcultures had neglected real analysis of girls and leisure. Much of what was subsequently written about girls and domestic leisure practices came out of the British cultural studies tradition. McRobbie noted in her book *Feminism and Youth Culture* (1991) that one of the main sites of male youth culture, "the street," had traditionally been off limits for girls (p. 29), and McRobbie and Garber explained over a decade earlier that girls' leisure activities tended to take place in domestic space, which was perceived to be less risky than "the street" and other public venues. Post–World War II girls, they argued, required access to private space to engage teenage activities, including those involving consumer culture, such as experimenting with make-up, listening to records, talking about boys, and reading magazines (1975/1991, p. 213).

In her empirical study of a group of British working-class teenage girls, Christine Griffin (1985) found that the girls indeed tended to hang out with each other in the home, listening to music, playing with make-up, and talking about school and sex. Mica Nava (1992) observes that girls are more likely than boys to spend their leisure time at home or at their friends' houses, and that their movements are more regulated inside the home and out than boys'.

The gendered division between the street and the home has deep roots that extend to early industrial society and is articulated in the notion of "separate spheres" for men and women. Prior to industrialization, the home had been a primary site of work for both women and men, but industrialization largely removed explicit processes of production from the home. As home and work were separated from each other, the home (especially the middle-class home) came to be seen as feminized, apart from the masculine world of work and public life (Spigel, 1992; Cowan, 1983). The culture of separate spheres serves patriarchal interests by dividing masculine and feminine, as well as public and private space, and it is perpetuated by cultural ideology and practice (Wolff, 1990). Janet Wolff further explains that the separation of spheres

[a]pplies both to women's place in cultural production (as artists, authors, patrons, and members of cultural institutions) and to the dominant modes of cultural repre-

sentation, particularly in literature and visual arts, and their construction of notion of gender. (p. 13)

In thinking about cultural production (and consumption) then, we should remember that the bedroom has been the site of cultural practices for many girl fans. Sheryl Garratt (in Steward and Garratt, 1984), in discussing her own 1970s British teenage music fandom, recalls that many of her and her friends' fan activities took place in domestic space, for instance, "running home from school to watch *Shang-A-Lang* on TV, dancing in lines at the school disco and sitting in each others' bedrooms discussing our fantasies and compiling our scrapbooks" (p. 144).

Digital technology provides a relatively new home-based tool for the production and consumption of culture. However, recent research shows that boys may more frequently engage with computer activities at home than girls; data gathered in the United Kingdom by Sonia Livingstone and Ellen Helsper (2007) indicates that boys tend to access the Internet from more places (presumably both inside and outside the home), and they are more likely than girls to be able to access the Internet from their bedrooms. In a study of Greek high school students, Marina Papastergiou (2008) found that girls, for whatever reason, were less likely to use computers in the home than boys, and they used computers less intensively.

Yet Livingstone and Helsper (2007) also discovered that "middle-class children have more access points, and the most affluent are considerably more likely than the poorest group to have home access, broadband and bed-room access" (p. 676), indicating that middle-class girls tend to have reason-ably better access to home computers than those of lower socio-economic status. In a study of Korean youth, Sook-Jung Lee and Young-Gil Chae (2007) found that while girls spent less time using the Internet than boys, it was not a statistically significant difference. Finally, in a survey of Dutch teens, Hans Kuhlemeier and Bas Hemker (2007) learned that boys and girls were quite similar in their experience with at least some computer applica-tions used in school-related activities, in their access to the Internet, and in their ownership of personal computers. One might conclude that across cul-tures, young people of both sexes, if of relatively high socio-economic status, have reasonably good access to home computers: computers they can use to engage in digital culture, in domestic space, and as a leisure activity.

But in what sort of digital culture might young women engage? In the first decade of the 21st century, concern continued over the growing gap be-

tween men and women majoring in computer science in college and entering professional information technology careers (see Stross, 2008). Mashable blogger Jolie O'Dell (2010) writes:

> Although women were well-represented early in computer programming history, women are today less likely to be found in the ranks of programmers, entrepreneurs, venture capitalists, product designers, web designers, all-purpose hackers, sysadmins, network security experts and just about any other profession that requires the slightest bit of scientific, mathematical and technical expertise.

O'Dell adds: "Ironically, teenage girls are using computers and the Internet just as much as teenage males…[but] Internet use does not a technologist make." For instance, one important way that boys become computer savvy is through playing computer games, something that girls have traditionally been less likely to do. The most popular and profitable games, as Virpi Oksman (2002) notes in her research, are action and adventure games created and marketed for boys and which invite masculine identification with the characters and action in the games. The pre-teen and teenage girls in Oksman's research showed little interest in violent, masculinely identified computer and video games.

There are initiatives to address the technology gap between boys and girls. A summer camp program in the Philadelphia area, for instance, engages girls in grades 4 through 8 in activities like robotics, computer programming, gaming, design, and animation. At the camp the girls "built robots and programmed them to play soccer, snapped digital pictures, edited in Photoshop, and created a logo for the Girls in Technology website that they'll help create" (Holmes, 2010). Such efforts are commendable, and getting girls interested in design is important, especially when one considers that only 17% of web designers are female (Mindiola, 2010). One might then think that the presence of women in design-oriented computer positions would count as a victory. However, John Mindiola (2010) observes that in the field of design "[t]here is also an unspoken expectation that women are very creative and make great print designers, but aren't wired to splice the intricacies of new and constantly changing software and platforms." In a similar vein, Justine Cassell, who directs Northwestern University's Center for Technology and Social Behavior, argues that web design and similar jobs pay less than programming jobs and do not affect how computers are used as much as software engineering jobs do (cited in Stross, 2008). And Jolie O'Dell (2010) warns that just because some jobs frequently occupied by

women involve extensive IT use and are located in technology companies doesn't mean that these are technologist positions:

> In the valance professions of advertising, marketing, public relations and communications, human resources, office management and assistance, women abound. When these positions are found under the umbrella of a tech company, the pink-collar job is transformed, and the woman in the position is said to be "in tech."

Judy Wajcman (2000) argues that "in contemporary Western society, hegemonic masculinity, the culturally dominant form of masculinity, is still strongly associated with technical prowess and power" (p. 454). Further, Gajjala and Mamidipudi (1999) ominously note:

> Whether located in the Northern hemisphere or the South, whether rich or poor, global structures of power (through their "invisible" control of the market, Internet service providers, software design, language and so on) clearly determine women's use of the Internet. (pp. 15–16)

But they also state:

> While there are hierarchies of power embedded in the very construction and design of Internet culture, there is still potential for using it in ways which might subvert these and foster dialogue and action on various unexpected fronts, in unpredictable ways. (p. 15)

Indeed, I should point out that girls and women using digital technology in any venue should not be overlooked or discounted. For instance, Virpi Oksman (2002), in her study of girls ages 10 to 15 who kept virtual horse stables online, which allowed them to own, ride, buy, and sell imaginary horses, found that "[f]or girls, interaction, creativity, and the making of new acquaintances seem to be the most powerful sources of inspiration for the use of new technology" (p. 200). There are sites for technology play using digital tools found in the most ordinary places, even girls' bedrooms.

Fans and Their Practices

The bedroom has been an important site of fan practice over the past several decades, and one would not expect that to have changed with digital technology. What has changed, however, is the technology available to engage in fandom-related activities. New communication and information technologies allow fans young and old to carve out a technologized space of their own in

fandom worlds. Nancy Baym (2007) points out that fan activities in the past 15 to 20 years have increasingly moved online; and Henry Jenkins (2006) claims that the new digital technologies available to ordinary people, including fans, have allowed people to more easily enter into serious public discourse and activism. We should acknowledge, however, that digital tools are not readily available to all, or perhaps even most, fans. In studying digital musical practices in remote locations, I note that broadband connections or even mere computer access is extremely limited (Kruse, 2010). Users in the developing world increasingly have access to online content, but tools for creating and disseminating their own content is still fairly inadequate compared to those of users with full-fledged computers and broadband connections.

Access to digital technology is not a prerequisite for fan activities. Baym (2007) defines fandom as involving "a collective of people organized socially around their shared appreciation of a pop culture object or objects." Whether online or off, fan culture is not passive but participatory. The pre-Internet 20th-century was rife with examples of participatory fan cultures, whether they involved movie magazine readers and writers in mid-century, teenagers listening to records in bedrooms and traveling together to pop and rock concerts, or science fiction fans writing "slash" fiction that featured characters from television shows in same-sex relationships and circulating it in photocopied fanzines.

All of these phenomena point to the key role that interaction among fans plays in fandom. Henry Jenkins (1992) maintains that fans' understandings are always affected by other fans' input. Although relationships among fans have long been noted in academic literature, it's certainly easier for fans to interact and to circulate their own texts and meanings in a digital universe.

Moreover, in an online environment, fans can interact with culture industries, something that many companies have taken advantage of. Baym (2007) observes that culture industries use the Internet to cultivate and connect with fans to help disseminate their products. For instance, in 2010 the Breeders' Cup World Championships, a two-day series of races sponsored by the National Thoroughbred Racing Association, held a video contest (Breeders' Cup Zenyatta Video Contest, 2010). The contest invited fans to submit videos they had made in tribute to champion thoroughbred racemare Zenyatta, who had defeated top male horses in the premier end-of-year race in 2009, the Breeders' Cup Classic, and was entering the 2010 Classic with an undefeated record of 19 wins in 19 races. The Breeders' Cup organization was at-

tempting to capitalize on the devoted fandom centered on Zenyatta to bring these fans and more casual racing fans to its website and Facebook fan page, and fans were able to further circulate their creations. Zenyatta has proven a potent site of meaning creation: for some she is a feminist icon who in 2009 was the first mare to beat males in the Breeders' Cup Classic and barely missed winning the same race against a tougher field in 2010. She has inspired a dedicated and vocal following, and several fans created videos that they posted to YouTube, some of which were also entered in the contest.

Significantly, some of the fans who posted videos on YouTube and some who entered videos in the contest "knew" each other (and me) in other online spaces such as Twitter. As Baym (2007) explains, "Over time, active fans will find that they bump into many of the same people wherever they go. Through this process, a sense of 'community' may be formed." Significant, too, is that of 26 videos entered, individuals with feminine first names—presumably women and girls—entered 20. Through my interactions with some of the entrants, I know that a couple of them are very young women. It should not be terribly surprising, given what we know about girls and women and the desire to create online content, that most of the entrants were women—and also because in the popular media and blogosphere, Zenyatta became something of a feminist (or at least "girl power," as signs held by fans at racetracks declared) icon.

Zenyatta's fan base, online and off, appears to be largely female, and quite devoted. Famed racehorse photographer Barbara Livingston (2010) observed that as Zenyatta accumulated wins:

> Fans, mostly women, began following her back to the barn—fans whose childhood dreams of the perfect racehorse paled in comparison to this real-life 17.2-hand mare. Along the way, Zenyatta became The Queen, Queen Z, Z, Zenny….The idolatry peaked at this year's Breeders' Cup, when fans lined up several rows deep to watch Zenyatta graze each day.

A non-racing female blogger posted the following shortly before the 2010 Breeders' Cup:

> Zenyatta will run in [the Breeders' Cup Classic]; the only mare in a sea of testosterone-filled boy race horses, and she is bigger physically than all of them. This will be her twentieth race, and she has won all nineteen of the races she ran prior to this one. This is also her last race. Normally I would write about her tomorrow after her history is permanently penned, but I want to make sure that all the women in the country watch her today and thank her for the gifts she gives us. (Merser, 2010)

Soon after, at a public ceremony held to celebrate Zenyatta's retirement from the racetrack and to welcome her to Kentucky, the large crowd was primarily comprised of women and girls (Oakford, 2010).

Seasoned turf writers who vote for the annual winners of horse racing's Eclipse Awards in the United States were not immune from charges of overly fan-ish behavior and sex bias. Horse racing blogger Jessica Chapel (2011) learned that, at the time of her blog post in early January, four of five female turf writers whose votes for 2010 Horse of the Year were known had voted for Zenyatta, while the nineteen male turf writers whose votes were known were split between Zenyatta and the male horse who narrowly beat her in the 2010 Breeders' Cup Classic, Blame. She adds that handicapper and writer Steve Davidowitz solicited votes for Horse of the Year from his readers and found that of the 147 fans who responded, 132 supported Zenyatta for Horse of the Year and only 15 supported Blame. He attributes this imbalance to the heavy presence of women (123) and relative absence of men (24) among the respondents. Only three of the women voted for Blame, even though he arguably had run in tougher races, and he had beaten Zenyatta when they finally met on the racetrack.

Like Zenyatta fandom in particular (and horse-related interests and activities in general; see Bjerke, Ødergårdstuen, & Kaltenborn, 1998), creating fan videos has chiefly been a gendered activity, and a femininely gendered one despite its technical nature. Henry Jenkins (2006) explains:

> In the female fan community, fans have long produced "song videos" that are edited together from found footage drawn from film or television shows and set to pop music. These fan vids often function as a form of fan fiction to draw out aspects of the emotional lives of the characters or otherwise get inside their heads. They sometimes explore underdeveloped subtexts of the original film, offer original interpretations of the story, or suggest plotlines that go beyond the work itself. (pp. 159–160)

The videos Jenkins discusses are tied to narrative forms of media and thus are not descriptive of the kinds of videos produced by female horse racing fans. As David Jenemann (2010) has noted, much highly visible academic television fan research has focused on narrative television and its pleasures and not on, for instance, televised sporting events and related fan practices. Still, fan videos related to non-narrative, non-scripted television may function in similar ways, connecting actions and imputed emotional states of individuals (including horses) in the video with the fan's (or fans') own

emotions, through editing and the addition of an audio track deemed appropriate by the video-maker.

Although many of the Zenyatta tribute videos posted on YouTube and some of the videos entered in the contest consisted of amateur video shot by the fan him/herself, and others were photo slideshows, the most popular Zenyatta Internet videos as measured by the number of votes received in the contest, and/or the number of views and comments on YouTube, were the ones that included a musical soundtrack and were primarily composed of found video. These videos demonstrate the most sophisticated use of digital production and editing technology, and they are also the most reliant on mainstream media content: primarily video from ESPN and the TVG horse racing television channel, and popular music in the form of dance tracks, country songs, and excerpts from symphonies and movie soundtracks. In this case, then, we have women and girls (and a few men and/or boys) appropriating popular media content to express their fandom, and seizing new, masculinely gendered technologies to create new texts that express their relationships to the object of their fandom in ways the producers of the original content may not have imagined. Does this situated practice, presumably largely done in domestic space, constitute cyberfeminist practice? Or, perhaps more precisely, is it resistant to patriarchy?

Resistance to Patriarchy?

According to Michel de Certeau (1984), the possibility of resisting dominant ideology exists in the use of the commodities imposed on them by capitalism. Any commodity can, therefore, be resistant, although the cultural commodity need not be explicitly subversive to be consumed in counterhegemonically productive ways. Media users are active and productive, manipulating the products of dominant media institutions to serve their own ends. Several theorists have attempted to adapt de Certeau's writings to the study of popular culture. John Fiske (1989), for example, maintains that despite the capitalist relations that govern the institutional production of popular culture commodities, these commodities can be consumed in resistant ways. Fiske chooses not to focus on what he calls "the omnipresent, insidious practices of the dominant ideology" but instead concentrates on

the everyday resistances and evasions that make that ideology work so hard and insistently to maintain itself and its values. This approach sees popular culture as potentially, and often actually, progressive (though not radical), and it is essentially

optimistic, for it finds in the vigor and vitality of the people evidence both of the possibility of social change and the motivation to drive it. (pp. 20–21)

Similarly, Henry Jenkins (1992) finds resistance in the media practices of ordinary people when he examines science fiction fandom, which he claims is "a 'scavenger' culture built from poached fragments of many different media products" (p. 232). Resistance here is manifested in the songs written and performed by science fiction fans. Jenkins argues that these songs are means by which displeasure with the status quo can be expressed and through which the preferred readings—the readings most in line with the dominant ideology—of primary texts can be challenged. However, Christine Scodari (2003) does not agree that such fan practices are truly resistant, stating:

> The very act of fans creatively laboring to adjust commercial texts to their interests is remarkable, but their particular adjustments or the motive behind them are not always resistive, despite the fact that much of the incipient works tends to frame such reservations as minor caveats rather than as emphatic claims. (p. 113).

We can consider these arguments about fandom and power, as well as technology and gender, by examining a couple of the most popular Zenyatta fan videos.

Among the most popular Zenyatta tribute videos on YouTube—one of which was entered in the Breeders' Cup contest—are two by a user who goes by "seggymon" (or by her name, Chelsea, in the contest) on YouTube and who often uses Lady Gaga songs to provide the audio tracks for her videos. The articulation of Zenyatta and Lady Gaga is an interesting move, because both are stars (though with different levels of recognition) with devoted, femininely gendered fandoms. Both are icons for "girl power," if not feminism per se, although Lady Gaga has admitted to being "a little bit of a feminist" (Williams, 2010). While we don't know whether Zenyatta is a self-avowed feminist, we do know that her human connections utilized all possible channels to make their horse accessible to her fans. Zenyatta had a Twitter account, a blog, and a webpage, and trainer John Shirreffs posted videos of Zenyatta's morning workouts, filmed with a camera attached to her exercise rider's helmet, on YouTube. "Team Zenyatta" also made their horse extraordinarily available to the public, even on the morning after her loss in the 2010 Breeders' Cup Classic, when hundreds of fans came to the barn area of Churchill Downs to visit their idol. Like Zenyatta, Lady Gaga is known for

being accessible to, and celebratory of, her fans, whom she calls "little monsters." Gaga explains: "I didn't fit in in high school and I felt like a freak, so I like to create this atmosphere for my fans where they feel like they have a freak in me to hang out with and they don't feel alone" (quoted in Corona, 2011, p. 2). Zenyatta's fans too often report feeling like outsiders; for instance, in their championing of Zenyatta as Horse of the Year in 2009, when she lost the title to the 3-year-old filly Rachel Alexandra.

Seggymon's fan tribute videos—tributes to Zenyatta, but also, by using her music to celebrate a beloved racehorse, to Lady Gaga—are quite well done, using footage from various television sources and editing it, when paired with the music, to evoke powerful moods. For instance, in the Zenyatta video that uses Lady Gaga's song "Starstruck" as the audio track, seggymon often matches Zenyatta's movements, especially her well-known "dancing," to the beat in the song. And when Gaga sings the phrase "cherry cherry boom boom," Zenyatta is shown from behind, bouncing in the paddock before a race. In another video, this one celebrating both Zenyatta and Rachel Alexandra, seggymon syncs the mood and music of Lady Gaga's "Telephone" to video of both horses. The song begins and ends quietly, with Lady Gaga singing while backed only by piano, and at the beginning and end of the video we see footage of both horses being walked in the morning and evening. When Gaga sings that she left her head and heart on the dance floor, we see the two horses (although mostly Zenyatta) prancing. And when Gaga says in the song that she's "kinda busy," we see video of both horses running hard in a variety of races. The articulation of video and audio content and thus meaning is sophisticated, as are the range of techniques, including match cuts and dissolves, used in the video.

These videos epitomize the facility with digital tools largely inspired by the kind of youthful, femininely gendered fandom posited by those who argued for the worthiness of studying bedroom culture. That the quality and content of the videos are appreciated by other fans is unquestionable. Seggymon's videos inspire comments from various users on YouTube such as "I love this video! I watch it quite often!"; "I love Z and have watched nearly every video on youtube - and this is just fabulous - I love it!!! Awesome job!!!"; "Hee hee it looks like she is stepping to the beat of the song in this video :)"; "Excellent work and great dedication to a great horse!" and "Nice tribute to the queen, I'm not a lady gaga fan, but this fits Zenyatta like a glove. Well done." These comments laud both seggymon's commitment to racehorse fandom as well as her technical and artistic prowess.

Of course, popular culture practices are ultimately not independent of institutional and thus patriarchal power. Even practices like poaching—appropriating mass media products and using them in different, usually non-commercial contexts—serve the culture industries by distributing their products to wider audiences. It is important to keep in mind that, under capitalism, consumption is to some degree structured. In the example of fan videos, the use of commercial media content and dissemination through established (and mainly male-dominated) organizations and new media channels, helps in part to maintain the ideological dominance of the leisure apparatus that is already in place.

This is not to say that the femininely identified fan activities described in this chapter aren't incredibly valuable and even empowering. It is only to say that they do not explicitly challenge hegemonic institutions, including those that are largely patriarchal in their power structures, such as technology industries, media industries, and the horse racing industry. The fact is, however, that fans who entered the Breeders' Cup video contest, and/or who post their racehorse tribute videos on YouTube, likely want their videos seen by other fans, and therefore want their creations disseminated as widely as possible using the tools available. When the technology is available, many girls and women, just by playing around with it, are able to create incredibly complicated and professional-looking products (as is the case with the Zenyatta fan videos I've examined) using complicated edits to build a narrative arc and matching action to beats.

We must always, in feminist analysis, describe and understand the interaction of physical environment, virtual environment, sex, gender, technology, and economic practice needs to be described and understood, at the very least. We must also be sensitive to all activities that indicate counter-hegemonic tendencies. Of girls and virtual stables, Virpi Oksman (2002) makes the crucial observation that rather than play the uninteresting (to them) commercially available games, the girls created their own online venue for play outside of existing media institutions and generated by their own interests. For Oksman, the phenomenon offers the possibility that producing original content will "become a permanent part of girls' own computer culture" (p. 206). Whether or not it is consciously feminist or resistant, the practices of women and girls in computer culture, the interventions they make in even the most mundane online (and offline) spaces, are important and meaningful, and it is crucial to understand them, even when they don't present

researchers with virtual worlds to explore and gender-bending avatars to interrogate or post-corporeal users to celebrate.

Works Cited

Baym, N.K. (2007). The new shape of online community: The example of Swedish independent music fandom. *First Monday: Peer-Reviewed Journal of the Internet, 12*(8). Retrieved from http://firstmonday.org/htbin/cgiwrap/bin/ojs/index.php/fm/article/view/1978/1853

Bjerke, T., Ødergårdstuen, T.S., & Kaltenborn, B.P. (1998). Attitudes toward animals among Norwegian children and adolescents: Species preferences. *Anthrozoös, 11*(4), 227–236.

boyd, d. (2009, November 17). Streams of content, limited attention: The flow of information through social media. *Web2.0 Expo.* New York, NY. Retrieved from http://www.danah.org/papers/talks/Web2Expo.html

Breeders' Cup Zenyatta Video Contest. (2010). In *Facebook* [Group page]. Retrieved from http://apps.facebook.com/contestshq/contests/68371/voteable_entries?ogn=facebook&view_entries=1

de Certeau, Michel. (1984). *The practice of everyday life* (Steven Rendall, Trans.). Berkeley: University of California Press.

Chapel, J. (2011, January 4). Zenyatta feminista? *Railbird.* Retrieved from http://jessicachapel.com/2011/01/04/zenyatta-feminista/

Corona, V.P. (2011). Memory, monsters, and Lady Gaga. *Journal of Popular Culture, 44*(2), 1–19.

Cowan, R.S. (1983). *More work for mother.* New York: Basic Books.

Daniels, J. (2009). Rethinking cyberfeminism(s): Race, gender, and embodiment. *Women's Studies Quarterly, 37*(1–2), 101–124.

Falkinger, J. (2003). *Attention economies.* Munich, Germany: CESifo Group.

Fiske, J. (1989). *Understanding popular culture.* Boston: Unwin Hyman.

Gajjala, R., & Mamidipudi, A. (1999). Cyberfeminism, technology, and international "development." *Gender and Development, 7*(2), 8–16.

Griffin, C. (1985). *Typical girls? Young women from school to the job market.* London: Routledge & Kegan Paul.

Harter, R. (1998, April 19). The unofficial soc.women FAQ. Retrieved from http://home.tiac.net/~cri/1997/womenfaq.html

Holmes, K.E. (2010, June 24). Montgomery County program encourages girls' interest in technology. *Philadelphia Inquirer.* Retrieved from http://www.philly.com/inquirer/education/20100624_Montgomery_County_program_encourages_girls__interest_in_technology.html

Jenemann, D. (2010). Stop being an elitist, and start being an elitist. *Flow.* Retrieved from http://flowtv.org/2010/12/stop-being-an-elitist-and-start-being-an-elitist/

Jenkins, H. (1992). "Strangers no more, we sing": Filking and the social construction of the science fiction fan community. In L. Lewis (Ed.), *The adoring audience: Fan culture and popular media* (pp. 50–65). London: Routledge.

Jenkins, H. (2006). *Convergence culture.* New York: New York University Press.

Kruse, H. (2010). Local identity and independent music scenes, online and off. *Popular Music and Society, 33*(5), 625–639.

Kuhlemeier, H., & Hemker, B. (2007). The impact of computer use at home on students' Internet skills. *Computers & Education, 49*, 460–480.

Lee, S., & Chae, Y. (2007). Children's Internet use in a family context: Influence on family relationships and parental mediation. *CyberPsychology & Behavior, 10*(5), 640–644.

Livingston, B. (2010, December 2). Zenyatta a reminder to celebrate life. *Daily Racing Form.* Retrieved from http://www.drf.com/blogs/zenyatta-reminder-celebrate-life

Livingstone, S., & Helsper, E. (2007). Gradations in digital inclusion: Children, young people and the digital divide. *New Media & Society, 9*(4), 671–696.

Luckman, S. (1999). (En)Gendering the digital body: Feminism and the Internet. *Hecate, 25*(2), 36–47.

McRobbie, A. (1991). *Feminism and youth culture.* Cambridge, MA: Unwin Hyman.

McRobbie, A., & Garber, J. (1991). Girls and subcultures. In S. Hall & T. Jefferson (Eds.), *Resistance through rituals: Youth subcultures in post-war Britain* (2nd ed.) (pp. 1–15). London: Routledge. Original work published 1975.

Merser, C. (2010, November 6). Homage to Zenyatta. Retrieved from http://www.freesialane. com/2010/11/06/homage-to-zenyatta/

Mindiola, J. (2010, November 12). Gender disparities in the design field. *Smashing Magazine.* Retrieved from http://www.smashingmagazine.com/2010/11/12/gender-disparities-in-the-design-field

Nava, M. (1992). *Changing cultures: Feminism, youth and consumerism.* London: Sage.

Oakford, G. C. (2010, December 6). Zenyatta and her fans enjoy one last dance. *ESPN.* Retrieved from http://sports.espn.go.com/sports/horse/news/story?id=5893321

O'Dell, J. (2010, September 7). Why we don't need more women in tech…yet. *Jolie O'Dell's web log.* Message posted to http://blog.jolieodell.com/2010/09/07/women-in-tech/

Oksman, V. (2002). "So I got it into my head that I should set up my own stable…": Creating virtual stables on the Internet as girls' own computer culture. In M. Consalvo & S. Paasonen (Eds.), *Women and everyday uses of the Internet: Agency and identity.* New York: Peter Lang.

Papastergiou, M. (2008). Are computer science and information technology still masculine fields? High school students' perceptions and career choices. *Computers & Education, 51*, 594–608.

Plant, S. (1997). *Zeros + ones: Digital women + the new technoculture.* New York: Doubleday.

Sassen, S. (2002). Towards a sociology of information technology. *Current Sociology, 50*(3), 365–388.

Scodari, C. (2003). Resistance re-examined: Gender, fan practices, and science fiction television. *Popular Communication, 1*(2), 111–130.

Spigel, L. (1992). *Make room for TV: Television and the family ideal in postwar America.* Chicago: University of Chicago Press.

Steward, S., & Garratt, S. (1984). *Signed, sealed, and delivered.* Boston, MA: South End Press.

Stross, R. (2008, November 16). What has driven women out of computer science? *The New York Times*. Retrieved from http://www.nytimes.com/2008/11/16/business/16digi.html

Sundén, J. (2001). What happened to difference in cyberspace?: The (re)turn of the she-cyborg. *Feminist Media Studies, 1*(2), 216–232.

✸ Wajcman, J. (2000). Reflections on gender and technology studies: In what state is the art? *Social Studies of Science, 30*(3), 447–464.

Wilding, F., & Critical Art Ensemble. (1998). Notes on the political condition of cyberfeminism. *Art Journal, 57*(2), 46–59.

Williams, N. (2010, March 11). Is Lady Gaga a feminist or isn't she? *Ms.* Retrieved from http://msmagazine.com/blog/blog/2010/03/11/is-lady-gaga-a-feminist-or-isnt-she/

Wolff, J. (1990). *Feminine sentences*. Berkeley: University of California Press.

Section II

Technology, Gender, and Agency

Chapter 6

What It Takes to Screen Her Film: A Feminist Study of UNESCO's Audiovisual E-Platform Submission Process

Debbie James

Emerging as one of the public manifestations of an intergovernmental institutional strategy to promote gender equity in access to information communication technologies, the United Nations Education Science and Cultural Organization's (UNESCO) Audiovisual E-Platform is an online catalogue promoting public service–oriented television content from developing countries to the international television market (UNESCO, 2008). The catalogue entries on the site include a select corpus of films that are produced by grassroots and independent filmmakers and are described as a "genuine expression of different cultures in the world" (Audiovisual E-Platform, 2004). The E-Platform offers interested filmmakers a social network, invites submissions to the catalogue, and promotes the benefit of exclusive access to television broadcasters. Filmmakers and independent producers whose films are accepted into the catalogue are subsequently endorsed as professional media producers of local culture.

The submission process is fascinatingly contradictory—providing unprecedented access to global media markets while simultaneously filtering, defining, and valorizing the work of marginalized filmmakers (Miller, 2009, p. 184). As such, it is an ideal site to consider through a critical cyberfeminist lens as a means to fully reveal and then to examine repressive and emancipatory characteristics for techniques to add to the arsenal for online collaboration and knowledge building. In this frame the purpose of this chapter is to look beneath site aesthetics to investigate the design and functionality of the E-Platform's submission process based on the premise that the site promotes producers who have the least access to the tools of production, training, and industry experience.

When we think of mass media from a local vantage point, the submission process concurrently supports and exploits culture as an innovative creative

economy (Miller, 2009, p. 185). Therefore, the primary research question framing this chapter is to ask how the E-Platform film submission process replicates the struggle for representation and identity in the mass media (Dávila, 2003). To engage with this primary question, a series of secondary assumptions are formulated. The submission process is constituted by cyber and real elements filling a gatekeeping and emancipatory role. The process serves to deliver on institutional policy objectives and filmmakers' interests, therefore maintaining, and deconstructing existing power structures. As identified, the process is a complex system of competing institutional, individual, and technological priorities. The submission process is part of an epistemological technology and the result of institutional policies and values enfolded into technology. To demarcate the institutional priorities from the technology enfolded within the film submission process, the E-Platform of UNESCO's media catalogue is compared with The Hub, a non-governmental social network and participatory media site for human rights media. These sites have a similar mission, and both are built around an online catalogue and studio.

To accommodate the study of tensions between the disparate, institutionally controlled media catalogue and grassroots filmmakers, the theoretical approach to examining these sites is assembled from critical cultural policy studies, feminist post-development, and new media theory. An institutional analysis identifies the political economy and subsequent capitalist pressures of institutional cultural policy on media production and content development. Feminist post-development theorists prioritize women's lived experience. In terms of the institution's adoption of a theoretical and practical shift toward women-focused development, post-development theory promotes basic needs and acknowledges the limited resources available to grassroots media producers as a means to deconstruct the gender bias of technology (Wiegersma, 1997). The channeling of Haraway's argument for an oppositional politic in the moral economy of Web 2.0—new media converged with the experiences of grassroots media workers—reveals the interstitial layer, gate, border or tension between the institution and the filmmaker (Haraway, 1991).

The E-Platform and The Hub are comparable despite differences in design and approach, because they are both forms of social networks where a studio converges with a database for the purposes of promoting human rights–related media. The E-Platform is described as an "alternative communications channel" and media network for promotion and marketing television content (UNESCO, 2004). Forums and news sections provide social

networking functionality for collaboration, debate, and knowledge sharing. Launched in 2007, The Hub is also an online catalogue and social networking site supported by Witness, an international human rights organization whose mission is to create conditions of partnership and learning (Witness, n.d., para. 3–5).

New media theorists argue that promoting women's grassroots media is advantageous to the institution, broadcasting stakeholders and producers in that it establishes a new market and a previously untapped resource of creative content. Setting this within the theory of moral economy of Web 2.0, Joshua Green and Henry Jenkins (2009) describe user-created media as a source of wealth for media companies who just need to figure out how to effectively harness this creativity for the purposes of self-promotion and thus establish authority over local media content. In the process of supporting the development of grassroots media training, other support is provided. This context provides ample opportunity for the application of Toby Miller's argument (2003) that audiovisual policy is designed to transfer the dominant value system of global media corporations to developing countries and support the economic objectives of the institution.

To examine UNESCO's E-Platform film submission process as a transformative, almost industrial exercise in making the local knowable, a layered framework is constructed in which a textual analysis of the process is completed while nested within an institutional analysis. This framework is designed to accommodate the power dynamic embedded in the interaction between the institution and the filmmaker within the process and to identify the characteristics that make a local film recognizable. Within this interdependent layered framework, four elements of the submission process common to both sites are compared. These elements are composed of actions required of the filmmaker, including finding the instructions and preparing the submission based on the criteria. Also included is an analysis of the representation of the film on the catalogue page, and viewer feedback on the film. Examined for evidence of digital gatekeeping and emancipation, these actions are determined by institutional and industry knowledge. The submission process can be broken down systematically and each step examined from the perspective of policy, site design, information architecture, and functionality, and compared to those found at The Hub.

The sponsoring Creative Content Programme offers different ways to gain access to the E-Platform catalogue, including film festivals and an open submission process. The open submission process is briefly mentioned on the

contact page of the E-Platform, and full submission information is available only at the Creative Content Programme site (UNESCO, 2004). The process forces local cultural goods through industrial processes based on economic considerations, not cultural development, resulting in a cultural product that is a "nonorganic, distanced, remotely conceived but locally delivered, sense of culture" (Miller, 1998, p. 31). At the same time, the filter ensures that the media content is recognizable to the broadest audience. The submission process marks the organization's adoption of user-created media—films produced by independent and grassroots media producers not contracted by the institution to complete this work. These filmmakers are beneficiaries of UNESCO's network and the promise to distribute through the catalogue to international broadcasters. These films are available to view in a degraded form, but not freely available for download and reuse.

A form of quality control, submission requirements serve a gatekeeping role and legitimize UNESCO's program activities over and above the mission to support local media development by marginalized women and men. The following discussion examines the functionality of the publicly available media submission process by which filmmakers gain access to the catalogue and examines how their work is then represented and evaluated in the E-Platform catalogue. This research draws on the theoretical and practical shift toward women-focused development that accommodates basic needs and acknowledges available resources of media producers (community media centers, informal training, and limited access to equipment) as a means to deconstruct the gender bias of technology (Wiegersma, 1997).

In this framework, three main points of the argument are formed based on current web usability standards against which the film submission process of the E-Platform is compared. Firstly, the institution uses non-user-friendly site development practices in the design of the E-Platform rather than adopting increasingly standard and intuitive social networking design practices. These practices, the information architecture and the associated functionality, are unclear, require an unnecessary layer of industry expertise, and parallel an institutional bias against local filmmakers. Third, the practices, design, and functionality of the E-Platform maintain the dominant/subordinate relationship between UNESCO and the media producers it seeks to engage with for the purposes of mission delivery and credibility. To exemplify these points, the process loop that filmmakers must go through to have their films included in the E-Platform catalogue and to then benefit from the UNESCO partnership is examined.

The Hub is a non-governmental social network and participatory media site for human rights built around an online catalogue. Witness, an international human rights organization whose similar mission is to create conditions of partnership and learning, supports The Hub site. This site promotes the use of video and media technologies to "transform personal stories of abuse into powerful tools for justice, promoting public engagement and policy change" (Witness, n.d., para. 1). Witness, the sponsoring organization, is a nonprofit that partners with grassroots human rights organizations around the world to collaborate on media development. Located in Brooklyn, Witness was started in 1992 by singer Peter Gabriel in the aftermath of the Rodney King, Jr., beating and the subsequent broadcast of amateur video footage of that event. Since then, Witness has stated that it has trained human rights advocates in over 70 countries to use video to further their campaigns. The Hub is a response to the increased access to mobile video technology and its potential as a tool for anyone to "witness" human rights abuses.

At this time, the E-platform catalogue contains 570 digitized films and videos produced by UNESCO partners, United Nations agencies, and independent producers. General access to the site's functionality is open to the public with registration. A registered member can view the film catalogue, forums, and news, as well as view compressed versions of the films using Real Player. Access to the upload features is limited to professionals (a term that remains undefined) pre-screened and endorsed by UNESCO's program specialist. The Hub lists over 1,200 videos. Access to the upload feature is open to all persons with an email address and human rights–related media they want to share. Access to the catalogue, forums, and news is open to the public without registration. The Hub does not limit access but rather states that media producers are assumed to be experts in their topic areas and are directed to promote media that is representative of their professionalism and in keeping with ethical standards.

To successfully submit a film and then be accepted into the catalogues, filmmakers/media producers demonstrate a standard level of information literacy not necessarily required to produce a film. To succeed, their approach to production must demonstrate that they are guided by institutional principals and guidelines. This includes the ability to construct concepts from existing information and to reuse/shape that information in such a way that is representative of an understanding of cultural, legal, ethical, and social issues (Dunn & Johnson-Brown, 2008). This text-based, reading/writing, computer-literate person is positioned in a formal educational system deemed as neces-

sary for "social inclusion and participatory citizenship" (2008, p. 89). However, this system negates oral traditions and is contrary to the accessibility of video technology that does not require reading literacy.

The threshold of text-based computer literacy as a requirement of participation contradicts the promise of a system that supports local knowledge and difference. To examine the difference between local versus institutional knowledge, Dunn and Johnson-Brown (2008) use the example of the Maroons, free Africans in Jamaica (prior to emancipation in 1883). To outwit and defeat the British troops, free Africans used their knowledge of local terrain and sophisticated communication systems. Yet media development organizations continue to force technology systems, demonstrating how non-Western notions of literacy have been negated in favor of text-based literacy (Jarman, personal interview, August 1, 2009). Information Communication Technologies (ICTs) such as the digital and computer training provided in community media centers are arguably pro-poor. These centers can address an individual's lived experience by providing the opportunity for developing communities with local and traditional information literacies to participate, gain access to information, and impart and express knowledge beyond their location (Dunn & Johnson-Brown, 2008). They are molded by local circumstances and needs. Access to international industry networks such as the E-Platform is based in a different system of literacy that privileges dominant languages and systems of knowledge and power, and are often disconnected from local realities. Dunn and Johnson-Brown limit their recommendations of ICTs to formal education environments. Limiting access to those who have the means to attend these institutions suggests that they focus on the easiest to serve, leaving behind poor communities and women (2008). This practice widens the gap between local media producers and the UNESCO distribution system.

Finding the information needed to make a submission requires information literacy in that a filmmaker can find, understand, and use the information provided (2008). In each case, the E-Platform proves difficult to navigate. The first barrier is language. English is the dominant language of the Internet and therefore not accessible to many marginalized women or poor and rural people (Jolly & Narayanaswamy, 2004). Both the E-Platform and The Hub provide various levels of language support in English, Spanish, and French at the click of a link. In testing their functionality, it was found that The Hub site pages, navigation, and links are mostly translated, while

translation on the E-Platform site is limited to navigation, leaving all page content (and submission information) in English.

Once a filmmaker has overcome the language barrier, The Hub provides two paths signposted by buttons leading to an information page detailing the submission process. Both buttons are located in the top navigation bar on every page. Addressing the conceptual and literal interpretation of submitting a film, one button is in the form of a tab entitled SHARE, and the other is a button entitled UPLOAD, accompanied by a graphic of an arrow pointing up. These links lead the filmmaker to a comprehensive guide that guides them through the upload process with step-by-step tips, suggestions on preparing the media, and information on privacy and security. In contrast, The E-Platform offers a non-operative graphic at the bottom of the catalogue and contact page that asks: "Would you like to have your productions in this plat-form?" Little other information is provided—only an email address if the button is discovered on the contact page. Upon further research, no other submission information is available at the E-Platform. Instead, this informa-tion is found at the Creative Content Programme site, where brief submission information is available, along with a link to the submission form in the port-able document format. Unlike the E-Platform, The Hub encourages submis-sion and actively seeks to create an accessible process.

Using the information to make a submission requires that the information provided is comprehensive and guides a filmmaker through the process of submission. This includes outlining the actual steps in sending the media to be submitted and the criteria by which a submission is deemed appropriate for the catalogue. The submission information provided at the Creative Con-tent Programme site outlines the criteria for a successful submission. Accord-ing to the information provided, grassroots organizations, and independent producers are the program's "privileged partners," whose media is chosen on "merit" based on their "talent to create meaningful and innovative content." However, the merit criteria and content specifications are undefined and thus left open to interpretation. The Hub, in contrast, starts from the premise that filmmakers are intelligent people who bring expertise to their area of know-ledge and are capable of making decisions on media production with the best intentions of the mission of the site. At The Hub, submissions go through a peer review process that is described as informal and based on adherence to the "Content Review Guidelines" that outline in detail what content is appro-priate for the site (The Hub, n.d.). The organization takes the perspective that media producers need clear guidelines to make decisions on whether their

content is appropriate—that is, in keeping with basic principles of human dignity—and consciously deciding that the film is not likely to put anyone involved in the project in danger (The Hub, n.d.). Determining the credibility of a submission is the responsibility of The Hub community, which is provided with the tools to critique the uploaded media and flag it as inappropriate, rate it, and tag it for consideration in another context.

The E-Platform submission process is more time consuming and arduous. The submission form requires significant information, including format of the original film, credits, budget, production details, broadcasting history, a film synopsis, and contact information. The submission must be mailed to the UNESCO office in Paris in VHS format, which assures the program specialist that the film meets basic broadcasting requirements and may allow for the circumnavigation of state-imposed Internet censorship, or access to Internet technology (Volkmer, 2004). All of this is within reason, except perhaps the requirement that the submission be sent in VHS format, which assumes access to technology that enables filmmakers to transfer their films to this format. The Hub allows for immediate digital upload of files, which assumes a consistent Internet connection with significant bandwidth. Both of these methods of submission have their drawbacks and challenges. Still, in reviewing the submissions uploaded to The Hub, filmmakers from all across the global south are represented in greater numbers than at the E-Platform, indicating that the technological demands are a manageable threshold.

Representation of the endorsed submission in the catalogue is the third step in the upload process. This confirms the filmmaker's relationship with the institution and is a visitor's first impression of the content. According to the submission information, once the Creative Content Programme specialist accepts the film for inclusion in the catalogue, the filmmaker receives access to the online upload features. This allows filmmakers to upload their films in a digitized format and to create a catalogue page with film stills, credits, synopsis, contact information, and an image of the filmmaker. The catalogue content page frames the Real Player screen with the title and date of the film, along with viewer ratings at the top. On the left side, a Google map shows the place of origin of the film, along with a list of related films in the catalogue. The Hub provides similar functionality, with the addition of the opportunity to subscribe to the catalogue page through Live Bookmarks and to search Technorati (two social networking tools that allow users to tag media

of interest, thus effectively empowering users to promote media of interest beyond the site) to see who else has linked to this catalogue page.

Films have similar quality parameters. Each is represented in the same video player, dimensions, and frame. The standardized format flattens the video and reduces differences that are present between cultural and national video production practices. As differences in production become less noticeable, the line between commercial and independent videos becomes blurred. A similar phenomenon has occurred on YouTube, in which commercial entities have appropriated independent and amateur authenticity by reproducing non-standardized production practices (Marshall, 2009). This suggests that the inclusion of video production of below-standard quality represents a more democratic production process and an authentic content, bestowing on the network a sheen of democracy of access and authenticity of purpose as archive and authority (Hilmes, 2009). Standardization also serves to unify the films as being representative of institutionally defined values and categories—affirming the definition and boundaries of the categories—serving to denationalize the production while integrating the subnational (subaltern) into the national through the pre-national process of media and communication development. In this case, it becomes easier to integrate dissent that may appear in the film into the service of the institution.

The design of the E-Platform catalogue page and associated assets indicates little concern for promoting the catalogue content. The quality of the images in the E-Platform catalogue page is poor. The stills are most often distorted and pixilated, and the digitized film is often so distorted as to obscure the picture and the subtitles. Associated information about the film is often incomplete and of questionable value. This lack of attention to the quality of the catalogue page suggests that the information provided for upload is incomplete, incorrect, or unclear. In any case, the lack of information provided, and the quality of the imagery and the film contradict the claim that this is valuable content, and relegates the work of the filmmaker to amateur status. In contrast, the design of The Hub catalogue indicates significant attention to promoting the catalogue's content. Each page provides enough information for a viewer to take action, to share and to engage in dialogue about the filmmaker's work. The aesthetics of each catalogue page complements rather than degrades the film, reinforcing the premise of this community that individual filmmakers are experts in their area. The Hub catalogue pages also include a counter, which lets the filmmaker and visitors

know what is popular or highly viewed, and records linkages outside and into the site, creating a knowledge network.

Feedback functionality provides for peer comments and represents an immediate and tangible networking benefit to the filmmaker for including a film in the catalogue. At The Hub, feedback and ratings provide a measure of accountability for each catalogue entry, informing subsequent visitors and the filmmaker of the impact of their work. The Hub's credibility is derived from action taken as a result of the film, which becomes a measure of success in social terms. In contrast, the E-Platform measure of success is the number of submissions from target countries and registered users. While each catalogue entry is designed to include broadcast information, that information is seldom available. In some cases the broadcasting location and dates are now missing in the wake of the site upgrade of June 2009. The measure of success of each catalogue entry in the E-Platform, therefore, is limited. While the E-Platform boasts 6,000 registered users as of June 2009, the forums area is seldom used, and the most recent entries are either announcements or posts that go unanswered by staff or visitors. With limited recorded interaction, success of the project seems also to be limited to the existence of the media hub with little emphasis placed on its use beyond the creation of the catalogue and the pages.

In terms of access, it is also useful to touch upon copyright. At the E-Platform, online viewing is encouraged, but downloading of films from the catalogue "is not allowed," which excludes viewers with limited Internet access. Despite the highly degraded quality, any use of the film requires the permission of the filmmaker, who must be contacted through the information provided. This is perhaps in keeping with the idea that this is a catalogue for TV broadcasters that happens to be hosted on the Internet. Converged with its technological context, The Hub itself is designed as a distribution tool and provides notice of the Creative Commons licensing agreement as determined by the filmmaker, allowing for appropriate use of the film almost immediately. The E-Platform excludes the user-determined copyright functionality and instead directs broadcasters to contact the filmmakers to negotiate a use agreement. As such, it replicates the functionality of a traditional paper catalogue—promoting inventory and controlling access, while decreasing the chances the films are seen and distributed—locally or globally.

Enfolded into the Creative Content Programme are numerous international instruments that initially ignored women and marginalized men, their lived experience, and basic needs followed by specific development projects

that situate the equality of women in society as a priority. As with the adoption of new technologies, new policies addressing women are designed to increase women's accessibly to industry opportunities while meeting commercial objectives (Bolter & Grusin, 1999). UNESCO states that the Creative Content Programme and community media centers provide opportunities for marginalized and subaltern populations to engage and participate in a public sphere. The media development framework of UNESCO's project remains in agreement with principles of free speech and free expression, while continuing to engage in practices designed to reconstruct an inclusive and flexible public sphere. Yet this public sphere is buttressed by rules established by the international community and folded into a process that is often exclusive of marginalized populations. Acceptance for distribution is dependent on the local producer adopting narratives that adhere to a predefined list of themes set by UNESCO (Hackett & Carroll, 2006). As such, the resultant media products—those directly supported and/or chosen for dissemination within the Creative Content distribution framework—are situated in overlapping and often competing institutional contexts: global governance, development communication practices, feminism, and Western filmmaking ideologies.

The Creative Content Programme E-Platform uses non-user-friendly site development practices, resulting in inaccessible and complicated submission, cataloguing, networking systems, and copyright. By examining the upload process within a framework of comparing sites with like mission statements and supporting functionality, this research reveals how the E-Platform site is not designed to facilitate access to the catalogue, nor is the E-Platform, as suggested, a social network site or a collaborative media catalogue. The E-Platform design systems are antithetical to social networking, collaborative, and basic web design standards, and gatekeep access to the information in such a manner as to prohibit access to the submission process and inclusion in the catalogue. With this in mind, the E-Platform serves to justify the program by claiming credit for procuring the work of local filmmakers and providing broadcasters with local representative content, but it fails to create the conditions for a participatory community of filmmakers. Furthermore, access to the catalogue, which is promoted as the benefit of the program, forces the content through an ideological process that ultimately shapes the media content archived on the E-Platform. This process transforms the media from a source of potential knowledge building and a community asset to a commodity cut free of specificity of location and disorganized from its origin by the

decontextualizing pressures of the E-Platform site. As a result, the site is temporarily invigorated as an emerging and legitimate authority on human rights and public service–related media from the global south, but over time it becomes apparent that the site lacks community, feedback, and thus sustainability. The filmmakers are not represented as partners but rather as beneficiaries of a program designed to assist in promoting "the best" representations of a particular culture to global broadcasters maintaining the subordinate/dominant relationship between the institution and local media producers.

In this context, women media producers are served by a marginal increase in access. Arguably, this access is assumed by the inclusion of the words "women" and "equity" in the E-Platform page content, site navigation, and database organization. However, unlike The Hub, which has adopted a social network of knowledge and learning, the E-Platform is designed to harvest the creative work of local filmmakers with recognizable skills and style for the purposes of promoting institutional values to traditional broadcasting outlets.

Works Cited

Bolter, J.D., & Grusin, R. (1999). *Remediation: Understanding new media.* Cambridge, MA: MIT Press.

Dávila, A. (2003). Crafting culture: Selling and contesting authenticity in Puerto Rico's information economy. In J. Lewis & T. Miller (Eds.), *Critical cultural policy studies* (pp. 302–310). Malden, MA: Blackwell.

Dunn, H.S., & Johnson-Brown, S. (2008). Information literacies and digital empowerment in the global south. In *Reports prepared for UNESCO on the occasion of the International Association of Media and Communication Research (IAMCR) 50th Anniversary Conference 2007—"Media, Communication, Information: Celebrating 50 Years Of Theories And Practice"* (pp. 78–102). Paris: UNESCO.

Green, J., & Jenkins, H. (2009). The moral economy of Web 2.0: Audience research and convergence culture. In J. Holt & A. Perren (Eds.), *Media industries: History, theory, and method* (pp. 213–225). Malden, MA: Wiley-Blackwell.

Hackett, R., & Carroll, W. (2006). *Remaking media: The struggle to democratize public communication.* New York: Routledge.

Haraway, D. (1991). *Simians, cyborgs, and women: The reinvention of nature.* New York: Routledge.

Hilmes, M. (2009). Nailing mercury. In J. Holt & A. Perren (Eds), *Media industries: History, theory, and method* (pp. 21–33). Malden, MA: Wiley-Blackwell.

The Hub. (n.d.). Things to keep in mind when uploading videos. Retrieved from http://hub. witness.org/en/node/484

Jolly, S., & Narayanaswamy, L. (2004). *Gender and ICTs: Supporting resources collection.* Brighton: Institute of Development Studies, University of Sussex. Retrieved from http://www.bridge.ids.ac.uk/go/bridge-publications/cutting-edge-packs/gender-and-icts/&id=52910&type=Document

Marshall, P.D. (2009). New media as transformed media industry. In J. Holt & A. Perren (Eds.), *Media industries: History, theory, and method* (pp. 81–90). Malden, MA: Wiley-Blackwell.

Miller, T. (1998). *Technologies of truth: Cultural citizenship and the popular media.* Minneapolis: University of Minnesota Press.

Miller, T. (2003). Introduction to part VIII. In J. Lewis & T. Miller (Eds.), *Critical cultural policy studies* (pp. 267–271). Malden, MA: Blackwell.

Miller, T. (2009). Can natural Luddites make things explode or travel faster? The new humanities, cultural policy studies, and creative industries. In J. Holt & A. Perren (Eds.), *Media industries: History, theory, and method* (pp. 184–198). Malden, MA: Wiley-Blackwell.

UNESCO. (2004, May 10). Audiovisual e-platform, an online catalogue for independent producers and broadcasters, to be launched today. Retrieved from http://portal.unesco.org/ci/en/ev.php-URL_ID=15694&URL_DO=DO_TOPIC&URL_SECTION=201.html

UNESCO. (2008). Medium-term strategy, 2008–2013. Retrieved from http://unesdoc.unesco.org/images/0014/001499/149999e.pdf

Volkmer, I. (2004). Media systems and journalism in the global network paradigm. In H. Jenkins & D. Thorburn (Eds.), *Democracy and new media* (pp. 309–330). Cambridge, MA: MIT Press.

Wiegersma, N. (1997). Introduction to section 5. In N. Visvanathan, L. Duggan, L. Nisonoff, & N. Wigersma (Eds.), *The women, gender and development reader* (pp. 352–261). New Delhi, India: Zubaan.

Witness. (n.d.). About Witness. Retrieved from http://www.witness.org/index.php?option=com_content&task=view&id=26&Itemid=78

Websites

Audiovisual E-Platform. (2004) *UNESCO.* Retrieved from creativecontent.unesco.org
The Hub. (2007). *Witness.* Retrieved from hub.witness.org

Chapter 7

Masters of Technology:
Defining and Theorizing the Hardcore/
Casual Dichotomy in Video Game Culture

Erica Kubik

I like to play video games. I get excited when new games come out. I read online reviews, interact on message boards, buy games the day they're released, even sniff around game stores days before a release date to see if they set product out early. I often ignore people I like when I'm into a game, sometimes playing for 8–14 hour stretches in a day when I first get them. Yet when talking about the release of *Halo 3* with my class after its release in 2007, a student asked if I had played it, and I responded that I didn't play First Person Shooters (FPS). After that he looked as if he doubted that I knew anything about games at all. At that moment I felt that my legitimacy as a gamer was called into question. How do certain games, and certain behaviors and patterns of consumption, come to define who is a gamer? Key to answering this question is the idea of "hardcore."

If you are a fan of video games, you have probably come across the term hardcore, especially during the 7th generation of console games. It's used to describe everything from games, to players, to demographics. For example, when the Nintendo Wii first launched in 2006, journalists, gamers, and industry analysts worried if the system would appeal to hardcore gamers, or if those gamers even mattered to the success of the system (Schiesel, 2006). But what is hardcore, hardcore gaming, or hardcore gamers? That is a bit trickier to pin down. There is no set definition of what hardcore means in the gaming world. In fact, part of the fun of hardcore is arguing over its definition.

Using online debate over what is hardcore and casual gaming and who are hardcore and casual gamers, I analyze the gaming modifier "hardcore" and its antithesis, "casual." While I became interested in the construction of video game culture as a fan and member of the community first—and in fact the 2005 Electronic Entertainment Expo (E3) represented my first stirring of

interest in researching the community—I actively collected data from October 2006 to August 2008 (and, as a fan, I still keep tabs on what is happening). During data collection, I explored online websites and blogs related to video games. I had originally planned to focus on two mainstream blogs, Joystiq and Kotaku, as well as explore less well-known gaming sites with more female-friendly atmospheres such as Girls Don't Game. Indeed, much of my data comes from these sites. However, I also signed up for a Google Alerts service at the beginning of my research with the text words "gender" and "video games." This allowed me to widely sample gaming culture. While it would be impossible to include all of the data I received and reviewed, I did sample more gaming websites and blogs because of this. Throughout, I focused primarily on cultural concerns about gaming consoles, rather than PC gaming or large, social games such as Massively Multiplayer Online Role Playing Games (MMORPGs), and my data reflects that.

I argue that definitions of "hardcore" and "casual" constitute gaming identity by asserting value for some at the expense of others. This is done by referencing gendered stereotypes about video gamers, games, behaviors, and so on. The end result is a normative value to the masculine hardcore gamer, and devaluation for the feminine casual gamer.

Masculinity as normative value is certainly not limited to online video-game communities. If we look at literature surrounding masculinity on the Internet, we see that men's relationship to technology is often seen as more natural, and hence more legitimate. Lori Kendall's work (2002) studying online spaces that discuss technology focuses mainly on the performance and maintenance of masculinity in these spaces. She understands her subjects to be mostly white, heterosexual, middle-class males, or subjected to those ideals. She gives a great ethnographic account of the ways in which one's gender, race, ethnicity, class, and other markers of identity are performed in online encounters, helping to create a sense of community and legitimacy among the group members. However, that legitimacy came at the exclusion of members who could not or did not fit in.

Key to her understanding of user participation online is her awareness that gendered norms of behavior shape and maintain social interactions in the community. These norms center on the idea of hegemonic masculinity, or "the configuration of gender practice which embodies the currently accepted answer to the problem of the legitimacy of patriarchy which guarantees (or is taken to guarantee) the dominant position of men and the subordination of women" (Kendall, 2002, p. 72). Kendall suggests that while few men actually

embody the ideal of the man in positions of domination, all men benefit from the maintenance of the "patriarchal divide" (Kendall, 2002, p. 73) Negotiating their relationship to and maintaining these ideals is how masculinity is used in discourse.

Of particular importance for this discussion is Kendall's awareness that in cyberspace one way of showing patriarchal dominance and therefore showing an ideal of hegemonic masculinity is through the use of dominance over technology. This particular style of masculinity requires "aggressive displays of technical self-confidence and hands-on ability for success, defining professional competence in hegemonically masculine terms and devaluing the gender characteristics of women" (Kendall, 2002, p. 73). So certain displays of self have to be valued at the denial or exclusion of other displays. For Kendall, many of the ways in which masculinity is maintained are through asserting dominance over women, which upholds a heterosexual ideal; or dominance over technology, which by showing marketable skills upholds certain class ideals in online conversations. We see this same process in action in video game culture through the elevation of masculinity through a performance of hardcore identity and the devaluation of femininity through the abuse of casual gamers or casual games, as I will highlight shortly. While theoretically everyone can participate in this hardcore image, they do so only as long as they don't upset the balance too much; they must pass, in other words.

Returning to Kendall, she suggests that women, men of color, or other non-normative groups can *possibly* participate in the masculine culture of the Internet. Because there aren't visible reminders of difference, "members of subordinated groups may more easily join interactions with the dominant group *as long as they conform to its norms.* Thus online forums have the potential to be nominally more inclusive but in terms that still effectively limit participation" (Kendall, 2002, p. 108). What this suggests is that cultural codes of conduct are organized around patterns of identity, which, while possibly inclusive, are also very rigid in definition. Those from subordinate groups have a doubly hard time fitting in, because they must maintain an identity that doesn't represent them. Further, that identity seeks to legitimize itself by claiming the identity of the other as abhorrent. In the case of gaming, legitimacy is produced by setting a dichotomy between the legitimate hardcore player and the less legitimate casual player. Before I explain this process more fully, the definition of hardcore needs to be explored.

Gaming identity relies heavily on references to hardcore within the gaming world. While the definition of who is a hardcore player is often nuanced and can be debated or flamed, many key characteristics started to emerge once I began to analyze definitions. The website of the MegaGames: The Hardcore Gaming Experience (2007) reads:

> A hardcore gamer is usually a male, between 14–34 years of age who has gaming in their top priority list, for example, someone who would prefer to play a game instead of sleeping at night or watching TV. Basically a game addict. With a very high technical knowledge on computer, console hardware and the whole computer industry in general, they keep up to date with the latest technological advancements.... One of their main characteristics is that they usually play a large number of games per year that could very well be over a 100 games.... As the trendsetters in the gaming industry, these elite gamers are so focused on gaming that some end up being game developers themselves.

The qualities of this person stated above are addictive, technically proficient, and highly committed to gaming. These qualities make them leaders in the gaming world. This is a common trope of hardcore gamers: that they are the elite of gamers and that industry leaders look to them to be the litmus test of quality when it comes to games, because they have assumed legitimacy through technical mastery in much the same way Kendall discovered.

This website focused on how hardcore gamers are the elite of the gaming community because their behavior ties them more closely to the development and production of games. As masters of technology, they are closer to the source of production than other gamers and certainly more influential to the production end of mass culture than older models of consumer/producer relationships would suggest.[1]

There are other ways to show technical mastery and assert "hardcoreness." People might be considered hardcore if they are so good at a game that they represent the elite of gaming. An example of this might be the person who can run through *Super Mario Bros.* in 5 minutes.[2] Or, players might prove their hardcoreness through longevity, claiming to have played since the Atari or NES era, showing they're not upstarts. Or they prove hardcoreness by knowing the lore, exhibiting proficiency in gaming history. This could be exemplified by gaming trivia quizzes in the back of *Game Informer* magazines that score you on your ability to know the minutiae of a game and rank you accordingly. All of these might be acceptable qualities of a hardcore gamer, and they all seem to rely on the ideal of technical mastery

(Ninj3w, 2008). Of interest here is that in the first web definition, technical mastery was being equated with a certain demographic: young males with disposable income and time. What of the above behavior makes this a specifically young male characteristic? Yet journalists and industry insiders unconsciously make the connection. A recent study showed that female gamers spend more time on some MMORPGs, which perhaps suggests they're more hardcore than men, but commenters rejected this idea, posting that being hardcore meant more than just putting in the time, and thus disavowing women gamers as hardcore (Mick, 2009).

This disavowal of women's "accomplishments" in technology is nothing new. The history of technology, as has been noticed by many feminist scholars, is one populated by white, middle-class men. They are the makers of technology, while women and people of color have technology done to them (restrictive reproductive technology, and so forth). Yet this history is largely a myth. Michelle Wright (2002) illustrates the ways in which histories of technology follow assumptions laid out by Western epistemologies. They follow a progress narrative in which white, European males are the privileged inheritors of cultural superiority. She writes: "Technology is deployed as the latest chapter of evidence for Western superiority. Yet, it is a specific representation of technology as white, male and Western that is championed and accompanied by a truncated history that grossly distorts the facts" (p. 49). To keep this narrative intact, much of the work done by females and people of color has to be ignored or erased from history. Further, when critics attempt to reacknowledge the work of people of color or women in these narratives of progress, the backlash is often great. This should not be surprising, considering the amount of power and legitimacy that is leveraged for one group at the expense of others by maintaining narratives of technological haves and have-nots (or dos and do-nots). However, by keeping these narratives intact, women and people of color are still seen as illegitimate producers and users of technology. Only by acknowledging the constructed nature of narratives of technology can we begin to take a step forward. Wright writes: "The information and communications revolution was not invented in a garage by two teenage boys, it came out of long and arduous advancements in metallurgy, mass production, an overwhelming accumulation of capital and, of course, slave labor" (p. 57). Rather than the work of some lone, white, male genius, the history of computing technology is deeply embedded in questions of power and access to resources.

While I am not saying that women playing games longer than men is some great achievement, it does suggest a presence within the video game community that should be acknowledged but in fact is disavowed through comments suggesting that time spent on a game does not prove that you belong. Disavowing women's participation as legitimate members of a video gaming community is possible when we assume hardcore players are men and that hardcore gamers are the normative members of the community.

To explain the process of legitimization through normativity more fully, I use Lisa Nakamura's theory (2002) of cybertypes to explore how some identity possibilities become more normative than others in the gaming world. I suggest that the figure of the hardcore gamer functions as a sort of cybertype. What is a cybertype? Nakamura writes:

> I coined the term cybertype to describe the distinctive ways that the Internet propagates, disseminates, and commodifies images of race and racism.... [C]ybertyping is the process by which computer/human interfaces, the dynamics and economics of access, and the means by which users are able to express themselves online interacts with the "cultural layer" or ideologies regarding race that they bring with them into cyberspace. (p. 3)

I take Nakamura to mean that the process of cybertyping occurs when people take the elements of identity they are familiar with from "reality" and retransmit, refigure, or reimagine those identities through the medium of technology. Our identities become retyped or recoded through our relationship with technology, not where we are totally free to configure whatever we want, but where we recreate old patterns of dominance and subordination.

For example, in Nakamura's examination of the cybertype, we imagine most bodies on the Internet to be white, because cybertyping normalizes the Internet as a white space. However, when bodies of color do appear (such as pictures of people on a web page), they exhibit characteristics or mannerisms that mark them as culturally other. Someone of indigenous origin, then, would perhaps be marked with stereotypical conventions of the "native" without any reference to a "real" body living in the present tense with real life concerns. This is how difference is celebrated on the Internet, a sort of imperialist nostalgia, in the words of Renato Rosaldo (1993). The virtual figure of the native or similar marked other is stripped of all history or contextual relevance to become a signifier representing inclusion/harmony, or simply to add background window dressing in the virtual fantasy/tourism of the white Internet user. If the concerns of or other reference to a real body

are made, that body is accused of not playing by the rules, being considered a whiner, or otherwise made to feel excluded or ignored. This is because these real bodies shatter the illusion of harmony that this culture tries to inculcate and gives the lie to the fact that difference isn't a problem in cyberspace.

Like Nakamura, who shows that racialized bodies help to maintain the normative, white, center that usually remains unmarked, the casual/hardcore divide is about delimiting who belongs and who does not without any named reference to identity markers in the discourse—stealth racism or stealth sexism in this case. The figure of the hardcore gamer is about defining the center in idealized form, using markers of masculinity while rarely naming gender as a feature of normativity. Meanwhile, the casual gamer also helps to establish what is normative, by showing what it is not. We cannot understand so clearly what hardcore means unless we know what it is not: the casual gamer.

I suggest that the power and privilege attendant with inhabiting a masculine gaming identity remains elusive and unmarked for most gamers. What I mean by this is that normative cybertypes like the hardcore and casual gamers obscure the devaluation of female gamers in game culture because gender as a marker of difference doesn't have to be evoked. Meanwhile, male gamers have access to discourse that reinforces their legitimacy as gamers.

What do I mean by legitimacy and gaming? Here is an example. G4 is a tech and gaming brand that hosts a cable station and website. It has several programs designed to serve the gaming community. One of its shows, *XPlay,* features co-host Morgan Webb, who is constantly asked if she actually plays games by her fans in interviews about her work. Her co-host, Adam Sessler, has never been asked this question as far as I know. Because Webb doesn't fit the normative ideal of the gamer, she constantly has to avow and reaffirm her status as a gamer. This occurs because while cybertyping creates legitimacy for some gamers—the hardcore gamers—Webb doesn't fit that cybertype. Because of this, she is not and never will be normative. Since there are set definitions of what constitutes a "true" gamer, the hardcore player, and because these definitions are inherently set up to exclude women and non-normative men, Webb as female co-host of a gaming show has to constantly reaffirm her status as a "true" gamer. This is done in interesting ways. For example, whenever a sports game or other game typically catering to a male audience is reviewed on the show, Webb is the one to give the review, helping to unconsciously support the idea that she plays games just like the men.

For Webb, we can clearly see how a gender-reinforced pattern of gamer identity can and does have negative consequences to her livelihood. As she performs in certain ways in order to maintain credibility for herself and the corporate entity she represents, it is easy to see how restricted her choices may become. Of course, this is not especially different from other areas of society. We are all daily asked to perform in certain ways that restrict the totally free expression of self. But what is troubling in gaming culture is how easy it is to see how legitimacy, and therefore power, are withheld from certain segments of the gaming population unless they overachieve to prove their credentials. That these categories of hardcore/casual are so sharply demarcated by gendered tropes again seems suspiciously like a reinforcement of traditional modes of domination through difference. That this is a culture meant for the entertainment of its members should not mean that the inequality within the culture shouldn't matter or that it is not important. On the contrary, as seen by how strongly argued and defended definitions of hardcore and casual gamers are by members of the community, we need to realize how serious this business of fun really is.

Though the focus so far has been to show how the definition of hardcore's reliance on technical mastery denies legitimacy to women and other gamers, the games people play also determine if they should be considered hardcore or not. If you play hardcore games, then you are a hardcore player.

But what are hardcore games? For most, the definition of what is a hardcore game relies on the genre and sometimes style of the game. Genre in video games reflects the type of play experience one might have with the game: shooters; action/adventure; role-playing games, and so forth. Shooters and MMORPGs are, not surprisingly, considered hardcore genres because of the skill or amount of time invested in the game (Vanya, n.d.)

The style of game is different from the genre, because style is referencing production qualities such as art direction. For example, a shooter could be hyper-realistic and violent, so the style would be considered more hardcore, like *Gears of War*. But within the genre you could also have a shooter that had a cutesier, artistic style, like *The Flying Hamster*.

Of course, not all games are considered hardcore. For example, is the Nintendo title *Animal Crossing* a hardcore game? This is most definitely not considered hardcore.[3] No, hardcore games exhibit certain features that the above game does not possess. Some elements of hardcore games might include: mature content, hyperrealism or superior visual effects, extremely violent content that may be really bloody, and definitely "macho" sensibilities

(and, because of the superior visual effects as well as other factors, high production costs). Like the definition of a hardcore gamer, a hardcore game is also hard to define, possibly because the answer is so obvious. Most shooter games are considered hardcore, but then definitions get a bit murkier. Games such as *Mass Effect, Call of Duty,* or *Fallout* exhibit many of the qualities cited above that have hardcore sensibilities.While I wouldn't consider the franchise *Halo* hyper-realistic, because you're fighting against a hypothetical alien race, it is a graphically sophisticated FPS, and your goal in the game is to kill others with efficiency and panache, and that labels it a hardcore game.[4] So the gamer playing it is hardcore. Since I don't really play these games, that must mean I'm not hardcore.[5]

The style of a game may also determine whether a game is hardcore or not, using gendered stereotypes. As noted above, many wouldn't classify *Animal Crossing* as a hardcore game, even if the gameplay one exhibited toward the game were hardcore. By gameplay, I refer to the process of playing a game, or—in other words—what you are doing in the game. It is not just the quality of the game that's at issue here, because both the *Halo* and *Animal Crossing* franchises are regarded as "good" in some way. Rather, the trappings of the game, the look, the gameplay, the ideals and objectives of *Animal Crossing*, do not fit the established patternsof hardcore. And part of the reason why this game does not conform is because it does not have the trappings of masculinity in its style.

To elaborate further, we might make a comparison between two games on opposite ends of the hardcore spectrum: *Animal Crossing*, already mentioned; and *Grand Theft Auto*, a highly successful franchise that many in the gaming world consider hardcore. I chose these games for their longevity and appeal, since both franchises have been around for a while and have good sales records. But I also think that while they are categorized differently (genre and style), they have many similarities in gameplay potential.

Animal Crossing, originally developed and published in Japan by Nintendo in 2001, has had remarkable success in the United States. Since its first appearance, the franchise has expanded to include a DS[6] game and a second console game for the Wii, as well as a fourth game in development as of this writing. The game starts by giving players the ability to play as a boy or a girl who is moving to a new town inhabited by talking animals. Once there, the player buys a house and pays for it by getting a job with the local retailer Tom Nook, a raccoon with an eye for business. Players can also do jobs around the town for their neighbors or collect fruit, fish, insects, fossils, and

other things to sell to earn bells, the local unit of monetary value. Players also spend their time buying things to decorate their house with; designing clothing to wear or give as gifts; interacting with neighbors by writing letters and giving them presents; and participating in town activities such as trick-or-treating during Halloween (the game takes place in real time and gameplay changes with the seasons).

In comparison, the *Grand Theft Auto* franchise, developed and published in 1997 by Rockstar Games, has expanded to 10 stand-alone games and 4 expansion packs. It has a different feel than *Animal Crossing*. In general, a player is invited to play as a lowly criminal moving up the ranks of organized crime. In one of the franchise's more successful games, *GTA: Vice City*, that means playing as Tommy Vercetti in a world modeled after Miami in the movie *Scarface*. To succeed in the criminal underworld, Vercetti must complete objectives that help to establish him as ruler of a cocaine empire, usually along the lines of killing rivals with various melee weapons and guns, all while evading capture by the police. Players also have the ability to interact in a variety of ways with the world of Vice City outside the main storyline: stealing cars and motorcycles to make jumps or tricks or just drive around the city; collecting packages to unlock secret weapons or vehicles; or mowing down innocent bystanders within the city just to create a sense of mayhem and chaos within the world. As the franchise has developed, other ways of expanding one's gaming experience have emerged, including avatar customization.

From a design standpoint, these games are very similar to one another. *GTA* is considered a sandbox game, meaning that while there are concrete objectives in the game, players are free to ignore those objectives and interact with the landscapes in the game to an unprecedented degree. The worlds are open-ended and interactive, and one could suggest that an "ending" to the game is up to the player. *Animal Crossing* has been called a "communication game" by Nintendo. Much like *GTA*, the game has objectives that a player must achieve, but the player is free to choose when and how to achieve those objectives. The real key to the game is interacting with the characters and environments in the game. So, like *GTA, Animal Crossing* thrives because of its open-ended gameplay (cf. Schneider, 2002; Perry, 2002).

But, as illustrated above, the style—and therefore the status—of each game as hardcore are very different. The overarching words one might use to describe *Animal Crossing* would be "cute," "cartoony," or "playful." The animals in the game are unrealistic and adorable, using a gibberish language

that further reinforces the idea that this world is one of make-believe. *GTA*, on the other hand, strives for graphic realism, ultra-violence, and sexual suggestiveness.[7] The characters in the game engage in violent behavior, foul language, and criminal activities. These are the very characteristics that make it hardcore.

The difference in how these games are perceived would be fine if value weren't being placed on certain games for their hardcore appeal and, by extension, the players who play the games, as will be seen when we look at the opposite of the hardcore player or hardcore game: the casual gamer or casual game.

In order to belong, there have to be people who don't belong—the casual, regular, or average gamers, who are misfits. What is worrisome is how easily dismissed casual gamers are, especially since most casual gamers demographically are women. In a study on social, or "casual" games, 55% of gamers were women of an average age of 43. These types of games tend to be on social networking sites, such as *Farmville* on Facebook (Ingram, 2010). So, when women gamers are referenced, the attitude is that if women are playing games, they're playing the games that aren't really "real" games. Then, women gamers who do play "macho" games have a harder time "proving" their hardcore status, because they are associated with this more casual player.

The complicated nature of the hardcore/casual dichotomy is demonstrated by another website. On the G4 website, poster John Manalang (2007) started a discussion on the meaning of hardcore after playing *Wii Sports* at a gaming party. This article, and the posts it generated, demonstrated that the definition of hardcore is almost always personal. It seemed that people almost always defined hardcore in relation to themselves. For what purpose? In describing hardcore, Manalang proved his own hardcoreness in order to create a sense of legitimacy. He listed trying to perfect a certain combo in a game, beating certain titles, calling in sick to a job to play a game, lying to significant others about time spent playing a game, all as behavior related to hardcore. Then he writes: "…does that sound hardcore enough?" (Manalang, 2007). And what did I do when I first tried to explain the definition of hardcore? I started with an example of my gaming habits. It seems here that it's about proving to ourselves and to others in the community that we belong. An abstract definition isn't enough. It's the relationship between definition and gamers that allows them to define themselves in relation to the community. It is not just about bragging rights. It is about constituting identity.

I have often wondered if I am hardcore or hardcore enough. When it comes to games, I have enjoyed them all my life—sometimes, it seems, a bit too much. But what can I reference as hardcore? I've certainly invested time in certain games. For example, I think my record was 16 hours in a day playing *Animal Crossing* during a particularly sad moment in my life. But, as noted above, this isn't a hardcore game. More recently, I replayed *Fire Emblem: Path of Radiance* over 15 times to get the bonus player of Ashnard for my game, investing hundreds of hours into the game in the process. Is that hardcore, or just dorky?

I also believe I have some skills with certain games, although I generally tend to like easier games. But I think I'm pretty good at certain genres. As for out of the ordinary, I've completed a no-death run on *Pikmin 2* (much easier than in *Pikmin 1*), which involves finishing the game without losing a single life, which takes considerable time and skill. But I couldn't go head to head with online players in any game, though I've tried with *Dr. Mario Rx* and *Super Smash Brothers Brawl.* I also participate in out-of-game community participation, like surfing the Internet looking for gaming news, and reading and participating in online forums.

Yet I still feel uncomfortable with labeling myself a hardcore player, because the stereotypical definition of hardcore player—that 18–34 white male who plays bloody FPS—is decidedly not me. In ways that may not be totally conscious, the gaming community makes it very difficult for some players to belong in the community because of the games they're playing. What makes this even more difficult is that my gender stereotypically relegates me to the antithesis of the hardcore gamer—the casual gamer.

I'm not trying to suggest some essentialist notion that boys/men act one way and that girls/women act another way, because clearly men and women exhibit a range of gaming behavior. Rather, I'm suggesting that gendered expectations embedded in the culture shape the way that we perceive appropriate behavior from men and women. And in the world of video game culture, the very definition of hardcore, the valued gamer, the elite that the industry looks to for trends, relies on stereotypical masculine behavior and tropes such as ultra-competitive gameplay that exhibits technical mastery or a conquering mentality (Martin, 2008). As for female gamers, it may be easier to assume that they are not serious gamers, but the casual gamer, in other words.

The antagonism between hardcore and casual gamers has come to matter even more as game producers realize the potential cash cows they have in the

casual gaming market. Previously, the largest home of casual games was the PC, where users could engage in a quick game of *Solitaire* or *Minesweeper* as desktop applications or go online to casual gaming portals like Pogo and play flash games or other easily downloadable applications from the Internet. Consoles, as far as the industry defined it, didn't really figure into the casual gaming demographic. The current generation of consoles, however, is changing. One could argue that beginning with *Guitar Hero* for the Sony PlayStation 2 from the last generation, game developers have had casual gamers set in their sights. As a rhythm game with a guitar-like controller and an intuitive feel, *Guitar Hero* represented one push toward catering to a casual market.[8] The Nintendo Wii, an entire console arguably organized around the casual market, represented another great push. Even the Xbox 360 and PlayStation 3, considered bleeding-edge technology marketed toward the hardcore crowd, gestured to the casual market with their online marketplaces that carry affordable and easy-to-learn games for the casual crowd and new, motion-controlled games jumping on the Wii Remote bandwagon. Clearly, then, casual games and gamers are seen as increasingly important to the industry, but the definition of who constitutes the casual gamer remains murky.

Complicating this is that a casual gamer and casual games don't always equate. Is a casual gamer just someone who plays casual games? Or is casual gaming a state of mind? A casual game could be defined as any game that is easy to learn and doesn't require much investment in time or money by the gamer. While I'm maybe not a hardcore gamer, I'm definitely more than a casual gamer. However, I play games labeled as casual, and I'm sure there are many hardcore players who do that as well. And someone who only plays games labeled as casual may play those games obsessively, to a point where the behavior becomes hardcore. For example, if FPSs are considered hardcore, one of the reasons they are called so is because they represent twitch gameplay, or games that rely heavily on precision and reaction time, increasing the game difficulty. If players achieve a certain prowess in a game so hard, their skills can be used as bragging rights. However, puzzle games such as *Tetris*, which are targeted toward the casual market and are pick-up-and-play-type games, can also showcase twitch gameplay at later levels, when blocks fall quite fast, and the adept player needs great reaction time and coordination to succeed. Is that casual player obsessed with *Tetris* now hardcore?

I would suggest that casual gamers employ a different relationship to games and the gaming community than hardcore gamers, which makes them

casual players. Some characteristics we might consider casual would be a more tenuous relationship to the community of gamers on the Internet or locally. (Though they may see their use of the game as a way to socialize with friends on social networking sites, they might consider this time spent socializing rather than gaming.) They might also have a different relationship to more formal channels in the game industry: for example, not surfing websites or subscribing to print magazines about gaming, or not keeping up with industry news. They might also pick-up games based on their own opinions or the opinions of friends rather than from gaming reviews, which causes some hardcore gamers to rant about the uninformed minds of casual gamers.

Of critical importance is that, just like the definition of hardcore, definitions of casual gamers are relational to those being described and those doing the describing. I've mentioned that one way to classify casual games is to imagine them on PCs, small flash games that can be added to a computer with little time or effort. To the gamer playing on a dedicated home console, those PC gamers are casual. But, for someone who spends thousands of dollars crafting, customizing, and upgrading a PC to make a game perform at the very highest graphic capabilities with no lag time, then playing on a home gaming console is seen as casual to the PC gamer. What matters is that the casual gamer, compared to the hardcore gamer, is less dedicated to spending time or money, or less skillful than the hardcore gamer, or "true gamer." The casual gamer also plays certain games that are seen as "less worthy" than hardcore games, such as pick-up-and-play sports, or racing games, or cooking simulations. But, like the definition of hardcore gamer, the definition of casual gamer is in the eye of the beholder. For example, The Urban Dictionary has several definitions of what constitutes the casual gamer. Definition 1.5 of "casual gamer" states:

> Hardcore gamers have a generally negative, and often derogatory view of casual gamers, looked upon as the plague of the video game industry. While hardcore gamers are in the minority of gamers they provide an invaluable resource to developers on both the hardware and software end. Without the hardcore gamers' passion and dedication to the art, we would not have the quality games that are available today.
>
> Since the purchase power of the casual gamer determines what becomes a best seller, it is understandable why the hardcore gamer has such contempt for the group. (Saga Slayer, 2005)

This definition employs a relational definition of casual gamers, putting them in a clearly inferior category in relation to the hardcore gamer, which the writer of the definitions assumes him or herself to be. This enables those who can claim a hardcore status access to power and privilege within the gaming community.

But though we might suggest that casual gamers spend less money or time on video games than hardcore gamers, it doesn't account for the aggression shown toward casual gamers in the above definition. The author of this definition seems to feel that because of their mass numbers, casual gamers get more games made and marketed to them. Perhaps this is the reason why there is so much antipathy toward casual gamers from hardcore gamers? Internet trolls policing the boundaries of gaming culture feel that casual gaming is going to bring down the industry as they know it, and they are mad about it.[9] Another contributor to the definition on Urban Dictionary demonstrates this point with his/her definition of a casual gamer:

> Gamers that will eventually bring the downfall to the gaming industry if us true gamers don't do something about it. I hope casual gamers aren't let into Heaven, for their ignorance and obliviousness will be the downfall of my afterlife as well!

While that definition may seem exaggerated, it does echo a lot of the sentiment found on the Internet about casual gamers, which is that because they don't read reviews, they play games that aren't "good," flooding the market with "crappy" games (called shovel ware because it's forced on consumers) at the expense of quality games that hardcore gamers enjoy (Orland, 2007).

Looking at these definitions, one thing does seem clear. It doesn't really matter what constitutes the casual gamer. The casual gamer functions as a type of straw man, used to shore up the identity of the hardcore gamer by elucidating what it is not. In the process, a lot of ill will is generated toward the casual gamer.

A further troubling aspect of these definitions of the casual gamer can be seen when we go back to the discussion of the relationship between hardcore/casual gamers and gender. What we have seen above is that the casual gamer, now othered by the hardcore gamer, has less credibility or legitimacy as a gamer than the hardcore, or "true," gamer. This discourse of legitimacy is explicitly connected to gender because the game players most valued in the culture are the stereotypically male hardcore players, In contrast, tropes of femininity are devalued in the game world, as when games seen as more

"girly" are called bad or less serious. But, as noted before, because the demographics of casual gamers show a majority of women over 30, when hardcore gamers abuse casual gamers by saying they will bring the industry down, they are in fact referring to real female bodies, even if their intention is not to degrade anyone personally. While game developers want casual gamers around, they're about the only ones, it seems. As mentioned above, the enormous outcry from the "true" gamers out there is that these casual gamers, these women, are bringing down the industry. So, not only are they illegitimate, but they're dangerous!

Notes

1 Henry Jenkins terms this convergence culture, in which fans of popular culture have more influence on the products they consume, becoming active rather than passive and potentially having greater power within mass culture. See Jenkins (2006).

2 See nintendogsg (2007).

3 This can be evidenced by the fact that when Nintendo suggested it was a hardcore game for the fans at its 2008 E3 press conference, most fans weren't buying it. See Plunkett (2008).

4 Some hardcore gamers think the game is too popular and argue that the mechanics of the game have been dumbed down to make it more accessible. So, to those gamers, the Halo franchise is not hardcore but mainstream, which still illustrates the point of this paper that hardcore is a term meant to differentiate between the common and the elite.

5 In fact, even women who do play FPS games often have to prove that they're real gamers, which again goes to the idea of their legitimacy being called into question. For example, in tournaments that feature all-women teams, oftentimes these women are accused of being successful because they wear cute outfits rather than display skill. See urrutiap (2008).

6 DS is the hand-held gaming system developed by Nintendo.

7 As evidenced by the Hot Coffee Incident in GTA: San Andreas, where players, hacking into the code, could engage in sexual simulations on screen. See Bangeman (2005).

8 However, the reality is that the game does have a learning curve, and not everyone finds the controls so easy. Also, the Expert levels are insanely difficult, making it appealing to someone wishing to achieve. So, you can take this casual game to hardcore levels.

9 They may be right. Ubisoft has announced that it is going to stop making games for the hardcore market, since it is too narrow a market and instead create games for a mass audience. Goodbye Far Cry, and hello Rayman and Bunnies! See Loftus (2008).

Works Cited

Bangeman, E. (2005). Rockstar breaks silence on "Hot Coffee" GTA: San Andreas mod. *Ars-Technica*. Retrieved from http://arstechnica.com/news.ars/post/20050713-5088.html

Ingram, M. (2010, February 17). Average social gamer is a 43-year-old woman. *GigaOM*. Retrieved from http://gigaom.com/2010/02/17/average-social-gamer-is-a-43-year-old-woman/

Jenkins, H. (2006). *Convergence culture: Where old and new media collide*. New York: New York University Press.

Kendall, L. (2002). *Hanging out in the virtual pub: Masculinities and relationships online*. Berkeley: University of California Press.

Loftus, J. (2008, March 17). Ubisoft says there's no money in hardcore FPS games. *GamePro*. Retrieved from http://www.gamepro.com/article/news/169368/ubisoft-says-theres-no-money-in-hardcore-fps-games/

Manalang, J. (2007, August 20). The definition of hardcore gaming. *G4*. Retrieved from http://www.g4tv.com/thefeed/blog/post/688753/The_Definition_Of_Hardcore_Gaming.html

Martin, J. (2008, May 27). Study: Male gamers have need to conquer. *BitGamer*. Retrieved from http://www.bit-tech.net/news/gaming/2008/05/27/study-male-gamers-have-need-to-conquer/1

MegaGames. (2007) Who is a hardcore gamer? Retrieved from http://www.megagames.com/hardcoregamer.html

Mick, J. (2009, December 28). Study: Male gamers not as hardcore as female gamers. *Daily Tech*. Retrieved fromhttp://www.dailytech.com/Study+Male+Gamers+Not+as+Hardcore+as+Female+Gamers/article17233.htm

Nakamura, L. (2002). *Cybertypes: Race, ethnicity, and identity on the Internet*. New York: Routledge.

Ninj3w. (2008, December 22). Hardcore gamer.*Urban Dictionary*. Retrieved from http://www.urbandictionary.com/define.php?term=hardcore%20gamer

Nintendogsg. (2007, January 3). How to beat Super Mario Bros [Video File]. Retrieved from http://www.youtube.com/watch?v=9yl_XPkcTl4&feature=related

Orland, K. (2007, December 6). Casual games get bad reviews, no one cares. *Joystiq*. Retrieved from http://www.joystiq.com/2007/12/06/casual-games-get-bad-reviews-no-one-cares/

Perry, D. (2002, October 28). Grand theft auto: Vice City review. *IGN*. Retrieved from http://ps2.ign.com/articles/375/375564p1.html

Plunkett, L. (2008, July 22). Iwata so very very sorry for Nintendo's E3 presser. *KOTAKU*. Retrieved from http://kotaku.com/5027984/iwata-so-very-very-sorry-for-nintendos-e3-presser

Rosaldo, R. (1993). *Culture & truth: The remaking of social analysis*. Boston, MA: Beacon Press.

Saga Slayer. (2005, July 22). Casual gamer. *Urban Dictionary*. Retrieved from http://www.urbandictionary.com/define.php?term=Casual%20Gamer

Schiesel, S. (2006, November, 24). Getting everybody back in the game. *The New York Times*. Retrieved from http://www.nytimes.com/2006/11/24/arts/24wii.html?ex=1322024400&en=0c9d6676f087a4c8&ei=5090&partner=rssuserland&emc=rss

Schneider, P. (2002, September 5). *Animal Crossing* review. *IGN*. Retrieved from http://cube.ign.com/articles/370/370203p1.html

Urrutiap. (2008, October 11). Professional game girl teams are posers and fakes. *Hot Gamer Girl Forum*. Message posted to http://www.hotgamergirls.com/phpbb3/viewtopic.php ?f=1&t=1228

Vanya. (n.d.). Hardcore gamers and serious games. *Split/Screen Co-op*. Retrieved from http://splitscreencoop.com/2011/01/13/hardcore-gamers-serious-games/

Wright, M.M. (2002). Racism, technology and the limits of Western technology. In M. Fernandez, F. Wilding, & M.M. Wright (Eds.), *Domain errors! Cyberfeminist practices* (pp. 45–62). New York: Autonomedia.

Chapter 8

Women's (Dis)embodied Engagement with Male-Dominated Online Communities

Jessica L. Beyer

Introduction

Studies show that the gender gap in Internet use has been narrowing (Fallows, 2005). Women have increasingly entered into highly populated social spaces online, many of which are anonymous or semi-anonymous (e.g., people use aliases or avatars), which means they have been integrating these male-dominated spaces. For example, many of the 10 most-frequented "posting boards and forums"[1]—each with millions of posts—are male-dominated, anonymous forums in which users choose their names and interact (Beyer, 2011).[2]

Among the online spaces seeing increasing numbers of women participants are the popular online game genre Massive Multi-Player Online Role Playing Games (MMORPGs). While women have always played these games, their numbers have been dwarfed by the number of male players. In November 2008, *World of Warcraft* (*WoW*) had 11.5 million subscribers, making it the largest MMORPG ever by several scales of size and causing it to eclipse all other MMORPGs in terms of number of players. In 2005, Nick Yee found that around 84% of *WoW* players were male, while around 16 percent were female. While the precise number of female *WoW* players is unknown, the overall number of women gamers has increased to about 40% of all gamers (Entertainment Software Association, n.d.).Therefore, it is likely that the number of women playing *WoW* has also increased since 2005.

Yee (2008) and Jenson and de Castell (2007) have found that although women players have the same types of in-game motivations as male players, they are underrepresented in the "hardcore" universe of players who pursue group achievements at the maximum character level in *WoW* (currently level 85). My analysis expands upon Yee's observation that female players "are constantly reminded of the intended male subject position they are trespassing upon" (2008, p. 93). My argument in this chapter is that the *WoW* in-

game environment is a substantial barrier to women's full participation in the game's potential. In particular, the re-embodiment of women in the disembodied space, the use and acceptance of language in *WoW* that reinforces the subordinate status of women in the game, and the beliefs that control women's equal access to what is valued in the game make participation in *WoW* more difficult for women than for men. Additionally, women who are tired of navigating the language and values of the male-dominated environment often enter "safe" social groups, usually guilds. Once in these "bubbles" of shared values, players opt out of experiences with people they do not know, leaving common areas to those who propagate the dominant culture.

World of Warcraft

WoW is an MMORPG created by Blizzard Entertainment. An MMORPG is a type of video game played on a computer in which a large number of players interact in real, synchronous time within a virtual world. In an MMORPG, each player controls a fictional character with a set of powers and abilities. The MMORPG world is "persistent"—constantly changing outside of the control of any single individual. In other words, the in-game world is changing even when an individual does not have the game on and is not playing— sometimes because of the actions of other players and sometimes because of the program itself.

Within *WoW*, players navigate a fantasy landscape to fight game-generated monsters, work collectively to kill powerful game-generated opponents, and fight the characters of other players in duel-like battles in which one player is "killed." Interactions in the game are structured by game-generated lore and tasks drawn from common, mostly Western, mythologies and fantasy tropes involving familiar creatures such as dwarves, elves, and orcs. Players move across a map made of different lands, cities, and open areas. Interaction with this landscape is similar to the way in which people interact with actual geographic space, with travel time being shorter or longer based on distances on the map and the safety and ease of travel depending on the route players choose to take.

Much of the game requires cooperative work between individuals. The game architecture has two temporary mechanisms to tackle cooperative tasks, "parties" of up to five people or "raid groups" of up to 40 people. There is also one more permanent mechanism to facilitate group play: guilds, which are institutionalized groups with names and rules. Finally, while play-

ers largely interact in text, many players also use voice software programs such as Ventrilo (Vent) to interact.

Methodology

I investigated the question of gender dynamics online by using participant-observer research methods, textual analysis, and process tracing. I participated in this community fully, both in-game, on the official *WoW* forums, and on non-affiliated forums and blogs.

I chose *WoW* as a case because it is one of the most popular MMORPGs, and its size serves as a proxy for significance. However, my observations and arguments about *WoW* could be extended to any of the male-dominated, anonymized online social spaces I study, with slight modifications based on the architecture of other spaces.

Observation occurred from September 2008 to July 2010. Field notes were kept in notebooks and also using Zotero, but I only screen-captured uploaded content meant for public consumption. Additionally, anything that I did not observe firsthand was constructed using blogs/news reports of behaviors, published interviews, and other archived community documents. All of this material was publicly available.

Because I am arguing about a dominant culture that is being reified across online forums, I also triangulated across online resources. An analogous methodology would be how researchers gain an understanding of what is happening in warzones where violence prevents civilians from entering into a space and recording what is happening. In such situations, researchers randomly sample many individuals and see if their experiences match.

In the anonymous world of the Internet it is impossible to know who is on the other side of the text. In this case, I relied on posters to reveal their own gender identifications. Additionally, while I accept the role of intersectionality, I did not investigate the complex navigation of transsexual players in these spaces, nor did I examine the experiences of other minority group members. However, while it is not included in this chapter, I also found substantial evidence that the dominant culture in these spaces marginalizes these groups as well.

Finally, because it is important to protect the online reputations of players, quotations have been slightly modified to prevent Googlesearches, and all names of players, guilds, or realms have been aliased. Initially, I retained dates attached to the quotations; however, date stamps could allow people to

find the poster, so I have removed these as well. I retained as much of the original language as I could, which means that there is sometimes offensive terminology and references to rape.

Disembodied Spaces

Initially, many people viewed the Internet as a potentially "perfect" public sphere. In this space, stripped of the physicalities and socio-economic tags that divide us, pundits argued that people would be able to debate and change society (Rheingold, 2000). For example, Rheingold mentions a time when he was invited to join a panel advising Congress about communication technology. Before he attended his first meeting, he was able to draw on the expertise and opinions of the people in his online community—gathering information much more quickly than he would have been able to in any other way (Rheingold, 2000). In such a conception, "cyberspace" is gender neutral (Rheingold, 2000, p. 11). However, as a multiplicity of studies examining everything from news consumption patterns to the digital divide to gendered use of technology have shown, "cyberspace" is embedded in the political, economic, and social realities of "RL" (real life) (e.g., Fallows, 2005; Pew Research Center for the People & the Press, 2008).

Further, even though online spaces are "disembodied" in that the person behind the keyboard is effectively masked, upon arrival into online spaces, people are given rhetorical bodies. Even in the case of MMORPGs where people choose their appearances in the space, there is one assumed, neutral form—a youngwhiteheterosexualmale. With that neutral form comes a set of expectations about orientation, beliefs, and taste. Additionally, the anonymous nature of many online spaces frees people from societal norms, so they are able to say whatever they would like about different social groups. In the safety of anonymity, speakers do not fear reprisals for expressing their views of women, and, when making misogynist statements, often can expect support.

Thus, contrary to being a utopic, post-body space, a ghost body is attached to every player, and it has a specific form. For example, women report across forums that people assume they are men. Therefore, when an individual who is not young, male, white, and heterosexual operates in the space, she must choose whether to reveal her deviation from the neutral. When a woman (or any other "deviant") chooses to reveal herself as different from the neutral, she knows—or soon finds out—that to reveal means to be

treated differently. The experience of deviation from the neutral is both an experience in the online space and the offline. Even in the case in which the female player decides *not* to disclose her status as other, avoiding invoking the host of preconceptions about her motivations, abilities, and intentions that come with such disclosure, she will still experience derogatory conversations about women. As Dibbell (1999) shows in his "Rape in Cyberspace" story in *My Tiny Life,* even these textual experiences can traumatize and emotionally scar online community participants, creating real consequences.

Further, while the *WoW* spaces themselves are cross-national, women become a shared symbol for *WoW* players. Haraway's warnings (1991, p. 173) about the imperialism of a common language are apt, and, as she warned, theorists must avoid using totalizing language that groups all women and their experiences into a single group. However, the dominant group in online spaces creates one rhetorical "woman" who is always considered in relation to the group itself. The idea of "woman" can be considered a "boundary object"—which is an object that has a local meaning but also has meaning across many communities (Star & Griesemer, 1989, p. 387). Thus, in spite of the national differences in the Western groups that populate anonymous, English-speaking online spaces such as *WoW*, the concept of woman is homogenized—or already shares enough commonality to retain "its integrity across time, space, and local contingencies" (Star & Griesemer, 1989, p. 387). Therefore, *WoW* players may inhabit many social, legal, and political contexts, but in the intersection between them, common beliefs and language become dominant. In *WoW*, "woman" becomes temptress, sexual object, weak, and sensitive. Furthermore, women players are continuously reminded of this status by—to directly quote from the forums—being "raped by the cock of logic" in debates about the issue.

Women report common experiences while playing the game, usually reporting them in "women"-based online spaces such as women-authored blogs or in response to Blizzard policies.[3] The experiences reported by women playing *WoW* are mirrored by women's experiences in other online spaces. Furthermore, women's reactions to common experiences are not the same. Even though all women report common experiences, some women read these interactive moments as sexism and some women do not. In other words, the experiences are similar, but the interpretation of the experiences is not the same.

Regarding being re-embodied in a disembodied space, women widely report a fixation on their physical appearance in *WoW*. In a post protesting

Blizzard's change to using legal names on the forums that was widely cited
across blogs and other discussion forums, a poster discussed (among other
things) the experience of women in online spaces. The post was widely cited
because many people believed that the poster expressed their own expe-
riences:

> Constant requests...asking for pictures....If you do post a picture (I never did)
> people either go nuts over how hot you are and won't leave you alone—and the
> guys...treat you in a condescending way because hot=stupid; having to hear that shit
> addressed to other girls on Vent was really infuriating and uncomfortable—OR they
> make a point of constantly telling you how ugly you are....There is no middle
> ground. They either want to fuck you or deride you. And it actually doesn't matter
> how hot or how ugly you are, either; the hottest girls will get called ugly (and FAT,
> ALWAYS FAT)....Any time the girl posts something thereafter, people will com-
> ment on her appearance, even though it has nothing to do with whatever is being
> discussed. If you don't post a picture they all sit around and speculate, and some
> people inevitably decide that you're not posting a picture because you're ugly, and
> therefore they don't like you.

Women frequently report that their online experiencesare wrapped up in
their offline physicality. Women who post are likely to get responses calling
for their pictures, as in "PIX PLS" ("Pictures Please"), which means that the
woman should post a photograph so her physical appearance can be eva-
luated; or "Tits or GTFO" ("Tits or Get The Fuck Out"), which means that
the woman should either post a photograph of her breasts or leave; or "PICS"
("Pictures"), which means that the woman should post a photograph. In a
survey of guild applications to raiding guilds, I found that, unlike men, women
who apply to guilds often receive comments requesting photos as a part of
their applications. Women who complain about this treatment are accused of
being ugly, fat, lesbians, or feminists. Women who express fear about being
stalked in-game also are subjected to the same harassment.

Tied to that assessment based on physicality, women are assumed to play
because of and through men. People assume both that female players are bad
at the game, and that because of that, women use their bodies to receive free
in-game items. In a widely cited YouTube video, the creator described player
stereotypes. Among them were the "flirt" and the "couple." The video crea-
tor states that the flirt is always a female. She tricks men in guilds into giving
her things and into helping her do things by flirting with them. Alternately,
the "couple" includes a female partner who is horrible at the game, but who
is included because she is attached to a good male player. The video was un-

iversally hailed as "so true." For example, one of the comments in response was "I hate when girls use their gender for attention, not saying that all or even a majority on *WoW* is, just most of the females I seem to meet...have this huge need for attention to get free items."

Players, both men and women, also argue that if women suffer from harassment for being female, it is the woman's fault for bringing negative attention to herself. For example, a female player said in response to a thread about being a woman in game:

> I talk in guild but people don't know or care if I'm a girl. I don't try to act like a guy, I just don't feel the need to talk about *Twilight*, my body, or giggle constantly.... I get sexist jokes, but they're just jokes.... In the end, most of the shit females get is brought on by themselves.

People state that it is because of the way women "talk" in game or that their need to mention that they are women brings the unwelcome attention on themselves. Some women express frustration at this, for example:

> It feels like if you are a girl you have to...hide your gender, or you'll be accused of "wanting attention.".I'm not going to draw attention to being a girl, but I'm not hiding it either. I'm really tired of having to consider everything I say...when I'm really just talking....And no, I don't expect to get special treatment for being a girl. Girls are not exactly rare on the Internet anymore. I expect to be treated just as any guy, but that also goes for being able to mention "my boyfriend" without being accused of attention whoring.

Women additionally report that most people assume they are playing with or because of a husband or boyfriend. While Yee's data (2008) about MMORPGs shows that the majority of women playing the game began playing because of a man in their lives, women often report that the men who introduced them to the game stopped playing, while they have not.

Women's experience of being re-embodied in the disembodied online space means that women are always engaging the space in relationship to an imposed ghost form. This is particularly the case for new female players who have not yet found enclaves of players who do not share the dominant value system.

Use of Language to Create Hostile Spaces

Bourdieu's (1985) concept of social spaces defines them as "fields," which are spaces formed by participants' "habitus," or bundles of rules, dominations, practices, beliefs, meanings, and behaviors. Bourdieu asserts that modern society is made up of multiple fields, many of which exist separate from wider social structures. Using Bourdieu's definition, we can consider *WoW* a social field. While the game architecture structures actors' behaviors, the bulk of the rules in the game are generated by the realm communities themselves (Beyer, 2011).

For Bourdieu, those in power within the field maintain their power through exercising "symbolic violence." Symbolic violence is the use of cultural beliefs to maintain social control, including practices such as naming, shaming, use of symbols, and asserting "tradition" steeped in values. Symbolic violence is exercised by those who have the power to "name"—i.e., proscribe and categorize.

In *WoW*, where the capacity for physical violence is nil—unless one considers Blizzard's ability to remove players from the game akin to the legitimate violence of the state—social control is exercised entirely through symbolic violence. Specifically, players shame and exclude other players based on their behavior, failure to live up to realm norms, and poor playing performance (Beyer, 2011). However, in the online world in general, and in *WoW* in particular, where all control is rhetorical, players are also clear about their places in the social hierarchy because of a culture in which misogynous, homophobic, and racist language is common and, in less regulated spaces, the norm (Beyer, 2011).

In the online space in which the neutral is male, power relationships and hierarchies are perpetuated with the use of language and exclusion. Examples of such language abound, but one representational example is the widespread use of the word "rape." For example, a guild name that nearly always makes it onto lists of "funniest guild names ever" is Sapped Girls Cant Say No. "Sapping" is a game ability in which a player incapacitates an enemy. The meaning of the name Sapped Girls Can't Say No is that an incapacitated woman is incapable of saying no to sex. The guild name is technically banned and removed when reported. However, as of November 2010, there are 40 guilds currently listed with this name and 185 arena teams in the American/Oceanic group of *WoW* realms. If readers would like to buy a commemorative T-shirt of the guild name, they are available online for $20.

The guild name reflects the widespread use of the word "rape," commonly used across Internet forums to mean dominate. Its use has been protested widely by bloggers across the *WoW* blogosphere, but the use of "rape" in *WoW* and in other online forums continues (Keeva, 2010). While people argue that the use of the word is divorced from its original meaning and point out that any gender can be "raped," work such as Dibbell's (1999) reminds us of the different effects words and actions in cyberspace can have on different people. For example, the following quotation illustrates the way in which the term "rape" is integrated into conversation about the game. The player is describing all the fun he had playing against other players in the game:

> I loved it in BC...rape whatever came close. We totally fucked up one dual rogue carrier team.... We had a good laugh at that saying how pissed the carrier must have been.... On my ret pally before WoTLK came out when they were majorly overpowered I ran with a shammy and we raped face.

The casual use of the word "rape" is most prevalent in player-versus-player environments, where people are fighting other real people, such as a confined "capture the flag" environment. However, its use is widespread throughout the game to refer to decisive victory. For example, here a player uses the term to congratulate a guild on its success: "You guys should get a medal for being the best, you just raped every other guild in the world." In another example, players use the term to describe success over computer-generated content in the game: "We totally raped Blackwing Lair and we kept on going deeper and deeper everyday." The term is also used commonly to refer to losing very badly: For example, "But standing in fire isn't an option on hard mode - you get raped hard and fast. And the twilight cutter beams will pretty much take off your entire health bar."

Additionally, the term "raped face" is common in *WoW* (and used across games). It is used to mean someone was dominated, lost decisively, or beaten in a game. In November 2010, there were 31 characters, 1 guild, and 28 arena teams named "rapeface" and 13 characters named "irapeface" playing on the North American/Oceanic realm group. T-shirts that say "It's not rape, it's surprise sex" or "it's not rape if you say surprise" are also available online.

While the use of any "clear and masked language which refers to extreme and/or violent sexual acts" is banned in the game, Blizzard does not actively regulate any of the game's chat channels (Blizzard Entertainment,

2010). This is particularly true of guild chat, where language rules are largely left to the guild leader. In theory, *WoW* players are always being watched, because Blizzard records all chat logs and interactions in the game; however, in practice, for Blizzard to enforce rules it has to be "called in" by other players. When a player reports an in-game issue, she opens a screen to report the issue to a "Game Master" (GM). The wait for a conversation with a GM can be as short as ten minutes or as long as many days. A short-term solution is to use the "mature language filter"—something players turn on themselves, which changes "bad" words into symbols. However, this list is also a bit idiosyncratic. For example, "rape" is not filtered, nor is "cock," but "penis" is filtered (November 2010).

On official *WoW* forums, Blizzard uses a different, more aggressive strategy in the regulation of forbidden speech. Forbidden terms are impossible to post through an often changing "ban list" of words. Predictable words such as "fuck" are banned, whereas other "drama causing" words are also banned, such as "Nazi." Other words seem to migrate on and off the list, with "lesbian" and "gay" being banned for a while and then unbanned, while "dyke" remained unbanned.[4]

"Rape" and "grape" have long been on the list. In response to posters' complaints about filtering the word "grape," a Blizzard Community Manager replied, "The word filter is not to reduce the need for moderation, but to avoid people having to read that kind of language." However, whether the filter is meant to reduce moderation or to save people the traumatizing experience of seeing offensive words, the need for it implies that the word "rape" is so widely used that the best way to handle it is to make it disappear.[5]

While the use of the word "rape" is a good example of symbolic violence in the game, there are other words and phrases about women that have become characteristics of *WoW* in particular, and male-dominated online social spaces in general. Some of these derogatory phrases are so repeated that it is now difficult to tell whether speakers repeat them to reinforce a sense of community or if they are serious. When Blizzard announced that it was going to require the use of legal names on its forums, one of the complaints from women was:

- I have no wish to hear "get back in the kitchen", "make me a sammich", and "You're just a girl, what do you know?" in response to friendly advice.
- If I make a valid point on the forums, I don't want it to be replied to with "get back in the kitchen and make me a sammach." or "tits or gtfo"

- Posting under my real name will expose me to prejudices that I don't have to deal with now. Whether it's "harmless" flirting or just people making "GB2Kitchen" jokes.

Misogynist language and constant marginalizing jokes serve to reinforce power hierarchies in the online space, reminding female players of their place. It also creates a rhetorically dangerous landscape that women must navigate in order to fully participate in the game.

Hierarchies and Unequal Access

According to Bourdieu, within fields, symbolic violence is used to maintain power hierarchies. Actor power is derived from "symbolic capital," which is constituted by anything that people in the field have imbued with value. Specifically, Bourdieu (1985) argues that each field contains its own logic and its own hierarchies of value. In the game, symbolic capital takes many forms. It includes reputation, how long a player has played, and, most important, prestige and access to in-game experiences. In particular, access to the most difficult experiences and the prestige gained from being one of the first groups to conquer new in-game content are controlled by prominent guilds.

While guilds that actually restrict membership based on gender are in the minority, and it is unclear if the most successful guilds actually do restrict based on gender, there is a widespread belief that the most successful guilds do restrict membership based on gender.[6] This belief is frequently mentioned when people discuss whether women are good players, what constitutes a successful guild, or what causes guilds to be unsuccessful. For example, "Girl raiders may have the connotation of being bad, but that can be proven otherwise. Big guilds don't recruit chicks because they cause drama."

Women may be members in the top guilds, but among those guilds the numbers of women who participate in the most cutting-edge raiding are fewer than the proportion of females who play *WoW*. For example, members of the current top *WoW* guild in the world stated in an interview that they have no problem with female raiders and do not differentiate while recruiting; however, their raiding ranks include only 2 women out of 25 (Interviewing Paragon, 2010). Another top guild, a Chinese guild raiding on a Taiwanese realm, also indicates that it has many women in its ranks and two women who are "as good as males" on its elite team of 25 (Thinking with the Stars, 2009).

Along with the belief that the most successful guilds exclude women from their ranks are a set of beliefs about why women should be excluded

from these groups. The three central beliefs about why women should be excluded are: women cause drama; women are not as good at the game as men; and women cannot handle the environment.

The first argument posits that all women destroy effective teams because they flirt with male leaders, and even in cases in which they do not flirt with male leaders, their presence is inherently dangerous because of how male players react to them. Women are framed as constantly seeking male attention, approval, power, and free stuff, and because they prey upon the weakness of men, they will destroy teams. Once they have destroyed one guild, they will then move on to another guild and repeat the cycle. Thus, this argument asserts that it is better to keep women out of raiding teams. For example, in response to a thread asking people to list common reasons for guild breakups, a player stated the following—a comment that was quoted repeatedly by other posters who agreed:

> I've seen a lot of guilds fall apart due to one girl. She whores herself out to an officer to get power in the guild and people leave. Guild falls apart, officer and their new-found gf go to a new guild. Girl leaves guy for an officer in the new guild, and the cycle starts anew.

The men who "fall prey" to the "drama-causing" women are never held responsible for their actions. When a woman asked in response to the previous quotation, "why isn't anyone blaming the BOYS? It's their fault too," posters responded that the boys could not be held responsible. For example:

> It isn't only female wow players that ruin guilds. The problem is that it only takes one girl to start flirting, and one male officer that keeps his brain between his legs....But blaming the guys is going a bit far. Cybering a hot elf...is probably the most action some players get.

Even in cases where the men were held responsible, posters still affirmed the choice to block women from guilds as the appropriate method to deal with the perceived problem. For example:

> The general problem isn't female raiders. People don't recruit female raiders because of all the male raiders and how they'll act around a female raider. If anything they're acting sexist against males, which, even being male myself, I can't blame them for.

A second claim is that women do not play as well as men. A variation of this claim is that there are good female players, but they are so rare it is better to avoid all women. For example, a post reads: "I like the girls who can play fine. I also like Santa Claus, the Easter Bunny and Unicorns." The argument that women are not as good as men at the game is often contextualized in relationship to women not being as good as men at sports or at other physical activities. Occasionally, the sports context is generalized to women's "natural" lack of competitive drive. A discussion participant states: "This is gonna sound sexist (and I'm not; I just know lots of ladies who don't play games). Most females don't get the competitive nature of the game."

Linked to this idea is a widely expressed idea—not just in relation to raiding—that women do not like to play the same way as men. Generalizations about women's ways of playing include that women only like to play avatars that heal (rather than do/take damage); they like collecting pets; they do not like to wear ugly armor or have ugly avatars; and they like to accomplish "meaningless" tasks in game. For example, in a thread in which a man asked the community how to get more women interested in playing *WoW*, responses that invoked stereotypes such as the following made up at least one-quarter of the thread. A respondent says, "Get her to roll a human female priest, give her the cooking & tailoring professions. She'll feel right at home."

A third cause given for why women should not be invited into guilds is that women just "can't handle" the type of environment necessary for a group to succeed, and serious players (men) do not have the time to hold women's hands. For example, while discussing women raiders, a guild leader said:

> Although, we let women in, we have a girl unfriendly environment and usually if they join, they leave because we don't cater to their whims like some others do. I can think of 1 maybe 2 girls that are currently in the guild and are in relationships with a member. After they listen to someone sit and yell at them for 10 minutes about being terrible that usually sends them off quickly.

Connected to this argument is the view that to include women in raiding environments will require "editing" of language and modes of interpersonal communication—and that "having" to do this is unreasonable and unfair of women to require. Most often this shows itself in comments about how women do not get yelled at as much as men. Two examples:

- Girls definitely don't get yelled at as much for making mistakes by our male leader. But he scapegoats a lot of the male players.
- I will not act differently on how I joke with my friends on vent. I am sick of having to act more politely when a lady is in vent. If you can't handle it, don't be on there. It's that simple.

The often-repeated beliefs that women are destructive to groups because of their sexual power, because they cannot play the game as well as men, and because they cannot "handle" a "real" playing environment reinforces the subordinate status of women in the game. Additionally, it removes all agency from women, giving them prescribed behaviors and bodies that they are required to occupy.

Negotiating the Space

In spite of a challenging environment, women continue to play *WoW* in increasing numbers. In a world in which feminism has become equated with extremist man-haters (particularly online), how do women negotiate this space? Women's responses to the environment are so diverse that it is difficult to categorize them. One common thread across responses is that both women who self-identify as feminists and women who argue that the treatment of women in *WoW* is not a big deal report exhaustion with this aspect of the environment. For example:

I've never had anyone in game be all like "hey baby, come and do dirty stuff" or anything like that. My guild knew I was female before I joined them and they've never been dicks. The only things that have been said were funny and I've never felt singled out, even though I seem to be the only female in the guild. Whenever I'm in vent in a pug there's usually the initial "OMG A GIRL!" then I proceed to show them I'm just as perverted as any guy and we'll go about our raid making dirty jokes. [But] I must say all the "there's no females on the internet," "get back in the kitchen," "girls don't play wow" can get pretty annoying, especially the worst player in the raid is the one saying it.

While the responses to the environment are mixed, two clear themes emerge. First, a small percentage of female players respond to the environment by pretending to be men. Second, the dominant coping strategy can be seen in the post above; women find enclaves, usually guilds, in which they feel accepted. Sometimes these guilds have language norms that bar the use of sexist language, but sometimes they do not.

Women who report that they cope with the environment by hiding their gender usually state that they play male avatars and refuse to speak using voice software, hoping that in hiding their gender they will be evaluated equally with male players and avoid negative experiences. A female discussant states: "I'm in one of the server top guilds now and there's no way I'm telling them I'm female. It causes too many problems, and now people really pay attention to the good player I am." However, as Yee and Ducheneaut's (2010) data indicates, women play male characters 8% of the time (while men play female characters 33% of the time). Thus, this coping strategy for women is rarer than others.

The second, and by far most frequent, response to the environment is that women find enclaves within the game, nearly always guilds, in which they feel comfortable. The people in this category include women who identify as feminists, women who do not mind the dominant culture of the game, women who say they exploit men in the game for free stuff, and men of all ages from all locations. Some find guilds that do not treat or view women as different from men. Alternately, others report finding guilds in which they hear a lot of sexist jokes, but in which they are not treated differently from men in terms of resource distribution. Three examples:

- Find a more mature player base, find sanctuary is the advice I can give to all female players.
- Almost every woman I know that plays WoW hides their identity, unless on vent with me or some of my friends who we know won't harass the shit out of her, bodyguards if you will. When we pug stuff and we are asked to go in vent we usually say she has no mike to avoid all of the sexual fiends out there….It's sad, and very degrading, and I feel so sorry for the lady players out there who have to deal with this sexist crap. If I could apologize for all the idiotic morons out there who make MMORPGing so hard for women I would.
- My opinion is that almost everyone on the internet are jerks, just have to find the right WoW friends to hang with in vent.

In addition, women have formed all-women guilds, and some women report moving to the realm where there is a network of GLBTA guilds, because this realm community is more inclusive. While the attempts of some women to segregate themselves could be seen as "ghettoizing" non-mainstream groups in *WoW*, there are some scattered reports across *WoW* conversation spaces that these guilds are changing the environment on their entire realm.[7]

The creation of enclaves as a coping strategy is observable in other on-line spaces. For example, on IGN, there is a "Girls Board" where female posters police male posters and inform them that their board is not the same as the other boards. They note that the misogynist behavior observed in other online spaces is not welcome. Most of these women do not inhabit the Girls Board as their major community, but visit it from time to time.

Conclusion

The number of women entering into male-dominated online spaces such as *WoW* is increasing every day. In *WoW*, the sexist in-game environment presents an often-unrecognized barrier to women's full participation in the potential of the game. Particularly harmful are ways in which the community reinforces the subordinate status of women in the game environment, with the anonymity and disembodied nature of the space amplifying ideas about women that exist in the real world across national contexts. This happens in spite of the large number of men and women who express frustration with the culture on *WoW*-related blogs and forums.

However, if there are so many people opposed to the dominant culture of *WoW*, why are they not protesting or fighting it aggressively? In other re-search into *WoW*, I have found that political organization and protest in *WoW* is "foiled" for a number of reasons. One reason is that the need for self-regulation in the game creates smaller groups with boundaries that are not based on cleavages normally observed outside the game, such as nationali-ties, ethnicities, sex, race, or age. Instead, the boundaries of these smaller groups are created by shared value systems. Once people exist in these "bub-bles" of shared values, they are less likely to engage in political activism (Beyer, 2011). In line with this, the men and women across the spectrum re-port "opting out" of general chat channels, groups that involve people they do not know, and other common conversation and cooperative areas. They stick exclusively to groups of people they know to avoid dealing with "jerks."

Thus, where are all the cyberfeminists in *WoW*? Many are playing in like-minded guilds with their general chat channels turned off. Functionally this means that common areas are left to those who propagate the dominant culture. New players then enter this common arena and are forced to find en-claves on their own.

Notes

1 Using Big Boards measurement: http://www.big-boards.com/ (Accessed: February 2011).
2 These are initial findings. I have observed most closely IGN, 4chan, Vault, and Something Awful.
3 There are many excellent women-centered and feminist gaming blogs. This chapter owes a huge debt to wow_ladies at http://community.livejournal.com/wow_ladies, The Border House at http://borderhouseblog.com/, and Empowered Fire at http://www.empoweredfire.com/, to mention a few.
4 Because of the changing nature of the list, this data was gathered based on people mentioning/complaining about certain words being on the list—meaning the data could be inaccurate.
5 It is also important to note that the word rape is also incorporated into the widespread homophobic discourse in all of the online spaces in which "gay" becomes a fill-in for emasculation.
6 It is widely reported that in 2007, a world-first guild stated publicly that it would not recruit women. However, the guild later said this was a joke that accidently made it onto its website.
7 I have begun gathering data on the WoW realm that has become the "magnet" for GLTBA players. The realm is a "magnet," because two very large, high-profile GLTBA guilds made the realm their home. Initial findings indicate that the discourse in general community spaces in this realm is markedly different from other realms because of policing by GLTBA players and guilds. And, because of this, women also move to this realm for the environment.

Works Cited

Beyer, J.L. (2011). *Youth and the generation of political consciousness online*. Doctoral dissertation, University of Washington, Seattle, WA.

Blizzard Entertainment. (2010). *Harassment policy*. Retrieved from http://us.blizzard.com/support/article.xml?locale=en_US&articleId=20455

Bourdieu, P. (1985). The social space and the genesis of groups. *Social Science Information*, *24*(2), 195–220.

Dibbell, J. (1999). *My tiny life: Crime and passion in a virtual world*. New York: Holt.

Entertainment Software Association. (n.d.). Industry facts. Retrieved from http://theesa.com/facts/

Fallows, D. (2005, December 28). How women and men use the Internet. *Pew Internet and American Life Project*. Retrieved from http://www.pewinternet.org/Reports/2005/How-Women-and-Men-Use-the-Internet/01-Summary-of-Findings.aspx

Haraway, D. (1991). *Simians, cyborgs and women: The reinvention of nature*. New York: Routledge.

Interviewing Paragon. (2010, August 2). *Raiding research online*. Retrieved from http://www.raidingresearch.co.uk/?p=173

Jenson, J., & de Castell, S. (2007, September). *Girls and gaming: Gender research, "progress" and the death of interpretation*. Digital Games Research Association. Paper presented at the DiGRA 2007 Conference. Tokyo, Japan.

Keeva. (2010, October 5). Habitual and negligent intolerance, or how I came to realize that I enable bigotry. Message posted to http://treebarkjacket.com/2010/10/05/habitual-and-negligent-intolerance-or-how-i-came-to-realise-that-i-enable-bigotry/

Pew Research Center for the People & the Press. (2008, February 6). Where men and women differ in following the news. *Pew Research Center*. Retrieved from http://pewresearch.org/pubs/722/men-women-follow-news

Rheingold, H. (2000). *The virtual community:Homesteading on the electronic frontier*. Boston, MA: MIT Press.

Star, S.L., & Griesemer, J.R. (1989). Institutional ecology, "translations" and boundary objects: Amateurs and professionals in Berkeley's Museum of Vertebrate Zoology, 1907–39. *Social Studies of Science, 19*(4), 387–420.

Talking with the Stars. (2009, September 11). *Frostshock.eu*. Retrieved from http://frostshock.eu/2009/09/11/dancing-talking-with-the-stars/

Yee, N. (2005, July 28). WoW basic demographics. *Daedalus Project*.Retrieved from http://www.nickyee.com/daedalus/archives/001365.php

Yee, N. (2008). Maps of digital desires: Exploring the topography of gender and play in online games. In Y. Kafai, C. Heeter, J. Denner, & J. Sun (Eds.), *Beyond Barbie and Mortal Kombat: New perspectives on gender and gaming* (pp. 83–96). Cambridge, MA: MIT Press.

Yee, N., & Ducheneaut, N. (2010, July 23). Gender bending. *PARC PlayOn 2.0*. Retrieved from http://blogs.parc.com/playon/2010/07/23/gender-bending/

Chapter 9

Guilding, Gaming, and Girls

Genesis Downey

Meredeath Backstabber is a redhead with ice blue eyes, shoulder-length hair and a jeweled circlet on her head. Throwing daggers are strapped to her ample chest; she wears lipstick and is particularly good at finding and disengaging traps. She's a tall, small-hipped, white, leather-bound, adult human rogue. Her role: trap hunter and DPS.[1] Her stats: high agility and dexterity. Meredeath Backstabber is tailor made for grouping[2] in *Dungeons & Dragons Online (DDO)*; she does not solo well,[3] since her hit points are lower than a solo fighting class. She is also a member in her first guild,[4] Defensive Line. But MaddieB, in all her pre-teen glory, stands with her hand on her hip. This one's blond, with cropped short hair and bangs that cover one blue eye. And she has a cocksure sneer that only a tween can pull off. MaddieB wears cargo pants, T-shirts, and sneakers. No makeup. No jewelry. An A cup chest at most. A dragon tattoo on her ankle. No grouping capability or focus on character stats and no guild association. And these identity markers change day to day, hour by hour, depending on her mood and level of engagement. MaddieB exists alone in the online social/gaming site called *OurWorld*, just like every other member there. According to Kathleen Sweeney (2008), MaddieB might be one version of a tomboy—a persona a girl is eventually expected to grow out of once she matures sexually. But Meredeath Backstabber codes as Woman Warrior—she's proactive and powerful, and sexualized in her appearance. She's also my 12-year-old daughter.

This essay is not about attacking the gaming industry—at least not directly. It is not the intention to criticize those who do play these games or judge their methods of play. It is not an attack on the desires, pleasures, and attitudes of gamers themselves. How gamers play (without wishing to fall into an essentialist fallacy) *should* be analyzed, but this essay is not the space for that discussion. It is also not my intention to be purely uncritical, either. There are numerous inconsistencies, injustices, hegemonic practices, and other overtly destructive aspects associated with digital gaming ranging from hate crime to gaming addiction. My argument isn't dismissive of these very

real problems, and in no way is my own focus designed as a salve for these social ills. Girl gamers should not be seen as some kind of panacea that will right the wrongs present in gaming subcultures. Race, gender identity, socio-economic class, genre taste preference, technology preference, accessibility: all of these factors prevent an essentialist definition of how a girl gamer should be identified and what should be done once they are labeled as such.

The point of Meredeath's avatar descriptions[5] is to instead highlight the main dilemma arising from a recent online research project hell-bent on trying to figure out how *one* girl tween not only negotiates an identity that is just beginning to manifest as a product of her post-adolescence, but particularly how that negotiation takes place in a gaming context centered on guild involvement. These two avatars, Meredeath and MaddieB, are merely aspects of a much more specific engagement. By tracing how this real-life tween negotiated a Massive Multiplayer Online Role Playing Game (MMORPG) such as *DDO*—particularly through the lens of her first guild experience, and then comparing it to her most used (and current) social networking site, *Our-World*, which contains gaming capabilities (although not an MMORPG), certain key connections to identity formation—the strong and weak ties found in community interaction, and identity-as-commodity—begin to coalesce. Above all, Watkins's (2009) and Morrison's (2010) analyses of tween online behaviors shed light—and reveal possible contradictions—on how one tween girl games while guilded, and what the potential ramifications might be in a broader context.

S. Craig Watkins's work (2009) explores the online and offline intersections that take place in the lives of today's youth. Primarily, it traces the genesis of the journey from traditional media outlets through the multi-faceted present usage, and questions how the constant immersion within this digital world will/could/should affect the present users and future generations. Watkins argues that this online/offline balance that youth presently maintain will no doubt evolve and spread into all aspects of society and that the influence of this relationship will continue to be felt in politics and academia.

Connie Morrison (2010) stresses this offline/online balance as well, focusing primarily on a case study involving 10 teenage girls and stressing that the avatar-creation process should be viewed as a possible autobiographical *fragment*. Morrison argues that the avatar can be seen as an extension of the owner, as it exists at the point of creation. But that creation process is highly negotiated and based on the limits of the technology and intentional design of the specific digital sites, as well as the social pressures that occur both on-

and offline. Because the choices present in the avatar formation process are restricted to overt gender binaries (girls have breast-size selection; boys do not) and are also contingent upon the social dynamics surrounding that avatar, particularly the desire to create what will essentially be viewed as *cool*, Morrison argues that <u>avatar as full embodiment of that real self is impossible</u>. However, she argues <u>further that these very limitations also have the potential to open up other ways of viewing the self that might have gone unnoticed</u>. It is this aspect of negotiation—the (re)building of a cyberself—that presents a non-temporal/non-linear/non-essentialist version of a true self that has the potential to open up new ways of examining how girl gamers might construct themselves not only in the avatar-creation process out-of-game but also as a groomed guild member in-game, or how that process of identity might be affected by the type of grooming that takes place.

The context for my own research site was fairly straightforward. Meredeath has grown up around online gaming environments, watching her parents play MMORPGs. In fact, most of the adults in her life outside of her immediate family also "game" on a regular basis—whether those games are console based (e.g., Nintendo DS), table-top role playing (RP) (e.g., *Dungeons & Dragons* or *Mutants & Masterminds campaigns*), online FPS or first-person shooters (e.g., *Quake* and *Unreal Tournament*), or MMORPGs such as *World of Warcraft* (*WoW*), *Everquest I &II* (*EQI & EQII*), or *DDO*. In other words, Meredeath is used to equating her parents' friendships with gaming within groups. Until the present project, she had watched mainly as a spectator. This experience with *DDO* was the first time that she had shown interest in participating within an online guild environment.

Meredeath's exposure to online life and digital media in general does predate her experiences with *DDO*, however. As Watkins stresses, digital media is almost completely integrated into every aspect of young people's lives (Watkins, 2009, p. xxi). Meredeath uses social networking sites, she plays various Facebook games, and she makes (unaired) YouTube videos. She emails, IMs, texts, posts, creates…all online. But *DDO* offered a rare opportunity to see how she navigated not only an MMORPG,[6] but how she did so within the context of a very specific group of people made up of adults and other young people roughly her age. Because guilds are the social cornerstone of most MMOs, Meredeath's involvement presented a unique perspective—a tween girl playing, behaving, and functioning within a group setting involving adults and young people. One central question that encompassed the entire project focused on discovering why adult guild members

would even want to game with young people in the first place. In a previous project, for example, I came up against this very issue when researching LGBT guilds in *WoW*. In an online *WoW* forum (2009), when a young poster had asked if there were any known LGBT guilds willing to recruit players under 18, the following two replies (Thorke & Zhebrica, 2009) were given:

> Well…the thing is it's not about your maturity. It's about our own safety. The legal division between adults and minors is set at arbitrary ages, of course, but it does exist, and ignoring it or deeming it "unfair" does not make it go away. Inviting kids into a community changes that community—it puts a responsibility on our shoulders not to be kid-inappropriate, or we could get in trouble in multiple ways that I'm sure you can easily imagine.
>
> And you know, speaking solely for myself, I like it that way. I enjoy knowing that I'm with a group of adults, that I do NOT have the responsibility of moderating what I say so I won't get myself and my whole guild in trouble. You may be a really great, mature person and an excellent player, but I hope you are able to see that those factors don't apply to the actual reasons guilds are run this way.
>
> Being a kid does suck, but luckily you grow out of it. (Of course there's no guarantee of growing out of immaturity, but that's another issue altogether….)
>
> This is exactly why we chose to have an age limit. Our guild chat can lean towards adult conversations and I didn't want the responsibility (legally, morally, parentally, etc.) of exposing minors to that. If you're a minor you're probably living at home with your parents which means your parents might one day glance at WOW over your shoulder and see an adult guild chat conversation.
>
> I applaud young gay people today for figuring out who they are and feeling free to express themselves at such a younger age than the folk of my generation. While I don't want the responsibility of running a LGB guild for young people, I would do everything I can to support the creation of one if someone were to champion it on Proudmoore.

This aspect of "getting a guild in trouble" does seem important—particularly because of the extra responsibility that guild members assume in terms of tempering language and guild chat subject matter, which do have a tendency to get bawdy. One key point to keep in mind, though, is that Meredeath's guild is not a random guild found off of a forum recruitment thread. Meredeath did not join a guild made up of strangers. The guild was made up of trusted family friends and their gaming children, whose friendships continue to be maintained in both online and offline settings—precisely the point that Watkins (2009) makes about the false assumption concerning cyberpredators preying on the naïve. Most young users stick with the people they already know.

But Meredeath's desire to join this specific guild wasn't just about safety. Meredeath originally decided to join because of her pre-existing friendship with Throsshaten offline. Very few of Meredeath's offline friendships involve gaming of any sort outside of Facebook games such as Farmville (which rely a lot less on any direct interactions between players and more on asynchronous play). And even fewer of her friends that game are female—indeed, almost all of her friends who do game are male tweens who prefer either *WoW* or console games. (In fact, her male cousins were the ones who gave her their old Nintendo DS games.) So, for Meredeath, a gaming presence has almost always coded as male—with the distinct exceptions of me (an adult) and Throsshaten (a tween cohort). Throsshaten and Meredeath have known each other since birth and are roughly the same age. (Thross is a year younger.) So having another tween girl gamer friend within the guild presented an opportunity to game with a person who was more *like her*. But it was her offline friendship with Throsshaten that pushed her into the online guild. This online/offline balance is precisely what Watkins (2009) stresses—intimacy (within the guild) online does not replace intimacy offline. If anything, the guild experience has the potential to fortify both types of relationships rather than negatively affect that engagement. Indeed, that is precisely what happened throughout the course of the project. Meredeath's friendship with Thross actually intensified in both spaces, furthering Watkins's claim that how youth use digital media might change, but they still maintain strong and weak ties.

Meredeath's desire to maintain her online/offline friendship with Thross, however, isn't the only reason she was initially persuaded to join the guild. The adult leaders in the guild played a crucial part in developing and maintaining the group ties within the guild experience. For example, the two main leaders in the guild—Throsshaten's father Akorashin, and Hendradus, a close gaming friend—both provided a consistent online presence that helped Meredeath navigate the avatar-creation process and also helped her understand the game mechanics. Throsshaten also helped in this regard, since she had been playing in the guild longer. But there are a few ulterior reasons why the adults in the guild not only tolerated the guild presence of another tween (which significantly alters the gaming experience for the adult because of the constant need for internal censoring of language) but also actively recruited other tweens in the process. By the end of the initial project, for example, there was an additional tween girl who had joined the guild—a neighborhood friend of Throsshaten's in her offline life. One major reason for the active re-

cruitment focuses on that earlier forum quote concerning "our own safety." All words apply directly to Meredeath's guild, for the younger members as well as the adults. The guild leaders acted as cultural gatekeepers and as cultural intermediaries who helped young guild members navigate gaming waters. In this way there was a level of protection for all involved.

This protection from without isn't the only factor, though. Because Watkins also stresses how important technology is for the "very well connected" (2009, p. 48), it is important to note that learning how to use the technology *properly* and *ethically* was also a factor in the way that the guild functioned. Watkins argues that one key aspect that educators are now focusing on involves teaching good digital citizenship. The KPK incident testifies to this need for a more thorough understanding of the social contexts that take place in online gaming (Thomas, 2008). By Akorashin and Hendradus actively monitoring the young guild members' experiences and interactions, they acted as digital mentors who teach proper guild etiquette. That includes what is said, how it is said, and who gets to participate within a group setting. The hope is that by the time the tweens grow into more sophisticated guild experiences, they will have learned how to be not only "good guildies" but also media literate, so that they will be able to see through the seedier sides of online representations and encounters.

But acting as a cultural gatekeeper isn't the only reason for allowing tween access to an adult guild. Akorashin's educational and career background revolves around utilizing technology in a K–12 school setting. Specifically, he works on using gaming technology as a way to reimagine educational methods—particularly using role-playing games as a way to help teach math concepts. For Akorashin, gaming isn't purely play; it's also a learning tool. So one reason for the focus on tweens in the guild wasn't just that it was a highly mediated outlet for his daughter (and Meredeath) to play in, but that it was also a possible media literacy site. Because Throsshaten has been diagnosed with ADD and a social anxiety disorder, her involvement in online gaming has been one way to foster not only a sense of empowerment for his daughter (and the other tweens), but also as a possible way for Thross to learn valuable problem-solving skills that are not necessarily strengthened through more traditional methods of non-digital education. One reason that tweens might be actively recruited, then, is that they may act as community builders who strengthen ties between the younger players, thus keeping them playing as problem solving cohorts. Developing strong ties is a key to this kind of community building.

There were other elements at play in this recruitment process. Again, using that quote of "our own safety" is a beneficial touch point. The emphasis isn't just on *safety*; it's also on *our own*. For the active guild recruiters, emphasizing the inclusiveness of guild membership was also a means of fostering a certain kind of identity building. Akorashin emphasized, for example, that his daughter's ADD and social anxieties mirror his own youth experiences. Because he empathized with her frustrations, her membership within the guild was one way in which he could not only help her navigate the more social aspects of the guild environment (while also acting as a moderator), but also provide her with possible social alternatives that included identification as "a gamer." Meredeath's social experiences outside of gameplay may not mirror Throsshaten's, but being part of a guild does offer up alternative identities that have until now excluded her, based on the fact that so few of her female friends actively enjoy gaming in the way that she does. The guild, therefore, reinforced that tween gamer girls not only exist, but that they also have a place to go where they "fit." Again, Watkins's focus on how online spaces are capable of fostering strong ties based on intimacy is crucial. He stresses, for example, that the "use of the Web is a way to fortify rather than forfeit their off-line relationships." Because *a place of our own* is so crucial to the way that a guild functions (indeed, that is the major purpose of a guild in general), ownership of a gaming identity could be seen as a powerful method of belonging, which in turn could lead to a stronger sense of agency.

For a while, Meredeath's first guild experience in an MMO was positive. Meredeath enjoyed the avatar-creation process, learning how to navigate dungeons and Player versus Player (PvP) environments—at times much more so than Throsshaten. She explored the immersive settings through solo play but through close monitoring also learned how to work with other guild members, no matter if they were other tweens or adults. The one aspect of *DDO* that changed the way that Meredeath behaved online the most, though, was her introduction to the voice interactive software Ventrilo. For Meredeath, hearing other guild members' voices *in real time* opened up a social component that was not readily available through the standard typed-chat feature found within game. In Meredeath's case, Ventrilo collapsed time and space to such an extent that it was possible for her to reimagine *being* in the game—and out of it. Before Akorashin had set up the technology, Meredeath could more easily disengage from the game play and from the other guild members. Without Vent installed on her computer, she was forced to read chat text, which required a more passive reaction. Reliance on the chat box

feature only reinforced how far away Throsshaten, and the rest of the guild, were from her physically, and therefore she had less incentive to play like "a good guildie" since they weren't really *there* with her. But once Ventrilo was installed, she could no longer disengage. The conversations were immediate and, as Kim Toffoletti stresses, "expansive ·and inclusive" (2007, p. 112). Thus, by analyzing Ventrilo as a technological mediation, Meredeath's use of Vent *in and out of game play* possibly influenced the way in which the guild experience reinforced the strong ties between the players. The relational aspect between the game and the girls shifted in such a way that Meredeath stopped playing *DDO* when Vent wasn't running. In so doing, Meredeath's physical body changed as a result—she wore the required headset at all times whenever she was online, even if Throsshaten wasn't.

The use of Ventrilo in a guild setting—and particularly from a tween girl's perspective—is a reminder of just how the posthuman image might actually contribute to the way in which we think of girl gamers in general. Toffoletti (2007) stresses that multiple sensory modalities do affect the way that humans have come to rethink time, space, and reality as a reaction to new media technologies, and Meredeath's engagement with the other guild members, based on the use of the technology (particularly the headphones), does seem to support this view. But the posthuman image does offer up another way of viewing girl gaming in general. Toffoletti argues, for example, that one way to think of the posthuman is to see it as a transformational process by "reformulating established categories of being" (2007, p. 14). Technology has complicated the way in which we have thought about the human body—whether through the way it blurs our online and offline selves or because it leads to critiques of natural/unnatural binaries that oversimplify these ways of being. Something that Toffoletti makes quite clear is that analysis of the posthuman does not, cannot, and should not rely on binaries if there is to be any mediation or healing taking place when thinking about the posthuman. Because technology has been seen as either utopian/dystopian, mind vs. body, or male tech vs. female nature, binaries are always seen as contested. The very setup is structured as a fight. Toffoletti seeks to deconstruct these binaries and reimagine the usual relationships in order to gain insight into new ways of seeing the posthuman construct. By viewing Meredeath's guild experience with Vent as a posthuman event, it is possible to see how an online life centered on group identity and ability can act as a site for renegotiating a real-life self-identity, particularly if that posthuman self has the potential to lead to a further increase in agency.

But the guild didn't "stick," and it's this aspect that will lead to future research dealing with the role that community identification plays in helping young players develop a gaming identity. It began with Throsshaten's desire to explore other gaming sites. With Meredeath's main connector and strongest tie to the guild effectively gone, Meredeath began exploring other online gaming sites on her own. At first she still wore the headset and checked to see if Thross was on Vent. But after searching through Girls Go Games (which further illustrates possible ways in which Meredeath actively sought out access to gaming through the lens of being a tween girl), she latched onto *OurWorld*. There are drastic differences between *DDO* and *OurWorld*: it's almost a polar opposite online site to an MMORPG. There are limited guild options (called clubhouses, which function more as private chat rooms and cliques), no group play features, simplistic solo playable games, and an extensive focus on the avatar-creation process. In fact, almost every feature found on the website caters to some form of identity-as-commodity. Whereas *DDO* focused more extensively on what that avatar could *do* in-game as a way of establishing that identity, *OurWorld* puts zero focus on capability. The *OurWorld* avatar is designed purely for how she *looks*, not how she *plays*. Granted, the avatar-creation process does allow for a more individualized construction, but there isn't an attempt to simulate a real physical body (or at least a hypersexualized fantasy version of a physical body) in the same way that *DDO* attempts to do. It's constructed as a youth, but it's a cartooned youth. The more cartooned version allows for more focus on body type, head shape, and physical features, but the graphics are simplified. This oversimplification tends merely to reinforce hegemonic ideas of what a "normal" girl should and should not desire when constructing a self, particularly if that self is expected to be created as an autobiographical version of that real body (Morrison, 2010). Because of the limitations placed on the creation process (and this also applies to the *DDO* avatar-creation process), Morrison stresses that this might lead to a possible silencing of certain aspects of identity that don't "fit" within a cultural ethos. Because Meredeath had initially joined the *DDO* guild as a way of possibly finding a place for herself as a girl tween gamer, a website like *OurWorld* may either help foster that identity further (by allowing for a simpler, but at least younger, avatar), or might (through the limitations in game play and emphasis on appearance) *shut it down.*

All of this leads to yet more fundamental questions that will need to be addressed in future research. Meredeath's experiences with *DDO* were extensively monitored and mediated by adult interaction. Her *DDO* avatar was

also adult—*by default*. Age was not a factor that could be adjusted through the creation process, and the actual body specifications were also dictated by the avatar-creation technology. What that avatar wore was also highly mediated through the game play itself. She could not merely try on different looks, since clothes in *DDO* are geared more toward function, not fashion. But the same quest reward does not appear the same on a male avatar as it does on a female. They may have the same stats, but the appearance of the item on that avatar morphs to accentuate the sexual attributes of that avatar based on his or her status as male or female. A breastplate on a male avatar, for example, might cover the entire chest, stomach, and shoulders. On a female, that same breastplate may look like a halter top—exposing cleavage, stomach, and clavicle. Clothes are also designed as quest rewards. She could not merely buy an item; she had to "earn" it. Commerce was important in *DDO*, though. In fact, there was a constant in-game presence of The *DDO* Store: a pop-up would appear on screen in random locations whenever Meredeath was in a city location. And The *DDO* Store also sent advertisements through her email account. So even though the game was "free" to download and play, the constant focus on buying in-game items to "enhance" that game play worked as a way for players to equate buying with pleasure. But Meredeath's use of *DDO* prohibited this type of equation. She never bought items with real money. She maintained a free account and was therefore more limited in her game options, in contrast to Throsshaten. In the long run, it shaped how Meredeath came to view not only her avatar but also the guild experience itself.

Her use of *OurWorld*, on the other hand, presented an entirely different side to the avatar-creation process and gaming experience, one that emphasizes shopping and fashion as a way of fostering identity. And even though the website appears to focus on other aspects of online community building—for example, blogs, forums, and multicultural avatars—on closer inspection each of these social networking tools is revealed as a mere front for more advertising. For example, the blog feature isn't really a blog—it's an in-game advertisement for premium members who pay a monthly subscription charge (and who then get to be named "Residents"). Again, Morrison's (2010) focus on Judith Butler is incredibly important in viewing a site like *OurWorld*, in part because "the market has increasingly separated children from adults and one another—offering them identities based along a consumption grid" (Kenway & Fitzclarence, 2000, p. 119). Separation, therefore, is precisely what is at stake here for Meredeath. The focus on *our* in *Our-*

World is one step in separating her tween self from the *DDO* guild's tween gamer self. But that separation also manifests in *OurWorld*, because the games in *OurWorld* are entirely meant to be played alone. Meredeath doesn't exist on *OurWorld*—instead, she is MaddieB, a young, cool, hip tween girl who likes to play games but isn't necessarily a gamer tween. But that *our* also implies a belonging that did not exist in the *DDO* guild where there were just too many adults and too few player-made options available. *OurWorld* is slickly made up of merely weak and temporary ties, but they are saturated within the confines of that digital space. Strong ties may have been stressed within Meredeath's guild, but the sheer number of weak ties on *OurWorld* has also proved to be quite seductive.

The point is this: gaming is still perceived as a predominantly male-centered space. Whether it's through hypersexualized avatar formations, game designs that privilege hegemonic concepts of race (Nakamura, 2009), gender,[7] and social class (Dyer-Witheford & de Peuter, 2009), or a profound lack of female game designers within the gaming industry (Kline, 2003), girl gamers have had no choice but to play from a negotiated space. But that is changing. Female gamers have begun to take back a certain level of agency through their negotiated positions and have carved out spaces and identities that are shaped by ability and not just by appearance. When a game places more focus on a player's ability to problem solve, strategize, and contribute to the overall task at hand (based on group participation), the gender of the person at the keyboard no longer dictates who should play (and thus leads to a possible site of the posthuman). Skill through ability has the potential to level the playing field. This leveling effect, while still not fully realized, could potentially lead to a more significant presence from within and without. With more in-game involvement, more out-of-game presence is surfacing.

Gaming as a possible cyberfeminist location surely has potential to go further with every new voice heard. Because MMORPGs work from a more bottom-up business model, that is, where players have a more pronounced voice in game content, design, and particularly in the governance of the *millions* of players who inhabit these virtual worlds, a girl gamer's voice must increase if there is to be any potential shift away from a negotiated positions and toward a clearer sense of agency built within game design.

Which is why this very brief, microscopic study of how a couple of tween girls negotiated their first guild experience in an MMORPG has the potential to shed light on a much larger issue. Online social game sites such

as *OurWorld* stress appearance in the avatar-creation process: there is no emphasis on ability modification. The game design is all solo, as it does not allow players to work together to solve puzzles or work with each other's strengths to complete a task. The most popular game feature revolves around style contests—basically, online avatar beauty pageants where players judge each other's ability to coordinate clothes, accessories, and hairstyles—all of which can be bought with in-game "gems" that manifest with a monthly out-of-game monthly subscription. The clubhouse feature, which appears to have guild-like potential to foster connections between players, is used to show off the interior decorating skills of the members. Overall, the main purpose of the existence of an *OurWorld* isn't to provide a space for community participation and identity formation. It's a grooming process for future consumers in which identity-as-commodity is the methodology. The fact that the tweens within this continuing study (there are now a total of five) have all glommed onto *OurWorld* instead of the *DDO* guild is telling. There is no more focus on Ventrilo, because there is no need to strategize. All communication is done through the keyboard, furthering the divide between these girl gamers. In other words, *OurWorld* isn't about connection. *It's about division.*

Granted, the girls' community involvement is not rigidly fixed. They are only 12 years old. Many gamers, no matter what gender, started off with solo play and limited group involvement. MMORPGs are also a fairly recent game evolution. It's inevitable that by the time these tweens transition into adulthood, the gaming industry will have evolved past MMORPGs entirely. And it's also quite possible that their guild abandonment had more to do with the specific MMORPG disenchantment (at some point all of the girls agreed that the game was a bit boring at times) and less to do with a lack of desire to belong to a guild in general. It is also possible that these girls just don't care about gaming the way that older gamers, including their parents, do (or, at least, not yet). As Watkins (2009) stresses, their lives are entirely immersed as a digital self whether they are playing an MMORPG or navigating social networking sites or IMing through Facebook. They are, after all, the first generation of digital natives. This collapse of an online/offline distinction is undeniably a factor in the way that tweens negotiate MMORPGs and a digitized identity. There are numerous factors here, and there are numerous reasons to doubt why guild involvement equates with cyberfeminism. Guilds can be just as oppressive as any other online group experience. Guilds are by no means synonymous with cyberfeminism. But *they could be*, and if girl gamers ever want to have an increased agency in the game creation process,

they must be. One point that needs to be made here is that guild involvement is social by nature, no matter how much emphasis is placed on team building and game strategies. Because there has always been an assumption that technology is used by males for building and playing and by girls for socializing, a closer look at how tweens navigate both the social and the strategic aspects of guild involvement has the potential to collapse simplistic binaries. This, in turn, could illuminate the very real social aspects of guild memberships for all gamers, no matter what gender.

So, based on the experiences of shadowing Meredeath's gaming practices and online negotiations, future research into the way that girl tweens develop into gamers needs to account for the way in which strong and weak ties are established and maintained. While it seems as if guild experiences do have the potential to be sites that could foster gamer identity, this identity, for a tween, is automatically in flux. This process of becoming a gamer must take into account gender, age, identity-as-commodity, strong and weak ties, media literacy, and community if a guild for young players is to have a lasting effect on maintaining emotional and psychological intimacy in the lives of these tween gamers. Otherwise, sites such as *OurWorld* might shape that gamer merely into a girl who likes to play games…and whose avatar looks really good while doing it. *[handwritten: → WHAT'S WRONG WITH THAT?]*

Notes

1 Damage per second. A high DPS is generally required for either melee class players who are non tanks or off tanks or range fighters such as spell casters and hunters. Because they are designed not to tolerate a lot of direct damage, they usually possess talents that are designed to help with avoidance of damage.

2 A term used in gaming that refers to a group of two or more players who combine their individual talents to complete a given quest. Grouping is used as a method of rapid quest completion as well as a requirement for most high-level game content.

3 A player whose avatar has high enough hit points or healing capabilities to complete quests without the help of another player. In MMORPGs, solo classes possess a wider range of stats, but typically at lower levels. They can perform multiple functions when in a group, but usually only in a supporting role (depending on the specific class). Class solo ability can be a site of conflict between the game designers and the players. Since game play periodically changes with every "patch" (routine maintenance times reserved for fixing in-game "bugs" as well as updating software code), it is common for certain classes to get "nerfed" if designers perceive that a certain class has an unfair advantage over other classes. Since MMORPGs stress group participation to such an extent, solo play can be a

disadvantage at high levels, since the best quest rewards can only be achieved through group work.

4 A guild is the primary social tool in MMORPGs and is designed specifically to foster strong ties between players and group identity. The main tenet of a guild is to gather players with similar methods of game play, to help other members in the guild progress through a given quest, and to help each other work towards a common goal—whether that goal is in-game or manifests in community building out-of-game. Guild involvement takes place online but can also manifest offline, depending on the specific locations of guild members and the amount of technology used to maintain offline connections, including Skype, IM, Facebook, and VoIPs such as Ventrilo. It is not uncommon for offline friendships to manifest as online guild memberships and vice versa. They can range in size from 10 different players to hundreds, depending on the desired outcomes of that individual guild. While some guilds are informally governed and include casual play styles (family guilds, for example), "hardcore" raiding guilds typically contain a formal hierarchy of governance and maintain specific requisites for game play involvement. Raiding guilds are typically larger in size, require a screening process before acceptance into the guild, and prefer players to have certain types of equipment, stats, raid knowledge, achievement level, and time commitment in order to be a member. There is typically an online application and interview process that must be completed before a member is accepted.

5 All references to the players associated with this study are referred to by their main avatars' names as a way to maintain a semblance of privacy.

6 One aspect to consider within the context of this study is the genre of the games listed. None of the girls present in the study play online games that are not heavily fantasy based. This is also true of the adults who acted and continue to act as mentors. While there are numerous digital games, console based as well as online, that stress overt military occupation e.g., America's Army and Full Spectrum Warrior, none of the girls have been exposed to this type of gaming. Nick Dyer-Witheford and Greig de Peuter explore the banalization of war as a method of empire building and hegemony in *Games of Empire* (2009).

7 Many of these aspects are discussed at http://www.gamergirlsunite.com/news.php and www.lesbiangamers.com.

Works Cited

Dyer-Witheford, N., & de Peuter, G. (2009). *Games of empire: Global capitalism and video games*. Minneapolis: University of Minnesota Press.

Kenway, J., & Fitzclarence, L. (2000). Institutions with designs: Consuming school children. In T. Seddon & L. Angus (Eds), Beyond nostalgia: Reshaping Australian education (pp. 105–128). Victoria, Australia: The Australian Council for Educational Research.

Kline, S. (2003). *Digital play: The interaction of technology, culture, and marketing*. Montreal, Canada: McGill-Queen's University Press.

Morrison, C. (2010). *Who do they think they are? Teenage girls & their avatars in spaces of social online communication*. New York: Peter Lang.

Nakamura, L. (2009). Don't hate the player, hate the games: The racialization of labor in World of Warcraft. *Critical Studies in Media Communication, 26*(2), 128–144.

Sweeney, K. (2008). *Maiden USA: Girl icons come of age*. New York: Peter Lang.

Thomas, D. (2008). KPK, Inc.: Race, nation, and emergent culture in online games. In A. Everett (Ed.), *Learning race and ethnicity: Youth and digital media* (pp. 155–173). Cambridge, MA: MIT Press.

Thorke & Zhebrica. (2009). All gay guild :). Message posted to http://forums.wowlite.net/thread.php?id=5974478802&pageNo=2&forumID=

Toffoletti, K. (2007). *Cyborgs and Barbie dolls: Feminism, popular culture and the posthuman body*. London: I.B. Tauris.

Watkins, S.C. (2009). *The young & the digital: What the migration to social-network sites, games, and anytime, anywhere media means for our future*. Boston, MA: Beacon Press.

Chapter 10

Back to the Future: Women Art Technology

Jennifer Way

"New cyberfeminism has just begun to scrutinize, publicize, and contest the complex effects of technology on many aspects of women's lives"
—Fernandez & Wilding (2002, p. 27)

Introduction

As the art world increases its reliance on technology to make, exhibit, study, teach, and preserve the visual arts, including technology-based art, we find ourselves not far advanced from the situation its members faced some 40 years ago—lacking of attention to women's activity. In response, this essay proposes that being a cyberfeminist obliges us to redress an ongoing pattern of omission in studying women using technology in the visual arts.

Scholars of the history of technology show that since the 19th century, as modern Western societies attributed the ability to create and wield technology to men, they concurrently socialized women to perceive that what technology consists of, how it works, and what it may be used for is beyond their ken. Also, until recently, histories of technology did not feature women engaging with technology in capacities other than as passive consumers. Consequently, researchers and educators, academic institutions, and philanthropic organizations developed programs geared to generating new knowledge about gender and technology and helping women obtain skills and networking requisite to their entering and remaining in what are known today as the STEM fields, or Science, Technology, Education, and Mathematics.

Similarly, the historiography of art has lacked discussion about women using technology in historical and contemporary art contexts. The omission continued even during the late 1960s and early 1970s, when criticisms about sexism in the historical record and in gallery and museum exhibitions gained traction in the art world. Since then, technology has become central to the operations and content of all facets of art-world activity, and it behooves us to inquire whether and how women in the visual arts are engaging with it. A reason to do so is the feminist insistence that, as a matter of parity in the his-

torical and contemporary record, women's participation in the visual arts warrants the scholarly and critical attention that men's does. In addition, historians of technology who adopt constructivist and feminist approaches show that the social and cultural construction of gendered identity is an ongoing process of mutual determinations involving technology. Yet although the cyberfeminist collective subRosa urged us to "make visible the effects of the interconnections of technology, gender, and difference" (subRosa, 2002), by and large we have not documented or interpreted technology, gender, and art interrelating in visual arts contexts.

As an art history professor, I teach courses in the history of art and technology to students enrolled in studio, design, art history, art education, and interdisciplinary degree programs. They want to learn about art's past, explore its connections with the present, and use existing research about art and technology as a context for and as content in their own work. In recognition of their interests and in response to subRosa's call, in 2008 I developed Women Art Technology. This ongoing oral history research project trains undergraduate and graduate students to remedy a lack of attention to the study of women using technology in the visual arts in ways that model the importance of the topic while advancing our knowledge about it.

Women Art Technology challenges students to learn how "[w]omen all over the world daily encounter...technology in their lives and communities" in the context of their participation in the visual arts (subRosa, 2002). It does this by training students to interview anyone over the age of 18 who self-affiliates as female and uses technology in the contemporary art world in any capacity, such as (but not limited to) artist, designer, educator, critic, historian, researcher, collector, museum and gallery worker, conservator, and image and object technician. Students ask their interview subjects to define technology in their own words and to explain how they use technology in the visual arts, whether they trained to use it and, if so, what the training consisted of, how they compare and contrast what technology is in the art world with what technology is in everyday life, and what advice they may have for young women interested in using technology in art. So that geographic distance does not preclude a subject from participating, students conduct all of the interviews by telephone. In my office, a device linking the project telephone with a dedicated laptop captures the interviews as digital audio files that software archives electronically. Subsequently, the interviews may be listened to individually, or passages among several may be identified for comparison. They may be uploaded into presentations and lectures or shared

telematically. To date, students have conducted more than 50 interviews, and 9 more are scheduled for the spring semester 2011.

To clarify why Women Art Technology interviews women about their use of technology in the visual arts, in what follows I revisit the work of first- and second-generation feminist art historians. Of importance is that as the concerns of the first generation emerged, on a parallel course the art world intensified its interest in technology but failed to notice women's lack of participation. Moreover, we shall see that a reason why Women Art Technology arches back to the work of feminist art historians active during the 1970s and 1980s is that some members of today's art world suggest that conditions have not improved for women in general. Fascinatingly, a review of emerging research fails to dispel a pattern of neglecting to study the relationship of women, technology, and art on other points. Then I shift to feminist approaches to technology in history-of-technology studies to highlight the conceptual foundations they give Women Art Technology. Additionally, I draw parallels between feminist interests in oral history and autoethnography, and the pedagogic significance of Women Art Technology. In my conclusion I review the state of the project and indicate how students' autoethnographic insights may modify its future.

Missing Women

During the 1970s, scholars, critics, curators, and artists of what would become the first generation of the American feminist art movement documented the activity of contemporary women artists and sought to recover historical women's art. Also, they debated how to answer the question that Nochlin (1971) posed: "Why have there been no great women artists?" In summarizing the research that subsequently responded to this question, Gouma-Peterson and Mathews (1987) noted:

> The debate over "greatness" exemplifies the nature of the issues raised among the first generation of feminist writers. By emphasizing the primary role of institutional factors in determining artistic achievement, Nochlin challenged the myth of the great artist as one who is endowed with that mysterious and ineffable quality called genius. However, as Norma Broude later pointed out, she did not question the authority or validity of the male-defined notion of greatness and artistic achievement. (p. 327)

From the vantage point of 1987, as they retrospectively pondered developments in scholarship on women artists since the early 1970s, Gouma-

Peterson and Mathews worked from an understanding of sexism as a flexing of patriarchy in their present-day society. Interestingly, like the first generation, they witnessed institutionalized patriarchy in major art world institutions, for example, in the ways the art world maintained economic disparity, and in the failure of exhibitions and published scholarship to equally represent men and women who were active in the art world (p. 351). In noting that during 1970, the 22% figure of women artists in a Whitney Museum of American Art annual exhibition actually represented an improvement in the number of women included—likely as the direct result of a protest held by the Ad Hoc Committee of Women Artists—Gouma-Peterson and Mathews commented that the percentage of women "remains almost the same today, despite continuing feminist activism" (p. 332). Nearly a quarter of a century would pass after Gouma-Peterson and Mathews published "The Feminist Critique of Art History" before the Whitney Museum of American Art's Biennial (2010) featured more women than men, which the museum's education staff noted "was a key point in much of the media's coverage of this year's exhibition."

The Whitney Biennial of 2010 notwithstanding, some scholars and critics say sexism remains a significant force in the contemporary art world. In her introduction to the catalogue for the exhibition, *Wack!Art and the Feminist Revolution,* Butler (2007) quoted Phelan for a definition of feminism: "the conviction that gender has been, and continues to be, a fundamental category for the organization of culture. Moreover, the pattern of that organization usually favours men over women" (p. 15). In reviewing a recent spate of exhibitions looking back at 1970s activity, including *Wack!* And *Global Feminisms*, which Maura Reilly and Linda Nochlin curated for the Brooklyn Museum of Art's opening of the Elizabeth A. Sackler Center for Feminist Art in 2007, Reckitt (2006) explained that she wrote an essay for the latter exhibition and realized in some respects that not much has changed. "Why have museums been so reluctant to acknowledge the feminist art movement" of that decade, she queried. "Sexism is still so insidiously woven into the institutional fabric, language, and logic of the mainstream art world that it often goes undetected. It's quite alarming—and disheartening—how prevalent it remains" (p. 40). As evidence, Reckitt offered this statement: "For my *Global Feminisms* catalogue essay I researched the ratios of male/female artists shown and collected by contemporary art museums. The statistics are even worse than I had imagined. And those for artists of colour are worse still" (p. 40).

Intriguingly, as Nochlin and her peers problematized the art world's failure to notice women, a particular theme in vanguard art activity was enfolding men and technology. Rosen says that by 1989 "women were slowly winning visibility within the validating network[s]" (1989, p. 10) of the art world, and "[i]f the term artist has become relatively gender neutral, it is in no small measure due to the relentless protests, exhibition activity, and revisionist writings of feminist artists, critics and art historians, which amounted to a prolonged consciousness-raising session" (p. 15). Nevertheless, during the 1970s and into the 1980s, technology certainly was not gender neutral.

The paradigmatic example was "[t]he exclusion of women artists from the major Art and Technology exhibition mounted by the Los Angeles County Museum of Art [LACMA], in 1971," which "set off a storm of protest, resulting in the formation of the Los Angeles Council of Women [Artists] (LACWA)" (LACWA, p. 98). Women were not included among the vanguard artists whom LACMA placed with corporations to collaborate in advancing knowledge about art and technology. Thus, whereas *Time* (1971) reported that a purpose of Art and Technology "was to show feedback and that its very unpredictability can be stimulating," the project did not motivate the art world to place women anywhere but on the project's margins, as museum workers. Also, the project represented women as mythological figures, in one case, as muses associated with primordial ooze. Participant artist Robert Rauschenberg's *Mud Muse* was

> a tank filled with sloppy, coffee-colored drillers' mud supplied from one of Teledyne's offshore oil rigs. Pipes in the floor of the tank emit air bubbles, which plop to the surface at random with a kind of lazy flatulence. The pipes in turn are controlled by an elaborate electronics system, which converts signals from taped music and random noise in the room into a pattern of air release. (Art: Man and Machine, 1971)

Nor did critics reviewing the project in vanguard art journals object to the absence of women artists. To be sure, in her review of the E.A.T. [Experiments in Art and Technology] installations and performances held at the Brooklyn Museum in 1968, Goldin (1972) reproduced an image of Casdin-Silver's piece called *Exhaust*. After all, Casdin-Silver (1972) was a pioneer of holography in art, though Goldin did not write about this. Instead, she asserted that "art-and-technology" is important because "it reaffirms art's ability to 'contain' certain kinds of reality" (p. 48), and "[m]aking art is not simply esthetic behavior. It is bound into the social system in very specific ways" (p.

51). Goldin apparently did not gauge women to be an important part of the reality of art or the art world's social system, but others did. In response to the failure of LACMA to include women artists in its Art and Technology exhibition, on June 16, 1971, the *L.A. Free Press* reported that LACWA calculated that "women represent 53% of the population. Yet at the Los Angeles County Museum of Art, between 1961 and 1971, only 4% of the works shown in groups have been done by women." According to the newspaper, LACWA stated:

> We were particularly provoked by the blatant discrimination against women in the highly publicized Art and Technology show new at the Los Angeles County Museum of Art. Sixteen artists are represented in this invitational show—NONE are women, NONE of the technical advisors with whom they collaborated were women.

Ironically, LACWA observed:

> The Art and Technology show has been heralded as "the wave of the future." If this is so, then we are most distressed to observe that there are no women in it. Distressed, but not surprised. Women in our patriarchal society are supposed to be consumers, not producers. The more museums and artists ally themselves with big corporations, which are sexist by definition, the more the art world will have a vested interest in ignoring the works of women artists.

Another critic noted the narrowness of Art and Technology's selection of artists: "no Europeans, and few artists outside the New York City Area" (Burnham, 1971, p. 66). He, too, failed to register the lack of women artists, though he credited "Jane Livingston and Gail Scott...for much of the best writing in the catalog" (p. 66). Only Kozloff (1971) reported that "artists, known and unknown, of every imaginable idiom, and many nationalities, were approached (excepting blacks, Chicanos, and women)" (p. 73). Those selected, he asserted, "became a nominal, if semidetached and temporary employee of a company. His status resembled that of an industrial intern" (p. 71) working with the corporate sponsors who amounted to a "rogue's gallery of the violence industries" that had "grown to their present bulk through their business of slaying" by producing military hardware, leaving the artists to "freeload at the trough of that techno-fascism" (p. 76).

If, as Reckitt posits, women in today's art world have yet to achieve consistent parity with men, how likely is it that their situation has improved since the early 1970s in regard to technology? On the one hand, any cursory review of existing scholarship about art reveals technology engaging with

every conceivable facet of the art world. On the other hand, as we have seen, the efforts of a first-generation feminist art movement to gather knowledge about historical women artists; achieve equal access to opportunities, critical attention, and recognition of participation and success for living women artists; and identify and interrogate the social and cultural conditions that make success in the art world possible failed to impact the then-most-visible, vanguard art-technology project. Furthermore, the question of what, if any, attention we are paying to women in the art world using technology today must be posed in light of insights from scholars of the history of technology. For instance, Judy Wajcman (2010) relates that "Women's identities, needs and priorities are configured together with digital technologies" (p. 151). Wajcman and her colleagues have shown that in the modern industrialized West, technology was conflated with men and masculinity in terms of agency and power and correspondingly understood to define a woman as its receiver and consumer. Moreover, Wajcman says technology continues to be gendered and to work by gendering: "[I]n contemporary Western society, the hegemonic form of masculinity is still strongly associated with technical prowess and power." Correspondingly, "[n]otwithstanding the recurring rhetoric about women's opportunities in the new knowledge economy, men continue to dominate technical work" (p. 145). If this is the case, we must inquire why we are failing to examine not simply what artists are doing with technology, including whether or not they are critiquing something about its social or cultural significance, but also what work with technology women are doing in the visual arts, how technology is organizing identity in the art world and as part of the work the arts contribute to society at large, including in terms of gender, and in what, if any, ways it is maintaining or changing a "hegemonic form of masculinity" affiliated with technology.

Undeniably, some vital contributions have been made to these topics. In developing her art project *She Loves It, She Loves It Not* (1995), Christine Tamblyn studied "the design of computer interfaces that are more user-friendly for women" and do not have a masculine bias of "a violent, aggressive character modelled on video games" or "are hierarchical, mirroring the militaristic male pyramid with its rigid chain of command" with "a predominantly visual bias, privileging the male gaze and masculine strategies for control through surveillance of territory" (Tamblyn, 1995, pp. 102–103). Tamblyn's work prior to and following this project and continuing until her death in 1998 made her one of a small number of artists who creatively inquired about gender and technology interconnections. During the 1990s Leo-

nardo On-Line posted a notice for a special project it called "Women, Art and Technology: Leonardo Papers." Although the page states that it was updated in 2006, the bibliographic entries it lists were published between 8 and 18 years prior. In 2003, Judy Malloy published the anthology *Women, Art and Technology*, "which originated in a *Leonardo* journal project of the same name." It featured short essays by women artists whom the MIT Press described as "play[ing] a central role in the development of new media practice."[1] Notwithstanding this initial effort to hear from and about women artists using technology in a specific art genre, a brief review of current literatures confirms ongoing deficiencies in academic research.

For one thing, major resources for information about new scholarship in art, technology, and science do not reveal graduate students studying women or gender in relation to art and technology. For example, the results of a keyword search of dissertation titles and abstracts compiled by Leonardo Abstracts Services indexing abstracts for PhD, Master's, and MFA theses "in the emerging intersection between art, science and technology" through September 8, 2010, showed 3 out of 313, or less than 1%, of new titles and abstracts referencing women and 8, or 2.5%, referencing gender. Figures compiled from other databases were no more impressive. In the humanities, through October 25, 2010, ProQuest Dissertations & Theses, which includes the UMI Dissertation Publishing Group listing more than 65,000 new dissertations and theses each year, indexed 31 titles for the combination of keywords technology, women or gender, art and art history, as compared with 1,201 titles and abstracts for the keywords women, art and art history, and 499 for art, art history and technology. WorldCat dissertations and theses, a subset of the WorldCat database, yielded the following numbers: for the combination of search terms gender, technology and art, 30 records; technology, women, art, 112 records; gender, art, 887 records; women, art, 3,960 records; and technology, art, 4,110 records.

Turning from emerging scholarship to published work, for the more than 100 books it reviewed during 2010, *Leonardo Reviews*, which publishes reviews of books, exhibitions, CDs, websites, and conferences exploring art, science, and technology, showed neither women nor gender in any title. The list of several hundred titles that the site reviewed between 2005 and 2009 showed one book with women in the title and none with gender. From those it reviewed between 2000 and 2005, four referenced women in the title and one, gender.

Another dimension to consider is that our current lack of scholarship about women using technology in the past or present may be impacting how we conceive of the future state of the field. In *Educating Artists for the Future: Learning at the Intersections of Art, Science, Technology and Culture* (Alexenberg, 2008), 22 scholars, artists, and educators discuss preparing artists to work at the front of technoculture. They grapple with questions of creativity, art education, art/science education, scientific knowledge, ethnicity, religion, interactivity, Eastern Europe, transgenic art, dance, graphic design, art history, graduate education, media literacy, immersion, play, creativity, and communication. Collectively, they ignore gender and the history of women's relationship to technology.

In itself, the dearth of scholarship about women and technology in the art world is unsettling. It becomes more grievous when considered in combination with scholarship from outside the art world that tells about women leaving technology fields, such as Thomas Misa's anthology *Gender Codes: Why Women Are Leaving Computing* (2010), and in light of conflations of masculinity with the origins of computer and information technology, as in Nathan Ensmenger's *The Computer Boys Take Over: Computers, Programmers, and the Politics of Technical Expertise* (2010), and Thomas Green's *Bright Boys: The Making of Information Technology* (2010).

Certainly, organizations devoted to educating women to work in technology fields abound. Think of both the National Center for Women and Information Technology and the Anita Borg Institute for Women and Technology. Their programs, funding, and literature supplement higher education curricula to redress the "digital divide" and other types of gaps between women having access to digital and information technology as well as technology, science, and engineering training, and those lacking access to it. Other examples directly involve educational institutions. Since 1994, the Lemelson-MIT Program funded by the Lemelson Foundation and managed by the Massachusetts Institute of Technology's School of Engineering has recognized inventors, supported high school and college student research, and bestowed awards on young, mid-career inventors including for the purpose of "promot[ing] role models who can inspire young people to pursue creative lives and careers."[2] Within the Smithsonian Institution's National Museum of American History in Washington, D.C., the Jerome and Dorothy Lemelson Center for the Study of Invention and Innovation promotes "Innovative Lives" programs and other resources for middle school students, including links to information about Women Inventors.[3] It makes the archival

material it collects available to scholars and educators, too. For example, videotaped lectures feature Janese Swanson who "developed video game software, a web site, and an array of toys and gadgets aimed at making technology more accessible to girls" through her company, GirlTech.[4] Now owned by Mattel, it markets a range of "real electronic products" internationally to tweens or girls ages 8–12.[5] The Lemelson Center includes Swenson with the other women inventors it covers in its "She's Got IT! Women Inventors and their Inspirations" educational programs and materials.[6] Laudable as they are, neither the organizations nor the research they fund about gender and technology address technology in the visual arts.

Incredibly, we lack within the art world both emerging scholarship and major institutions researching women, art, and technology. To be sure, some excellent institutions make information about women artists and their work available to researchers and the public. Two important examples are the Rutgers Institute for Women and Art, which encompasses the Feminist Art Project and WAAND (Women Artists Archives National Directory), and the Brooklyn Museum's Elizabeth A. Sackler Center for Feminist Art. Both have constructed impressive online databases searchable by "technology." Like them, Women Art Technology wants to support "the work and agency of individual women artists," including but not limited to "the idea of a feminist expression grounded in women's real life experiences" (Broude & Garrard, 2005, p. 2). Yet neither institution emphasizes technology, although as part of National Women's History Month in March 2011 the Feminist Art Project, an "annual series [that] considers the most current critical issues and concerns for women artists," presented a two-part artists' panel, "From the (Trans)Gendered Body to the Cyborg: Feminism, Art, and Technology," which considered the question: *How has our relationship to the body changed as various areas of technology, including medical technology, have advanced"?*[7] Art institutions that do focus on technology, such as the Daniel Langlois Foundation for Art, Science and Technology, and the Rose Goldsen Archive of Media Art, Cornell University, are not treating women or gender as a major topic of research or collecting, although at the former, one can search using "women" or "gender," and the latter houses artist Lynn Hershman Leeson's archive.

Feminist Approaches to Studying Technology

The conceptual foundations for Women Art Technology were largely inspired by the work of history-of-technology scholars who explore feminist approaches to studying technology. They reject "the notion that technology is simply the product of rational technical imperatives" and embrace a "social constructivist framework" that understands "technology as both a source and consequence of gender relations" (Wajcman, 2020, p. 149). Crucially, they allow that "different groups of people involved with a technology…can have very different understandings of that technology, including different understandings of its technical characteristics" (MacKenzie & Wajcman, 1999, p. 21).

Furthermore, the notion that art informed by technology is gendered follows from the precept that "[o]bjects and artefacts are no longer seen as separate from society, but as part of the social fabric that holds society together; they are never merely technical or social" (Wajcman, 2010, pp. 148–149). Conversely, "gender relations can be thought of as materialized in technology, and masculinity and femininity in turn acquire their meaning and character through their environment and embeddedness in working machines. Such a mutual shaping approach recognizes that the gendering of technology affects the entire life trajectory of an artefact" (p. 149). Beyond the artefact, "[t]he gendering of technologies can then be understood as not only shaped in design, but also shaped or reconfigured at the multiple points of consumption and use" (p. 150). There is also the gendering of people with and through technology conceived as a social and cultural relationship that produces gender identity and difference, including inequalities. Thus, feminist approaches to the history of technology hold that "the increasingly complex intertwining of gender and technoscience [is] an ongoing process of mutual shaping over time and across multiple sites" (p. 150).

The ideas are fairly recent. Oldenziel reminds us that "the word technology…did not enter American culture as a key word until World War II" (2002, p. 55). Nor did "women," "gender," or phrases like "gendering of technology" appear in mainstays of technology research until later, including in *Technology and Culture*, the journal that the Society for the History of Technology began to publish in 1959. For more than a decade, its issues lacked women as authors of peer-reviewed articles or as a topic studied in relation to technology. Then, a few years after Nochlin asked why there weren't any great women artists, *Technology and Culture* began publishing

articles about machines in the home that were written by women and dealt with women as users and subjects of technology. Wajcman (2010) says the "initial challenge for feminists" was "to demonstrate that the enduring identification between technology and manliness is not inherent in biological sex difference" (p. 144). This led them to inquire about conditions and choices that contributed to conflating technology with masculinity to the extent, as Oldenziel reported, that "[m]achines became a dominant metaphor, model, and material embodiment of [technology's] subject matter and, as such, a symbol of male power" (Oldenziel, 2002, p. 56). Subsequently, Cockburn (1992), Wajcman (2010), and Oldenziel (2002) respectively traced features of the history of what Cockburn calls "technoscience" (p. 41) involving what Wajcman charted as the growth of the disciplinary knowledge and professional practice of this "male power." Wajcman explained, "mechanical and civil engineering increasingly came to define what technology is, diminishing the significance of both artefacts and forms of knowledge associated with women. This was the result of the rise of engineers as an elite with exclusive rights to technical expertise" along with "the creation of a male professional identity" that "involved an ideal of manliness, characterized by the cultivation of bodily prowess and individual achievement" (Wajcman, 2010, p. 144). Occasionally, women surfaced in the historical record as an odd absence. Stanley studied the U.S. Patent Office's intentional omission of recording women's inventions during 1876, which "coincided with the paradigmatic shift to seeing inventions as machine-bound and masculine" (Oldenziel, 2002, p. 57).

Of critical importance to Women Art Technology is that the conflation of technology with masculinity has not remained a thing of the past. Wajcman (2010) reiterated, "in contemporary Western society, the hegemonic form of masculinity is still strongly associated with technical prowess and power" (p. 145). Unless otherwise stated, so do men remain its implicit creators, distributors, analysts, and users, although especially in regard to consumption, women now feature as the subjects of history of technology studies. Yet, as with the first generation of feminist scholars in art history, questions about women's access and opportunity vexed early scholars researching the history of technology, and they continue to interest their contemporary peers. Even so, this has not prompted Women Art Technology to recover an as-yet-unwritten history of women's achievements using technology in the arts that would stand as an art historical corollary to Autumn Stanley's *Mothers and Daughters of Invention: Notes for a Revised History of*

Technology (1995), which discovers women contributing to the development of computers and computing. In fact, Women Art Technology does not document the creation of a technology or dwell on innovation or technological change, as many technology studies have done. It declines seeking out originators because it assumes that creativity informs all types of cultural and social practices with technology. Using technology encompasses making do with, repurposing, and retooling. Equally, "technological innovation is itself shaped by the social circumstances within which it takes place"(Wajcman, 2010, pp. 148–149). Interestingly, some interviewees expressed the notion that "the social meanings of technology are contingently stabilized and contestable, that the fate of a technology depends on the social context and cannot simply be read off fixed sets of power arrangements" (p. 150). This is a reason why the project wants to continue to hear from women what they perceive are the social and cultural circumstances in which they use technology in the visual arts and what, if any, bearing these have on their activity. On this point, the project more closely follows Stanley's "Women Hold Up Two-Thirds of the Sky" because, as Stanley explained, a "revised account [of technology]...fairly and fully evaluating women's contributions through the ages, is long overdue" (1983, p. 17), including in the art world.

To be sure, embracing individuals who self-identify as "women" makes Women Art Technology vulnerable to maintaining the unproblematized, hegemonic heteronormativity that Landstrom revisits in terms of Butler's (2007) notion of the "heterosexual matrix"; it "assumes that for bodies to cohere and make sense there must be a stable sex expressed through a stable gender (masculine expresses male, feminine expresses female" and "stabilized bodies of women and men" are "represented as 'oppositionally and hierarchically defined through the compulsory practice of heterosexuality'" (p. 14). Therefore, "[t]o be recognized as a 'woman' it is necessary to remain in the heterosexual-feminine corner" of this grid (p. 14); because "[t]echnology is located on the 'masculine' side," "[f]emales doing masculinity and lesbians (who are regarded as expressing a 'masculine' desire for women) are not covered by the signifier 'women' in this semiotic grid" (p. 14). Still, Women Art Technology does not expect "that all women relate to technology in a way that reflects heteronormative femininity" (Landstrom, 2007, p. 12). Its open-ended questions intend to it make it possible "for women to express something other than femininity" (p. 12). In response to the notion that "[t]echnology was seen as socially shaped, but shaped by men to the exclusion of women" (Wajcman, 2010, p. 147), the project's purpose is to redress

that "not enough attention was paid to women's agency" (p. 147) by chronicling real women reflecting upon their agency with what they define as technology in and out of the art world.

Students "Listening to Women's Words" and to Their Own

When I organized Women Art Technology I planned to conduct all of the interviews. However, as I wrote questions about women's training in technology, I realized the project had great potential for student learning. Consequently, I became its administrator and served also as the mentor for students conducting interviews. I anticipated that interviewing women active in the art world would help to raise students' consciousness about women using technology in visual arts contexts as a vital research topic and empower them with skills to generate new knowledge about it.

In these respects, I thought of Women Art Technology in terms of feminist pedagogy and oral history that emphasize "acquiring and practicing (embodying) skills, knowledge and consciousness" (subRosa, 2002). I liked that this also moved the project toward the problem-based learning valued at my home institution. Problem-based learning shifts the focus of classrooms from teachers delivering information to students in lectures, to students learning as teachers charge them with problems and facilitate their developing solutions. Problem-based learning seeks to place "the learner and the process of learning at the very heart of its activity," the activity being the exploration and creation of knowledge" (Office of the Provost and Vice President for Academic Affairs, 2008).

The first students who volunteered to conduct interviews had no sense of the project's motivations or contexts. In fact, they reminded me of the young women whom Fernandez and Wilding taught:

> Our experience teaching in various institutions of higher education in the United States suggests that many young college women (ages 18–23) of various classes and backgrounds know little of the history of feminist thought and action. They talk incessantly about the tyranny of the fashion world and mass media, the pressure to be thin, pretty, nice, and to get a boyfriend, as well as the high incidence of eating disorders and sexual violence experienced by themselves and their friends. When asked for a definition of feminism they most often say that it means equal rights for women, and they are quite sure that in the United States we have these. (2002, p. 20)

I realized that once I placed students at the project's center, I had to train them in its purpose and methods. Conversely, insofar as the project would

benefit directly from their participation, I wanted to make sure students would learn about themselves, too. I began to limit student interviewers to students enrolled in courses I was currently teaching and for whom I could offer conducting interviews as an option they were invited to select for an assignment. A downside is that this may have slowed the production of interviews by reducing the potential number of students who would create them. A benefit is having steady access to student participants for an entire semester when I can train and supervise them and benefit from their insights.

For additional guidance I studied feminist research and activist projects that are issue driven or seek to engage with topics impacting women by referencing specific historical figures. Two examples are the cyberfeminist collective subRosa, the name of which "honors feminist pioneers in art, activism, labor, politics, and science: Rosa Bonheur, Rosa Luxemburg, Rosie the Riveter, Rosa Parks, Rosie Franklin" as it creatively researches technology and "women's bodies, lives, and work" (subRosa, 2002). Also, since 1985, members of the Guerrilla Girls have been known by the names of historical women artists when they wear "gorilla masks in public, concealing their identities and focusing on the issues rather than their personalities," primarily sexism in the art world.[8]

Now, in my courses dealing with methods, theories, or histories of technology in the visual arts, I ask all of the students to analyze (1) texts that survey art history, and (2) texts that survey the history of technology and art, for information about gender and evidence of the representation of historical and contemporary women. Also, students consider how their degree programs model connections between history and the present day. I realize I am trying to show students the relevance that history has for their studies and increase their sensitivity to questions about what and whose activity merits chronicling. The topic of history's merit occasionally elicits a charged discussion. Depending on their major, students may find themselves learning about the relevance of history in my courses yet hear in another that they should ignore it in order to innovate in a cutting-edge manner that transcends what has come before, because this is a paradigm for artistic creation. So I have tried to present history as a practice that happens in and informs the present insofar as we use the present to define and narrate the past, because of the improbability that we transcend existing contexts that shape us discursively, and based on what history of technology scholars show is the reality of discovery—a painstakingly slow, multi-step, non-linear process of building closely upon the current state of knowledge. In one class, this last theme inspired

discussion about technological determinism and launched questions about voice, which informs Women Art Technology in several ways.

In class I ask students to explain how they would revise histories of art and technology to include more discussions about gender and women. Also, I ask them to compare their recommendations with what I relate about Women Art Technology's approach to documenting women using technology in the art world. I tell them the project uses a feminist appreciation of oral history to provide "women [with] having access to the position of speaking subjects and 'having a voice' in our culture" (Tamblyn, 1995, p. 104). Furthermore, they learn that instead of my voice dominating, from the start I organized the project to feature its interview subjects in their own words. Typically, this point generates discussion because—at least tacitly—some students are learning that as part of the era of postmodern art and theory, the personal narrative representing a "coherent, individual self has been...called into question" (Reed-Danahay, 1997, p. 2). Nonetheless, they learn from me that in addition to its importance in feminist and oral history scholarship, the interview remains a staple of contemporary art criticism and scholarship. Typically, it treats the living subject as a resource that should be consulted about the art in question. In addition, according to Miller, interviews with artists "document procedures of networking and serve to embody one in particular," the activity and interests of the art world and corresponding ways in which both interviewers and interviewees are beholden to its terms through their formal and informal roles and affiliations. They

> are hostage to the influence passing through them, neither is free to follow their own devices. Both come to the table with baggage, cases criss-crossed with the stickers of the ports that they have passed through and a couple of visas which might yet be revoked—some of which they don't even know they have. (Miller, 2009, p. 9)

Whereas Miller has famous artists in mind, Women Art Technology aims to capture a first-person account of an individual self-identifying as a woman over the age of 18 who is willing to respond to questions about her use of technology in any capacity in the art world.

In reference to her art, Tamblyn wrote: "Just as feminist theorists have stressed the importance of women having access to the position of speaking subjects and 'having a voice' in our culture, it is similarly important for women to have role models for computer literacy as computers become an essential communications tool" (1995, p. 104). Pedagogically, students par-

ticipating in Women Art Technology are taught that historical and present-day models for understanding technology hold importance for all students. In a recent press release, the Lemelson-MIT program said that its 2011 Invention Index survey showed that "American women ages 16–25 possess many characteristics necessary to become inventors, such as creativity, interest in science and math, desire to develop altruistic inventions, and preference for working in groups or with mentors—yet they still do not see themselves as inventive."[9] While men "echo these characteristics," in contrast to women, men see themselves as more inventive. The report quotes the Fall 2009 U.S. Department of Education, National Center for Education Statistics, from its 2008–09 Integrated Postsecondary Education Data System (IPEDS), showing that "while more women are entering college and obtaining degrees, less than ten percent earn them in technical majors such as computer and information sciences, engineering or math." In other words, women are not moving into "inventive careers." The report graphed "Young Adult Invention Interests" as a percentage of male and female interest in six areas of invention. Women trail men in areas ostensibly most related to new media and technology programs in the arts: interest in web-based invention and performing arts invention.

In the classroom and also as part of Women Art Technology, I integrate "'having a voice' in our culture" with demystifying research and increasing agency. In the classroom I ask students to become aware of "exclusive expertise" and "proprietary knowledge" (subRosa, 2002) about technology by questioning how historiography associates technology with what and whom a society considers powerful and empowering. Students also analyze whether they are affiliated with or belong to forces that historically or currently are considered powerful and empowering, and whether and if so how this impacts their uses of technology.

Conducting an oral history interview has turned out to be a major point at which research is demystified to an extent for participating students. When they come to my office to conduct interviews, students are both amazed and confounded that their teacher's guidance, assigned readings and related homework, class discussion, a few meetings, a telephone connection, a simple recording system, and software to capture, edit, and archive audio files are all that is needed to interview subjects and build an oral history archive that aspires to contribute significant knowledge to academia and the art world. The project's telephone often serves as a catalyst for intriguing exchanges. The students are surprised that in the era of wireless technology and

social media, they are helping to develop knowledge about technology by us-
ing what to them is a very old-fashioned machine consisting of a clumsy
large handset connected by a cord to a stationary base featuring numbers that
appear gigantic in contrast to the minute key pads on the digital phones they
carry in their smallest pockets. As students sit in front of the project tele-
phone searching on their iPhones for the phone number of their subject, I ask
them to identify what to them seem like other technological anachronisms in
their studies.

Another point of demystification involves students learning what oral
history is and in what ways some of the project's practices and technologies
do not conform. For example, all of the participating students ask their sub-
jects the same questions, in the same order, during only one session, instead
of "occurring in multiple sessions, where a researcher aims at interviewing a
person about her or his life or a significant aspect of it" (Hesse-Biber &
Leavy, 2006, p. 190). I explain that available resources—mainly low-cost
hardware and software—and time limited by semester course schedules have
given the project its workable shape. Recording the interviews as digital files
as they take place does away with the need to find funds to hire someone to
transcribe oral accounts into typewritten documents. In contrast to changing
personnel and subjects, having students pose the same questions to all of the
subjects gives the interviews and thus the archive consistency and allows for
the archive to be searched by question and keyword or phrase.

It may be that as Women Art Technology "accept[s] women's own in-
terpretations of their identities, their experiences, and social worlds as con-
taining and reflecting important truths" (Geiger, 1990, p. 170), it will "survey
the dominant ideologies shaping women's worlds; listening to women's
words, in turn, will help us to see how women understood, negotiated and
sometimes challenged these dominant ideals" (Sangster, 1994, p. 7). The lis-
tening part of students' involvement is indebted to oral history. Moreover, it
encompasses aural as well as reflexive modes of paying attention.

I teach students that Women Art Technology aspires to capture "an ac-
count of one person's life as told to another, the researcher" (Brettell, 1997,
p. 224), with as many women as possible. What the subject tells her inter-
viewer represents "a [selected portion of a] life-focused life story that treats a
life as a window on the objective facts of historical and ethnographic events"
(p. 225). Yet students soon realize that doing interview-based research is not
a simple matter of acquiring rote skills. Some struggle to articulate questions
about research methods in general as they work out how interviews contri-

bute to the production of new knowledge. For others, conducting research with living subjects constitutes a welcome shift from what they sometimes experience as isolating studio work or library research. Most students benefit from a pre-interview practice session consisting of a face-to-face interview followed by one in which two students alternate in the roles of interviewer and subject sitting back to back. This alerts students to the challenges of understanding a subject and responding to her responses with follow-up questions using only her voice as a guide. Happily, it tends to give them a new respect for attentive listening, and it has even encouraged some students to remain alert and fully present in the classroom, which contravenes the disengagement I may have observed in them previously.

Participating students must listen reflexively to their interviews and to themselves. Pedagogically, the project transposes the notion that oral history is tantamount to "making a commitment to understanding meaning from the perspective of those being interviewed" (Hesse-Biber & Leavy, 2006, p. 162) into a post-interview task for which students compare themselves with "those being interviewed." The task asks students to experience that "[t]he role of the 'interpreter,' 'informant,' 'interviewee,' or 'subject' is to discuss the development of all or part of her life, as an individual, as a representative of a specific group, or as an eyewitness to specific historic events or periods" (Reinharz, 1992, p. 131). Since for so many students technology is a pervasive, normative, and unquestioned part of their lives, here they are challenged to consider what the interviewee said that might help them to perceive technology in a new way. An objective in asking students to compare themselves with what they learned about someone else especially involves developing empathy, "[t]he desire to discover and make room for the worldview of others [that] suits a postmodern sensibility, in which no one right form of knowledge exists and multiple viewpoints are acknowledged and valued" (Duncan, 2004, p. 30). The exercise also comes from the practice of "connect[ing] the autobiographical and personal to the cultural, social, and political" (Hesse-Biber & Leavy, 2006, p. 190) in the tradition of feminist research that aims to raise the consciousness of the individual in relation to the group and in relation to the group's contexts and histories.

Sometimes interview subjects voice metastatements: "they have made a statement, but now they are going to return to that statement in order to comment on it" (Hesse-Biber & Leavy, 2006, p. 162), and this leads to "moments of realization, awareness, and, ideally, education and empowerment during the narrative process" (p. 182). The project wants participating

students to benefit from self-awareness, too. After they conduct at least one interview, students pose the interview questions to themselves. In doing so, they become autoethnographers, that is, "researchers [who] use themselves as the subject of their research" (p. 82). Individually, students answer the questions in writing and synthesize and evaluate their responses to generate self-reflexive insights about their involvement in the project and uses of technology in the visual arts. Because the autoethnography produces personal narratives that students analyze in increasingly wider social contexts, it helps them grasp that the interviews are "a form of self-narrative that places the self within a social context" (Reed-Danahay, 1997, p. 9), say, within the art world as a microcosm of society or activity in the art world perceived in relation to non-art society, it helps them to understand subjectivity or a sense of self as an ongoing process.

Autoethnography implicitly asks student interviewers to appraise their experience as a valid source of information about their work and life. That most have embraced the exercise tells me the students want to "connect the[ir] autobiographical and personal to the cultural, social, and political" (Hesse-Biber & Leavy, 2006, p. 190) contexts of technology about which they are learning. Conversely, I have been educated by students rejecting my simply telling them that the project uses oral history as "[p]redominantly a feminist method…[that] allows us to get at the valuable knowledge and rich life experience of marginalized persons and groups that would otherwise remain untapped, and, specifically, offers a way of accessing subjugated voices" (Hess-Biber & Leavy, 2006, p. 151). Alternatively, I brought voices—the women subjects' and the student interviewers'—into the classroom, where together they helped us to appreciate that "the way that themes are brought into the person's narrative and their relation to other themes is important data" (Hess-Biber & Leavy, 2006, p. 162) for the art world to generate and analyze.

Conclusion: Foreword to the Future

Now that Women Art Technology has created over 50 interviews, it is time to publicize them and reflect on their potential uses while reassessing the project's methods. Some interviews have already been shared outside the classroom. Last year I presented an overview of the project at an international conference devoted to oral history research in the visual arts. Early in the project, six undergraduate students presented their research on women and

technology in the art world at a state-level art education conference. I will continue mentoring participating students to present on the project in order to deepen their understanding of connections between knowledge production and distribution and, through them, introduce Women Art Technology to academia.

According to Geiger, asking women to talk about technology is a feminist project of importance because it "presuppose[s] gender as a (though not the only) central analytical concept" that "serve[s] as a corrective for androcentric notions and assumptions about what is 'normal' by establishing or contributing to a new knowledge base for understanding women's lives and the gendered elements of the broader social world" (Geiger, 1990, p. 170). It is crucial that Women Art Technology is publicized in the art world because the art world's historical and ongoing lack of a knowledge base about women using technology in the visual arts continues to serve as the project's key motivation. Therefore, in an upcoming graduate art history seminar, the students and I will collaborate on an essay about gender and voice in the archive to submit for publication in a contemporary art journal. Furthermore, in my seminar my students and I will converse with creative and academic researchers in new media studio art, art history, cultural studies, gender studies, and the history of technology about the types of methodological approaches that research using the interviews warrant, and on how we can publicize our research and perhaps facilitate external scholars studying the interviews. Our goal is to publish research on the interviews in art world venues and thereby advance discussion on an understudied topic in the art world.

As the students and I shift from making to using the archive, I will continue to guide them in creating interviews, although the format may change. Students who completed the autoethnography grasp the value of self-reflexive and interview-driven insights, and consequently some have asked if it is possible to build more of this into the project by extending the interviews to several hours scheduled over a series of days or weeks. They are eager to assess the efficacy of the interview questions in light of what their own experience indicates the project may contribute to the contemporary scene of socially informed, collaborative art projects as well. I especially want students to consider how the project can serve their learning and research. For this reason, and in response to the assertion that "[b]iography and oral history have the potential of bringing women 'into' history and making the female experience part of the written record," I ask participating students how they recommend using the interviews in the classroom. Moreover, "This

form of research revises history, in the sense of forcing us to modify previously published accounts of events that did not take women's experiences seriously" (Reinharz, 1992, p. 134). To this point, I ask students what sorts of histories does Women Art Technology compel you to ask read, write, and be a part of.

Notes

1 http://mitpress.mit.edu/catalog/item/default.asp?ttype=2&tid=9905
2 http://web.mit.edu/invent/a-prize.html
3 http://invention.smithsonian.org/centerpieces/ilives/index.html
4 http://invention.smithsonian.org/resources/fa_swanson
5 http://uk.girltech.com/facts-historyMission.aspx
6 http://invention.smithsonian.org/downloads/wminventorsguide.pdf
7 http://feministartproject.rutgers.edu
8 http://www.guerillagirls.com/index.shtml
9 http://web.mit.edu/invent/n-pressreleases/n-press-11index.html

Works Cited

Alexenberg, M. (Ed.). (2008). *Educating artists for the future: Learning at the intersections of art, science, technology and culture.* Bristol, UK: Intellect Books.

Art: Man and machine. (1971, June 28). *Time.* Retrieved from http://www.time.com/time/magazine/article/0,9171,905268,00.html

Brettell, C.B. (1997). Blurred genres and blended voices: Life history, biography, autobiography, and the auto/ethnography of women's lives. In D.E. Reed-Danahay (Ed.), *Auto/ethnography: Rewriting the self and the social* (pp. 223–245). Oxford, UK: Berg.

Brooklyn Museum. (n.d.). Elizabeth A. Sackler Center for Feminist Art: Feminist Art Base: Joyce Kozloff. Retrieved from http://www.brooklynmuseum.org/eascfa/feminist_art_base/gallery/dcmooregallery.php

Broude, N., & Garrard, M.D. (2005). *Reclaiming female agency: Feminist art history after postmodernism.* Berkeley: University of California Press.

Burnham, J. (1971). Corporate art. *Artforum, 10*(2), 66–71.

Butler, C. (2007). Art and feminism, an ideology of shifting criteria. In C. Butler & L.G. Mark (Eds.), *Wack! Art and the feminist revolution* (pp. 14–23). Cambridge, MA: MIT Press.

Cockburn, C. (1992). The circuit of technology: Gender, identity, and power. In R. Silverstone & E. Hirsch (Eds.), *Consuming technologies: Media and information in domestic space* (pp. 32–47). New York: Routledge.

Duncan, M. (2004). Autoethnography: Critical appreciation of an emerging art. *International Journal of Qualitative Methods, 3*, 28–39. Retrieved from http://www.ualberta.ca/~iiqm/backissues/3_4/html/duncan.html

Fernandez, M., & Wilding, F. (2002). Situating cyberfeminism. In M. Fernandez, F. Wilding, & M. Wright (Eds.), *Domain errors! Cyberfeminist practices* (pp. 17–28). New York: Autonomedia.

Geiger, S. (1990). What's so feminist about women's oral history? *Journal of Women's History, 2*(1), 169–182.

Goldin, A. (1972, March/April). Art and technology in a social vacuum. *Art in America, 60,* 46–50.

Gouma-Peterson, T., & Mathews, P. (1987). The feminist critique of art history. *The Art Bulletin, 69*(3), 326–357.

Hesse-Biber, S.N., & Leavy, P. (Eds.). (2006). *Thepractice of qualitative research.* London: Sage.

Kozloff, M. (1971). The multimillion dollar art boondoggle. *Artforum, 10*(2), 71–76.

L.A. Council of Women Artists Report: Is woman a work of art? (1971, June 15). *L.A. Free Press.* Retrieved from http://collectionsonline.lacma.org/mwebcgi/mweb.exe?request= erecord;hiliteid=501947;hilitetype=803;id=176461;type=305

Landstrom, C. (2007). Queering feminist technology studies. *Feminist Theory, 8*(1), 7–26.

MacKenzie, D., & Wajcman, J. (Eds.). (1999). *The social shaping of technology.* Buckingham, UK, and Philadelphia: Open University Press.

Malloy, Judy. (2003). *Women, art and technology.* Retrieved from http://mitpress.mit.edu/ catalog/item/default.asp?ttype=2&tid=9905

Miller, D. (2009, March). Now let us interview famous men. *Art Monthly, 324,* 9.

Nochlin, L. (1971, January). Why have there been no great women artists? *ARTnews, 69,* 22–39, 67–71.

Office of the Provost and Vice President for Academic Affairs (2008). Five year strategic plan, 2008–2013. Denton: University of North Texas. Retrieved from http://vpaa.unt.edu/ strategicplan0813/StrategicPlan0813.pdf#page=9

Oldenziel, R. (2002). Object/ions: Technology, culture and gender. In V. Buchli (Ed.), *The material culture reader* (pp. 48–60). Oxford: Berg.

Reckitt, H. (2006). Unusual suspects: Global feminism and *Wack! Art and the feminist revolution. n.paradoxa, 18,* 34–42.

Reed-Danahay, D.E. (Ed.) (1997). *Auto/ethnography: Rewriting the self and the social.* Oxford, UK: Berg.

Reinharz, S. (1992). *Feminist oral history: Feminist methods in social research.* London: Oxford University Press.

Rosen, R. (1989). Moving into the mainstream. In R. Rosen & C.C. Brawer (Eds.), *Making their mark: Women artists move into the mainstream, 1970–85* (pp. 6–25). New York: Abbeville Press.

Sangster, J. (1994). Telling our stories: Feminist debates and the use of oral history. *Women's History Review, 3*(1), 5–28.

Stanley, A. (1983). Women hold up two-thirds of the sky: Notes for a revised history of technology. In J. Rothschild (Ed.), *Machina ex Dea: Feminist perspectives on technology* (pp. 151–170). New York, Pergamon Press.

Stanley, A. (1995) *Mothers and daughters of invention: Notes for a revised history of technology.* New Brunswick, NJ: Rutgers University Press.

subRosa. (2002). Tactical cyberfeminisms: An art and technology of social relations. In M. Aagerstoun (Ed.), *Cyberfeminism right now*. Artwomen.org. Retrieved from http://www.artwomen.org/cyberfems/index-intro.htm

Tamblyn, Christine. (1995). "She loves it, she loves it not": Women and technology. *Leonardo,28*(2), 99–104.

Wajcman, J. (2010). Feminist theories of technology. *Cambridge Journal of Economics, 34*, 143–152.

Whitney Museum of American Art. (2010, May 3). The biennial and women artists: A look back at feminist protests at the Whitney. Retrieved from http://whitney.org/Education/EducationBlog/BiennialAndWomenArtists

Section III

In Search of Feminist Space Online

Chapter 11

Structuring EDNOS as Cyberpostfeminist Rule

Dara Persis Murray

Introduction

EDNOS, an acronym for Eating Disorder Not Otherwise Specified, describes individuals who experience significant emotional and physical struggles in their negotiation of complex cultural messages about food and bodies. ED-NOS individuals exhibit eating-disordered behavior and suffer from similar health repercussions, but do not meet the diagnostic criteria for anorexia nervosa or bulimia nervosa. Many individuals with degrees of eating disorders fight daily with food consumption in solitude, as the medical community denies them, their families and friends, and agents of institutional power a plan for treatment. New media, though, is a space wherein individuals communicate around similar interests and struggles. This feminist critical discourse analysis examines an online community comprised of young women whose interactions speak to their response to EDNOS: EDNOS University[1] (referred to as EU) is a site produced by a young woman with EDNOS who supports EDNOS as a positive lifestyle.

EU's power dynamics and its community ideology of eating-disordered approaches to food and exercise are unpacked by placing EU against the diet program Weight Watchers (WW), which was created by a woman as a weight-loss support group for women and is now an agent of institutional power in popular culture. This investigation reveals that EU's webmistress encourages the subjectification of women, aligning her with agents of institutional power (the diet and fashion industries) even though she states a resistance to them. EU and WW both enforce female behavior (dieting) and appearance (the dominant ideology of beauty). EU—perhaps even more obviously than WW)—is a hegemonic structure that solidifies the webmistress' power, even to the degree that EU may be a new sort of agent of institutional power. I argue that the contemporary meaning of a cyberfeminist needs to be expanded to consider the influence of postfeminism on female au-

Tema: Analisar o conteúdo de M de Mulher (fem/pósfem?)

diences/users; EU's webmistress is viewed as a cyber*post*feminist who communicates a postfeminist view of agency and scholarly conceptions of immaterial/affective labor that, taken together, invest her with social power in her new media space.

Institutional Power and the Dominant Ideology of Beauty

Many women and girls struggle to pursue the dominant ideology of female beauty, a cultural value produced by hegemonic power structures. Their Western cultural context is "obsessed with the human body and a lean and lithe appearance. Beauty is sold as the key to happiness and the ultimate goal" (Body Image Health Task Force, n.d.). Messages about beauty are produced by what Frankfurt School theorists Max Horkheimer and Theodor Adorno (2001) call a "culture industry," which desires passive audiences who strive for their industry-defined logic through ideological and material consumption. For them, a culture industry promotes messages that homogenize audience identities, since "the power of the culture industry resides in its identification with a manufactured need" (p. 81–82). The beauty industry, which I characterize as comprised of diet, cosmetic, and fashion industries, represents a culture industry. The beauty industry's ideology advances that girls and women should strive for their definition of socially acceptable beauty: the ultra-thin body.

For over a century, the beauty industry has communicated the dominant ideology of beauty through static images (such as advertisements and women's magazines) as well as through the female bodies of celebrities (including actresses, singers, and fashion models) who signify cultural power. As media critic Jean Kilbourne (2000) points out, "The glossy [media] images of flawlessly beautiful and extremely thin women that surround us would not have the impact they do if we did not live in a culture that encourages us to believe we can and should remake our bodies into perfect commodities" (p. 132). In this environment, women and girls are encouraged to see the body as an object to be transformed into the desirable representation.

The dominant ideology of beauty is problematic for female audiences' bodies and minds. Girls' and women's effort to attain to this extremely thin female physique has manifested in a loss of self-esteem and eating disorders (Kilbourne, 2000). Anorexia (as self-starvation) and bulimia nervosa (characterized by a binge and purge cycle) are eating disorders whose symptoms have been communicated by media discourse, often through celebrity suffer-

ers, to popular audiences. EDNOS is a gray area comprised of people who struggle with meanings of diet and beauty in order to achieve the body promoted by the culture industries. As the most common eating disordered group, EDNOS individuals may possess many of the clinical symptoms of anorexia and bulimia but do not "meet all the criteria" (Button, Benson, Nollett, & Palmer, 2005, p. 134). The health repercussions of EDNOS are similar to anorexia and bulimia and include dehydration, kidney problems, heart attacks, and death. However, it "can be extremely difficult to detect because the victims are often close to their normal weight.... Many people, including health care professionals, are uneducated about EDNOS....[and t]he failure of medical personnel to take EDNOS seriously leads to feelings of despair on the part of the patient and an escalation of the disorder" (Livingston, 2007). Through its identity as a "university," EU suggests that it provides structure for its users around the meanings and practices of EDNOS, which individuals with EDNOS feel have been left vague by existing medical institutions.

Girls' and women's negotiation of meanings of beauty and health is complicated by a contemporary culture marked by an obesity epidemic wherein many bodies visually conflict with the dominant ideology. In steps the diet industry, characterizing itself as the promised path for audience control over food consumption and achievement of the thin body. WW, one of the most successful diet programs, has over one million members in 27 countries (Weight Watchers International, n.d), and its members are predominantly women (Moisio & Beruchashvili, 2009). WW's messaging circulates in popular culture to non-members as well, as the corporation spends an estimated $90 million per year on advertising campaigns. WW credits its support networks as key to members' success; in fact, it is "the world's largest support group for weight loss" (Moisio & Beruchashvili, 2009, p. 860), and this is perhaps the reason for its *Consumer Reports* rating as having "the best long term adherence rate" ("Weight Watchers Gets Nod," 2005) of any diet program. WW encourages more than dieting—it promotes a lifestyle and community centered on attention to food consumption. WW's credibility as a "healthy" diet is supported by its relationship with institutional power, as its employees have testified as experts at hearings that contributed to formulation of the U.S. government's Dietary Guidelines (Weight Watchers—Four Decades, 2008). WW represents an institutionally validated diet program that serves as a point of interrogation for assessing EU's discourse and power relations.

Feminist Approaches to Eating Disorders

Feminist scholarship on women and eating disorders has emphasized agency through the communication of individual choice in shaping their bodies as meaningful cultural texts or subjectivity by examining the patriarchal struc-ture as shaping attitudes and behaviors. By considering the influence of post-feminism in the production of EU and looking at EDNOS as an in-between eating disorder concept, this analysis suggests that EDNOS as a subject of inquiry can broaden feminist literature on meanings of agency and subjec-tivity around the female body. Since EU perpetuates eating disorders as a de-sired lifestyle rather than a psychiatric disorder, this section includes feminist perspectives on pro-ana websites (comprised of individuals who similarly "choose" to be anorexic).

Pro-anas have been interpreted as having feminist agency driven by the desire to enact social change. This viewpoint is supported by postmodern theorists who consider how "the grand narratives or meta-narratives" (Gill, 2007, p. 66) construct philosophical binaries, such as female/male and sex/gender, and they work to *de*construct these narratives. While there are a variety of positions within postmodern feminism, a binding thread interprets that female subordination is not solely produced by institutional power. Agency, then, relates to individuals' constructions of their bodies as processes unto themselves. In this framework, pro-ana websites "are a post-modern form of agency" (Richardson & Cherry, 2005, p. 1), and their com-munication "foster[s] motivational discourse/rhetoric to keep the movement alive" (Banuelos & Battaglia, 2007, p. 2) that "challenge[s] the power of such cultural structures as the medical community" (Richardson & Cherry, 2005, p. 1). Pro-anas, thus, are not viewed as victims or mentally unstable because they "recognize both the social stigma and the moral censure, and therefore proclaim the positive benefits of creating their own community" (Shade, 2003, p. 2). Moreover, Roxanne Banuelos and Judy Battaglia (2007) argue that eating-disorder websites are venues for political action and that female bodies are texts for the inscription of action:

> [P]articipants use their bodies (personal) to promote larger social agendas (political). They see their bodies as discursive texts, which therefore politicizes the body and places it into the social arena. The personal as political is taken further by using the internet to tell their individual tales, ideas, and thoughts, connecting them to a much larger community of other pro-participants. They see themselves as communities in

resistance to, not in accordance with, larger social systems and structures that reinforce domination and perpetuate hegemony. (pp. 1–2)

Deborah Pollack (2003) makes a significant counterargument in communicating her concern that "postmodern feminists may romanticize pro-eating disorder websites as political statements, and thus, in essence, condone the inherent self-destructiveness that such a protest entails and create new possibilities for the pro-anorexic subject to become a symbolic martyr" (p. 249). This viewpoint aligns with Foucauldian feminist Susan Bordo (2003), who emphasizes anorexia as a retreat from social resistance. She writes:

> I want to emphasize the counterproductive, tragically self-defeating…nature of that protest. Functionally, the symptoms of these disorders isolate, weaken, and undermine the sufferers; at the same time they turn the life of the body into an all-absorbing fetish, beside which all other objects of attention pale into unreality. On the symbolic level, too, the protest collapses into its opposite and proclaims the utter capitulation of the subject to the contracted female world…muteness is the condition of the silent, uncomplaining woman—an ideal of patriarchal culture. (pp. 176–177)

Like Bordo, Foucauldian feminist Sandra Bartky (1990) sees the female body as a site of contentious power relations between the individual and the social structure wherein social institutions impress their ubiquitous power upon female subjects. For Bordo and Bartky, women's identities are shaped through social meanings that are imposed on the female body, and eating disorders are disciplinary practices that shape subjectivity. Bordo (2003) states that eating disorders "train the female body in docility and obedience to cultural demands" (p. 27); these "docile" bodies derive from female audiences' absorption of the dominant ideology of beauty.

Rather than interpreting EU's webmistress and textual meanings as simply reflecting agency or subjectivity, I argue that EU and its webmistress can be understood as reflecting a postfeminist "sensibility." Feminist media studies scholar Rosalind Gill (2007) contends that this sensibility is comprised of many themes including: "femininity is a bodily property; the shift from objectification to subjectification; the emphasis upon self-surveillance, monitoring and self-discipline; [and] a focus on individualism, choice and empowerment" (p. 255). In this context, agency is conceived as subjectivity in the cloak of empowerment. Postfeminist messaging is circulated by the culture industries, minimizing meanings of female (political, social) power

while facilitating ideological and material attachment to institutional power. EU's webmistress is interpreted as a *cyberpostfeminist*—that is, I maintain that she utilizes new media in a way that speaks to a "postfeminist sensibility" rather than to feminist thought and activism—whose immaterial/affective labor engages the aforementioned postfeminist themes in EU's ideology and community. These themes will be elucidated through the webmistress' construction of EU via her discourse and posting of images.

Understanding Agency through Immaterial and Affective Labor

Social theorist Michael Hardt built his affective labor theory on the work by American feminists on gendered forms of labor (such as service-oriented domestic work or the helping professions, paid and unpaid) and the work by French and Italian economists and labor sociologists regarding intellectual labor. The theory of affective labor allows the researcher "to consider it together with the various other forms of labor whose products are in large part immaterial, that is, to think together the production of affects with the production of code, information, ideas, images, and the like" (2007, p. xii).

Sociologist Elizabeth Wissinger (2007a) adds to this conception of labor to complicate understandings of the female body in Western culture. She argues that affective labor is central to a fashion model's job; this labor is "performed either through actual or virtual human contact or interaction, which produce 'intangible feelings of ease, excitement, or passion'" (Hardt and Negri, cited in Wissinger, 2007a, p. 253) and "'always directly constructs a relationship'" (Hardt and Negri, cited in Wissinger, 2007a, p. 254) between the model and other people. The model's techniques involve self-monitoring and regulation to intuit and bring about an affective flow so that her labor grabs the attention of the viewer by working as an autonomic physical response (Massumi, cited in Wissinger, 2007b, p. 237). Wissinger contends that a model's work involves modulating the affective flows.

Significantly, EU's webmistress engages in immaterial labor in the production of her text, as the time and energy spent on EU is, by definition, unpaid. This analysis is concerned with how the immaterial labor of the webmistress leads to her power in her community. More, I examine how the webmistress manipulates her affect to draw users' attention to her texts. Along these lines, the affective and immaterial labor of EU's webmistress is examined to understand her sense of agency and power in constructing the subjectivities of her users, as well as the realization of EU as a new sort of

agent of institutional power that achieves resonance by promoting specific emotions and logic in response to the gray area of EDNOS.

Critical Discourse Analysis

[handwritten margin note: → USAR NA ANÁLISE DO M DE MULHER.]

Linguist Norman Fairclough's Critical Discourse Analysis (CDA), which unpacks language and images, serves as a methodology for exploring the relations of ideology, power, and discourse in EU. CDA is an interpretive research method that "approaches discourse as a circular process in which social practices influence texts, via shaping the context and mode in which they are produced, and in turn texts help influence society via shaping the viewpoints of those who read or otherwise consume them" (Richardson, 2007, p. 37). CDA views the text as possessing ideological and interpersonal functions, and the role of analysis involves understanding the identity of the text's creator, the nature of relations in the text, and assessing what is (and is not) present in the discourse to maintain or transform social structures.

CDA interrogates discourse through the complementary components of the *communicative event* and the *order of discourse*. The communicative event represents the text and incorporates culturally normative aspects that maintain continuity and creative innovations that suggest change. Fairclough (2000) articulates three dimensions by which to analyze a communicative event: text (written, oral, or visual), discourse practice (text production and consumption), and socio-cultural practice (economic, political, and cultural contexts of the communicative event). CDA also exposes cultural changes by recognizing how they are reflected in a text. These shifts are manifested "discursively through a redrawing of boundaries within and between orders of discourse....These boundaries are also sometimes a focus of social struggle and conflict" (Fairclough, 2000, p. 310). Fairclough views discourse as the communication of meaning to audiences through language and nonverbal images and gestures. The *order of discourse* pays attention to the way the discourse is configured within the text, particularly concerning how it is structured in relation to other socially adjacent orders of discourse. This analysis focuses on the discourse and images utilized by EU's webmistress. EU's communicative event is unpacked through its home page and the "General Rules" and "Programs" pages and compared against WW's home page and tabs that communicate its rules and programs. I place EU's discourse against WW's and the discourse of institutional power (diet, medical, fashion

industries, and postfeminism) to provide a close textual reading as well as a social and cultural analysis of EU.

EDNOS University

Shea is EU's 21-year-old webmistress. She writes that the idea for EU "came out of boredom!" and that her domain of EU responsibility is practically ubiquitous (she creates its programs and writes EU's text). Prior to EU, she maintained multiple pro-ana sites (including "Perfect_Beauty," and "Past_Imperfect"). Her sense of agency regarding the production of her body appears to be through resistance to institutional power. This is illuminated in Shea's disclosure of her history of anorexia and experience with physicians, wherein she postulates a power struggle between the authority of the physician and her (as the eating-disordered patient) whose voice was demeaned or ignored. Perhaps in response, she positions herself as someone who offers dieting advice to her EU "students" that recognizes them as individuals. She, too, expresses how she is unique: romantic, persistent, a problem solver, and someone who values perfection, beauty, and an eating-disordered lifestyle. Shea promotes an ideology of EDNOS that advances eating disorders as a positive lifestyle choice to EU's users and facilitates a community through an educational structure wherein her students follow her weight-loss programs that support extreme and risky food and exercise behavior.

WW was founded by Jean Niditch and was created as a community for women centered on meanings of food and diet. Niditch endured a lifelong struggle with her weight and, at the time of WW's inception, weighed 214 pounds (Weight Watchers International, n.d.). She began weight-loss support groups in her home and discovered that "empathy, rapport and mutual understanding" (Weight Watchers International, Inc., n.d.) and behavioral management techniques were essential to successful weight loss. Niditch lost over 70 pounds through "commiserat[ion] and…talk about their struggles" (Weight Watchers Biography, 2011) through this network. Eventually she "stumbled upon a formula for weight loss that was embraced by the masses" (Weight Watchers Biography, 2011), modeling her program on the cardiac prevention Prudent Diet developed by the New York City Department of Health's Bureau of Nutrition. WW has reached the status of an agent of institutional power for popular female audiences.

Textual Analysis: The Communicative Event

EU's communicative event is analyzed through Gill's themes of the postfeminist sensibility. WW and EU's home pages are similar in language and design that appear to be simple and informational, yet differ in how they communicate "individualism, choice and empowerment": EU connects these qualities to EDNOS ideology and practices of dieting, while WW emphasizes consumer brand attachment. EU's "General Rules" and "Programs" promotes "self-surveillance, monitoring and self-discipline," and, like WW, its discourse is embedded with psychological language. The thinspiration images in EU invite ideological participation through conveying femininity through the body and communicating self-display (objectification) as empowerment.

EU and WW situate their textual significance within their respective social contexts (institutional power for WW, and within the eating disordered community for EU). WW communicates its plan's uniqueness among other mainstream diet plans on the tab, "How We Are Unique," which is linked to "Our Approach to Weight Loss." WW also emphasizes that its diet plan is for individuals, as it offers "Flexible Food Plans" (Weight Watchers, 2008) to suit members' lifestyles. Yet WW's discourse expresses conflict in members' individualism, as members "Follow our [WW] plan step-by-step," which micromanages dieters' behavior. WW members follow the "guidance from a leader who lost weight with Weight Watchers," a process wherein dieters are homogenized as a group ("people like you").

EU is unique in its structure as a "university" and in its communication about eating disorders. In these ways, though, EU does not present its uniqueness as positive in the same vein as WW. EU's home page acknowledges the cultural crisis of eating disorders and the existence of pro-ana sites, situating its philosophy about dieting within this framework. Of its structure, the "Welcome" section states: "We are not a real university....We do not consider ourselves 'pro-ana'....If you don't like the way we think or don't know about the dangers of eating disorders. Read this" (EU, 2008), linking to information about anorexia. EU presents its meaning of individualism for its users through its response to EDNOS, which reflects conflict about its eating disordered identity: "We do not teach you how to get an eating disorder. We provide support for those that know [that they] have a problem and don't want to recover. We do however encourage recovering" (EU, 2008).

EU's home page discourse stresses users' choice of EDNOS as an identity. This sentiment is furthered in its mission statement, which characterizes EU as a vehicle for users' choice to challenge themselves: EU "is a University for those wanting to do a program that is geared towards wight [sic] loss, restricting and wanting a challenge…[O]ur programs are…ed[eating disorder]-related for those who want serious weightloss [sic]" (EU, 2008). By contrast, WW presents its brand as an easy lifestyle choice: "Weight Watchers works because it is not a diet. You'll learn how to eat right and live healthy so you can lose the weight and keep it off" (Weight Watchers, 2008). As will be illustrated, Shea facilitates EU's community, but WW presents its members as having a choice on how to engage with the plan, site, and community through self-explanatory tabs, including "How Weight Watchers Works," "Food and Recipes, "Fitness &Health," "Community," and "Marketplace" (Weight Watchers, 2008).

EU directly addresses its participants' sense of empowerment: "Keep your head up high" (EU, 2008). This emotional tagline, repeated in other areas of EU, differs from WW's functional tagline: "Start losing weight today" (Weight Watchers, 2008). The images on these home pages connect empowerment to the dominant ideology in different ways as well. EU presents models and celebrities whose main characteristic is thinness and, therefore, connect empowerment through achievement of the dominant representation. WW showcases laughing young women positioned near drinks and food with copy stating, "See why we think you should stop dieting" (Weight Watchers, 2008). WW highlights pleasurable socialization as the ultimate result of WW-style dieting, which also aids in achieving the desired body.

"General Rules" and "Programs" regulate and communicate EU's ideology of EDNOS. Its "Objective" underscores users' emotions: "for our students to learn about themselves and achieve the goals that they set for themselves" (EU, 2008). EU's "Purpose" is to enable users to help themselves: "to help people who already have one to love themselves and resort to better choices instead of purging, laxies [laxatives], or extreme fasting" (EU, 2008). Rules for "Conduct" emphasize a unified community centered on equality and respect: "We do not support haters or people who think they are better. We do not categorize people by their ED. We do not use profanity or any obcene [sic] language." Parameters are also established for community discourse ("Do not EVER say anything rude to another member of the school" [EU, 2008]) and membership—"We do not discriminate against

race, sex, weight, height, or age (except if you are under 15...then the school is not for you!)" (EU, 2008). Shea encourages users' self-surveillance, and their participation in EU underscores acceptance of her monitoring of them.

In "Termination," Shea establishes her authority through authoritative discourse. She declares: "If you get dropped from the program and wish to rejoin you will be put in probation for one term....That way everyone will take the school seriously and not just join because everyone is doing it!" (EU, 2008). The headings simulate an educational setting: "Probation Week," "Homework," "Tests," "Grades," and "Student Records." Importantly, the language transforms the webmistress into the headmistress, who supervises and judges others' actions and has the authority to include and exclude people from her community. For instance, Shea writes that Probation Week allows her to find out "who are the girls that quit programs and who are the true good students" and "If I go to your site and you haven't posted anything saying you are gone....I will mark that and put you in the danger zone. 2 weeks of unactive will cause you to be dropped from the program" (EU, 2008). A person who drops out can rejoin 45 days later, unless Shea deems her to be a continual quitter.

WW does not communicate such rules of membership. This may be due to the brand/consumer relationship, wherein participants can terminate their membership when they no longer wish to follow the diet plan. WW's discourse is careful to facilitate brand loyalty so as not to lose its financial power. WW's language emphasizes consumer responsibility and, unlike EU, does not represent itself as a surrogate parent/person of authority:

> Why Weight Watchers? Because we know weight loss....What we've learned from our customers has helped us to develop an effective approach that goes beyond food and addresses the whole person. And 97% of Weight Watchers meetings members say they would recommend us to a friend. (Weight Watchers, n.d.)

WW notes that attention to food should be placed in an appropriate balance with other important activities in life. WW states that its dieters can "eat what you like" and provides two plans counting daily food points (points are based on a formula that considers each food's calories, fat, and fiber grams). WW highlights its incorporation of "the latest, most reliable scientific research," thereby emphasizing its relationship to institutional power. EU offers 18 programs, each of which has a syllabus for food and exercise, to reflect students' goals, behaviors, and personalities. Students follow their

chosen program's daily syllabus for food and exercise, hand in homework, take tests for which they receive grades, and participate in the community. Courses are described as "effective," "geared towards major weight loss," and "versatile."

WW's assessment of dieters' caloric intake is based on calculations of their goals and current weight, in accordance with government guidelines. They conform to the National Institute of Health's suggestion of a minimum of 1,200 calories per day (Medical Encyclopedia, 2008). WW participants are instructed to learn how to prepare food and count points. In addition, WW employs invitational language in discussing exercise, such as: "Activity is an important part of weight loss. When you're ready, you can find the exercise that's right for you" (Weight Watchers, 2008). By contrast, EU's programs promote extreme self-discipline, allowing no more than 800 calories daily in any program, and many programs are 1,000 calories per week. Two programs allow for 800 calories per day, and the lowest number of calories stated for a day is 0 (fasting). EU's programs generally require at least 30 minutes of exercise per day or more, except on the fasting day (when yoga or light walking is recommended).

While WW does reference agents of institutional power (the science and medical communities), it does not reference the beauty industry as EU does in several of its programs. "Top Model" (connoting the television program *America's Next Top Model*), *Picture Perfect* (connoting the popular colloquialism), and "Next Thinspo" (connoting "thinspiration") address constructing oneself to align with the values of the beauty industry. "Thinspiration" images and discourse have been identified as important components of pro-eating disorder sites (Chesley, Alberts, Klein, & Kreipe, 2003). "Thinspiration" has been defined as "two words put together....Thin and inspiration...[the images] motivate and inspire you to lose weight and become or stay thin" (Peckham, 2005, 2007). EU students pursue the dominant ideology of beauty by working to emulate images of fashion models, actresses, and celebrities; their bodies uphold traditional norms of femininity through presentation of the body as ultra-thin and sexual.

EU's thinspiration images emphasize sexuality as a component of femininity, reflecting the "postfeminist sensibility" wherein "femininity is defined as a bodily property rather than (say) a social structural or psychological one" (Gill, 2007, p. 255). Typical photographs posted on EU present women in skimpy clothing (short dresses, T-shirts revealing breasts, bikini underwear), and camera angles emphasize their bodies as sexual

(close-up shots of breasts, cropping of images near genitals). Models with their ribs and hipbones jutting out appear in sexually suggestive positions while also connotating romance and success. For instance, a girl in underwear sleeps on a bed while two birds imprinted on the wall behind her fly toward each other. Another model, whose sexuality is stressed through the image's cropping near her breast, wears sunglasses with lenses shaped like stars. The birds (symbolizing love) and stars (symbolizing success) suggest hope and reflect whimsy—similar to the white wallpaper that is punctuated with cartoon-like strawberries, cupcakes with pink icing, and multicolored stars—but the images connote emotional internalization and social isolation. When pictured with men, women are presented as sexually charged, sitting (clothed) in the missionary position on top of a (clothed) boy. Shea's discourse and selection of images suggests that she maintains a postfeminist view of "sexual objectification…as the freely chosen wish of active, confident, assertive female subjects" (Gill, 2007, p. 259).

Textual Analysis: Order of Discourse

The discourse practice on EU emulates features of hegemonic discourse but also particularizes the discourse for its eating disordered audience. It functions primarily as a text for consumption of the beauty ideology of thinness/EU's EDNOS ideology, and secondarily as a text for material consumption (Shea does not receive remuneration, but EU's diet programs do promote the consumption of products such as diet soda). This is a different structure than WW, which is a text that stimulates both audience consumption of its products (membership, meals, cookbooks, magazines) and ideological WW brand consumption.

The type of discourse analyzed from the home page and links pertaining to the diet are seemingly intended to be welcoming and informational. The first level of EU discourse is much like the cover or introduction to a book (home page) whose function is to tell audiences why they should read the text. The second level of EU discourse, "General Rules" and "Programs," is similar to that of a self-help diet book that prescribes a regimen for the dieter to follow closely. EU combines both the normative and creative, reflected in its positioning as a "university" and "diet program" alongside language such as "pro-ana" and "thinspiration." Shea originated the concept of EU by drawing on the traditional social structure of the university. Similarly, she provided structure to EDNOS through rules for diet and exercise; while her

instructions are more extreme than WW, her diet plans emphasize calories, self-monitoring, exercise, and adherence to a diet plan's belief system (such as no-carb, low fat, and so forth) as existing institutional diets do. Finally, while "pro-ana" and "thinspiration" language is creative in that it began in eating-disordered communities, Shea is not the one who invented it and it is thus normative language that she replicates in EU.

Shea's hybrid style of interpersonal communication (friend and headmistress) suggests relationships that further blur the boundaries between her creativity in EU and the norms of institutional power. WW developed its diet by drawing from institutional messages (the New York City Department of Health's Bureau of Nutrition). Shea's incorporation of messages produced by the diet industry likewise replicates oppositions of food as good/bad and diet success/failure. In doing this, however, she breaks the link with messaging that constructs traditional diet discourse by offering her own oppositions: being someone who is healthy/eating disordered, one who accepts/rejects institutional messages, and one who chooses to fast/eat. While pro-ana sites have been characterized as "an online subculture" (We Bite Back, 2008) wherein the site creators and users resist the dominant group to establish their own identity (Edgar, 2002), EU is not a subculture. It functions much like WW, but a more severe version of it in terms of its discourse and images that prescribes information to female audiences.

Characterizing the *Cyberpostfeminist*

For Shea, new media provided a space where she was able to apply rules to EDNOS that offline authorities did not when they described EDNOS as an open-ended diagnosis characterized by not "meet[ing] all the criteria" of other eating disorders. By providing structure through rules and ideology to EDNOS, Shea was afforded power that may have otherwise been afforded to the medical industry. EU presents an ideology of diet and exercise, potentially entrenching women in her ideology in which health is a superficial value that is part of a problematic message of beauty. As this analysis has revealed, I view Shea as a cyberpostfeminist who uses technology to spread her values and approach to EDNOS. Yet her text is a product of culture, as is she; EU thereby reproduces postfeminist messaging that saturates contemporary media culture, a context wherein Shea is the model postfeminist figure to gratify the culture industries.

Shea's affective labor enables like-minded peers to employ unhealthy dieting strategies via a support group. The success of her affective labor can be measured by the count of visitors at the bottom of her website (almost 150,000 as of April 2010) and the number of students who joined her university. This level of interest suggests that she is able to be an engaging leader, and thus her discourse—which has been influenced by the power of mainstream source texts—may influence others physically and emotionally.

Shea's ability to stimulate interest in EU may derive from the authoritative communication of her identity. Although she presents herself as relatable to her students through a shared eating-disordered identity, she is nondisclosing (her biography is brief and hidden). Similarly, she does not post her picture or disclose how she selects her students. In her virtual interactions, Shea reinforces the isolation of her students and enforces her authority, as she learns of their journeys but they do not learn of hers. She distances herself from the community experience, which is the essence of social media. Shea is neither self-reflexive nor a transformative subject in her own text. Is this the meaning of a cyberpostfeminist in pro-eating-disorder websites—one who uses her power to shape others while she remains stagnant?

Conclusion

Shea as a cyberpostfeminist wields her power to spread postfeminist messaging and uses her immaterial/affective labor to cultivate her own social power. She indoctrinates women in her EU philosophy, enabling physical and mental self-destruction and stipulating pro-EDNOS behavior beyond the boundaries of cyberspace (the offline enaction of diet and exercise instructions). Like WW, Shea's power is situated within the network of the traditional agents of institutional power and suggests troubling consequences for those who follow her messages. EDNOS and new media are important areas for investigating meanings of the female body and postfeminism.

Note

1 The website and webmistress have been given pseudonyms to protect their identities.

Works Cited

Banuelos, R., & Battaglia, J. (2007, May). *Demystifying the weigh-in: Body politics and identity formation of pro-ana and pro-mia girls*. International Communication Association.

Paper presented at the annual meeting of the International Communication Association. San Francisco, CA.

Bartky, S.L. (1990). *Femininity and domination: Studies in the phenomenology of oppression.* New York: Routledge.

Body Image Health Task Force. (n.d.). Eating disorder causes. *The Ohio State University.* Retrieved from http://ehe.osu.edu/cs/bitf/issues/eating-disorder-causes.php

Bordo, S. (2003). *Unbearable weight: Feminism, Western culture, and the body* (2nd ed.). Berkeley: University of California Press.

Button, E.J., Benson, E., Nollett, D., & Palmer, R.L. (2005). Don't forget EDNOS (Eating Disorder Not Otherwise Specified): Patterns of service use in an eating disorder service. *Psychiatric Bulletin, 29,* 134–136.

Chesley, E., Alberts, J.D., Klein, J.D., & Kreipe, R.E. (2003). Pro or con? Anorexia nervosa and the Internet. *Journal of Adolescent Health, 32*(2), 123–124.

Day, K., & Keys, T. (2008). Starving in cyberspace: A discourse analysis of pro-eating-disorder websites. *Journal of Gender Studies, 17*(1), 1–15.

Edgar, A. (2002). Subculture. In *Cultural theory: The key concepts.* New York: Routledge.

EU website. (2008). Pseudonym EDNOS University given to protect the site due to privacy issues. Site initially found on www.freewebs.com (now webs.com)

Fairclough, N. (2000). Critical analysis of media discourse. In P. Marris & S. Thornham (Eds.), *Media studies: A reader* (pp. 308–325). New York: New York University Press.

Gill, R. (2007). *Gender and the media.* Malden, MA: Polity.

Hardt, M. (2007). Foreword: What affects are good for. In P.T. Clough & J. Halley (Eds.), *The affective turn: Theorizing the social* (pp. ix–xiii). Durham, NC: Duke University Press.

Horkheimer, M., & Adorno, T.W. (2001). The culture industry: Enlightenment as mass deception. In M.G. Durham & D.M. Kellner (Eds.), *Media and cultural studies: Keyworks* (pp. 71–101). Malden, MA: Blackwell.

Kilbourne, J. (2000). *Can't buy my love: How advertising changes the way we think and feel.* New York: Simon & Schuster.

Livingston, K. (2007, February 23). Recognizing EDNOS: The little known eating disorder wrecks lives. *Associated Content.* Retrieved from http://www.associatedcontent.com/article/152664/recognizing_ednos_the_little_known.html?cat=5

Medical Encyclopedia. (2008). *Medline Plus.* Retrieved from http://www.nlm.nih.gov/medlineplus/ency/article/001940.htm

Moisio, R., & Beruchashvili, M. (2009). Questing for well-being at Weight Watchers: The role of the spiritual-therapeutic model in a support group. *Journal of Consumer Research, 36*(5), 857–875.

Peckham, Aaron. (2005, 2007) "Thinspiration and Thinspo." Urban Dictionary. Entries posted on 3 Dec. 2005 for "Thinspiration" and 3 Mar. 2007 for Thinspo. Retrieved from http://www.urbandictionary.com/define.php?term=thinspo

Pollack, D. (2003). Pro-eating disorder websites: What should be the feminist response? *Feminism & Psychology, 13*(2), 246–251.

Richardson, A.S., & Cherry, E.R. (2005, August). *Anorexia as a lifestyle: Agency through pro-anorexia websites.* Paper presented at the annual meeting of the American Sociological Association. Philadelphia, PA.

Richardson, J.E. (2007). *Analyzing newspapers: An approach from critical discourse analysis.* New York: Palgrave Macmillan.

Shade, L.R. (2003). Weborexics: The ethical issues surrounding pro-ana websites. *ACM SIG-CAS Computers and Society, 33*(4). Retrieved from http://portal.acm.org/citation.cfm?doid=968358.968361

We Bite Back. (2008). We bite back FAQ. Retrieved from http://www.webiteback.com/faq.html

Weight Watchers. (2008). Weight Watchers home page and tabs. Retrieved from www.weightwatchers.com/index.aspx

Weight Watchers Biography. (2011). *The Biography Channel.* Retrieved from http://www.thebiographychannel.co.uk/biographies/weight-watchers.html

Weight Watchers—Four Decades of Leadership in Healthy Weight Loss and Weight Management. (2008). *Weight Watchers.* Retrieved from www.weightwatchers.com/about/prs/wwi_template.aspx?GCMSID=1002801

Weight Watchers Gets Nod from Mag. (2005) *CNN Money.* Retrieved from http://money.cnn.com/2005/05/10/news/midcaps/weight_watchers/index.htm

Weight Watchers International Inc. (n.d.) The history of weight watchers: From a woman's obsession with cookies to a worldwide weight-loss service. *Dottie's Weight Loss Zone.* Retrieved from http://www.dwlz.com/WWinfo/historyofww.html

Wissinger, E. (2007a). Modelling a way of life: Immaterial and affective labour in the fashion modelling industry. *Ephemera: Theory & Politics in Organization, 7*(1), 250–269.

Wissinger, E. (2007b). Always on display: Affective production in the modeling industry. In P.T. Clough & J. Halley (Eds.), *The affective turn: Theorizing the social* (pp. 231–260). Durham, NC: Duke University Press.

Chapter 12

Debating Intimate Partner Violence in Lesbian Fan Communities

Becky Walker

My interest in the issue of intimate partner violence was the result of follow-ing the sudden and intense flame wars in online lesbian fan forums based on *The L Word* television series (Showtime, 2004–2009) over the apparent vi-olence between women in a long-term relationship. These flame wars sparked my interest in the passionately argued positions that lesbians took over the possibility that a woman could (or could not) be violent to her part-ner. This led me to look at other representations of violence in the series be-tween a transgender character and his female partner, and between a heterosexual male character and his female partner, and to the question of why these did not lead to the same level of passionate argument in the fo-rums as did the incident between the lesbian couple.

Australian television schedules and DVD releases of *The L Word* series were behind that of the United States, so I watched the episodes discussed on the forum long after reading the forum debates. Although the series finished in 2009, it survives in some cable or free-to-air schedules in much of the world, and it continues to be sold or downloaded in many countries. As the first mainstream American series to centre on lesbians, the series itself is seen as an iconic (and contested) representation of lesbianism for many les-bians in countries that do not actively censor lesbians from their screens or Internet. The forum debates from 2006 to 2009 are still relevant today. Al-though the field of digital studies sometimes demands instantaneous exam-ples, older but iconic moments and examples that challenge the field are worth examining. On another level, iconic lesbian or queer representations in the media encompass several decades of examples that define the field of lesbian and queer representations (e.g., Russo, 1987; Walters, 2001). The 2006–2009 cyber debates over *The L Word* television series suggest in a more complex fashion the evolving nature of lesbian representation and defi-nitions through public debates—in this case intimate partner violence in a cyberlesbian context.

This chapter explores the issue of debates over intimate partner violence in an online lesbian fan community. The focus is feminist and non-feminist understandings and debate over moments of intimate partner violence in *The L Word* television series. These debates, and these moments, were chosen as iconic flashpoints that highlighted tensions and emerging discourses over the controversial issue of intimate partner violence. The issue is a confronting one for many lesbians, and the sudden representation of violence in a long-term lesbian relationship in the series made the issue even more confronting for fans who had placed many hopes and dreams in the survival of that relationship.

Cyberfeminism in general explores the possibility of carving out online spaces that are empowering to women (Fernandez, Wilding, & Wright, 2002). Women espousing competing feminist rhetorics in lesbian fan communities based on *The L Word* created spaces that I argue were empowering for women. *The L Word* fan communities were not explicitly feminist, but there were moments in the deliberations and flame wars that could be read as such—as empowering women and as invoking feminist paradigms. I argue that although this is evolving, a traditional feminist paradigm about intimate partner violence is that rape and other violence against women is gendered (Fraser, 1997) and that violence against women is about power and control and derives from men who are physically stronger. The depiction of violence and possible rape in *The L Word* between lesbians problematized this traditional paradigm and opened spaces for debate among fans.

I chose three scenes in particular as representative of intimate partner violence covering a range of sexual and gender identities. In the finale of Season 1 (Episode 14) ("Limb from Limb"), the main protagonists of the series, the femmes Bette and Tina, were involved in an apparent rape and sexualized violence while they were breaking up over Bette's infidelity. The second scene selected was Episode 8 of Season 3 ("Latecomer"), in which Jenny struggles over her laptop with her transgendered partner, Max. The last scene chosen was Season 1, Episode 6 ("Lawfully"), in which a bisexual character, Jenny, said "no" to her boyfriend, Tim, but he persisted with a penetrative sexual act. (Earlier in the day he had discovered Jenny having sex with a woman, Marina.)

The two large fan forums, *The L Word* Fan Site and *The L Word* Online, were chosen as large, very active forums that gained a prominent place in Google searches of *The L Word* over the 4-year period. The two sites were far more active and attractive to a semi-global membership than many of the

smaller *The L Word* fan sites. These fan sites could be searched without membership, and so could be considered to be "published." The flame wars that these scenes provoked contained competing feminist rhetorics and paradigms. Although none of the posts referenced emerging feminist research on intimate partner violence, many of the posters did argue that a woman could be violent to her partner.

Bette and Tina and the Femme-Femme Relationship

The representation of intimate partner violence between the femme characters Bette and Tina in the season finale of Season 1 was ambiguous, but it generated heated and passionate debate. As Tina yelled at Bette for being unfaithful 7 years into their relationship, Bette restrained Tina and pinned her to the bed. After being slapped, Tina, still pinned to the bed, grabbed Bette's arm and moved it toward Tina's genitals. The violence of this scene was hotly debated in fan forums and has also received some scholarly attention. Lorna Wheeler and Lara Raven Wheeler (2006) concluded that no rape occurred in this scene, because Tina reversed the power by grabbing Bette's arm. They argue that the mutual aggression of this scene could instead be read as spontaneous, unplanned, queer, sadomasochistic sex. I would argue against this reading of the incident since, as Wheeler and Wheeler point out, sadomasochistic encounters tend to be negotiated. The incident was, however, ambiguously represented, and a reading of either rough sex or sexualized violence is possible. The fans were divided in their readings of this scene. Some fans read it as "mutual rape." Other fans suggested that violence between women in relationships was impossible, because domestic violence and rape were about masculine power over women.

Several fans related to the violence in *The L Word* scene and narrated their experiences as victims or perpetrators of this kind of "intense" and "emotional" encounter. A poster called "Tinwoman" posted to *The L Word* Fan Site on April 7, 2005:

> I am new here so I hope you will not mind me jumping in. I just saw the break up scene and even though I am not an emotional person by nature, that scene hit me like I had been punched in the stomach. I watched it several times and was totally impacted by the raw emotion of the characters. Incredible acting, awarding winning stuff in my opinion.
>
> I did try and place a man in the role to see if I felt any different about the scene, in particular Tina slapping Bette. Would that be acceptable to me? In real life that would be domestic violence. But being the same gender Bette and Tina are more

like physical equals. So I would be interested in any ones' opinon if gender roles were changed to a man and a woman in the same sceniero, and do you feel it would change your view if Bette or Tina had been a man?

This poster denied the possibility that domestic violence had taken place in the scene but did raise questions about the potential for the scene to have been violent if those characters had been male. One of the responses to this post was from "spacystacy" (2005):

Hi Tin. Welcome. I think if the gender roles were changed, a man slapping a woman would be uncalled for because he is physically stronger. I think of Bette and Tina as equals and the scene worked because of that.

A response that more intensely mirrored the abuse of the scene came from posters who identified with the character who slapped and restrained her girlfriend. One of the posters, "Chantemoi" (2005), said that the scene reverberated for her, and that she would behave in the same way as Bette to try to control her girlfriend if she found herself in the same situation of having cheated:

All I know is that scene was so intense and so "real" I could hardly breathe, let alone actually think "what is going on here!?". I still get all tense and teary-eyed when I watch it over. I know if I were in Bette's position I would do everything I could to keep my girl from leaving.

It came pretty close to home for me too—my wife of 5 years could be Tina's understudy if *The L Word* were a play. She looks and acts very much like her. And with the exception of the great job, the great hair every single day, the money, & the affair, I come pretty close to being "Bette" in the relationship. The whole thing just really makes me uncomfortable to watch, but not because I think that their final scene from S1 was anything even close to resembling an assault, but because it was so convincing, especially in a lesbian relationship.

I know the turmoil & anguish for Bette & Tina has just begun.

The following poster, "Paragonvictim" (2005), also describes her experience of being in a relationship that was similar to the fictional one portrayed by Bette and Tina. "Paragonvictim," however, narrates her experience as a recipient of "raw aggression" from her female partner without naming this as violence:

I totally agree with Chantemoi, I've been thru it to, the same scenerio in the final episode. And I can only speak for me, but that raw aggression my girlfriend of 6 years

displayed made me realize how much I love her, I mean you really have to be in love to go through something like that. The people who are saying that this scene was assault just haven't been through anything like that yet. No, it wasn't wrong. No, it wasn't disturbing, it was raw and real. Being in love is not wrong, finding out your girlfriend (Long Term) has cheated on you will bring out emotions exactly like Bette and Tina portrayed. Chantemoi also hit the nail right on the head when she said how amazing Jenneifer Beals and Lauren Holloman's acting is. Everybody has a right to their opinion and thank god for that !!!!!!!!!!!!!

Other fans also denied that an incident of rape or domestic violence had occurred. Many of these fans referenced the apparent capitulation or control taken by Tina as she was pinned to the bed when she freed an arm enough to touch Bette's genitals. These fans sometimes accepted that a woman could rape her partner. These fans asserted, however, that because of Tina's gesture, either no rape had occurred, or it was unclear who raped whom, or the incident could be described as "mutual rape." The poster "Emony" (2004) posted to *The L Word* Fan Site on the thread, "Another take on it":

I had a discussion about this with a friend of mine and I thought she had some valid points that I wanted to share with you all. This was her assessment of the scene (I edited out her name for her privacy):

<*> Guys do that too though. They think "If I can just hold her still and pork her, she'll settle down."

<*> [I]t was stuff like this the courts had in mind when they ruled it is possible for a husband to rape his wife.

<*> Back in the not too distant dark ages it was assumed anything a man did to his wife was simply privaledge of his relationship with her.

<Emony> ::nods:: I can see how it could be thought of as assault

<Emony> Yeah

<*> Tina was not attacking or damaging property. There was no reason to restrain her, other than to try to gain control of her. And rape is all about control.

<Emony> I don't really think that rape was Bette's intention though

<Emony> She was trying to gain control of her but I think it was more to calm her down

<*> Oh, I don't think many rapists actually consciously think "I am going to commit rape".

<*> I think many of them are thinking "If I can just show her how good it can be...."

...

<*> What it comes down to is Bette did not respect Tina, and Tina lost all respect for Bette.

<Emony> ::nods::

<Emony> and the sex?
<*> Part of that was leftover emotional stuff, and maybe mutual rape. I mean do
you think either of them was seriously concerned with making the other feel good?
<Emony> no

These posters' otherwise thoughtful debate over the issue of rape in a lesbian relationship concludes that the Bette/Tina interaction had been a "mutual rape," which contradicts the poster's own arguments that rape was about control. The term "mutual" implies consent, which would logically cancel out the possibility that a rape had occurred.

Another poster, "baby_dom06" (2005), argues on the thread "Control" that the sex was mutual, but that Bette needed to control the situation, her partner, and her life. This poster offers a chilling take on the control issue that also negates the possibility that a woman could rape another woman, even if her aim was to control:

I feel that it was about control the thing that bette needs the most....Bette is some-
body like me. Afraid to show their feelings cause somebody might not approve or in
Bettes case think your as perfect as u seem. She wanted tina to think that Bette could
give her the perfect life the perfect family etc. And in order for that to happen Bette
needs to be in control.
 As for the finale scene thats what the issue was it was just more intense than
what Bette has handled before and it hits her heart because she losing control over
the 1 thing that she thought was secure in her life. I believe that it was make-up sex.
Tina took Bettes hand and forced Bette into her therefore it was mutual.

The intensity of this debate, of the passionately argued position for and against the possibility that a woman in a long-term relationship with another woman could be violent to her partner, is in stark contrast to fan reactions to ambiguously represented violence against a woman from her transgendered and heterosexual male partners.

Jenny and Max and Jenny and Tim

In Season 3, Episode 8, the character Max grappled with his girlfriend Jenny over her laptop because he wanted to delete a story that she was writing about him. The responses in the fan forums to this incident were of unstable transmen who were violent as a result of "roid rage" and illegal hormone use (metalsmith, 2006). The fans in the forums also reiterated other stereotypes about transmen that were already circulating in lesbian communities, for ex-

ample, that the trans character practiced a "cheap imitation of masculinity" (lwordfan4, 2006).

The forum reactions to the representation of Max being violent toward Jenny were for the most part condemnatory. Max generally was an unpopular character, and his decision to transition from female to male was very unpopular in the forums (Walker, 2009). Max was represented in the series, as well as by many posters, as violent because of his choice to transition. Although his violence was read this way by the majority of people posting about the issue in the forums, there is some challenge to this reading from transgender supporters. For example, "Mr Piddles" (2004) argues that forum posters are transphobic and need to sympathise with the character Max because he is affected by hormones:

> Folks also need to know that when someone is starting a female to male transition they are basically like teenage boys tons of hormones that bring on horniness, rage and other emotions. Once again I think IC's [Ilene Chailken] was trying to show an important part of our community but has not given everyone enough information to fully understand what is going on for that character.

Jenny is praised by posters on *The L Word* Online for standing up to Max, but the systemic problem of intimate partner violence in both heterosexual and queer communities is not addressed. I did not find any posts that suggested that Jenny or her friends should have called the police or sought any legal redress for any of the incidents of violence against her. The only solution offered by forum members was that Jenny leave her partner, Max, making the intimate partner violence a problem not only of individuals but also of individual relationships.

There was very little fan reaction in *The L Word* Online or *The L Word* Fan Site to the other scene of apparent intimate partner violence that Jenny was involved in: the "obligatory sex" with her ex-boyfriend, Tim, in Season 1, Episode 6. Pam Cole (2005) asked in a fan editorial on *The L Word* Fan Site, "why did Tim 'rape' Jenny before disappearing forever?" There did not appear to be any debate in response to this editorial. There were passing references to the representation in the series. "[B]chluvr3" (2005), in a post called "Best and worse," lists a number of worst moments in the series, including "Worst Sex Scene Tim's rape of Jenny (total wtf moment)."

The overall lack of response to this incident in *The L Word* Online or *The L Word* Fan Site leads me to speculate that that this reading—that the incident constituted rape—was an accepted one in the forums and therefore not

controversial enough to garner comment or to spark a flame war. Since other claims that a character in the series raped another, such as that Bette raped Tina, sparked intense denials and a passionate flame war, the lack of response to the assertion that Tim raped Jenny is surprising. The character Jenny was extremely unpopular in *The L Word* Fan Site and *The L Word* Online, and there was a very lukewarm reaction to the heterosexuality or bisexuality of the character at that time, but this in itself is not sufficient to explain the lack of response to the incident in the forums. It may suggest that there is no controversy for lesbians in claims of either obligatory or retaliatory sex for bisexual women who are caught cheating with a woman on their male partners. In an obituary to Jenny, who dies for unexplained reason in the final season of the series, a fan named "Katie295" (2009) also says that Tim raped Jenny. "Katie295" suggests that this is because Tim is hurt by Jenny's falling in love with a female character, Marina:

> As is often the case, while still fucking her boyfriend, she realizes that she is a lesbain herself and falls in love with the "only in your dreams" beautiful Marina who seduces her (wish that could happen to me, but oh well that's television wish fulfillment for you). Jenny makes mistakes common to many women coming out. But it particularly hurts boyfriend Tim who acts out by marrying her, divorcing her, then raping her onhis way tp Case Western to be the new swim coach.

This in itself is a concern for feminist researchers, but it was certainly not the only response to Tim and Jenny in fan forums.

Several threads were established in *The L Word* Online and *The L Word* Fan Site that specifically focused on Jenny (for example, photogem, 2005), so although the character was not popular in these forums, she did attract a minority of fans who praised her. Tim was also mentioned favourably in the forums. One fan, "spacystacy" (2005), compared Tim's reaction to discovering Jenny cheating favorably to Tina's reaction to Bette's cheating, "I think a real man handles a cheating partner much the way that Tim handled walking in on Jenny and Marina. Be mad but do not hit." This fan identified Tina's slapping of Bette in Season 1, Episode 14 as violent, and Tim's behaviour as non-violent.

Evolving the Feminist Paradigm on Intimate Partner Violence

Although domestic violence is understood under a traditional feminist paradigm as strictly tied to gender and patriarchy (Fraser, 1997), there is an

emerging literature that understands intimate partner violence to include violence in lesbian relationships. This literature still understands violence in feminist terms but extends the traditional feminist paradigm. Intimate partner violence can be defined as any violence between people in intimate relationships. The change in name—intimate partner violence compared to domestic violence or wife battering—reflects the change in understanding violence in relationships as restricted to heterosexuals (Hester & Donovan, 2009). There is a danger in promoting or advocating this change in paradigm. As Beverly McPhail, Noel Bridget Busch, Shanti Kulkarni, and Gail Rice (2007) point out, feminists have fought for many years to have serious and endemic violence against women addressed globally. To argue that women could themselves be violent to their lesbian partners risks having this argument appropriated by those involved in the backlash against feminist services and support for women. Shamita Das Dasgupta (2002) argues that a non-gender-specific or gender-neutral understanding of intimate partner violence that allows for heterosexual women to be violent to their partners misrecognizes the overall pattern of abuse by men in heterosexual relationships. Dasgupta (2002) distinguishes between abuse by women against women with whom they are in intimate relationships, and retaliatory violence by women in heterosexual relationships who may be violent on a short-term basis in an attempt to stop a pattern of being victimized. McPhail and colleagues (2007) suggest that an understanding of intimate partner violence that encompasses violence in lesbian relationships can still be framed in feminist terms. They tested their Intimate Feminist Model (IFM) with women working in women's services and found that these workers were generally open to discussion of intimate partner violence perpetrated by women against other women. Some of them had also had experience in providing services to women who had been abused by other women. They found that in the context of attacks on women's services, the need for a feminist model and understanding of intimate partner violence was vital.

Jude Irwin (2008) argues that activists in some queer, feminist, and lesbian circles have been advocating recognition of intimate partner violence that includes queer, gay, and lesbian relationships for many years. Lori Girshick (2002) conducted a study of intimate partner violence in lesbian communities and argues that denial of the possibility of violence by women against other women is widespread. Grace Giorgio (2002) discusses the reaction of disbelief of those in the criminal justice system to any victims of in-

timate partner violence in lesbian relationships. Giorgio (2002) also suggests that GLBTs underreport intimate partner violence.

Jeffrey Todahl, Deanna Linville, Amy Bustin, Jenna Wheeler, and Jeff Gau (2009) argue that sexualized intimate partner violence in lesbian or transgendered communities is still very much a taboo subject. They suggest that violence against transgendered persons may be higher than that of the general population. Girshick (2002) mentions violence against transgendered people in intimate partner violence but suggests that one transgendered respondent to her study identified as a woman at the time the violence occurred. The scholarship on transmen and intimate partner violence is sparse. There is one study by Nicola Brown (2007) of lesbians in relationships with transmen. Brown argues that lesbians who reported intimate partner violence sometimes blamed hormonal fluctuations for this violence. However, she found that the literature on hormone use did not consistently support this theory. Brown also suggested that F-T-Ms who were preoperative were most vulnerable to challenges about their new gender status and more likely to adopt a hyper-masculine style and behaviors. These hyper-masculine behaviors could include intimate partner violence. In her study, Brown found the stereotype of transmen becoming violent because of steroid rage. Henry Rubin argues that transmen reported a mixture of reactions to hormones, some of them becoming calmer after taking hormones (cited in Brown, 2007). Any discussion of intimate partner violence in lesbian or transmen relationships, or calls for a new paradigm of intimate partner violence that encompasses these forms of violence, risks supporting the backlash against feminist activism on domestic violence (Girshick, 2002). I am skeptical about the men's movement's claims to the victimization of men by women, and critical of their subsequent attacks on services to help women to escape domestic violence and attacks on laws designed to protect women from the predominant forms of sexualized violence around the globe, including the rape of women by men (Mann, 2008).

Conclusion

In a review of literature on same-sex domestic violence, Paula Poorman (2001) found that same-sex couples were more likely to be referred to couple counseling than heterosexual couples, because same-sex domestic violence was perceived to be less severe than heterosexual domestic violence. In the fictionalized, albeit ambiguous, relationship of intimate partner violence in

The L Word, the lack of recognition or acknowledgement of the violence did not even allow for an individualized response to this violence.

Several of the feminist responses to the above scenes in the fan forums suggested that fictionalized representations of intimate partner violence need to name abuse as abuse, and to provide possible solutions for the characters and, by implication, the audience. These debates contained elements of feminism and feminist activisms over intimate partner violence. However, they confirmed research on offline lesbian communities that there is widespread denial about the possibility of intimate partner violence in lesbian relationships. Ironically, lesbian feminist rhetoric from the 1970s about women's equal strength and power in same-sex relationships was invoked by some of the posters in their denial of the possibility of same-sex domestic violence or rape. Paradigms of male violence and female victimhood do not translate well to acknowledge, describe, or analyze same-sex violence. These paradigms are invoked against transgenders, but not against women-born lesbians. I argue, along with Girshick (2002), that a new paradigm needs to evolve to describe same-sex violence, which encompasses the messages and statistics being collated and published by queer intimate partner violence activists. The paradigm could still encompass a feminist understanding of intimate partner violence rooted in issues of unequal power and control (McPhail et al., 2007). The forums revealed a number of posters who admitted to behaving in ways that activists would describe as violent, without acknowledging that their behavior would be interpreted in that way. The denial in the forums that lesbians could be violent in relationships was consistent with findings from Giorgio (2002) and Girshick (2002) that this denial is widespread in lesbian communities.

The online spaces themselves can be seen as spaces that allowed diverse—at times feminist—lesbian voices. The online spaces can also be understood as spaces that allowed deliberation over competing feminist paradigms regarding intimate partner violence, spaces that allowed debate and consideration of different viewpoints. There were obvious constraints on the extent of the community as spaces for lesbian deliberation. The forums were semi-global Internet communities conducted predominantly in English and based on a series that was available only on premium cable or in DVD format in many countries. In some countries that censor lesbian popular culture, such as Lebanon, *The L Word* DVDs were seized at customs. In countries that censored lesbian debate on the Internet, such as China (Farrell, 2008), there were further obvious barriers to participation in the online

communities. The digital divide in all countries (Carpentier, 2007) further limited participation in any online debates. Within these constraints, there were further limitations on participation. Many lesbians who watched part of the first episode stopped watching the series in protest at the representation of lesbians (Reeder, 2004). So the diversity of participation in the forums was limited to passionate fans in anglo-centred countries. Within these constraints, I would argue that a form of cyberfeminism that allowed deliberation in public over evolving norms for lesbian communities is alive and well. I would also argue, however, that the forum debates were missing important aspects of evolving feminist understandings of control and unequal power within lesbian relationships, and that the work of feminist activists over the issue needs to be further published and disseminated to a wider audience.

Works Cited

baby_dom06. (2005, March 12). Season ender—Rough sex or assault? *The L Word* Fan Site. Message posted to http://discussion.lword.com/viewtopic.php?t=936&sid=54c324047f22f16006bccdbd0bdc3319

bchluvr3. (2005). Best and worse. *The L Word* Fan Site. Retrieved from http://discussion.l-word.com/viewtopic.php?t=4044&highlight=jenny+rape

Brown, N. (2007). Stories from outside the frame: Intimate partner abuse in sexual-minority women's relationships with transsexual men. *Feminism & Psychology*, *17*(3), 373–393.

Carpentier, N. (2007). Participation, access and interaction: Changing perspectives. In V. Nightingale & T. Dwyer (Eds.), *New media worlds: Challenges for convergence* (pp. 214–228). Melbourne: Australia: Oxford University Press.

Chantemoi. (2005, February 16). Bette and Tina keepin' it real. *The L Word* Fan Site. Retrieved from http://discussion.l word.com/viewtopic.php?t=936&sid=54c324047f22f16006bccdbd0bdc3319

Cole, P. (2005). Season 2 premier. *The L Word* Fan Site. Retrieved from http://www.l-word.com/fane/ar_8.php

Dasgupta, S.D. (2002). A framework for understanding women's use of non lethal violence in intimate heterosexual relationships. *Violence Against Women*, *8*, 1364–1389.

Emony. (2004). Another take on it. *The L Word* Fan Site. Retrieved from http://discussion.l-word.com/viewtopic.php?t=936&sid=54c324047f22f16006bccdbd0bdc3319

Farrell, K. (2008). Corporate complicity in the Chinese censorship regime: When freedom of expression and profitability collide. *Journal of Internet Law*, *11*(7), 11–21.

Fernandez, M., Wilding, F., & Wright, F. (Eds.). (2002). *Domain errors! Cyberfeminist practices*. Brooklyn, NY: Autonomedia.

Fraser, N. (1997). *Justice interruptus: Critical reflections on the "postsocialist" condition*. New York: Routledge.

Giorgio, G. (2002). Speaking silence: Definitional dialogues in abusive relationships. *Violence Against Women, 8,* 1233–1259.

Girshick, L. (2002). Book review: *No more secrets: Violence in lesbian relationships* by Janice L. Ristock. *Violence Against Women, 8,* 997–1003.

Hester, M., & Donovan, C. (2009). Researching domestic violence in same-sex relationships: A feminist epistemological approach to survey development. *Journal of Lesbian Studies, 13*(2), 161–173.

Irwin, J. (2008). Discounted stories: Domestic violence and lesbians. *Qualitative Social Work, 7*(2), 199–215.

Katie295. (2009, March 8). Enter your Jenny Schecter obituaries here. *The L Word* Wiki. Retrieved from http://lwordwiki.sho.com/thread/2487766/ENTER+YOUR+JENNY+SCHE CTER+OBITCHUARIES+HERE!?offset=60

lwordfan4. (2006, March 28). Don't hate me but I feel bad for Max. *The L Word* Fan Site. Retrieved from http://discussion.l-word.com/viewtopic.php?t=12012&highlight=roid+rage

✳ Mann, R. (2008). Men's rights and feminist advocacy in Canadian domestic violence policy areas: Contexts, dynamics, and outcomes of antifeminist backlash. *Feminist Criminology, 3*(1), 44–75.

✳McPhail, B.A., Busch, N.B., Kulkarni, S., & Rice, G. (2007). An integrative feminist model: The evolving feminist perspective on intimate partner violence. *Violence Against Women, 13*(8), 817–841.

metalsmith. (2006). Don't hate me but I feel bad for Max. *The L Word* Fan Site. Retrieved from http://discussion.l-word.com/viewtopic.php?t=12012&postdays=0&postorder=asc& highlight=roid+rage&start=15

Mr Piddles. (2004, March 14). Transphobia. *The L Word* Fan Site. Retrieved from http://discussion.lword.com/viewtopic.php?t=11815&postdays=0&postorder=asc&highlight=tr ans&start=0

Paragonvictim. (2005, February 11). Season ender—Rough sex or assault?. *The L Word* Fan Site. Message posted to http://discussion.l-word.com/viewtopic.php?t=936&sid=54c324 047f22f16006bccdbd0bdc3319

photogem. (2005). To all the wonderful Jenny fans. *The L Word* Fan Site. Retrieved from http://discussion.l-word.com/viewtopic.php?t=10393&highlight=jenny+rape

Poorman, P. (2001). Forging community links to address abuse in lesbian relationships. *Women & Therapy, 23*(3), 7–24.

Reeder, C. (2004) The skinny on *The L Word*: Loser ludicrous lewd lame laughable lacking leering laborious lazy leaden lying limited lugubrious lackluster lousy loo low-fat lackluster lamentable languid languorous lassitude loathsome loutish loveless loopy lobotomized lithium limited lima beans lies. *Off Our Backs, 34*(1/2), 51–53.

Russo, V. (1987) *The celluloid closet: Homosexuality in the movies.* New York: Harper & Row.

spacystacy. (2005, May 19). Season ender—Rough sex or assault? *The L Word* Fan Site. Message posted to http://discussion.l-word.com/viewtopic.php?t=936&sid=54c324047f22 f16006bccdbd0bdc3319

Tinwoman. (2005, April 7). Season ender—Rough sex or assault? *The L Word* Fan Site. Message posted to http://discussion.l-word.com/viewtopic.php?t=936&sid=54c324047f22f1 6006bccdbd0bdc3319

Todahl, J.L., Linville, D., Bustin, A., Wheeler, J., & Gau, J. (2009). Sexual assault support services and community systems: Understanding critical issues and needs in the LGBTQ community. *Violence against Women, 15*(8), 952–976.

Walker, B. (2009). Imagining the future of lesbian community: The case of online lesbian communities and the issue of trans. *Continuum, 23*(6), 921–935.

Walters, S. (2001). *All the rage: The story of gay and lesbian invisibility.* Chicago, IL: University of Chicago Press.

Wheeler, L., & Wheeler, L.R. (2006). Straight up sex in *The L Word*. In K. Akass, J. McCabe, & S. Warn (Eds.), *Reading The L Word: Outing contemporary television* (pp. 99–110). London and New York: I.B. Tauris.

Chapter 13

Is Your Space Safe?
Cyberfeminist Movement for Space Online
at *Unnine*

Yeon Ju Oh

Introduction

In 2000, *Unnine* (meaning a sister's house in Korean), a cyberfeminist community and webzine, was initiated by a group of young Korean feminists. These young feminist entrepreneurs witnessed both dystopian and utopian visions of cyberspace in the dot-com boom years. On the one hand, cyberviolence against women was prevalent, and commercial websites targeting female consumers masqueraded as so-called "web portals for women." On the other hand, the low entry cost offered feminists a chance to build alternative communities to commercial websites, and women online had already shown the Internet's potential as space for self-expression and empowerment (Cho, 2000). *Unnine* was born amid these frustrations and hopes. The staff of this community was involved in college feminist movements and experienced the moment when their independent press on campus brought the community to feminist agendas with everyday gender politics. While the organizers believed this to be the case in cyberspace, they were aware that this would be accompanied by frustration, as they had learned through the experiences of the feminist movement in a higher education setting as a microcosm of male-dominated society.

Founded as a feminist webzine, *Unnine* has grown to allow users to create a personal profile, exchange messages, and set up groups, thus serving as a feminist social network service. Although the website has been framed as a feminist media or a feminist community, I focus on its attention to a woman's right to online space as summarized in its mission statement: "We endeavor to make women-friendly cyberspace." The organizers' involvement in feminist movements on campus inspired them to make male-centered space safe for female students and help them to gain a sense of belonging. This ideal of community was the inspiration for *Unnine*; thus it is a feminist

movement for space online, and at the same time a feminist movement for online space. This study is an attempt to investigate the physical and the virtual as interconnected, and to link the recent feminist movement online to an earlier generation of feminist politics that radically challenged the notion of space as gender neutral and fought to build an online community for women.

The Feminist Movement for Rights to Space

The feminist movement for rights to space traces back to the 1970s. In Susan Brownmiller's memoir (1999), the international march known as "Take Back the Night" was remembered as one of the accomplishments of the 1970s feminist movement (1999). Despite the progress of this movement over the last 30 years, a woman may still feel anxiety walking alone at night. Birth, reviewing the 30-year long movement, states: "With every shadow she sees, and every sound she hears, her pounding heart flutters and skips a beat. She hurries her pace as she sees her destination become closer" (2009, p. 4). Whether I am walking in metropolitan Seoul, hanging out in a gay-friendly neighborhood in Vancouver, or living in a small college town such as Bowling Green, Ohio, my fear and anxiety do not disappear. I intentionally walk down a dark street and expose myself to late-night dangers, resisting the caution that tells me I should confine myself to a safe female place. This desire was encouraged by the 1980s MTV representation of Madonna's video *Borderline* and Cyndi Lauper's *Girls Just Want to Have Fun*—go to the street, appropriate the male space, and confound the social binaries drawn around men and women (Lewis, 1990). However, this fear resurfaces when I receive mail sent from the small college town government's office telling me that a sexual offender has moved into an apartment three blocks away from me.

Home is supposed to be safe. It is where I was assigned to be and was supposed to be protected. However, as I log on to the Internet, I see that the space is not safe anymore. When I read abusive comments tagged under my feminist postings, see pictures of Facebook girls wearing no more than underwear on torrent websites, or pass through hate websites to search race-, gender-, and sexuality-related issues, I am attacked in a place that is assumed to be safe. As I detour potentially threatening places online, like women who bypass dark and deserted areas, a few questions arise. Am I safe in cyberspace, since no one can physically harm me? Does cyberspace replicate the gendered order of physical space? Can the dangers in cyberspace be compared to those in physical space? Is it my cyber-self who is being assaulted,

or is it my offline-self who is being abused? Or is it impossible to draw the line between my virtual and physical selves?

Unnine began with these questions, and its answer was that virtual space is an extension of physical space. In Korea, where digital technologies have quickly developed, violence against women online has increased. Cyber crime doubled between 2002 and 2006, when women were more often exposed to sexual insult and violations of privacy (Chung & Kim, 2008). Although *Unnine* was primarily concerned in its early stage with the most conspicuous violence online, it did not merely emphasize the need for safety. *Unnine's* organizers envisioned a place where women can promote their growth by stimulating deliberate discussions based on self-reflexivity and respect for differences in women's experiences. As the movement developed, the issue of what kind of feminist community they can build online became more critical than merely ensuring women's safety online.

Spatial Metaphor or Spatial Reality

What *Unnine* had to challenge was the presumption that cyberspace is not a hollow space consisting of spatial metaphors. William Gibson, in his science-fiction work *Neuromancer* (1984), envisioned a future technology that is a complex network of data and human interaction and described it as:

> Cyberspace. A consensual hallucination experienced daily by billions of legitimate operators, in every nation, by children being taught mathematical concepts. A graphic representation of data abstracted from banks of every computer in the human system. Unthinkable complexity. Lines of lights ranged in the nonspace of mind, clusters and constellations of data. Like city lights, receding. (Gibson, 1984, p. 51)

As seen in Gibson's use of the term cyberspace, the ideas of networking through the Internet have been constructed in association with spatial metaphors. From the large-scale terms referring to the infrastructure, such as *information super-highway*, to the small-scale terms indicating the tools of communication, such as *chat room*, spatial metaphors fill the Internet lexicon. There have been debates over how we began to use these spatial tropes to frame the online environment. In a Kantian sense, "space is the *a priori* form of human perception" (Kitcher, 1996, p. xxxvi). For Kant, space as well as time is the form of cognition that develops our sense of and understanding of the world. Chesher (1997) and Dallow (2001) also find that spatial analogy is

integral to the cognitive processes of human beings. The arguments from scholars, who emphasize the practicality of spatial metaphors, resonate with the view of space as essential to human cognition. Behind the statement that spatial metaphors help Internet users to visualize the abstract flows of digital codes and electronic signals (Sawhney, 1996) and make the abstruse technological structures tangible (Wilson & Corey, 2000), the assumption that human knowledge is better constructed through spatialization is subsumed.

From a critical stance, the use of territorial metaphors is a reflection of power dynamics rather than the inevitable outcome of the workings of the human mind. Comparing the description of cyberspace as a new world to the discovery of America, Gunkel and Gunkel (1997) argue that the territorial tropes are suggestive of European expansionism. According to them, naming is a political project that is concomitant with "an exercise of power" (p. 133). As Columbus discovered "what he thinks he should encounter" (p. 124) from the new continent, cyberspace as a new world has been constructed, through the politics of naming, in a way that the Western discoverers believe it should be. In a similar vein, the term *electronic frontier* symbolizes the American mythology of the pioneer spirit, which viewed the Wild West as a land of infinite dreams and opportunities (Paasonen, 2009). Jordan (1999) connects dot-com companies' desire for ownership of cyberspace in the 1990s to the 19th-century railroad company that controlled the means of communication and supply in the frontier, as corporate power in both times functioned to limit the potential of networking. In this sense, the territorial tropes mirror Western values that view cyberspace as a new land to discover, conquer, and own rather than see it as shared space for communication and networking.

Although these two perspectives on the spatial metaphors—inevitability and Western expansionism—have been deemed as an incompatible binary, they are not irreconcilable. In that the camp emphasizing the politics of naming does not necessarily oppose the idea that spatialization is integral to human cognition, framing those two perspectives as an opposition might be misleading. To contend that spatial visualization as a means of constituting the online space is inevitable, the Kantian ontological argument should be challenged. However, scholars critical of geographic allegory do not confront the necessity of spatialized thinking but problematize a specific type of naming grounded in European expansionism and American pioneering.

Instead of positioning myself between the existing frames, I aim to drive the debate in a different direction. From the perspective of human cognition,

cyberspace is understood in a metaphoric sense that connotes the unreality of the space. As William Gibson commented, cyberspace "seemed evocative and essentially meaningless. It was suggestive of something, but had no real meaning" (Neale, 2000). That is, metaphor making is a process that makes the visible invisible, the incorporeal tangible, and the meaningless meaningful. However, a sense of space is not inevitably gained by sensory information. The sense of space is obtained from "books read long ago, from films, from her own memory, and maybe from her ancestral memory" (Kundera, 2002). Harking back to the etymology of nostalgia, Kundera narrates that "What in English is called 'homesickness.' Or in German: *Heimweh*. In Dutch: *heimwee*. But this reduces that great notion to just its spatial element" (2002, p. 5). Cyberspace can be sensed as real if the perception of a homeland, a concrete geographical site, is formulated by the assemblage of images, memories, and human interactions, not by the tangibility. As Doreen Massey (1993) suggests, we need to conceive of places as "articulated moments in networks of social relations and understandings" rather than as "areas with boundaries around" (p. 66).

From the view upon which the Western vision of invasion is focused, the multiplicities of individual human interactions online are ignored. Technological revolution at the macro-level, in complicity with corporate power, tends to reproduce the influence that Western invaders exercised on the new continent. The vision of telecommunication companies that seek to impose a tiered service model (Basse, 2008) exemplifies the critical scholars' concern that cyberspace may become a gold mine that resembles the economic structure offline and creates artificial scarcity. However, "there are multiple, heterogeneous networks, within which telecommunications and information technologies become closely enrolled with human actors, and with other technologies, into systems of sociotechnical relations across space" (Graham, 1998). Whereas the naming of cyberspace as a new world reflects the desire for capital expansion, cyberspace, for individual human actors, is a different new world in which social relations and the structure of the space are mutually constitutive.

Avoiding the existing position of regarding places online in a metaphorical sense, I see them as tangible and material rather than metaphorical. By tangible or material, I do not mean that the interactions online can be equivalent to physical presence or face-to-face contact offline. Rather, I mean that concrete human interaction and social relations formulated online can provide the sense of being there without physical encounters. Meanwhile, I fo-

cus on the human interactions that both affect and are affected by the structure of cyberspace. While I do not undermine the politics of naming, the social relations online are not only affected by the naming but are also influential in the meaning the names would have. Feminist geographies, in particular, enable us to examine the interrelationships between cyberspace and social relations in terms of gender.

Feminist Geography and Cyberspace

As Massey (1993) states: "The social relations of space are experienced differently, and variously interpreted, by those holding different positions as part of it" (p. 4). Scholars of feminist geography and feminist scholars of geography have attempted to unpack the gendered structure of space and the social relations affected by the structure by weaving the embodied experiences of women into the politics of public and private space and the politics of nation/state (Nelson & Seager, 2005). Despite its short history of less than 4 decades, feminist geography has developed, covering various sectors including body, workplace, city, environment, and nation/state, and establishing several sub-fields such as feminist political, historical, and urban geographies.

Some of the nascent works in feminist geography have focused on the impact of urban design on women's lives, along with industrialization and the local government-driven division of zones. Suburbanization of domestic lives and the centralization of working activities in urban areas reflect the view of women's roles as housewives whose mobility toward the public sector is deemed unnecessary and even undesirable. A suburbanization project was accelerated with middle- and working-class women's entry into the public sphere, since their entry into the labor market was considered to be a danger to marriage and pregnancy, and a threat to working-class men because of labor competition (Women and Geography Study Group, 1984). As the zoning process that segregates residential and industrial areas was settled, women's accessibility to paid labor became more restricted. Since women's dual roles of productive and reproductive labor had to be performed in separate places, maintaining the balance between the two types of work was important (Hanson & Pratt, 1988).

Later studies in feminist geography extended the scope to include the intersectionality of women's multiple oppressions, interrelationships between the lives of women in developed and less developed areas, im/migration of

women, warfare, and citizenship. Whereas the early examination of urban design indicated the effect of spatial structure on (mostly white) women in a developed part of the world, the later studies began to take into account the connection between the local and the global in a transnational economy and the internal diversity of women's experiences, reflecting the criticism of 1970s and 1980s feminism that considered white women's experiences the norm (Nelson & Seager, 2005; Johnson, 2008). Meanwhile, embodiment has been another emphasis of feminist geography. Feminist scholars emphasize that "the differences in physicality that construct and reflect gender norms create ways of being in space" (McDowell & Sharp, 1997, p. 203), and those ways, in turn, modify women's bodily practices.

In cyberspace, the restriction of mobility and the limitation of accessibility in a physical sense are not factors that produce the oppression of women. Unlike the city landscape, cyberspace was not designed to sustain the assumed gender roles. Further, national boundaries that create stratified citizenship for women and migrant others do not determine women's experiences in cyberspace. In postulating the relationship of women and cyberspace, feminist geography focuses on the sense that is gained through gendered experiences in spaces and places. Women's access to a physical space, whether it is a working space or a foreign space beyond one's own national affiliation, does not generate a shared sense of the space regardless of the gender or other multiple positions of the subjects who live within it. Home can be a place where women perform labor and suffer violence and abuse while men find rest. Fenster (2005) eloquently narrates the salience of examining the sense of belonging: "The affective dimension of belonging— not just of be-ing, but of longing or yearning" (p. 243), is central to characterizing the experiences within a space. Although cyberspace is not where the users have physical attachment, its spatiality can be examined through the affective dimensions, including belongingness. →▷ TEORIA DOS AFETOS !

The other critical aspect of feminist geography is its attention to the social relations in space and place. As Massey (1993) stresses, social relations determine the structure of space and, in turn, the spatial dimensions serve to determine the social relations within a space. Watson (1997) contends that online communities are still communities, although they are different from offline communities. Cyberspace as a community is where existing social relations are reproduced, and the spatial particularity generates different forms of social relations. Social, economic, and cultural activities in cyberspace are performed on the basis of a sense of community, which is interplayed with

social relations, rather than being detached from communal engagement. As a feminist politics, feminist geography is attentive to the characteristics of social relations, which are "inevitably and everywhere imbued with power and meaning and symbolism" (Massey, 1993, p. 4). Looking at cyberspace in terms of gender relations is an attempt to unpack the power played out in the space and the meaning of space and gender constructed in the relationship with broader social relations. The women's rights movement for space online offers an analytical tool to ponder cyberspace in a spatial sense and unravel the mutually constitutive processes of gender relations and spatial structures.

Unnine, a Community Filled with Feminism

Wajcman, in her book *TechnoFeminism* (2004), introduces the vision of cyberfeminism. She states: "An optimistic—almost utopian—vision of the electronic community as foreshadowing the 'good society' is also characteristic of cyberfeminism" (p. 63). Although cyberfeminism can be interpreted in various ways, cyberfeminists share the optimistic vision of new technology as a space where women can realize liberating and alternative ways of communicating (Lagesen, 2008). Feminist scholars envisioning the utopian community in cyberspace contend that the communicative aspects of computer technologies offer women room to find pleasures.

Unnine originated in both utopian and dystopian visions of cyberspace. While *Unnine* as a feminist medium values "the interactive way of communication" online, it is cognizant of the prevalence of violence through forms of cyber sexual assault, cyber stalking, and distribution of obscene materials. In addition, there is a sense of threat in that feminist or women's realms are not secure in cyberspace, and that the feminist community could repeat the history of being left behind by oppressive dominant power. Thus, the mission of *Unnine* was to establish a place where women are safe from sexual violence online and where the vision of a feminist online community can be realized.

The Mirror of Violence against Women Offline

As revealed in *Unnine*'s initiative, a repetition of violence against women in the offline world is what it saw as problematic in cyberspace. Although there is no restriction on visiting a place online unless it is barred for reasons of marketing, privacy, or political ideology, accessibility does not guarantee the right to move freely in communities. The constant assault from sexually ha-

rassing representations and utterances violates the right of women to be safe in cyberspace. The focus of *Unnine* on the issue of violence against women is resonant with the feminist movement known as *Reclaim the Night,* which began in the 1970s. One of the movement's accomplishments was directing women's self-regret—summarized as "If I hadn't gone out that night..."—to the community's efforts to promote a safe environment at night from harassment and sexual assault. *Unnine*'s awareness is parallel to the 1970s movement in that it endeavors to improve safety in the cyber community as a whole, rather than require women to protect themselves.

As *Unnine* gains insight into the connection of cyberspace to violence against women, it finds aspects of harassment and assault distinguished as online or offline. A recent case of sexual assault online reveals how *Unnine* frames violence against women in cyberspace. In 2007, the bulletin board "My Life and My Story," located on a website called Myclub—the first women-focused commercial website in South Korea—was attacked by a male Internet user. The user consecutively posted repellent pictures of men's muscular arms and other objects inserted in women's anuses and wrote messages detailing verbal and sexual abuse. Several pages of the bulletin board were filled with the comments he posted. The so-called "Ministry of Men's Rights," an Internet community established to parody the Ministry of Gender Equality, replied to his postings with supportive comments. The male user was arrested after a 3-year investigation, and the Ministry of Men's Rights was closed upon the filing of a criminal complaint by female users and the Ministry of Gender Equality.

Byeol-Sa, one of *Unnine*'s editors, filed the criminal charge against the harasser. She finds that the boundary between the distribution of obscene materials and sexual assault online becomes nebulous due to the characteristics of online communication. The case was at first framed by the criminal investigators as distribution of obscene material. However, in contrast to the distribution of such materials offline, where the audience has the right to choose to view the material or not, distribution in an online environment can lead to the exposure of unwitting viewers to the material. Given that cyberspace makes simultaneous, interactive communication possible, one's activity should be interpreted in relationship with the other parties receiving the message. Byeol-Sa claims that the case is not about the mere distribution of obscene materials but about a sexual assault. The transmission of sexually abusive materials in photos and writings showing sexually exploited women's bodies can be interpreted as threatening and abusive rather than obscene.

An individual assault can function as a form of mass violence against women in cyberspace. A total of 124 *Unnine* users participated in the complaint procedure, and more than 1,000 users reported the case to the Information Communication Ethics Committee, asking it to close the Ministry of Men's Rights. These numbers imply that the violence caused massive damage to female community members, hindering an orderly management of the community. Byeol-Sa defines this incident as systematic violence against women rather than an isolated case for three reasons. First, given that the website is a so-called "women-focused portal service," and the harasser targeted a public bulletin board, the incident was against women as a whole. Second, the harasser attacked the website during a weekend when the web master was absent, so that his postings were not removed. His attack was not extemporaneous but well planned in that his violence reached a larger audience. Third, and most importantly, the violence was supported by the Ministry of Men's Rights. Not only did the ministry members offer encouraging comments to the harasser's postings, they also appointed him "Member of the Month." Byeol-Sa explains that the communicative aspect of cyberspace contributed to the formation of a male coalition. While the coalition supported the violence in a visible way by posting comments, it was complicit in the assault through "a cartel of silence" that helped the case to fade away after the harasser was officially accused. Although Byeol-Sa sees in the female users' collective reaction to the attack the potential of resistant feminist alliance online, she claims that the male coalition buttressing violence against women in cyberspace remains strong.

Feminist Knowledge Playground

In the 1970s and 1980s, a group of American women consisting of publishers, printers, editors, and distributors convened to develop ideas and methods to circulate feminist and lesbian writings and thoughts. Thanks to this movement, feminist books—which were often denied publication by major publishers—could be displayed in bookstores (Travis, 2008). Cyberspace, because of its lower institutional and financial barriers in distributing knowledge, can be a venue for disseminating feminist thoughts. However, as Jordan (1999) states, "offline hierarchies are subverted by cyberspace but are also reconstituted in cyberspace" (p. 85) in terms of producing and controlling information.

Unnine problematizes the duplication of offline hierarchies that have restricted women's knowledge from being circulated online, as opposed to men's privileged knowledge. In an investigation of a community-generated social knowledge platform similar to Answer.com or Yahoo Answer, *Unnine* found that the answers to women-related questions were dominated by low-quality information. Looking at the information produced and consumed online, *Unnine* points to an ambivalent future for knowledge formation. On the one hand, what has not been recognized as knowledge has begun to be considered worthwhile for narrating and sharing in cyberspace. That is, a cyber community has a potential as an alternative space where women's lived experiences, which were made invisible by the traditional academic realm, can be made visible by women themselves. However, the prevalence of common sense prevents women's experiences from being contextualized and evolving into knowledge that helps women raise their consciousness. Common sense is produced through negotiations and contestations among community members rather than based upon clear consensus. As common sense that reflects cultural norms and values held by the privileged is projected upon women or other marginalized groups, their experiences are at times ignored. Using abortion as an example, *Unnine* contends that it is difficult for a woman to find solid information on how to get a safe abortion. In the flood of pros and cons in the abortion debate and the simple narration of abortion procedure, the consequent physical and mental effects on women do not capture the interest of those who offer the information. While the narration of women who went through an abortion procedure can shed light on the complexity of the issue, such stories were outweighed by the presence of uncontextualized information.

Unnine calls the limitation of information online "the wall of common sense" or "the violence of common sense." At best, the knowledge of women-related issues is produced at a common-sense level that does not explore how the broader social and cultural structures interact with women's experiences. At worst, the knowledge ignores and even deprecates women's experiences. We often witness how sexist arguments lacking reasonable explanations become accepted knowledge through various media venues, including blogs and social networking services. For instance, in a widely viewed YouTube clip, Betty Friedan and Susan Sontag appear as Jewish lesbian abortionists who engage in mass abortion without their positions being contextualized. Rather than presenting women's experiences with the politics of reproductive rights surrounding the abortion issue, the experiences are undermined by

claims of knowledge that perpetuate an ignorant view of women's positions. The existing process of knowledge production that is centered in academia, and which has systematically essentialized and denounced women's knowledge, is perpetuated in cyberspace through a misleading form of common sense by individuals.

Revisiting Freedom of Expression

As communities in cyberspace are built upon the users' modes of communication, the discussion of rights for space online should consider whether the preconditions for freedom of expression are given to the users. *Unnine* claims that there is invisible censorship that precludes women's voices from being heard. So-called "cyber terrorism" against a women's online community exemplifies the censorship that regulates women's voices. In 1999, the official website of Ewha Woman's University in South Korea was "terrorized" by Internet users who opposed the abolition of the "extra score" system that guarantees veterans—both conscripted and professional soldiers—additional scores at the time of employment tests. Once again, in 2002, the website was attacked by opponents of conscientious objection to military service. Since most of the complainants were faculty members and students, the university became the target of attacks by male netizens, who saw it as a place that historically nurtured feminist sympathies. The bulletin board on the student government's website that publicized statements criticizing the existing military culture of South Korea was filled with postings that contained abusive comments and combinations of nonsensical words. Moreover, the website was unable to function because of excessive traffic, a strategy planned by a group of males. Since then, in the South Korean context, the term cyber terrorism has been used to refer to a collective attack that targets and accuses an individual or a community. Although the term is seemingly gender neutral, female individuals and women's organizations have been the main target.

Unnine finds that the online discussion over freedom of expression has taken place without considering the gender-stratified structure that restricts women's voices. In the promising vision of cyberspace as a venue where political voices can be heard without institutional obstacles offline, attention to how women's perspectives have been and would be excluded from the public sphere in both online and offline space has been absent. Quoting Susan Herring (1996), *Unnine* argues that "males' utterance disapproving, criticizing

and admonishing women is indirect censorship for women." *Unnine* further contends that "freedom of expression is the right that needs to be contextualized in order to make the political meaning of freedom justified." That is, when the marginalized cannot enter into the public sphere without censorship, freedom of expression should be revisited.

Unnine's argument is based on the South Korean experience in particular. In South Korea, the interactive aspect of the online network is more prevalent than in many other parts of the world. For instance, most news articles published online have a reply function that allows readers to share their thoughts with others. Abusive and violent comments that occupy the public sphere serve as constraints that cause the marginalized to keep silent. When it comes to gender-related issues such as mothering, affirmative action, sexual violence, military service, or sex ratio in educational and professional areas, the discussion forum often deteriorates into a space that censures women's perspectives and reaffirms male privilege. The interactive tool that was designed to realize deliberate democracy has turned into a means of perpetrating "violence of expression" in the name of freedom of expression.

Unnine claims that anonymity, which guarantees freedom of expression online, should be contextualized in a way that reflects gender hierarchy. While anonymity can be used by the privileged in order to exercise undue power over women and sexual minorities, it can be a strategic tool for the marginalized to make their perspectives heard. That is, anonymity as a precondition for uncensored expression of opinion online has ambivalent qualities. In the nationwide debate over the so-called "Internet Real-Name System" that mandates registration for Internet websites with a real name in order to participate in discussion forums, a consideration of the conflicted meanings of anonymity has been missing. While the rationale for objecting to the system focuses on its possible effect of inhibiting freedom of expression, the content of the expression has not been examined. *Unnine* claims that it is questionable that the expressions that function as "violation of privacy, cyber sexual assault, cyber defamation, and online censorship" are within the same context as other less malign expressions. In revisiting freedom of expression online, *Unnine* asserts the need to ask "why freedom of expression was claimed by whom" in order to understand the power played out in conferring the rights of expression.

Building a Safe Space Online

Despite *Unnine*'s 10-year presence in the cyberfeminist movement, the meaning of cyberfeminism has been debated in its own community. While it began with the attempt to build a cyberspace wherein women can safely interact with each other and share feminist thoughts without concerns about violence against them, the definition of violence online has been fluid rather than static. If in its early stage *Unnine* focused on online sexual assaults that resemble those from offline, such as verbal and visual sexual harassment, it has extended the scope of violence to include the knowledge production system and the mechanism for freedom of speech online, which facilitate the invisibility of women's knowledge and the tacit censorship imposed on women's perspectives.

Although the meaning of cyberfeminism is still evolving in *Unnine*, it is notable that its vision is broader than some of the feminist movements online that view cyberspace as merely the extension of offline movements. While cyberspace is often used as a means of distributing feminist agendas offline, *Unnine* sees cyberspace as not only a means but also a version of society where the power relationships online reflect the characteristics of new technology. As Massey (1993) points out, "what is at issue is not social phenomena in cyberspace but both social phenomena and space as constituted out of social relations" (p. 2). Although *Unnine* connects the social phenomena offline to those of online, it examines how the phase of social phenomena offline shifts in cyberspace. That is, *Unnine* focuses on communicative aspects online that accommodate male coalitions, the violence of common sense, and the violence of expression in a different way from offline space.

Despite the negative reality of cyberspace, *Unnine* has envisioned a promising cyberfeminist movement. Opposing the knowledge production system online, *Unnine* has endeavored to collect and distribute women's knowledge that has not been "approved and recognized" by the existing system of knowledge production and the current prevalence of popularized knowledge online. "Knowledge Playground" is one of the sections where *Unnine* tries to breathe life into women's experiences and the knowledge obtained from experiences. While academic writings of women's issues are collected and shared, in this section the difficulties that women face in their everyday lives are addressed, supported and debated by the users who have gained their own positions through embodied experiences. The concerns about sex/sexuality, sexual violence, relationships, women's health, and

working as women are expressed without consciousness of aggressive reactions from those who problematize women's emotions and experiences. Although at times the wall of common sense keeps the discussion from being developed into the basis of women's consciousness, *Unnine* has attempted to reconstruct the feminist aspect of network online by "restoring women's knowledge that has been undervalued."

Another positive aspect of the cyberfeminist movement is its closeness to the everyday politics of women's lives. A section called "One's Own Room" has functioned as a place where users narrate the conflicts and inconsistencies in terms of gender relationship they face in their everyday lives. In this section, users can open their own rooms and write individual columns that develop their experiences into feminist views or consciousness. While the articles *Unnine* publishes become the catalyst that helps the users to look at their lives as related to gender politics, the writings in "One's Own Room" reciprocally give *Unnine* ideas of what issues are vital to women's everyday lives. Through this section, *Unnine* aims to incorporate women's most intimate and personal issues into its feminist agendas, avoiding a feminist movement's pitfall that detaches it from the everyday gender politics that women face.

The cyberfeminist movement in *Unnine* generally takes two different but related forms. It constantly interrogates the qualities of cyberspace that serve to reproduce and reinforce the existing gender hierarchies offline. This interrogation helps to envision how feminists intervene, deconstructing cyberspace as gender-neutral and making the space safe for women. Meanwhile, it experiments with the potential of cyberspace as a feminist communicative space. "Knowledge Playground" and "One's Own Room" are ongoing experiments in examining the ways in which cyberspace can be built into the kind of optimistic space that the existing cyberfeminists imagined. As a decade-long cyberfeminist movement, *Unnine* helps to speculate about gender politics in cyberspace in relationship to offline spaces and envision the ways in which cyberspace can deconstruct power relations.

Works Cited

Basse, S. (2008). *A gift of fire: Social, legal, and ethical issues of computing and the Internet.* Upper Saddle River, NJ: Pearson Education Inc.

Birth, N. (2009). History of Take Back the Night. In A. Escobar & J. Hill (Eds.), *Take Back the Night Foundation event guidebook* (pp. 5–7). Retrieved from http://www.takeback thenight.org/TBTNEventGuidebook2009-12-14.pdf

Brownmiller S. (1990). *In our time: Memoir of a revolution.* New York: Dial Press.

Chesher, C. (1997). The ontology of digital domains. In D. Holmes (Ed.), *Virtual politics: Identity and community in cyberspace* (pp. 79–92). London: Sage.

Cho, J.H. (2000). 그래서 사이버스페이스로 간 그 여자아이는 어떻게 되었나? [So, what happened to the girl who went to cyberspace?]. *Yonsei Journal of Women's Studies, 6,* 28–39.

Chung, Y.K., & Kim, Y.H. (2008, February 21). "사이버 폭력에" 여성들 멍든다 [Women suffer from "cyber-violence"]. *The Hankyoreh.* Retrieved from http://www.hani.co.kr/arti/ society/women/272678.html

Dallow, P. (2001). The space of information: Digital media as simulation of the analogical mind. In S. Munt (Ed.), *Technospaces: Inside the new media.* New York: Continuum.

Fenster, T. (2005). Gender and the city: The different formations of belonging. In L. Nelson & J. Seager (Eds.), *A companion to feminist geography* (pp. 242–256). Malden, MA: Blackwell.

Gibson, W. (1984). *Neuromancer.* New York: Ace.

Graham, S. (1998). The end of geography or the explosion of place? Conceptualizing space, place and information technology. *Progress in Human Geography 22*(2), 165–185.

Gunkel, D.J., & Gunkel, A.H. (1997). Virtual geographies: The new worlds of cyberspace. *Critical Studies in Mass Communication, 14*(2), 123–137.

Hanson, S., & Pratt, G. (1988). Reconceptualizing the links between home and work in urban geography. *Economic Geography, 64*(4), 299–321.

Herring, S.C. (1996). Gender and democracy in computer-mediated communication. In R. Kling (Ed), *Computerization and controversy: Value conflicts and social choices* (2nd ed) (pp. 476–489). San Diego, CA: Academic Press.

Johnson, L.C. (2008). Re-placing gender? Reflections of 15 years of *Gender, Place and Culture. Gender, Place and Culture, 15*(6), 561–574.

Jordan, T. (1999). *Cyberpower: The culture and politics of cyberspace and the Internet.* NY: Routledge.

Kitcher, P. (1996). Introduction. In I. Kant, *Critique of pure reason* (W.S. Pluhar, Trans.) (pp. xxv–lix). Indianapolis, IN: Hackett.

Kundera, M. (2002). *Ignorance* (L. Asher, Trans.). New York: HarperCollins. Original work published 2000.

Lagesen, V. A. (2008). A cyberfeminist utopia? Perceptions of gender and computer science among Malaysian women computer science students and faculty. *Science, Technology and Human Values, 33*(1), 741–763.

Lewis, L.A. (1990). Consumer girl culture: How music video appeals to girls. In M.E. Brown (Ed.), *Television and women's culture: The politics of the popular* (pp. 89–101). Newbury Park, CA: Sage.

Massey, D. (1993). Power-geometry and a progressive sense of place. In J. Bird, B. Curtis, T. Putnam, G. Robertson, & L. Tickner (Eds.), *Mapping the futures: Local cultures, global change* (pp. 59–69). London: Routledge.

McDowell, L., & Sharp, P. (1997). Body maps: Editors' introduction. In L. McDowell & P. Sharp (Eds.), *Space, gender, knowledge: Feminist readings* (pp. 201–208). London: Arnold.

Neale, M. (Producer & Director). (2000). No maps for these territories [Documentary]. New York: Docurama.

Nelson, L., & Seager, L. (2005). Introduction. In L. Nelson & L. Seager (Eds.), *A companion to feminist pedagogy* (pp. 1–12). Malden, MA: Blackwell.

Paasonen, S. (2009). What cyberspace? Traveling concepts in Internet research. In G. Goggin & M. McLelland (Eds.), *Internationalizing Internet studies: Beyond Anglophone paradigms* (pp. 18–31). New York: Routledge.

Sawhney, H. (1996). Information superhighway: Metaphor as midwives. *Media, Culture and Society, 18*(2), 291–314.

Travis, T. (2008). The women in print movement. *Book History, 11*, 275–300.

Wajcman, J. (2004). *TechnoFeminism*. Cambridge; Malden, MA: Polity.

Watson, N. (1997). Why we argue about virtual community: A case study of the Phish.net fan community. In S. Jones (Ed.), *Virtual culture: Identity and communication* (pp. 102–132). Thousand Oaks, CA: Sage.

Wilson, M.I., & Corey, K.E. (2000). *Information tectonics: Space, place, and technology in an electronic age*. New York: Wiley.

Women and Geography Study Group of the Institute of British Geographers. (1984). *Geography and gender: An introduction to feminist geography*. London: Hutchinson .

Chapter 14

Where Is My Profile Picture? Multiple Politics of Technological Mothering and Gendered Technology

Natalia Rybas

Introduction: Scandalizing Breastfeeding

In this chapter I explore the production of gendered and otherwise culturally marked practices and bodies in the public spaces online. In particular, I examine conversations about breastfeeding and parenting in one specific group in a social network system. These online discussions serve as constitutive of motherhood and technology, for they work through the rhetoric of romantic and scientific mother, activist parent, and cosmopolitan woman. Thus, technology and gender get co-produced and co-performed. Breastfeeding is not only a personal but also a cultural and political process: the act of breastfeeding contributes to the social construction of gender, sexuality, motherhood/parenting, work/family/play as well as social networks online, technology, and public space. I argue that participation in online breastfeeding spaces such as the Facebook group "Hey Facebook, breastfeeding is not obscene!" disrupts and simultaneously reaffirms dominant cultural values related to gendered practices, women's bodies, and gendered technologies.

Breastfeeding is a practice loaded with meaning. This way of nourishment is a site of political and ideological struggle where the meaning of the female body and sexuality is continuously formulated, interpreted, and contested. In feminist literature, breastfeeding has been argued to be controversial (Bartlett, 2005; Kukla, 2006; Nadesan & Sotirin, 1998; Young, 2005). Alison Bartlett's publication explores the narratives of public breastfeeding in Australia that generated scandals. Bartlett argues that the instances of public breastfeeding challenge the dominant idea of stay-at-home mothers and challenge the structure of urban citizenship. Majia Nadesan and Patty Sotirin (1988) explore the contradictions in the rhetorical construction of breastfeeding as a romanticized, natural way of mothering and as a subject of science and medicine. These discourses represent the cultural and political struggles

over the value and status of women's subjectivities. Because breasts visibly and tangibly signify womanliness, breasts undergo a cultural construction in male-dominated Western society. Thus, breasted experience cannot escape the problematic status (Young, 2005).

Like Alison Bartlett (2005), I focus on a scandal related to breastfeeding. I refer to a practice of posting photos of nursing babies on the profiles in the social network system of Facebook. The curators of Facebook occasionally remove profile pictures of women breastfeeding their babies. This situation gained notoriety at the end of 2008 through coverage on television and in newspapers. The women whose photos were flagged for removal, as well as their co-thinkers, formed a group called "Hey Facebook, breastfeeding is not obscene!"[1] Since then, the participants in this group have been protesting against tagging the images as violating the policy about obscene, porno-graphic, or sexually explicit content. The group's life focuses on discussions about questions, problems, and accomplishments related to parenting. Civility issues in the online social network as well as physical spaces are also often explored. In addition, the group organizes events such as virtual nurse-ins (the last one was scheduled for March 8, 2010). As of October 2010, the group was going strong, with more than 260,000 registered members, up from 100,000 in January 2009. By analyzing the work of the group, I ask the following questions: When the issues of breastfeeding spill into the digital realm, what cultural values come to the surface in online conversations and actions? What is at stake when breastfeeding occupies public space online? What changes and what remains stable if mothers and lactation enthusiasts initiate, develop, and promote the public aspect of breastfeeding in the con-text of the social network Facebook?

The study of the scandal about the removed pictures of breastfeeding and the developing discussions in the online social network fit the fabric of the cyberfeminist agenda that addresses women's issues in technological culture (Blair, Gajjala, & Tully, 2009; Wilding, 1998). Using the metaphor of "cy-berfeminism as a browser through which to see life" (Wilding, p. 12), this chapter accounts for the specific construction of gender that takes place in the Facebook group. Serving the cyberfeminist program to critique the social and cultural conditions emerging in the context of technologies, I reach to today's articulations of this academic research area and feminist movement strategy.

Performing Gender and Technology

The notion of performativity provides lessons in theorizing both gender and technology. In relation to gender, performativity emphasizes the lack of essence in the identity construction and focuses on the continuous production of both gender norms and heteronormative structures that help make sense of the everyday materializations of gendered bodies. Judith Butler (1990) articulates that the materiality of gender is sedimented through ritualized repetitions of conduct. She suggests that gender must be done—that is, performed repeatedly—"put on, invariably, under constraint, daily and incessantly, with anxiety and pleasure" (p. 277). According to Butler, performativity describes the scripted character of identity, which is generated through repeated citations of norms and preventative punishment for their transgression. I join Butler and other feminist scholars in rejecting the essentialist conception of gender and conceptualizing gender as constructed through social rituals.

The concept of performativity of gender opens possibilities of thinking about the breast and breastfeeding in ways that underscore the emergence of the meaning of this practice as a result of repeated patterns of interaction. Breastfeeding appears as an active and functional engagement related to motherhood and parenthood. Breastfeeding is a learnable process that requires effort and time to become accustomed to for both a mother and a baby. The learning happens first rhetorically, in talking about this approach to feeding an infant, discussing the process with others. Then the theory is applied in practice: in the actual holding, latching, sucking, feeling the let-down, and filling up the hunger. Breastfeeding is time- and place-bound: the process of learning to breastfeed and the act of nursing are spread in time, and the performance of breastfeeding is located in place. Breastfeeding is "quite specific to each act, rather than…homogeneous experiences between women or even for one woman over time and place" (Bartlett, 2005, p. 113). Even though breastfeeding may seem, as is often argued, natural, the bodies of mother and baby have to strategically engage together to develop and then use this technique of feeding and eating. Mothers who try breastfeeding learn early in their parenting career that babies, even though born with the sucking reflex, may not suckle on their own. A nurse in the maternity ward or a lactation consultant in the hospital may provide guidance for the successful beginning of breastfeeding. As a marker of material body, breastfeeding defines the self as it modifies movement through physical and digital spaces. The lactating breast engages discourses forming and reflecting special knowledges, skills,

and practices, and then contributes to the reproduction of mothering and gender.

In relation to technology, the performative approach claims that phenomena can be made and remade in the various ways they are said to exist or made to emerge in practice. The performativity of technology suggests that specific material processes, such as participating in activities associated with a social network and talking about the network, create a social network online. John Law and Vicky Singleton (2000) argue that *"particular and located enactment or performance of technological knowledge and practice"* (p. 767) does particular kinds of work through telling the stories and acting out realities. They imply that descriptions and stories of technological projects as well as the actions that materialize a technology perform a particular notion of technology-mediated organization and work to make the technocultural world. Theorizing the emergence of the "Hey Facebook!" group in this social network suggests that an argument about what should or should not be done and how the argument is presented (in what tone of voice, to whom, and when) is a located enactment of technological knowledge.

When performativity of gender and performativity of technology come together, the enactments of technology and enactments of gender co-produce visions and incorporations of social network online and breasted experience of motherhood or parenthood. Landstrom (2007) supports this by suggesting that gender emerges in the processes whereby people and technology are engaged in producing specific understandings of humans and specific variants of technologies. These specific understandings of identity and specific variants of technologies become interpellated in multiple stories, which conflict and interfere with each other so as to produce multiple realities, multiple belongings, multiple subject and object positions (Landsrom, 2007; Law, 2000).

Last, it is through the act of performance, I argue, that breastfeeding is a communication phenomenon that occurs in human interaction. I live through some of the notable moments of my breastfeeding career to note how this process is communally constructed and sanctioned. Through an auto(cyber)ethnographic participation in social networks and online communities, such as Facebook (Rybas & Gajjala, 2007), I investigate the collective production of the social movement for lactation freedoms in the group "Hey Facebook, breastfeeding in not obscene!" I analyze my experiences and relationally read the online dialogues of mothers and activists focusing on the themes emerging in the posts and critically analyzing these themes (Mitra &

Gajjala, 2008). Thus, focusing on the talk on the surface and the situations at hand (Landstrom, 2007) helps to see how identity is coproduced with technology. Through these various lenses of theory and research practice based on performativity, I explore the multiple politics of technological mothering and gendered technology.

Gender(ed) Objectifications

Putting oneself into being in online environments requires knowing self, others, contexts, and contextual conventions of representation. In other words, a social network member becomes both the subject and the object in narratives and digital artifacts displayed and composed online. As such, these "stories, effective stories, perform themselves into the material world...in the form of social relations, but also in the form of machines, architectural arrangements, bodies, and all the rest" (Law, 2000, p. 2). Therefore, the conversations in the "Hey Facebook!" group as well as beyond the community produce multiple discursive objects, or objectifications. In particular, the work in the social network systems objectifies identities of users and the network. In feminist theory, the term objectification critiques patriarchal gendered relationships that promoted essentializing of gender qualities. According to this line of thinking, facebooking strengthens understanding of mothering as a natural mode of being while the group emphasizes association of mothering with the female breast. These layers of objectification mark the active positions in the construction of subjectivities of those who participate in the activities of the "Hey Facebook!" group and those who are implicated in this process.

An aspect of work in the social system focuses on maintaining one's self on the profile or in groups, whereby self-creation and self-maintenance stands in the center of facebooking work. Collectively, notes, status updates, posted links, and thoughts on the wall contribute to the production of self. Online network participation is premised on the act of knowing—making sense of one's reality and producing one's reality in the means provided by the network. The web pages visually and textually assemble a member who types his or her knowledge about oneself into being. A subject of network membership emerges from texts, links, comments, images, and other traces of digital presence.

Such self-production implies the mechanisms of spectatorship, which involves consuming knowledge about others, looking from a distance, and gazing. In feminist literature, such gazing has been theorized as a way to reduce

women to sexualized objects, that is, to objectify, which leads to dehumanizing and alienating of women. Young (2005) explains that "We [women] experience our position as established and fixed by a subject who stands afar, who has looked and made his judgment before he ever makes me aware of his admiration or disgust" (p. 77). However, Myers (1987) argues that any sort of representation involves objectification and may not involve violence but reflects aesthetic and spatial relations, refers to the traditions of gender and sexual representation, and corresponds to other forms of regulations (Attwood, 2004). Comparing pornographic and fashion images, Myers moves to consider the modes of address and the contexts of production and consumption of such images. Thus social networking complicates the feminist argument and clashes two processes referred to as objectifications: producing the object and consuming the object, knowing the knower and knowing the known.

Objectification in the social network occurs at multiple moments of self-production and other-consumption. First, individuals objectify their identities when they strategically create profiles. For example, a profile picture provides significant strokes in identity building that target specific and unspecified audiences. I explore my profile to see how I build my Facebook page, and the picture stands out most prominently. Since the removal of the pictures was the most contentious event in the scandal with the "Hey Facebook!" group, I examine my own images in detail. Of the 22 photos posted from the moment I joined Facebook in September 2006, only 6 of the photos are not related to my motherhood. All other photos trace my son through his life. Out of these profile pictures, it is easy to assume that the person emulated in the profile is a mother. I also have a note that "breastfeeding is not obscene." This note, on its own, does not identify me as a mother, yet in the context of my profile it confirms my family status. In my status updates I occasionally refer to my family. These minute moments of online performance construct my mothering image in lieu of my self-image, whereby I claim to know the self through my mothering.

As a network user, I reach out to public discourses about mothering. I act upon the generally positive attitude to parenting in public, which I know from others' reactions to my being. When I walk with my son and my husband in the neighborhood, mall, or park, passers-by smile and ask nice questions such as "How old is the boy?" or "What is his name?" I often hear comments that "He is cute" or such. I perceive that the society welcomes the image of motherhood: young, healthy-looking mother with a son holding her

hand. The same holds true with the network participation. The people I know who have children and Facebook accounts emphasize the parenting aspect of their lives by posting pictures, videos, various updates, and referring to their children in conversations. I find presenting myself as a mother on Facebook a safe strategy, which evokes affirmative responses from the Facebook friends.

Culturally, to be a mother is a symbol of female power. Seeking recognition as a parent projects an obvious confirmation attitude toward the self. In comparison, being a parent is different from being a university professor. The two aspects of the self require different interpellative work. While motherhood is often on the surface and perceived with a kind nod, professorship requires extra explanation, in Law's words (2000), to soften the darkness of misunderstanding in the lack of obvious features. As a professor, I would have to explain my specialty, my place of work, and my teaching responsibilities. As a mother, I need to mention that I have a toddler, and my status is crystal clear. This way, the role of a mother is easier to carry in public: my presence as a mother validates my place in the culture.

Another aspect of objectification emerges inside and outside the "Hey Facebook!" group. In this culture, breasts are objectified as the most visible sign of femininity and female sexuality (Young, 2005). The activist group, as well as the site curators, focus their discussions on breastfeeding, locating it on a particular part of the female body. Both sides dissect and construct the female body for the activity of visual consumption, literally for the sake of appearances. The issue of the conflict between the group members and the network administrators ultimately boils down to the question: To post or not to post the images showing mothers nursing? The group members vehemently argue for the right to post pictures of nursing mothers on Facebook. The major argument of the group members is generally that the network is flooded with images of naked bodies, which are not considered obscene or offensive. The network argues, in turn, that the images violate the policy that limits imagery offense for the audience, and the network managers rely on the users' calls to report violations.

The interrelated layers of objectification—of identity, of gendered roles, and of the female breast—may form strategic and patriarchal relations among community members depending on who relies on which means of objectification, to what end, and in which context. The situated practices of objectification reach out to the bodily ways of knowing, per Haraway (cited in Law, 2000); that is, the knower argues for a particular way to know the self

and the other. As applied to the activities of the group in question, these layers of objectification refer to the production of the images of normalized mother, activist woman, and cosmopolitan parent. I explore these themes further.

Producing Normalized Motherhood

The group "Hey Facebook!" produces enormous discursive work about breastfeeding and mothering. The discussions focus on multiple topics that may be of concern to mothers who breastfeed, who did so in the past, and who plan to nurse in the future. The discussions do not always feature human milk and nursing, but they necessarily relate to mothering. As of June 15, 2010, the discussion board includes more than 5,000 topics. They include ways to treat eczema or thrush, the age at which women start and end breastfeeding, objections to resorting to formula feeding advised by a doctor, the best time to stop co-sleeping, the ways to encourage independent sleeping, and frustrations about the aches and pains of nursing. The comments in the discussion, as well as on the wall of the "Hey Facebook!" group, work toward the production of an ideal mother and an ideal gendered subject/object that fits the patriarchal ideology of a heterosexual relationship.

My readings of discussion cases suggest that the members of the "Hey Facebook!" group adopt the philosophy of the national campaigns to encourage breastfeeding under the slogans of "Breast is Best!" and "Babies are Born to be Breastfed!" Similar to the national campaigns announced by the U.S. Centers for Disease Control, the discourses in the online group focus on the romance of the natural mother and the science of breastfeeding. Majia Nadesan and Patty Sotorin (1998) explored these themes in detail when they analyzed the examples of La Leche League documents and popular media images. The study of "Hey Facebook" group illustrates how the themes identified by Nadesan and Sotirin materialize in online discussions in the breastfeeding community on Facebook.

The theme of the natural mother emerges in considering motherhood a "natural fulfillment of maternal duty and capacities" (Nadesan & Sotirin, 1998, p. 219). This trope is evident in the discussions that emphasize the moral responsibility of mothers and mothers' connection to nature. One of the participants in the discussion about why people do not even try breastfeeding states: "breasts have been so far sexualised I dont think it comes to peoples minds sometimes their true purpose!" (June 15, 2010). Even though

the speaker notes the duality of female breasts, she suggests that sexuality is not the right purpose; rather, she implies that nursing is a more appropriate way to understand the female body. This quote is one of many that collapse the distinction among womanhood, motherhood, and breastfeeding to one aspect of parenting. Another group member appeals to morality and maternal duties when discussing parenting in the forum about approaches to training independent sleeping: "A parent's responsibility is to meet the needs of their children" (June 10, 2010). Thus, a good parent and, by association, a good mother, will meet the needs of the children, including finding an acceptable method of training to sleep independently. A similar approach of responsibility and morality establishes the values of breastfeeding: "I agree that there is a place for formula, when it's medically necessary, but I think that it is *a shame* that some women think that formula is a satisfactory substitution for breast milk." Here mothering is viewed as work, at times hard and hurtful, that needs to be done: "We live in a world ruled by instant gratification. When things are difficult, the majority seems to decide it's [breastfeeding] not worth the trouble. They fail to understand that the things you have to work for are the most worthy of all." These discussion excerpts suggest that the members of the group support an approach to parenting where morality and duty take the highest value.

Understanding mothering and breastfeeding as a moral duty supports the rhetorical construction of nature as an aspect of breastfeeding. In the discussion about the choices mothers make about feeding their babies, one of the participants boasts: "I live in reality and know that not everyone is blessed to be a natural Holstein like me!" Humorously referring to the highest-producing breed of dairy cow, the speaker positions milk as a gift of nature. The response—"you're not 'blessed' to be able to breastfeed. You're a human mother—it's just biology"—strives to remove the meaning of randomness and suggests that breastfeeding is a systematic occurrence in nature. Another post reiterates this connection to nature: "We wouldn't be a very successful 'animal' if we were unable to feed our young and enable them to thrive and grow" (June 15, 2010). The production of milk for supporting the newborn is often cited as a reason to breastfeed at classes and websites for new moms, which rhetorically rehearse the connection of mothering to nature. This connection actualizes breastfeeding as a moral order stimulating perception of mothering as an essential womanly call.

The image of the normal mother draws from scientific, medical, and commercial spheres, and thus this image strengthens the trope of scientific

breastfeeding (Nadesan & Sotirin, 1998). The members of "Hey Facebook!" often appeal to medical and other sciences to build their case in support of breastfeeding. The group members believe in the benefits of breastfeeding because it is cast as scientifically and medically sound: for example, as a remedy for common skin or digestion problems in infants, as a prevention of obesity in future child and adult life. The argument that breastfeeding is less costly for a family budget is often repeated in forums. Because breastfeeding is supported by contemporary medicine, a mother must be educated to be able to make the right choices.

A more complicated logic emerges when views on breastfeeding benefits clash with formula benefits or with the scientific achievements in nutrition or development. Despite the fact that breastfeeding is effectively supported by references to contemporary medical science, the members of the group often admit that formula may be medically necessary as well. For instance, in this excerpt formula may be justified as an alternative to breastfeeding: "I do have friends that weren't able to [breastfeed] because of medical issues/medication they HAD to take, or just NEVER got in ANY milk…and that's fine." In the difficult moments when nature is helpless in providing adequate health to the mother, the science and technology of producing faux human milk seem acceptable. Nadesan and Sotirin (1998) explain that for medical science, breast milk and formula have equal nutritional value, yet formula promises to regulate the unpredictable practice of breastfeeding and infant development, which both correspond to the unruly character of nature. The scientific goals of controlling and predicting may lead to the medical professionals' support of formula. As a result, a mother may opt for formula in cases when nature does not work.

However, the voices of doctors may clash with the voices of mothers; this way, nature becomes opposed to science. The group members may share their frustrations when they argue against medical or other institutional discourses if they do not encourage nursing. A request for advice was posted in the forum regarding the dilemma of starting or not starting supplementing if a baby's weight gain slowed at 9 month. All 14 respondents suggested continuing breastfeeding and avoiding formula. Another mother refused giving formula to her baby as recommended by medical personnel; she explained that she did not trust the doctors and nurses who believed that the baby was too big to survive exclusively on mother's milk. In this case, mothers in the group support each other in the decision to go against a doctor's opinion. Ultimately, medical and other sciences serving as the reference source for mak-

ing a decision about the mother's and the child's bodies may play contradictory roles in swaying for or against breastfeeding.

Overall, a closer look at the forums and wall posts suggest that the group participants produce the image of an ideal mother who considers her parenting role a natural call of duty and who knows how to understand the achievements of science and use the gifts of nature.

Riding the Contemporary Wave of Feminism

The rhetorical production of ideal motherhood in the face of an oppressive patriarchy and a capitalist economy coincides with the production of contemporary forms of feminism. It embodies rhetorical activisms operating in private arenas available from everyday, face-to-face conversations or online forums. The discussions about lactation and mothering practices reframe the ideals of desired motherhood. As I suggest above, the group "Hey Facebook!" reproduces the heteronormative system of oppression by engaging the images of the natural mother and scientific breastfeeding. However, by bringing the engagement with these discourses from the institutional to the personal level and merging public and private spheres, the members of the group act in the name of lactation freedoms that seek to develop legal and cultural practices in order to support and protect breastfeeding in public and private contexts. Sowards and Renegar (2006) argue that the methods of contemporary feminist activism often target immediate personal interests, yet these small contributions make changes for the sake of the common good. In the process, the Facebook group engages in strategic objectification of mothering and breastfeeding in order to reframe the pleasures of motherhood and to produce individualized changes.

In general, the most prominent ways to construct activism in the "Hey Facebook!" group include constructing grassroots leadership, using strategic humor, building feminist identities, sharing personal stories, and resisting stereotypes, as suggested by Sowards and Renegar (2006). Resistance to gender stereotypes and labels, a strategy of contemporary feminists identified by Sowards and Renegar, requires more in-depth discussion. The engagement in the issue of lactation freedoms and the process of discussing breastfeeding in a public forum already make both participants and audiences question the communication norms of everyday life. As the discourses of gender normativity are so complex and so ingrained in the habitués of everyday life, it is unproductive to identify a lactation movement online as a fe-

minist class action. Oppressive culture norms, stereotypes, and labels are hard to resist and refute in bulk because of the multiplicity of human experiences. Gajjala (2004) argues that women-centered and women-friendly analyses still reproduce gender binaries. The single-themed analyses contrast women's spaces with male-dominated ones and produce invisible privileges by failing to acknowledge that men and women are situated within diverse cultural locations. To embody a critical approach, the examination of practices should make a commitment to avoiding the pitfalls of universal claim making. Gender stereotypes are a part of the system of oppression that includes multiple layers and axes of privilege based not only on gender but also on class, ethnicity, race, and other temporary or situational markers of difference. Resisting a single stereotype such as attitudes toward breastfeeding makes a difference in somebody's life, but the systemic changes require more continuous work in critiquing everyday practices, stimulating empowerment, and producing oppositional consciousness.

These strategies of contemporary feminist activism emerge due to the strategic engagement of objectification. The scandal on Facebook about images of nursing mothers objectifies breastfeeding, making it the center of the gaze and the focus of discussions inside and outside the group. Since the members of the group appropriate these conversations for bettering their own lives, the objectification takes on a strategic character, for it serves the purpose of the authors of the discourse. In theorizing strategic objectification, I refer to Gayatri Spivak's strategic essentialism, a way for minority groups to represent themselves by bringing forward a significant feature of their identity, thus reaffirming this identity. Essentializing from outside creates stereotypes, leads to privilege, and constructs oppression. Strategic essentializing, from the point of the knower, serves as a temporary measure against oppression. Likewise, strategic objectification allows emphasizing an important individual or group feature.

One of the aspects of strategic objectifications is an engagement of patriarchal dichotomies embedded in the cultural understanding of the breast. Young (2005) suggests that finding the means to "celebrate breastfeeding as a sexual interaction for both the mother and the infant" may serve as a radical move to shift the border between motherhood and sexuality in the perception of the female body. In other words, Young argues for the need to focus on the experience in mothering as a possibility of pleasure, as opposed to or in addition to being a moral or natural duty or scientifically proved need. The actual cause advocated by the "Hey Facebook!" group—to exhibit photos of

breastfeeding—simultaneously promotes and denies sexualized perception of the female breast. This approach calls for sexuality and eroticism to participate as ever-present shadows in mothering, yet they also point to other than sexualized meanings. These double invocations allow the boundaries between the sexual and the motherly to blur.

Since members of the group continuously insist in words and in actions on the right to post pictures on their profiles and in this group, the participating women have an opportunity to celebrate the pleasure experienced in mothering, breastfeeding, and parenting. The participants of the "Favorite Breastfeeding Moments" thread recount the pleasures of breastfeeding.

> My daughter pats me while she eats. She takes her little hand and plays with my shirt and my bra. Recently she's started to pause mid-feed to look up at me and grin. Love when she does that :)

And another one:

> My son does not nurse any more but when he sometimes falls asleep in my arms, and he looks so quiet and peaceful I rush back in my memories to the moments when he would fall asleep when suckling and the firm grip of the latch would loosen and he would relax and the brown skin of areola would come out of his empty gums, slowly, his lips open…those moments are so dear :) oh, memories!

These stories are so intimate and so dear to those who tell them, and the experiences of joy overwhelm the readers. A member who joined the discussion after a few posts had been made says that the story makes her teary, and another one writes that she loves the thread.

An important role is delegated to males—husbands, sons, and significant others—in the process of nursing. Even though breastfeeding emphasizes participation of lactating mother and asexualized baby (Nadesan & Sotirin, 1998), the group participants occasionally refer to their male partners as members of a nursing entity. A Facebook group member explains:

> I even turned my hubby into a lactivist he works at a baby/toy store and proudly gives advice to his coworkers and friends about how to support you[r] SO [significant other] when they choose to breastfeed, and has actually changed some male opinions….(I do believe he mentioned that you get to see the boobies a lot, even though you may not be seeing much else for a while! LMAO).

This post makes a link between multiple meanings of breast: the speaker here conflates the meanings of sexuality perceived from an exclusively male patriarchal perspective and includes other meanings not associated with sexual intercourse. Another post makes a similar connection: "Oh, and my ex likes to complain that I'm radical and crazy for still BF but I know he enjoys still being able to see my boobs." These references include the trope of female sexuality central to the breast; the meaning, however, gets reformulated to include pleasures other than sexual when a nursing woman takes control of the situation.

Even telling stories about how males play an unexpectedly active role in the process of breastfeeding serves as a strategic moment of empowerment. Young (2005) writes that women's breasts undergo exemplary objectification because they are fetishized in comparison and opposition to the phallus. The objectification of breasts happens through language (breasts are referred to a certain way, like "knobs" and "boobs") and actions (breasts are handled, touched, encased in certain ways) to underscore their culture-specific meaning. In these narratives of pleasure, the narrators still use similar language: "Boobs" and "boobies" are often-used ways of addressing the breast (especially when a male is involved). Breasts are still objectified through the actions done upon them: Children are known to hug, pat, grasp, and cuddle mothers' breasts, point at the chest with open mouth like little birds, play with a shirt and bra, and seek comfort at the bosom. These ways of objectification do not exclusively focus on the phallocentric opposition of men and women. That is, the language and the actions do not strive to measure the breast against a standard of perfect shape and proportion. Rather, these ways of performing motherhood and parenting shift attention to other meanings. These stories show a variety of parenting experiences in their intimacy and the immediacy of interaction. In other words, these meanings help to break down the rigid boundary between motherhood and sexuality.

The new perspectives on breastfeeding as a pleasurable moment help ride the contemporary wave of feminism when members of the group exercise additional meanings of motherhood. This argument can be twofold. First, the boundary between motherhood and sexuality can serve the purpose of strategic objectification. Second, it can be the very reason that those pictures are considered obscene, and breasts are looked at as objects by the mostly male subjects. Nevertheless, the encounter of the two meanings—the play on the multiple sides of mothering and parenting—suggests the limitations of traditional meanings of motherhood.

Boundary Building

Research on gender communication typically suggests that women-centered spaces online often adopt supporting styles of posting that focus on generating agreement with and respect for each other. In line with this assertion voiced by multiple researchers on gender styles of communication, "Hey Facebook!" follows the non-adversarial and non-assertive way of interaction, which is welcoming to the participants and encourages strong consensus building. However, such lack of disagreement may become problematic, for it erects invisible boundaries based on differences. Radhika Gajjala (2004) makes an argument that non-conflicting spaces lead to the silencing of contradiction: "being non adversarial and supportive on this list [that Gajjala moderated and studied] came to mean that participants could not express their dissent outside the essentialist 'women's way' framing of discourse on-list" (p. 72). This implies that even women-centered spaces can inadvertently create inclusions and exclusions. In the analysis of the "Hey Facebook!" group, I refer to the boundaries based on differences created and perpetuated by the Facebook network as a whole, and this Facebook group.

Breastfeeding and facebooking are not innocent engagements because they carry cultural values and instill not only gendered models of communication but also class, race, and other meaningful categories of difference. Facebook presents itself as a space where a certain layer of population spends time. Scholars argue that Facebook users are differentiated by class markers—those with higher levels of education and of a more resource-rich background (e.g., boyd, 2007; Hargittai & Hinnant, 2008; Zillien & Hargittai, 2009). Therefore, the activity of social networking and the protests on Facebook relate to the conditions of leisure and the process of consumption that facebooking is based upon. Access to technology may still be out of reach for low-income, minority, or socially vulnerable mothers, who have the highest level of failed breastfeeding, according to the research by Kukla (2006). Not all mothers or parents have access to the training or activist opportunities (that is, support) available from Facebook and/or other special interest sites and online groups.

It is not only the access to a computer and the Internet that builds those invisible barriers. Participation in the "Hey Facebook!" group and chiming into the virtual nurse-ins are possible only in the presence of certain digital and other forms of literacy. Clay Shirky, who consults, teaches, and writes on the social and economic effects of Internet technologies, suggests that the

conversation around the digital divide has shifted from the gap between who has access to hardware and network connections and who does not to the discussions of "the sense of permission and to the sense of interest" (Simon, 2009). In other words, the issues of digital divide concern less material but more social questions, such as

> [H]ow do we go to people who don't sense they have permission to speak in public and offer them that permission? If there are people who are just uninterested in this stuff, how can you make an experience that's still satisfying for them as, you know, traditional consumers of media, without making them feel bad for not being the people...adding a comment to an NPR story?

Even if somebody has access to a computer and the Internet, he or she may not participate in online social networks or may participate at various degrees of commitment.

I further refer to my own experience in the group. As a supporter, I participated in the virtual nurse-in in February 2009. The organizers suggested that participants become involved in two ways. First, those who were willing to participate in the nurse-in were asked to change their status to "Hey Facebook, breastfeeding is not obscene!" Second, the organizers suggested that the nurse-in participants should change their profile picture to one related to breastfeeding. After some holding back, I changed the status on my profile. I firmly decided against posting my own image, yet I wanted to support the cause. It was a struggle. I borrowed one image from the collection offered by the community. It was a photo of a reclining statue of a breastfeeding woman. I lingered because I felt as if I was coming out, as if I was telling a secret nobody was expecting me to share. This is the moment when I pushed a particular aspect of my identity to the surface, into the public realm, to the point of becoming. Mary Gray (2009) suggests in her study of queer youth coming out online that in engaging with websites, rural gay and lesbian young people "confirm the existence of queerness beyond their locals and strategize about how to bring that queerness home to roost" (p. 1172). Similarly, my announcing the allegiance to the group's event was equal to giving myself another aspect of social identity and taking a moment to exercise and perform this aspect of identity.

The lingering doubts in my partaking in the protest efforts directly relate to what Shirky (in Simon, 2009) argues about the nature of digital divide. Shirky hints at what he calls "the sense of permission," that is, the self-

censoring and self-controlling drive that I experienced when making my decisions. In online social networks, users not only mark their actual friends but also navigate the publicly displayed relationships and identities. These imagined and egocentric communities allow participants to express who they are and locate themselves culturally so as to properly socialize with other participants. danah boyd (2007) conceptualizes socially constructed, or imagined, audiences, because those who do public performances on online networks envision spectators without actually knowing who is reading the information on profiles. In articulating relations on social network sites, participants not only represent their connections but also perform these relationships, taking into account the assumed audience characteristics and requirements. Similarly, in my earlier work (e.g., Rybas, 2008), I argue that the network members strive to filter their web presence on the profiles to fit the requirements of the program and to fit the imagined expectations of the audience. The differences, based on various factors—gender, ethnicity, sexuality, age, and interests—become augmented, erased, or smoothed out through the process of facebooking. Thus, the silences and voices emerging in the group "Hey Facebook!" obtain meaning not only for their direct agreement with the cause of the group but also for the relation to the various circumstances and mappings of technology-mediated conversations.

Invisible boundaries emerge through the discourses of inclusion and expulsion. Despite the fact that the community of "Hey Facebook!" is very supportive of its participants, the dissenting voices can be silenced. For example, in a thread about formula feeding, one participant suggested using the samples distributed by companies. The reaction to this suggestion was the following:

> So L.,…your stance is that buying formula is stupid because the kind hearted and concerned formula companies will give you various samples for free so that you have the choice of many inferior products to give your newborn on hand. *Why exactly are you still here?* (italics added)

In this example, the respondent pointedly stated that the general philosophy of the group on breastfeeding babies and limiting formula feeding is not welcomed.

The tendency to silence dissenting voices is evident when group members laud the preferred parenting behaviors and preferred logic of thinking. Romanticizing natural mothering, the group members often reach out to the

decision to breastfeed or not. One participant described how she felt when a mother planned to breastfeed yet had a few packs of formula just in case: "I came across a discussion that *made me cringe* to even think of commenting on, and *frustrated me* to walk away from. [In the discussion,] not one mother said that she was going to breastfeed exclusively" (italics added). Such discussions and posts often downplay the formula-feeding parent, even though the members concede their respect for the personal choice. One of the posters confesses: "I support whatever decisions my friends and family make around me concerning feeding their children...however they accept that if they decide to give formula instead, that I am going to open my mouth and voice an opinion." These examples clearly show the allegiances of the group members: the discussions emphasize the image of the good mother who chooses to breastfeed.

The issue is not only that good mothers choose to nurse their babies, but also that the construction of this decision as a personal choice is not innocent but rather politically and culturally loaded. Positioning breastfeeding as a choice provides evidence to material and class distinctions of the group members. Nadesan and Sotirin (1998) refer to the studies that show that middle-class women have more opportunity to stay at home with their children, take maternity leave or arrange for flexible schedules, and thus are more likely to breastfeed. Kukla (2006) also claims that for women from socially vulnerable groups, breastfeeding is not a viable choice. In the "Hey Facebook!" group, formula is positioned as an odd choice and looked down upon. Thus, the membership inadvertently makes a welcoming gesture for more affluent families.

Not only does the positioning of breastfeeding as a choice invoke particular visions of mothering identities but so, too, does the construction of a cultural center and margins build the invisible mappings of the community on Facebook. The references to other parts of the world draw connections and emphasize similarities and differences across the globe. For example, one of the group members argues that it matters what a child eats: "In certain parts of the world they make patties out of mud and water to eat so that they don't feel hunger pains...a full tummy is by far not always a happy tummy!!!" The simplistic imagery of poor nations clearly demarcates the membership of the group as belonging to more prosperous nations in the world that have access to more than "patties out of mud and water." Group members mark both territories where "there is a definite need for formula in the world" as well as countries "with near perfect breastfeeding rates." In another instance, a

mother shares a story about her son who is "learning about how people in different countries live, and about how many people in third world countries go hungry everyday." Her son wrote in a school essay that "one way that we could help stop people from starving would be for more mommies to nurse their babies and then there would be more food for everyone else, and less kids would be sick and die." These examples of rhetorical construction of distance, wherein the speakers interpellate themselves as knowledgeable subjects positioned in the center and looking out at the marginal communities, supports a capitalist social order that establishes invisible barriers based on particular modes of parenting.

Conclusion: Who Gains, Who Pays?

The "Hey Facebook, breastfeeding is not obscene!" activities concern these questions: Who gets the last word? Whose voice is counted at the end of the day? What does this voice provide and limit? Very often the commentators suggest that it is a matter of personal opinion about what to post to the public realm. No doubt one has to decide this in every case where the key is punched to upload an image or make a post. However, an opinion is a loaded term. Some tend to read it as a personal freedom of expression, yet they forget that opinions never emerge in a vacuum—they are formulated under the influence of discourses. Opinions and opportunities emerge in contexts, for example, the expected Internet freedom, the urban coolness of social network vibe, the user-friendly structure of Facebook, or the ambiguous meaning of the female breast. Acting upon these opportunities and responding to these discourses make one participate in a contested cultural site that both reflects and constructs practices associated with them.

Who reaps the gains and who bears the costs of the events and activities associated with the protest about photos of mothers' breastfeeding their children in the urban spaces both online and offline? I am the one who benefits. I learn to navigate the stormy waters of public opinion. While browsing the posts on "Hey Facebook!" I have learned the arguments about breastfeeding in public; I have learned what to think and how to deal with crises. The predominant doctrine in the United States positions breastfeeding as a choice, and this group helps pursue that choice. I learn about the landscape of opinions and practices that train my body to move through digital and physical landscapes in certain ways. Thus, I continue to modify my own practices of motherhood *because, through, and with* Facebook (Rybas, 2008).

Citizenship in the digital city allows for developing breastfeeding and motherly consciousness, which serves an empowering potential, yet it traps the body and mind nonetheless. It promotes thinking that these are the ways things should be done, as in "Hey Facebook, breastfeeding is not obscene!" What about those for whom breastfeeding is not a choice? What if somebody does not choose to breastfeed? What if breastfeeding is not a choice to make, but a burden to take and carry? What about the poor and those with little access to the networks? What about those who have no say in this privileged discourse of breastfeeding (as a practice, in public, on Facebook)? Indeed, the hyper-mobility of social networking within the freedoms and confines of the digital city allow experiencing emancipatory impulses, which are also dependent and entangled with existing social ideologies.

Note

1 I will use a shortened version of the group name, "Hey Facebook!"

Works Cited

Attwood, F. (2004). Pornography and objectification: Re-reading "the picture that divided Britain." *Feminist Media Studies, 4*(1), 7–19.

Blair, K., Gajjala, R., & Tulley, C. (2009). The webs we weave: Locating the feminism in cyberfeminism. In K. Blair, R., Gajjala, & C. Tulley (Eds.), *Webbing cyberfeminist practice: Communities, pedagogies, and social action* (pp. 1–19). Cresskill, NJ: Hampton Press.

Bartlett, A. (2005). *Breastwork: Rethinking breastfeeding*. Sydney, Australia: UNSW Press.

boyd, d. (2007). Why youth (heart) social network sites: The role of networked publics in teenage social life. In D. Buckingham (Ed.), *Youth, identity, and digital media* (pp. 119–142). Cambridge, MA: MIT Press.

Butler, J. (1990). Performative acts and gender constitution: An essay in phenomenology and feminist theory. In S-E. Case (Ed.), *Performing feminisms* (pp. 270–282). Baltimore, MD: The Johns Hopkins University Press.

Gajjala, R. (2004). *Cyber selves: Feminist ethnographies of South Asian women*. Walnut Creek, CA: Alta Mira Press.

Gray, M. (2009). Negotiating identities/queering desires: Coming out online and the remediating of the coming-out story. *Journal of Computer-Mediated Communication, 14*, 1162–1189.

Hargittai, E., & Hinnant, A. (2008). Digital inequality: Differences in young adults' use of the Internet. *Communication Research, 35*(5), 602–621.

Kukla, R. (2006). Ethics and ideology in breastfeeding advocacy campaigns. *Hypatia, 21*(1),157–180.

Landstrom, C. (2007). Queering feminist technology studies. *Feminist Theory, 8(1)*, 7–26.

Law, J. (2000). On the subject of object: Narrative, technology, and interpellation. *Configurations, 8*, 1–29.

Law, J., & Singleton, V. (2000). Performing technology's stories: On social constructivism, performance, and performativity. *Technology and Culture, 41*(4), 765–775.

Mitra, R., & Gajjala, R. (2008). Queer blogging in Indian digital diasporas: A dialogic encounter. *Journal of Communication Inquiry, 32*(4), 400–423.

Myers, K. (1987). Towards a feminist erotica. In R. Betterton (Ed.), *Looking on: Images of femininity in the visual arts and media* (pp. 189–202). London: Pandora.

Nadesan, M., & Sotorin, P. (1998). The romance and science of "breast is best": Discursive contradictions and contexts of breast-feeding choices. *Text and Performance Quarterly, 18*, 217–232.

Rybas, N. (2008.). *Technoculture in practice: Performing identity and difference in social network systems.* Unpublished doctoral dissertation, Bowling Green State University, Bowling Green, OH.

Rybas, N., & Gajjala, R. (2007). Developing cyberethnographic research methods for understanding digitally mediated identities. *Forum Qualitative Sozialforschung/Forum: Qualitative Social Research, 8*(3). Retrieved from http://www.qualitative-research.net/fqs-texte/3-07/07-3-35-e.htm

Simon, S. (2009, September 12). Social media's growing influence. NPR. Retrieved from http://www.npr.org/templates/story/story.php?storyId=112779080

Sowards, S., & Renegar, V. (2006). Reconceptualizing rhetorical activism in contemporary feminist contexts. *The Howard Journal of Communications, 17*(57), 74–90.

Wilding, F. (1998). Where is the feminism in cyberfeminism? *N. paradoxa, international Feminist Art Journal, 1(2)*, 6–13.

Young, I.M. (2005). *On female body experience: Throwing like a girl and other essays.* New York: Oxford University Press.

Zillien, N., & Hargittai, E. (2009). Digital distinction: Status-specific Internet uses. *Social Science Quarterly, 90*(2), 274–291.

Chapter 15

Migrant Youth Invading Digital Spaces: Intersectional Performativity of Self in Socio-Technological Networks

Koen Leurs

"Electronic mediation and mass migration mark the world of the present not as technically new forces but as ones that seem to impel (and sometimes compel) the work of the imagination."

—Arjun Appadurai (1996, p. 4)

Introduction

Mass migration and mass mediation are two developments that characterize the current post-colonial condition in overdeveloped parts of the world. Mass migration and information and communication technologies (ICTs) have had a joint effect on the ways in which they enable and restrict subject positions. Subjects and their Internetworked remediations circulate concurrently across the globe, creating irregularities and/or ruptures that are not bound within local, national, or regional spaces. Appadurai (1996) emphasizes the role of media production and consumption in the social imagination, locating transnational media practices as both catalysts and primary evidence of a changing world that is no longer confined to the centre-periphery model of mediation, as "there is growing evidence that the consumption of mass media throughout the world often provokes resistance, irony, selectivity, and, in general, agency" (p. 7).

Right-wing politicians and a sensational press speak of economic migrants as *alien others* who are flooding the gates. This is the case in not only the former imperial center of "Fortress Europe" from which I write this chapter, but also in other overdeveloped countries such as the United States, Canada, and Australia. European borders are increasingly policed against unwanted migrants, and only highly skilled migrants have a chance of obtaining citizenship. In the United States, fences are set up with the help of remote sensing and cameras, and border patrols seek to halt the flow of "il-

legal border crossings" from Mexico, while Canada and Australia have sought ways to block ships with migrants from Sri Lanka and Indonesia respectively.[1] Once inside, migrants often have to struggle to acquire a desired position in society and to work against being othered.

Puwar (2004) explains this dynamic by describing minoritarian subjects, including migrants, as "space invaders." She looks at everyday and institutionalized spaces where certain bodies are considered to be "out of place" (p. 8). Since the recent revolutions across North Africa, the Middle East and especially the war in Libya, people seeking refuge in Fortress Europe are sometimes literally seen as space invaders. The depiction in the spring of 2011 by European right-wing politicians and mainstream news media of Lampedusa, the Italian island off the coast of Tunisia, as in need of being "rescued" from "invading migrants" fleeing Libyan turmoil is exemplary (Reyes, 2011).

Nonetheless, Puwar (2004) argues there has been a "metonymic shift in the increased presence of women and racialized minorities into spaces in the public realm which have predominantly been occupied by white men" (p. 7). For instance, women and racialized minorities can legally enter the British Parliament, but, she argues, they are "space invaders" who do not fit the "template," that is, "white male bodies of a specific habitus continue to be the somatic norm" (p. 141). They sometimes remain out of place, being "symbolically homeless" in the white, masculine environment (Grosz, cited in Puwar, 2004, p. 147). As they increasingly present themselves in spaces they were previously excluded from, women and minorities may subvert the status quo but have to actively reposition themselves from within the spaces they invade.

The digital realm is one area of "space invasion" that is often overlooked. The question arises as to what happens when subordinated subjects go online. Going beyond early utopian and dystopian reflections on cyberspace, cyberfeminists have laid bare how digital embodiment is structured, but not fully determined by what I call material-embodied, semiotic-discursive, and socio-technological norms and practices. Their focus has principally been on the analytical category of gender. Also, although the field is rapidly diversifying, "*cyberfeminism* has tended to include mostly younger, technologically savvy women, and those from Western, white, middle-class backgrounds" (Consalvo, 2003, p. 108). However, as immigrant youth and youth born in the diaspora begin to use the Internet to manifest themselves online and connect with others—their peers, the wider diaspora, and youth

culture—there is an urgent need for cyberfeminists to broaden their foci to account for their specific concerns.

The socio-technological network has its particular history and norms, and the question is raised concerning how young migrants negotiate its templates along or against "symbolical grammars of difference" (Wekker, 2009, p. 153) such as gender, race, diaspora, generation, religion, and youth culture. Thus, in this chapter I want to connect feminist technoscience to postcolonial intersectional thinking in order to argue for intersectional cyberfeminism. Reading prior scholarship on migrant youth digital performativity of self through an intersectional lens, I highlight how intersectional cyberfeminism offers a means for a grounded and richer understanding of the technological affordances/restrictions and agency of the user in the contemporary multicultural online/offline context.

Puwar (2004) argues that space is formed through "the historically embedded relationship between 'reserved positions and certain social types,'" adding that available "positions have a gendered and racialized symbolism to them" (p. 33). In the section below, I first set out how norms and digital templates in digital spaces also reserve certain gendered, racialized, and perspectival positions and semiotic-discursive types, and I subsequently argue how the intersectional performativity of self and technologies are mutually shaping each other. In the second section, three digital communicative spaces "invaded" by migrant youth are discussed, spaces where these subjects are not necessarily the normative figures. These three different spaces highlight three distinct approaches taken to appropriate communicative space, illustrating also how migrant youth are actively maneuvering across digital spaces. In each space discussed, works on the Internetworking of migrant youth in the context of the United States are brought into dialogue with studies of various disciplinary backgrounds on migrant youth in the European context.

Digital Templates

Lykke and Braidotti (1996) made a plea to:

> try to rethink the world as interaction between material-embodied and semiotic (that is sign-producing and communicating) actors and subjects, who cannot be divided along the traditional lines of human versus non-human, conscious mind versus stupid matter. (p. 27)

In early work, inspired by postmodernist thinking, cyberfeminists celebrated the liberating potential of ICTs. Reid (1993) wrote that Internet Relay Chat

users self-select their gender, allowing for experimentation with social roles and deconstruction of the "sacred" institution of gender. She asserted that "this fixity, and the common equation of gender with sex, becomes problematic when gender reassignment can be effected by a few touches at a keyboard" (p. 63). Turkle (1995) described opportunities for "gender bending" and identity experiments. The Internet would offer "new models of mind and a new medium on which to project our ideas and fantasies" (p. 267). Sundén (2003) conceptualized online textual embodiment; "having to type oneself into being" (p. 3), arguing that digital embodiment is mostly mediated through typed, textual cultures. As people can choose themselves which information they want to put forward, the potential for fissures and experimentation arises.

The somewhat utopian view on cyberspace has been nuanced; scholars highlight the normative ways of being—masculine, white, and Western— that are standardized in the digital realm. Rephrasing Puwar (2004), the Internet has certain "natural occupants" and "reserved positions" (p. 33). Illustratively, Herring (2003) argues that power relations in computer-mediated communication (CMC) are gendered. Linguistic features of agonism such as assertiveness, use of profanity, and rudeness correlate more with males, and features of social harmony such as verbosity, politeness, use of smileys more with female CMC users. Herring sums up: "women's concern with politeness tends to be perceived as a 'waste of bandwidth' by men" (p. 209). In popular renderings of our globalized techno-cultural world, persons of color as active agents are still mostly absent, strengthening the myth of the technological lag of minorities (Everett, 2002). Gómez-Peña (2000) exposes how Chicanos living in the Mexican-U.S. borderlands are often perceived as somehow "culturally handicapped" and culturally unfit to handle technologies and contribute to cyberculture (p. 249), while in Europe "migrants have been mostly represented as emblematic figures of technological backwardness" (Kambouri & Parsanoglou, 2010, p. 11). Nakamura (2010) asserts that the content and interface decisions on the Internet reflect and produce racial hierarchical categorizations. Digital profiles and avatars can often be constructed only on the basis of a restricted "range of faces, bodies, and features. This creates a normative virtual body, one that is generally white, conventionally physically attractive, as well as traditionally gendered" (Nakamura, 2010, p. 338).

Next to the white, masculine norms, the Internet is also shaped by Western standards. Palfreyman and Al Khalil (2003) analyzed the representation of Arabic using the Latin alphabet in instant messaging conversations in the

United Arab Emirates by female students. Their use of Latin characters is attributed to the influence of the American Standard Code for Information Interchange (ASCII) upon online communication. Palfreyman and Al Khalil (2003) recognize ASCII as "a kind of lingua franca of the internet." Arabic script does not meet the technological default of the ASCII computer character set. The standard mainly covers Latin letters, most commonly used in European languages, and excludes Arabic script (among other non-Latin scripts).

Wajcman (2007) argues that cyberfeminists can bridge accounts of techno-phobia and techno-philia when focusing on the "mutual shaping of gender and technology, where neither gender nor technology is taken to be pre-existing, nor is the relationship between them immutable" (p. 287). Thus, a middle-ground perspective is needed to acknowledge the entanglement of digital materiality and embodiment: digital media practices concern more than wholly voluntaristic fabrications of the self, and that they can also move beyond pure reifications of pre-existing power relations such as gendered and racial orders and Western hegemony. Internet practices are always situated in "specific socio-cultural personal contexts," allowing users to question dominant cyber spatial configurations of sociality by relocating and, to a certain extent, disrupting disciplinary assignments and regulatory practices of social identificatory mechanisms (Gajalla, Rybas, & Altman, 2008). Wajcman (2007) adds: "we require more nuanced research that captures the increasingly complex intertwining of gender and technoscience as an ongoing process of mutual shaping over time and across multiple sites" (p. 296). In my attempt to do so in this chapter, I connect below technoscience with feminist poststructuralist theory and intersectional thinking to theorize how categories of difference and technologies can be approached as processes of co-construction.

Mutual Shaping: Intersectional Performativity of Self and Technologies

Haraway (1997) recognizes that the computer is "not a Thing Acting Alone" (p. 126), as connections between humans and computers remake worlds. The question remains, however: How do we disentangle the interactive encounters between human and nonhuman actors through different technologies, which materialize "worlds in some forms rather than others"? (p. 129). Technologies can be understood as vehicles that can enact (enable and disable) processes of allying human and nonhuman actors. In this section, I turn

to performativity and intersectionality to better grasp processes of mutual shaping in the lives of migrant youth engaging with socio-technological networks. Combining poststructuralist thinking and feminist technoscience is urgent; as Barad (2007) states, "there has been surprisingly little cross-pollination between feminist poststructuralist theory and science studies.... Even in the feminist science studies literature, one is hard pressed to find other direct engagements with Butler's work on performativity" (p. 57). Similarly, Haraway (1997) argues that:

> Either critical scholars in antiracist, feminist cultural studies of science and technology have not been clear enough about racial formation, gender-in-the-making, the forging of class, and the discursive production of sexuality through constitutive practices of technoscience production themselves, or the science studies scholars aren't reading or listening—or both. (p. 35)

Butler famously deconstructed the category of gender by foregrounding that gender is to be understood as something *we do* rather than something *we are*. There is no preceding or following "I" that exists apart from gender performativity; rather, we come into existence through a matrix of gender relations. With her notion of performativity, Butler goes beyond distinctions between material-embodied and symbolic-discursive domains. Gender performativity is the constitutive stylized repetitious process through which one acquires a gendered subjectivity: "language sustains the body not by bringing it into being or feeding it in a literal way; rather, it is by being interpellated within the terms of language that a certain social existence of the body first becomes possible" (Butler, 1997a, p. 6). The body becomes fundamentally constituted through performative repetitions of sedimented gendered norms "through a series of acts which are renewed, revised, and consolidated through time" (1997b, p. 406). Extending this notion, other axes of differentiation migrant youth experience such as race, ethnicity, diaspora, and age also get constituted through performative acts. In the repetitive process, room is left for subversion; as Barad (2007) asserts, in the context of socio-technological networks, "gender performativity constitutes (but does not fully determine) the gendered subject" (p. 62). By contesting enacted identities in their embedded contexts of hegemonic power relations, people have the chance to re-signify themselves.

Feminist technoscience approaches human-computer interactions as heterogeneous, related assemblages where some subjects enjoy privilege while others are underprivileged.[2] The focus on performativity helps to focus on

how power is actively distributed. Humans engage in alliances with technologies resulting in certain world-building practices whereby specifically located subjectivities and modes of speaking are materialized and signified. These alliances can "be teased open to show the sticky economic, technical, political, organic, historical, mythic, and textual threads that make up its tissues" (Haraway, 1997, p. 68). Performative angles on human-technology relationships point to an underlying process of entanglement, making it possible to unravel the particularities of normalized and taken-for-granted circumstances.

The ways in which migrant youth's digital performativities of self are distributed become especially apparent when considering the various categories of difference traversed in their social trajectories. Brah (2003) argues that migrant identities are constructed around multi-axial locationalities across various spaces "where multiple subject positions are juxtaposed, contested, proclaimed or disavowed; where the permitted and the prohibited perpetually interrogate" (p. 631). Wekker (2009) describes intersectional thinking as guided by "central insights that gender and 'race' or ethnicity (and other axes of signification such as class, sexuality, age, religion, and so forth) operate simultaneously as social and symbolical grammars of difference and coconstruct each other" (p. 153).[3] Symbolical grammars of difference can be limiting and oppressive, but also empowering. Illustratively, Durham (2004) posits that South Asian immigrant girls in the United States negotiate diaspora affiliations but also experience the turbulent waters of adolescence: "diaspora adolescents' negotiations of nation and culture intersect with the struggles around gender and sexuality that are a hallmark of coming of age in America" (p. 241). Cyberfeminists have recognized how various categories co-construct one another in multiple ways. Sundén (2007) argues that "cyberfeminist theory and practice is required to be more explicitly aware of the multiplicity of differences that constitute techno-bodies" (p. 46). For Sundén, technologies are not only the interface in and through which socio-cultural categories are constituted; rather, "intersectional cyberfeminism would explore the ways in which differentiated bodies collide and intersect with digital technologies; how corporeal differences transgress the boundaries between natural and artificial, human and machine" (p. 37).

Below, three spaces in the digital realm are discussed where migrant youth have manifested themselves as "dissonant bodies" who do not necessarily meet the template/image of "who is seen to really belong" (Puwar, 2004, p. 34). These spaces exemplify the constitutive processes of technology

and migrant youth subjectivity. Each space raises theoretical questions on migrant youth engagement with digital media that would benefit from more cyberfeminist scrutiny with an attention to intersectional performativity of self and the co-construction of technology.

Space 1: Hypertextual Selves in Online Social Networking Sites

The first space of invasion I want to describe is the online social networking site (SNS). Scholars working on the ways in which migrant youth perform their identities in online social networking sites showcase how their identities are dynamic and hybrid. Authors set out how migrant youth in their hyper-textual performance of self perform hybrid identities that cut across various symbolic grammars of difference. Aoyama (2007) writes about Japanese Peruvians in Peru using the SNS Hi5.com. These youth label themselves as Nikkei, and Aoyama found that "a starburst shape of identity construction and negotiation" is observable (p. 119). Nikkei-ness gets performed by combining Japanese affiliations such as the *Hello Kitty* brand, *anime* videos, *Kanji* writing, *kimonos*, as well as "Latino" and "Chino" (Chinese) celebrities on profile pages. Users join and hyperlink to different "groups" on their profile page, and Aoyama writes that "these groups stretch across a large and varied scope of topics, including that of national, racial/ethnic, and cultural identities" (pp. 2, 104–110).

In his research on migrant youth in Oslo, Norway, Mainsah (2009) analyzed self-representational strategies by users of online social networking sites and found that profile pages allow youth to be active agents in their own representations. These representations often go beyond mere ethnic/diasporic affiliations. For instance, Mainsah describes how Yamane, an Eritrean Norwegian girl, expressed herself in a multi-layered way on her MySpace.com profile page. The groups she joined go beyond identification with her Eritrean ethnicity. The groups "'Rafiki's Children,' and 'Rock for Darfur' represent an attachment with Africa. 'Malcolm X Grassroots Movement' represents solidarity with the African American Diaspora in the US." Yamane said that "these groups I have joined represent bits of my personality, and they stand for values that I find elementary." Mainsah concludes that his informants connected to groups "to establish new ties and to develop and cultivate a wide range of religious, cultural, political and social interests" (pp. 195–197).

Leurs and Ponzanesi (2011a) note that Moroccan Dutch youth hyperlink to and participate in a wide range of communities within the Dutch social networking site Hyves.nl. When users join online groups on Hyves, a hyperlinked avatar appears on their profile pages. Moroccan Dutch youth were seen to affiliate with groups "ranging from feminist interests (*'Women in charge'*), Dutch nationalism (*'I love Holland'*), ethnic affiliations (*'the Moroccan kitchen'*) to clothing (*the brand H&M*), and global junk food (*McDonalds*)." The authors conclude that "These diverse affiliations—that are advertised online simultaneously—add nuance to the typical, one-dimensional stereotype about migrant youth, integration, and Islam in the context of Europe and Netherlands." The strategic use of hyperlinking is the basis for a differential performativity of self. Haraway (1997) elaborates on the two-sidedness of hypertext: "Although the metaphor of hypertext insists on making connections as practice, the trope does not suggest which connections make sense for which purposes and which patches we might want to follow or avoid" (p. 127). Odin (1997) suggests that the web reflects a new mode of post-colonial embodiment, as hypertext "is composed of cracks, in-between spaces, or gaps that do not fracture reality into this or that, but instead provide multiple points of articulation with a potential for incorporating contradictions and ambiguities" (p. 598). As research on Japanese Peruvian, Eritrean Norwegian and Moroccan Dutch youth's digital practices showcase, hypertext enables fragmentary, decentered subjectivity and identity formation, recurrent for post-colonial subjects. For instance, Trinh (1992) states that fragmentation denotes a way of living with differences at the margins, where "one finds oneself, in the context of cultural hybridity always pushing one's questioning of oneself to the limit of what one is and what one is not" (pp. 156–157).

Highlighting various symbolical grammars of difference simultaneously, SNSs can be taken up to circulate a multiaxial self. Illustrating how identities are actively in the making as hypertextual webs, migrant youth carve out a space to assert, for instance, ethnic/gendered/religious identifications. However, performing hypertextual selves also allows migrant youth, as dissonant bodies in the space of online social networking sites, to emphasize that they do share belongings with the majority of the mainstream users, such as global and local clothing, food, music, lifestyle preferences, and attachments to political causes. The question arises as to what extent offline contexts allow for similar differential identity performances. Are these youth only able to assert various dimensions of their subjectivity online, and not offline, as a result of

narrow discursive labeling practices that emphasize alterity—as youth with a migration background, for instance, constantly remain interpellated as "migrant boys" or "Muslim girls" in offline settings?

Also, hypertextual performativity of self in the production of digital space in social networking sites is not always simply enabling. Not only are its users economically exploited, as online social networking sites collect personal data and sell it for niche-marketing purposes. Indicating the growing policing of the digital realm, certain minoritarian practices become restricted as well. For instance, when Facebook.com administrators were asked by Israeli Public Diplomacy and Diaspora Affairs Minister Yuli Edelstein to take down an Arabic-language page calling for a third Intifada against Israel to "liberate" the Palestinian territory, they first prided themselves on the Facebook "Terms of Service" for promoting freedom of expression and deliberation: "While some kinds of comments and content may be upsetting for someone—criticism of a certain culture, country, religion, lifestyle, or political ideology, for example—that alone is not a reason to remove the discussion. We strongly believe that Facebook users have the ability to express their opinions." However, under increased Israeli government pressure, the page was deleted soon after by Facebook administrators (Protalinski, 2011). Similarly, Kambouri and Parsanoglou note that "Migrant digital networks are increasingly conceptualized as an Internet security threat, in particular after September 11th and the rise of Islamophobia" (2010, p. 30). They stress that digital Muslim/migrant networks are treated as risks to society, illustrating how new ICT's also "generate new means of intensified monitoring and surveillance of migrant bodies" (p. 10).

Space 2: Instant Messaging as a Private Space

The second communicative space concerns migrant youth claiming instant messaging (IM) as a communicative space of their own. Comparing online social networking sites such as Facebook with instant messaging, which facilitates the exchange of synchronous messages, Quan-Haase and Young (2010) assert that with IM, "users can engage in more intimate conversations, allowing them to share their problems with communication partners more easily" (pp. 358–359). IM allows for more privacy. This is interesting, because Kelly and colleagues (2006) learned from their interviewees—adolescent girls in Canada—that activities such as instant messaging "allowed them to rehearse different ways of being before trying them out offline" (p. 3). This could be

particularly important for migrant youth who have to negotiate their presence across online/offline spaces. However, in their work on instant messaging, most scholars (such as Kelly et al.) have singled out the category of gender.

Scholars have, for instance, set out how in IM practice, gendered dimensions become apparent. Studying IM exchanges between college students, Fox and colleagues (2007) noticed that female students differed from male students in, for instance, use of emphasis, frequency of laughing, use of emoticons, and reference to emotions. They conclude that "women sent messages that were more expressive than those sent by men" (p. 389). Baron (2008) also compared IM conversations between female and male students and argues that women are more "talkative," which may reflect a "female writing style" (p. 67). While males used more contractions, females were prime users of emoticons. She found that "female-female conversations were roughly a third longer (in both number of transmissions and time on the clock than male-male conversations" (pp. 65). Building on the vocabulary of Goffman's performance of self, Jacobs (2003) asserts that among American adolescent girls, "the backstage conversations [one-on-one IM exchanges] are where alliances are formed, problems are discussed and solved, and plans are made beyond the hearing of others....The onstage places [display names and the buddy list] are where alliances are declared and social positions and presence are established" (p. 13). In these studies, IM use is scrutinized with a focus on the category of gender in isolation from other axes of differentiation.

In the context of the United States, studies by Lam (2009) and Yi (2009) are notable exceptions. Recognizing that there is a "paucity of research on immigrant adolescents' practices with digital media," Lam (2009, p. 175) examined instant messaging use among immigrant youth and paid attention to the particular characteristics of instant messaging. She argues that "to perform different voices and versions of one's self dependent on the audience has come to characterize the aesthetics and epistemology of IM" (pp. 380–381). Working with Kaiyee, a Chinese American adolescent girl, Lam found that Kaiyee traverses local, translocal, and transnational affiliations through IM. Mobilizing diverse cultural resources and linguistic repertoires, she used IM to (re)design her social and symbolic affiliations with multiple communities. She connected locally with "urban-identified teenagers of diverse ethnicities," but she also expressed belonging to her diaspora (pp. 387, 394). Similarly Yi (2009) argues that the crafting of display names of her informants, two Korean American adolescents, shows how solidarity with different social networks was established. The subjects foregrounded various

elements, mixing Korean and American pop culture and, "in doing so, they negotiated their way through multiple languages, identities, and worlds" (p. 122). Korean was used as a strategic resource. When his school friends saw it as "'cool' for him to read and write Korean," one of her informants "seemed to (re)learn the value of his heritage language and to construct a positive-self-image" (p. 108).

In Europe, Leurs and Ponzanesi (2011b) explored how Moroccan Dutch adolescent girls made IM into a communicative space of their own. They recognize that these girls have to negotiate between motivations. Parents who migrated from Morocco can, for instance, be prohibitive about direct contact with the opposite sex. "For girls this often also meant to 'shame' themselves in their presence, i.e., to behave timidly and modestly and to refrain from any looseness in appearance or expression" (Pels & De Haan, 2003, p. 58). Durham (2004) adds that "at the same time that immigrant families exercise rigid restraint over adolescent girls' sexuality, Western culture continues to hypersexualize girls and women of color" (p. 145). In one-on-one conversations, the "backstage" of IM, the informants in the study by Leurs and Ponzanesi (2011b) use IM as a "relatively safe practice-ground" to engage in relationships and schedule dates. In the more public "onstage" of display names, Moroccan Dutch adolescent girls "claim diverse group-memberships and belongings" by combining multiple linguistic, gender, diasporic, religious, and Internet culture affiliations (pp. 56–79).

The space of IM appears to be a space taken up by migrant youth where they feel comfortable to perform multiple versions of themselves, tapping into diverse linguistic repertoires. Lo Bianco (2000) discusses the urgency of a pluralistic response to everyday linguistic creativity in the context of globalization, such as "literacies which invoke ethnic, ideological, religious, script, technical and nation-identity statuses." He emphasizes that "diversity in the plural literacy practices of minority children is often relegated to the margins of their lives. Yet they have within them the power to open up new intellectual worlds which are, at the moment, linguistically and intellectually closed to us" (p. 101). However, the appropriation of IM space also has its downside. Next to recognition of pedophiles turning to IM to contact young girls, Leurs and Ponzanesi (2011b) learned from their informants about a Moroccan Dutch friend who was severely beaten by her father and brother. She befriended a boy through IM. After he gained her trust, she digitally shared sexually explicit pictures. The boy subsequently circulated the pictures among his friends. When her family found out, they became furious with her.

Space 3: Public Community and Voice on Discussion Boards

AsianAvenue.com, MiGente.com, and BlackPlanet.com are online discussion boards that represent Asian American, Mexican American, and African American digital public spheres. These sites are frequented by millions of users, including migrant youth, indicating that "the dissolution of racial identification" as often celebrated in early cyberfeminist accounts "is neither possible nor *desirable*" (Byrne, 2008, p. 15), as there is a great demand for such dedicated sites. Byrne compares these "dedicated sites" to "hush harbors," a notion used to describe spaces in which slaves gathered away from supervision from their white masters. The hushedness of these sites is valuable for developing "group cohesion" and a shared sense of belonging "because they are relatively free of *mass* participation by ethnic outsiders" (p. 17).

Byrne states that online discussion boards highlight how "ethnic communities construct, stabilize, modify, and challenge individual and community senses of identity over a relatively long period of time." These communities offer the space to strengthen a sense of collective identification and racial pride. In establishing digital communities, the sites are valuable for the production and circulation of "community-centered knowledge" (2008, p. 17). Consciousness of oneself in these sites gets associated with "racially, and often gender-, appropriate behaviors." The boards can be seen as "informal learning spaces" where "ideologies are likely to be developed, promoted, contested and institutionalized" (2008, pp. 29–31). Digital communities offer youth the chance to circulate their own content and establish their own norms.

Studying a website for women of South Asia, Mitra (2004) has argued that "the Internet is providing a unique forum for the dispossessed to find a voice in the public sphere" (p. 492). The Internet as such might be taken up by minorities to assert their presence. In her study on the use of discussion boards by Moroccan Dutch girls, Brouwer (2006) extends Mitra's notion and states that these boards are informal meeting places that give Moroccan Dutch girls a voice. Focusing on issues of religion, gender, ethnicity, and sexuality, she argues that Moroccan Dutch girls "are more restricted in their freedom than boys," again illustrating how migrant girls are often seen as the upholders of traditional values. Moroccan Dutch forums are taken up by girls to voice the struggles they experience in their efforts "to negotiate strict Muslim demands placed on them with liberal youth culture." In the relative

anonymity of the site, "girls raise all kinds of sensitive issues such as rela-
tionships, marriage, or religion which they would dare not discuss in public."
The discussion boards allow girls to escape the social control of their parents
and negotiate their positionality in between in a complex field of power rela-
tions by discussing "their own ideas about the role of Dutch Moroccan
women in society, stressing the importance of independence, education, and
making individual choices within an Islamic context."

Discussing portals and discussion boards developed in England by black
British, Indian/South Asian, Chinese, and Muslim communities, Siapera
(2006) argues that these sites bridge two dilemmas of multiculturalism, that
of "particularism that leads to isolation and fragmentation" on one side of the
spectrum and "universalism that ultimately negates all difference" on the
other, far side of the spectrum. She notes that the sites allow a glance at quo-
tidian multicultural politics. Users of the boards show "everyday or more
prosaic multicultural conduct where one can observe the ongoing struggle
between different understandings of our life together" (p. 21). As a contem-
porary counterpart to "hush harbors" where slaves gathered away from the
gaze of white masters, migrant youth and other minoritarian subjects turn to
discussion boards to carve out a space for public community formation and
to assert their voice.

What is, however, lacking in these studies is an assessment of gender,
class, and religious power relations that operate in forums. Nor do these stu-
dies report which practices are surveilled, included/excluded, and by whom.
More research is needed to assess how these hush harbors relate to main-
stream society and the dominant discourses that persist there. Judging by the
popularity of these forums, hush harbors are apparently still necessary, indi-
cating that migrant youth's voices remain isolated from mainstream (offline)
discourses. Do these hushed voices ever invade the mainstream online and/or
offline, or are they a digital dead-end, as they remain ghettoized? And what
happens when members of the majority engage with these boards? Are they
excluded or welcomed? And what do they contribute? A closer look at how
such practices in the digital realm relate to and cross over to the offline world
would provide us with more insight into the roles of these harbors in the lives
of minoritarian subjects.

Conclusions

Turning to the interaction between mass migrations and digital mediation, this chapter has explored the intersectional performativity of self of migrant youth across centers and margins of the digital realm. Puwar (2004) recognizes that "different bodies belonging to 'other' places are in one sense out of place as they are 'space' invaders" (p. 33). Migrant youth do not fit some of the white, masculine, and Western normative templates of the Internet. By means of their digital practices, they become "space invaders" of material-embodied, semiotic-discursive, and socio-technological norms and practices. The three communicative spaces explored—online social networking sites, instant messaging, and online discussion boards—offer a view of the various ways youth manifest their multiply located selves. Lefebvre (2002) argues that "each living body is space and has its space: it produces itself in space and it also produces that space" (p. 170). Recognizing also the downside to these spaces, such as the commodification of digital behavior by profit-oriented corporations as well as increasing governmental surveillance in the case of SNS, dangers of pedophiles who pass as young people in the case of IM, and the apparent disconnect of migrant voices with the mainstream in discussion boards, the works discussed highlight how migrant youth are actively becoming producers of digital spaces. The three digital spaces have strong implications for thinking about what happens when "those whose bodies are not the norm in these places take up these very positions" (Puwar, 2004, p. 34).

The symbolical grammars of difference with which migrant youth cope are not only oppressive regimes but can also be empowering tools. From sometimes being "symbolically homeless" offline (Grosz; cited in Puwar, 2004, p. 147), they are able to assert and transform their own multi-axial and differential representations online. By doing so, they can work against narrow-fitting allocated positions and expose shallow stereotypes of migrant youth as absolute others. Intersectional cyberfeminists attuned to minoritarian subjects can uncover more such hidden experiences in order to assert how various intersecting axes of differentiation—such as gender, sexuality, religion, and diaspora—impact lives across online/offline divides.

Acknowledgments

This chapter was developed in the context of the Utrecht University *Wired Up* research project on "Digital media as innovative socialization practices

for migrant youth" and the E.U. *MIG@NET* project on "Transnational digital networks, migration and gender." My appreciation goes to Radhika Gajalla and one anonymous reviewer for their helpful comments and suggestions. Honor and respect to my mother, Jeannette Leurs-Kersten, who went to eternal rest as I was writing this chapter.

Notes

1 See, for instance, Rajaram and Grundy-Warr (2007) and Tsianos and Karakayali (2010).
2 For an overview of feminist technoscience studies, see the special issue on feminist technoscience studies of the *European Journal of Women Studies* edited by Åsberg and Lykke (2010). They characterize cyberfeminism as a theoretical and methodological approach for doing feminist technoscience studies (2010, p. 300).
3 For a thorough discussion of intersectional thinking, see the special issue of the *European Journal of Women Studies* edited by Phoenix and Pattynama (2006). They argue that intersectionality "foregrounds a richer and more complex ontology than approaches that attempt to reduce people to one category at a time" (p. 187).

Works Cited

Aoyama, S. (2007). *Nikkei-ness: A cyber-ethnographic exploration of identity among the Japanese Peruvians of Peru*. Unpublished thesis, Mount Holyoke College, South Hadley, MA.

Appadurai, A. (1996). *Modernity at large. Cultural dimensions of globalization*. Minneapolis: University of Minnesota Press.

Åsberg, C., & Lykke, N. (2010). Special issue on feminist technoscience studies. *European Journal of Women's Studies, 17*(4), 299–444.

Barad, K. (2007). *Meeting the universe halfway: Quantum physics and the entanglement of matter and meaning*. Durham, NC: Duke University Press.

Baron, N. (2008). *Always on: Language in an online and mobile world*. Oxford: Oxford University Press.

Brah, A. (2003). Diaspora, border and transnational identities. In R. Lewis & S. Mills (Eds.), *Feminist postcolonial theory: A reader* (pp. 613–634). Edinburgh: Edinburgh University Press.

Brouwer, L. (2006). Giving voice to Dutch Moroccan girls on the Internet. *Global Media Journal, 5*(9). Retrieved from http://lass.calumet.purdue.edu/cca/gmj/fa06/gmj_fa06_brouwer.htm

Butler, J. (1997a). *Excitable speech: A politics of the performative*. New York: Routledge.

Butler, J. (1997b). Performative acts and gender constitution. In K. Conboy, N. Medina, & S. Stanbury (Eds.), *Writing on the body: Female embodiment and feminist theory* (pp. 401–418). New York: Columbia University Press.

Byrne, D.N. (2008). The future of the "race": Identity, discourse, and the rise of computer-mediated public spheres. In A. Everett (Ed.), *Learning race and ethnicity: Youth and digital media* (pp. 15–38). Cambridge, MA: MIT Press.

Consalvo, M. (2003). Cyberfeminism. In S. Jones (Ed.), *Encyclopedia of new media* (pp. 108–109). Thousand Oaks, CA: Sage.

Durham, M.G. (2004). Constructing the "new ethnicities": Media, sexuality and diaspora identity in the lives of South Asian immigrant girls. *Critical Studies in Media Communication, 21*(2), 140–161.

Everett, A. (2002). The revolution will be digitized: Afrocentricity and the digital public sphere. *Social Text, 20*(2), 125–146.

Fox, A.B., Bukatko, D., Hallahan, M., & Crawford, M. (2007). The medium makes a difference: Gender similarities and differences in instant messaging. *Journal of Language and Social Psychology, 26*(4), 389–397.

Gajalla, R., Rybas, N., & Altman, M. (2008). Racing and queering the interface: Producing global/local cyberselves. *Qualitative Inquiry, 14*(7), 1110–1133.

Gómez-Peña, G. (2000). *Dangerous border crossers: The artist talks back.* London: Routledge.

Haraway, D. (1997). *Modest_Witness@Second_Millenium.FemaleMan©_meets_OncoMouse™: Feminism and technoscience.* New York: Routledge.

Herring, S.C. (2003). Gender and power in on-line communication. In J. Holmes & M. Meyerhoff (Eds.), *The handbook of language and gender* (pp. 202–228). Oxford: Blackwell.

Jacobs, G. (2003, April). *Breaking down virtual walls: Understanding the real space/cyberspace connections of language and literacy in adolescents' use of instant messaging.* American Educational Research Association. Paper presented at the Annual Meeting of the American Educational Research Association. Chicago, IL.

Kambouri, N., & Parsanoglou, D. (2010). Transnational digital networks, migration and gender: Literature review and policy analysis. *Mig@Net deliverable, 3.* (pp. 1–45). Retrieved from http://www.mignetproject.eu/wp-content/uploads/2011/02/MIGNET_Deliverable_No3_Literature_review_and_policy_analysis_Final1.pdf

Kelly, D.M., Pomerantz, S., & Currie, D.H. (2006). "No boundaries"? Girls' interactive, on-line learning about femininities. *Youth & Society, 38*(1), 3–28.

Lam, E. (2009). Multiliteracies on instant messaging in negotiating local, translocal, and transnational affiliation: A case of an adolescent immigrant. *Reading Research Quarterly, 44*(4), 377–397.

Lefebvre, H. (2002). *The production of space.* Oxford: Blackwell.

Leurs, K.H.A., & Ponzanesi, S. (2011a). Mediated crossroads: Youthful digital diasporas. *M/C Journal* [special issue on "Diaspora"], *14*(2). Retrieved from http://journal.media-culture.org.au/index.php/mcjournal

Leurs, K.H.A. & Ponzanesi, S. (2011b). Communicative spaces of their own: Migrant girls performing selves using instant messaging software. *Feminist Review* [special issue on "Media Transformations"], *99, 56–79*.

Lo Bianco, J. (2000). Multiliteracies and multilingualism. In B. Cope & M. Kalantzis (Eds.), *Multiliteracies: Literacy learning and the design of social futures* (pp. 92–105). London: Routledge.

Lykke, N., & Braidotti, R. (Eds.). (1996). *Between monsters, goddesses and cyborgs: Feminist confrontations with science, medicine, and cyberspace.* London: Zed Books.

Mainsah, H. (2009). *Ethnic minorities and digital technologies. New spaces for constructing identity.* Unpublished doctoral dissertation, Oslo University, Norway.

Mitra, A. (2004). Voices of the marginalized on the Internet: Examples from a website for women of South-Asia. *Journal of Communication, 54*(3), 492–510.

Nakamura, L. (2010). Race and identity in digital media. In J. Curran (Ed.), *Media and society* (pp. 336–347). London: Bloomsbury.

Odin, J.K. (1997). The edge of difference: Negotiations between the hypertextual and the postcolonial. *Modern Fiction Studies, 43*(3), 598–630.

Palfreyman, D., & Al Khalil, M. (2003). "A funky language for teenzz to use": Representing gulf Arabic in instant messaging. *Journal of Computer Mediated Communication, 9*(1). Retrieved from http://jcmc.indiana.edu/vol9/issue1/palfreyman.html

Pels, T., & De Haan, M. (2003). *Continuity and change in Moroccan socialization.* Utrecht: Verwey Jonker and Utrecht University.

Phoenix, A., & Pattynama, P. (2006). Special issue on intersectionality. *European Journal of Women's Studies, 13*(3), 187–298.

Protalinski, E. (2011, March 29). Facebook backpedals: Removes Third Palestinian Intifada pageagainst Israel. *ZDNET.* Retrieved from http://www.zdnet.com/blog/facebook/face book-backpedals-removes-third-palestinian-intifada-page-against-israel/1049

Puwar, N. (2004). *Space invaders. Race, gender and bodies out of place.* Oxford: Berg.

Quan-Haase, A., & Young, A.L. (2010). Uses and gratifications of social media: A comparison of Facebook and instant messaging. *Bulletin of Science Technology & Society, 30*(5), 350–361.

Rajaram, P.K., & Grundy-Warr, C. (2007). *Borderscapes: Hidden geographies and politics at territory's edge.* Minneapolis: University of Minnesota Press.

Reid, E. (1993). Electronic chat: Social issues on Internet relay chat. *Media International Australia, 67,* 62–70.

Reyes, L. (2011, March 31). Berlusconi rescues tiny Italian island from invading migrants. *Digital Journal.* Retrieved from http://www.digitaljournal.com/article/305224

Siapera, E. (2006). Voices of the marginalized on the Internet: Examples from a website for women of South Asia. *Journal of Communication, 54*(3), 492–510.

Sundén, J. (2003). *Material virtualities. Approaching online textual embodiment.* New York: Peter Lang.

Sundén, J. (2007). On cyberfeminist intersectionality. In M. Sveningsson Elm & J. Sundén (Eds.), *Cyberfeminism in northern lights* (pp. 30–50). Newcastle, UK: Cambridge Scholars Publishing.

Trinh, M.T. (1992). *Framer framed.* New York: Routledge.

Tsianos, V., & Karakayali, S. (2010). Transnational migration and the emergence of the European border regime: An ethnographic analysis. *European Journal of Social Theory, 13*(3), 373–387.

Turkle, S. (1995). *Life on the screen*. London: Weidenfeld & Nicolson.

Wajcman, J. (2007). From women and technology to gendered technoscience. *Information, Communication & Society, 10*(3), 287–298.

Wekker, G. (2009). Where the girls are...some hidden gendered and ethnicized aspects of higher education in the Netherlands. In S. Vandayar & M. Nkomo (Eds.), *Thinking diversity, building cohesion: A transnational dialogue on education* (pp. 151–164). Amsterdam: Rozenberg.

Yi, Y. (2009). Adolescent literacy and identity construction among 1.5 generation students. *Journal of Asian Pacific Communication, 19*(1), 100–129.

List of Contributors

Lauren Angelone has her PhD in Cultural Foundations, Technology, and Qualitative Inquiry from Ohio State University. She is currently Adjunct Professor of Instructional Technology at the University of Cincinnati and an eighth-grade science teacher.

Jessica L. Beyer recently completed her PhD in Political Science at the University of Washington, Seattle. Her research focuses on technology and society, in particular online communities, youth political mobilization, and the state.

Jessie Daniels (PhD, Sociology, University of Texas-Austin) is Associate Professor of Urban Public Health at the City University of New York (CUNY) Graduate Center and at Hunter College. She is also a Senior Fellow at the Center for Health, Media and Policy at Hunter College. Her work on race, gender, sexuality, and new media has appeared in the journals *New Media & Society*, *Women's Studies Quarterly*, and in her books, which include *Cyber Racism* (Rowman & Littlefield, 2009) and *Google Bombs, Cloaked Sites and Astroturf* (Routledge, 2012).

Genesis Downey is Associate Professor of English at Owens Community College, Ohio, where she teaches composition, Holocaust literature, and popular culture. She received her MFA in Creative Writing at the University of Michigan and is presently pursuing her doctorate in American Culture Studies at Bowling Green State University. Her academic interests include game studies (particularly in regard to second- and third-generation gamers), dystopian film, production culture, and RPG narrative structures.

Radhika Gajjala (PhD, University of Pittsburgh, 1998) is Professor of Media and Communication at Bowling Green State University and currently Director of the American Culture Studies program. Her book *Cyberselves: Feminist Ethnographies of South Asian Women* (Altamira) was published in 2004. She has co-edited collections on *South Asian Technospaces, Global Media Culture and Identity,* and *Webbing Cyberfeminist Practice* (Peter Lang, 2008). Her latest book, *Weavings of the Real and Virtual: Cyberculture and the Subaltern,* is forthcoming in 2012. She is currently working on two interrelated projects—one on microfinance online and money in virtual worlds and social media in relation to the ITization and NGOization of Global socio-economic work and play environments, and the other on coding and placement of affect and labor in digital diasporas, while also working on an edited collection on digital diasporas and globalization.

Debbie James is Assistant Professor of Emerging Communication Technology and Media Convergence Practices at Governors State University (Illinois), Department of Communication. James won the International Communication Association's Top Paper and Top Graduate Student Paper awards in 2011 in the Global Communication and Social Change Division and has published her work in *Studies in Documentary Film, Flow,* and *Scope.* She was further honored to share a 2010 Emmy award for the documentary project *WatRUfightn4,* which she received while serving at Wayne State University's television production studio. Along with her academic activities, James has collaborated on a digital storytelling workshop with the Stockholm Challenge Award-winning Container Project in Jamaica.

Holly Kruse is Assistant Professor in the Department of Communications at Rogers State University. Her research on communication technologies has been published in the journals *New Media and Society, Television and New Media, Popular Music and Society, First Monday,* and others. She is the author of the book *Site and Sound: Understanding Independent Music Scenes* (Peter Lang, 2003) and has a doctorate in communication from the Institute of Communications Research at the University of Illinois.

Erica Kubik completed her doctorate in American Culture Studies at Bowling Green State University. She is currently teaching at Davenport Uni-

versity for its online Social Sciences Department. She continues to be interested in spaces of gaming culture and their impact on gender formation. She can be contacted at Erica.Kubik@davenport.edu.

Koen Leurs is a PhD candidate in Gender Studies at Utrecht University, The Netherlands. For Wired Up, a research project on digital media as innovative socialization practices for migrant youth, he examines the gendered and ethnic interfacing of digital technologies, migration, and global/local youth cultures. He also participates in the E.U.-funded MIG@NET project, exploring education and knowledge in the context of transnational digital networks, migration, and gender. Among his publications are "Communicative Spaces of Their Own: Migrant Girls Performing Selves Using Instant Messaging Software," in *Feminist Review, 99* (2011); "Mediated Crossroads: Youthful Digital Diasporas," in *M/C Journal, 14*(2) (2011); "Gendering the Construction of Instant Messaging," in *Women and Language: Essays on Gendered Communication Across Media*, edited by Melissa Ames and Sarah Himsel Burcon (McFarland, 2011); and "Dutch-Moroccan Girls Performing Their Selves in Instant Messaging Spaces," in *The Handbook of Gender, Sex and Media*, edited by Karen Ross (Wiley-Blackwell, 2012), all with Sandra Ponzanesi.

Marina Levina is Assistant Professor in the Department of Communication at the University of Memphis. Her research focuses on critical cultural studies of science, technology and medicine, visual culture, and media studies. She has published work on health information technology, personal genomics, networks and globalization, and visual culture's engagement with scientific and medical research. She is currently working on a manuscript entitled *Pandemics in the Media* (under contract with Peter Lang); an edited collection, *Monstrous Culture in the 21st Century* (first editor with Diem-my Bui); a book chapter on biocapital and biotechnology in the film *Splice*; and articles on anticipation and affect in health information technology, biocitizenship and network subjectivity in personal genomics, and autoethnographic study of identity in personal genomics. She can be contacted at www.marinalevina.com.

Dara Persis Murray is a doctoral candidate in Journalism & Media Studies at Rutgers University, where she completed a Certificate in Women's and Gender Studies.

Yeon Ju Oh is a PhD candidate in the School of Media and Communication at Bowling Green State University. Her research interests encompass women in technology, the relationship between gender and new media technologies, gender/racial/ethnic identities in online space, and feminist knowledge production. She is currently working on her dissertation on female software programmers and their ethics and politics in producing digitally mediated knowledge. She was a researcher in the Korean Women's Development Institute in South Korea and participated in writing a draft of "The 3rd Basic Scheme for Korean Women's Policy." She was also involved in the War and Women's Human Rights Center in South Korea as a researcher and an activist, co-editing a testimony book of "Comfort Women" survivors.

Natalia Rybas is Assistant Professor of Communication Studies at Indiana University East. She does research at the intersections of critical cyber culture and feminist studies. Her research and teaching interests revolve around the issues of identity and difference in the context of computer-mediated communication. The key words describing her work include cyber culture, relationships and identity online, ethnography online, cyber feminism, and power and difference at the intersections of online and offline communication. Her work has appeared in *Qualitative Inquiry, Feminist Media Studies, Forum: Qualitative Social Research,* and edited collections.

Rosalind Sibielski received her PhD in American Culture Studies from Bowling Green State University, where she is currently Instructor in the Department of Theatre and Film. Her research interests include representations of girlhood in popular media and popular attitudes toward feminism. She has had essays published in *The Projector: Film and Media Journal, Feminist Media Studies*, and *Rhizomes*, and is currently working on a study of the discourse of girl power in contemporary U.S. popular culture.

Becky Walker received her PhD from the University of Wollongong in 2010. Her main research focuses on queer fandom and lesbian communities online. Her recent publications include "Deliberative Democracy in Online

Lesbian Communities," in *the International Journal of Feminist Media Studies* (2008); and "Imagining the Future of Lesbian Community: The Case of Online Lesbian Communities and the Issue of Trans," in *Continuum: Journal of Media and Cultural Studies*, and "The L Word fan fiction reimagining intimate partner violence," in *Participations, 7*(2) (2010). She has also co-published on wider media issues such as the Olympics in D. Marshall, B. Walker, and N. Russo, "Mediating the Olympics," in *Convergence, 16*(3) (2010). Her email is walkerresearch@y7mail.com.

Jennifer Way is Associate Professor of Art History at the University of North Texas, where she teaches the history, theory, and methodology of art since 1900.

Index

General Editor: Steve Jones

Digital Formations is the best source for critical, well-written books about digital technologies and modern life. Books in the series break new ground by emphasizing multiple methodological and theoretical approaches to deeply probe the formation and reformation of lived experience as it is refracted through digital interaction. Each volume in **Digital Formations** pushes forward our understanding of the intersections, and corresponding implications, between digital technologies and everyday life. The series examines broad issues in realms such as digital culture, electronic commerce, law, politics and governance, gender, the Internet, race, art, health and medicine, and education. The series emphasizes critical studies in the context of emergent and existing digital technologies.

Other recent titles include:

Felicia Wu Song
Virtual Communities: Bowling Alone, Online Together

Edited by Sharon Kleinman
The Culture of Efficiency: Technology in Everyday Life

Edward Lee Lamoureux, Steven L. Baron, & Claire Stewart
Intellectual Property Law and Interactive Media: Free for a Fee

Edited by Adrienne Russell & Nabil Echchaibi
International Blogging: Identity, Politics and Networked Publics

Edited by Don Heider
Living Virtually: Researching New Worlds

Edited by Judith Burnett, Peter Senker & Kathy Walker
The Myths of Technology: Innovation and Inequality

Edited by Knut Lundby
Digital Storytelling, Mediatized Stories: Self-representations in New Media

Theresa M. Senft
Camgirls: Celebrity and Community in the Age of Social Networks

Edited by Chris Paterson & David Domingo
Making Online News: The Ethnography of New Media Production

To order other books in this series please contact our Customer Service Department:

(800) 770-LANG (within the US)
(212) 647-7706 (outside the US)
(212) 647-7707 FAX

To find out more about the series or browse a full list of titles, please visit our website:
WWW.PETERLANG.COM